GENDER MATTERS

GENDER MATTERS

Women's Studies for the Christian Community

June Steffensen HAGEN, General Editor

Academie
Books Grand Rapids,
Michigan
Zondervan Publishing House

Gender Matters
Copyright © 1990 by June Steffensen Hagen

ACADEMIE BOOKS is an imprint of Zondervan Publishing House,
1415 Lake Drive, S.E., Grand Rapids, Michigan 49506.

Library of Congress Cataloging in Publication Data

Gender matters : women's studies for the Christian community / June
 Steffensen Hagen, general editor.
 p. cm.
 Includes bibliographical references.
 Contents: Theology and feminism / David W. Diehl — The new
 reality in Christ / Scott E. McClelland — Discovering their
 heritage : women and the American past / Douglas W. Carlson —
 Reading with feminist eyes / June Steffensen Hagen — "That one
 talent which is death to hide" : Emily Dickinson and America's women poets
 / Marilyn I. Mollenkott — Absence and presence in the history of
 the arts / James W. Terry — Gender, society, and church / Winston
 A. Johnson — Prelude to equality / Sarah J. Couper — Encounter with
 women's spirituality / Roger M. Evans.
 ISBN 0-310-23571-5
 1. Women (Christian theology) 2. Feminism—Religious aspects-
 -Christianity. 3. Women's studies. I. Hagen, June Steffensen.
 BT704.G46 1990
 305.4'0242—dc20 89-38118
 CIP

Edited by Jan M. Ortiz
Designed by Jan M. Ortiz

Woodcut by Bethany Ruark Winkel

Printed in the United States of America

90 91 92 93 94 / EE / 10 9 8 7 6 5 4 3 2 1

For all our sisters and brothers
and, as promised,
especially for John and Anne

CONTENTS

ACKNOWLEDGMENTS

The authors appreciate the help received from the following:

The Alumni Association of The King's College— numerous grants

Samuel J. Barkat—vision and support

Sheila Barkat—hospitality

Michael Barnard—word processing

Crescent Street Writing Group—feedback

Diefenbaugh Technological Learning Center Staff— computer assistance

Joyce Quiring Erickson—inspiration

James Garcia—chart design for chapter four

Irene Genco—permission to use unpublished poems

Leonard G. Goss—sponsoring editor

David Langley—style assistance

Literature of the Oppressed—permission to reprint parts of "Jane Eyre at Fourteen, Twenty-Four, and Forty-Four" from vol. 1, Fall 1987

Jan M. Ortiz—editing

President's Discretionary Fund, The King's College—travel grant

William David Spencer—permission to reprint "A Gift of Sight: A Christmas Fable," *Daughters of Sarah*, November 1976

Nancy Staley—technical support

The spouses, families, friends, and students who urged us on with this project are too numerous to mention by name, but we thank you all.

FOREWORD

Arrangement of Chapters

Those wishing to read the book in large units should know that the chapters are arranged this way:

GENERAL AREA	DISCIPLINE
Religion	Chapter 1: Theology
	Chapter 2: Biblical Studies
	Chapter 9: Spirituality
Literature and the Arts	Chapter 4: Literary Criticism and the Novel
	Chapter 5: Poetry
	Chapter 6: Music and Art History
Social Sciences	Chapter 3: History
	Chapter 7: Sociology
	Chapter 8: Public Policy

Documentation

We use the Modern Language Association system of documentation—parenthetical notes in the text combined with "Works Cited" lists at the end of chapters. (In the social sciences chapters, the year of a study is sometimes included in the parentheses.)

Study Guide

For classroom or church-group use we offer study guides for each chapter. These consist of discussion questions, impromptu writing suggestions, topics for research, a short list of readings, and an extended list of readings. These bibliographies often go beyond the works cited in the chapters themselves.

ABOUT THE CONTRIBUTORS

June Steffensen Hagen is Professor of English at The King's College, Briarcliff Manor, New York. She received an M.A. from Duke University and a Ph.D. from New York University. An active scholar and teacher, she is the author of *Tennyson and His Publishers*.

Douglas W. Carlson is Associate Professor of History at The King's College, Briarcliff Manor, New York. He received an M.A. from Colorado State University and a Ph.D. from the University of Illinois, Urbana.

Sarah J. Couper is a therapist in New York. She received her M.S.W. from Fordham University. She was formerly Program Planner at Victim Services Agency, New York City.

David W. Diehl, a theologian, is Professor of Religion and Director of Academic Resources for Adult Education at Nyack College, Nyack, New York. He is a former Professor of Biblical Studies at The King's College. He received a Th.M. from Westminster Theological Seminary and a Ph.D. from Hartford Seminary Foundation. He has written articles for the *Journal of the Evangelical Theological Society* and for the *Evangelical Dictionary of Theology*.

Roger M. Evans is Professor of Religious Education, The King's College, Briarcliff Manor, New York. He received an M.A. from Bethel Theological Seminary and an Ed.D. from Southern Baptist Theological Seminary. He has also been adjunct Assistant Professor of Christian Education at Alliance Theological Seminary, Nyack, New York, and is a leader of workshops and retreats.

Winston A. Johnson is Curriculum Coordinator of Leadership Education for Adult Professionals (LEAP), and Associate Professor of Sociology at Indiana Wesleyan University. He received an M.A. from Gordon-Conwell Theological Seminary and a Ph.D. from SUNY, Buffalo. He has also served as full-time faculty at The King's College and Nyack College and as part-time faculty at Rockland Community College and Marist College. Dr. Johnson has authored articles for a number of publishers on sociological concerns and faith/learning issues.

13

Scott E. McClelland is Associate Professor of Religion, The King's College, Briarcliff Manor, New York. He received an M.A. from Wheaton College Graduate School, a Th.M. from Westminster Theological Seminary, and a Ph.D. from New College, University of Edinburgh (Scotland). He is the author of six articles in *Evangelical Dictionary of Theology* and "Galatians" in *Evangelical Commentary of the Bible* edited by Walter Elwell. He is also pastor of Grace Community Evangelical Free Church, Lake Katrine, New York.

Marilyn I. Mollenkott is Assistant Professor of English and former English Department Chair at The King's College, Briarcliff Manor, New York. She received an M.A. and a Ph.D. from New York University. During 1989-90 she will be preparing her dissertation on the "Sonnets of Gerard Manley Hopkins" for publication.

James W. Terry is Assistant Professor of Music, The King's College, Briarcliff Manor, New York. He received a Mus.M. from Westminster Choir College and an M.A. from Queens College.

INTRODUCTION

June Steffensen Hagen

The nine authors of this text never expected to write it—that is, five years ago we didn't. There we were, happily cultivating our own respective little gardens, turning over soil, watering seeds, sometimes encouraging a sprout to grow, even to flower. We ourselves were, for the most part, garden variety professors in a small Christian liberal arts college a short distance north of New York City.

But for differing reasons we all found ourselves working a new field: "women's studies." We banded together, turning our individual plots into a communal effort: we read, we taught, we wrote.

This introduction to that new field and the fruit of our labor offers an overview of the nine chapters to come and answers these questions:

What *is* "women's studies"?

Why should we write a book about it "for the Christian community"?

WHAT IS "WOMEN'S STUDIES"?

Women's studies is the name given to "research and learning in a feminist context" (Ruth xi). This new scholarly discipline has two sides: the *corrective* side that presents and analyzes experience in order to overcome intentional or unintentional omission, distortion, or trivialization of women in past learning; and the *creative* side that

contributes innovative research and theorizing about gender, societal patterns, human nature, and female achievement and culture.

Women's studies is a cutting-edge endeavor. In fact, "the explosion of research on women's experience is a revolutionary factor reshaping American education in the final two decades of the twentieth century" (Schuster 4). Such reshaping, of course, does not come without struggle. Some people treat this new learning as an aberrant byway, a dead-end specialty that lacks academic respectability as its subject lacks significance. Others respond that to attach the label, "insignificant," to over half the world's population and its experience through the millennia may suggest that traditional education has taken a limited-access highway or even a back road. These proponents—and we count ourselves among them—agree with the shapers of the women's studies program at Duke University, who recently observed:

> Faculty members—the vast majority male. . .—have been comfortable with the conventional view of their disciplines which, for the most part, did not include women. Where were the women artists in art history? How did women's writing fare in survey courses of literature? What part did women play in major historical events? What ideas about women's nature underlay philosophical and psychological discussions of them? The new scholarship on women is answering these and many other questions. Women's studies is helping to create that knowledge and is seeing to it that the answers find their way into the [college] curriculum. (Duke 1)

A curriculum limited mainly to the achievements of men accompanies other inequities in college education. Male students, for example, are encouraged to expression and leadership more than female students are. Furthermore, women students have fewer role models and potential mentors of their own sex throughout the institution because there are few top women administrators and few women senior faculty. The lower-paying, lower-prestige ranks are the woman's place in the academic home.

Those of us in Christian higher education, especially those struggling for a holistic vision of learning and faith, find the subtle academic limitations placed upon women doubly difficult to counter because women also carry a burden that the Christian community, unable or unwilling to perceive the full meaning of freedom in Christ, imposes on them. While preaching that Christ has set us free, Christians seem too often to practice societally generated patterns of bondage. Yet the Christian community has even more reason than others to examine itself and to break out of unfair patterns. The Gospel demands that we work to free the oppressed, that we be on the

side of the poor, that we strive for justice and peace. The example of Jesus himself shows us the possibility of respecting the dignity of every human being. All of Scripture bears a theme of equality.

The impetus for women's studies by scholars committed to the Christian faith, then, includes the kind of challenge American poet Adrienne Rich gives to the classroom teacher:

> Look at a classroom: look at the many kinds of women's faces, postures, expressions. Listen to the women's voices. Listen to the silences, the unasked questions, the blanks. Listen to the small, soft voices, often courageously trying to speak up, voices of women taught early that tones of confidence, challenge, anger, or assertiveness, are strident and unfeminine. Listen to the voices of the women and the voices of the men; observe the space men allow themselves, physically and verbally, the male assumption that people will listen, even when the majority of the group is female. Look at the faces of the silent, and of those who speak. Listen to a woman groping for language in which to express what is on her mind, sensing that the terms of academic discourse are not her language, trying to cut down her thought to the dimensions of a discourse not intended for her *(for it is not fitting that a woman speak in public)*; or reading her paper aloud at breakneck speed, throwing her words away, deprecating her own work by a reflex prejudgment: *I do not deserve to take up time and space.* (Rich 243–44)

The nine authors of this text have looked at our classrooms, we have listened to our students, we have learned our own limitations — and, as a result, we have worked in women's studies. Out of our efforts have come an introductory course and this book.

WHY "FOR THE CHRISTIAN COMMUNITY"?

In the spring of 1987 ten faculty at The King's College, an evangelical Christian liberal arts college in Briarcliff Manor, New York, team-taught to forty-five students an introductory women's studies course. We had prepared for the course for almost two years, tentatively working out some of the implications of this discipline in our traditional fields of theology, biblical studies, history, literature, music and art history, sociology, psychology, public policy, and Christian education. Because we value biblical truth, we engaged in a wholehearted effort to understand and then articulate the particular imperatives and concerns of the Christian faith as they supported, modified, and informed our woman-focused study.

Teaching that course also affected our teaching in the usual subject areas. There have been changes in content and methodology,

but even more significant have been the changes in our relationships to students. Women's studies has encouraged us to eschew the hierarchical patterning of our classrooms, to change the life of the mind from ladder climbing into quilt making. It has challenged us to encourage our female students out of the "sin" of low self-esteem instead of assuming that the male "sin" of pride bedevils them. We have tried to become exceptions to the usual rule that instructors call on male students more, encourage them more, and even learn their names faster than they learn the names of their female students.

Our own ways of learning have been affected, too. We have worked more collegially. Our awareness of other academic disciplines has increased. Because our group included both men and women, those married and those single, parents and those without children, those currently teaching and those in service professions such as counseling, social work, and church pastorates, we have crossed many of the often invisible barriers separating those of us with similar Christian commitments and academic training. Our richly varied denominational backgrounds (Baptist, Evangelical Free, Presbyterian, Christian and Missionary Alliance, Plymouth Brethren, and Episcopal) have also become a strength as we studied women's issues together. We have experienced some of the "unity in diversity" often spoken of by the body of Christ but seldom lived out.

Now as we present this introduction to women's studies to the Christian community, to study groups in churches and classrooms, and to individuals, we are able to articulate points of agreement that we did not have when we began our work. At first, for example, we quibbled over the word "feminist." Some felt the word fit us, others felt it did not, and all experienced uneasiness that even if the word fit it raised such red flags in so many minds that perhaps it was better avoided. Through time, however, and through a growing familiarity with "what's right with feminism" (Storkey 1986), we have found that this word, though coming out of a societal movement not universally valued by the church, can be used comfortably by those committed to Christ's kingdom. In fact, we have in common with all feminists the following beliefs:

> that women are not automatically or necessarily inferior to men, that role models for females and males in the current Western societies are inadequate, that equal rights for women are necessary, that it is unclear what by nature either men or women are, that it is a matter for empirical investigation to ascertain what differences follow from the obvious physiological ones, that in these empirical investigations the hypotheses one employs are themselves open to question, revision, or replacement. (Stevens and Stewart 76)

But as *Christians* who are biblical feminists we have even more fundamentally shared perspectives present from the start of our study and still central:

1) a commitment to taking the Bible, God's inspired word, seriously as the guide to faith and practice;

2) a biblical understanding of human beings, both male and female, as created in God's image—and marred by sin;

3) an assumption, again based on the Bible, that God intended male and female to live together in this life, caring for the world and each other and practicing love and justice;

4) an appreciation that Christ's redemptive work has changed the possibilities for human beings, that now we can fulfill God's intentions whereas without Christ we could not;

5) a recognition that the imperatives of the Gospel sometimes call us to go against the grain, to oppose received opinion, even when it has been received by the Christian community and thus seems sacrosanct.

Not all readers, of course, share these perspectives with us. And we would not expect them to do so. The reader who is not Christian, for example, may be able to start only from a point of simple curiosity: "I wonder what these Christians can possibly be doing in women's studies when the history of their own faith seems so filled with antiwoman campaigns and prejudices?" We hope that by the end of the book such readers will appreciate that Christian scholars have a valuable contribution to make to the wider world of women's culture.

On the other hand, some readers who share our Christian faith may be vehemently opposed to our feminist perspectives. We invite those readers to journey with us as fellow learners, able to take truth where we find it because we are secure in our knowledge of the one who calls himself "the way and the truth and the life" (John 14:6).

Most Christian readers probably share some of our starting points about gender, but not others. That is the group this book is most directly addressing—those who want to know more about women's studies because they suspect that the Christian community *should* be examining and debating and learning about this field. To these readers we offer our expertise in our respective disciplines and our investigations of how our respective disciplines are being dramatically changed.

Notice that we say "our investigation." We, too, are in the process of finding out. Though young in women's studies, as evidenced by our beginning with what Gerda Lerner in women's history calls "compensatory" and "contributory" efforts, we are old

enough to know that the very critical methods employed in our fields also need the insights of feminist criticism.

Each chapter of this book, therefore, has a common task:

—to provide a brief description of the specific field, be it theology, literary criticism, sociology, etc., including its subject matter, methodology, and inherent limitations;

—to build some framework, either explicitly or implicitly, for the way the Christian faith intensifies our involvement with that discipline;

—to give some analysis of why the new scholarship on women must be addressed by and incorporated into that discipline;

—to survey the different ways this is happening;

—to include an applied case discussion, on, for example, the Bible's "problem passages," *Jane Eyre*, battered women, the abolition and suffrage movements, and Clara Schumann.

VARIATIONS ON A THEME

Even with a shared task and our common perspectives as feminists and Christians, the writers provide different emphases in each chapter. These we think of as variations on a theme: we embroider with many colored threads the single fabric of creation and redemption—male and female in the image of God, "all one in Christ Jesus" (Gal. 3:28).

The first chapter, on theology, emphasizes the fair-minded reading of theologians doing a feminist critique of traditional religion. David W. Diehl gives full authority to Scripture while moving us beyond simplistic readings and quick judgments of theologians who may not conform to our party line. At the end he introduces issues such as patriarchy, women in ministry, the use of inclusive language, the cultural factor in biblical interpretation, and the large issue of general revelation, but he does not prescribe how such issues must be dealt with.

The biblical studies chapter, however, while still leaving many issues open because the texts are unclear, does commit to the grammatico-historical method of interpretation. Author Scott E. McClelland identifies this method as a "somewhat agreed to reference point among evangelicals within which to argue the meaning of texts." After a survey of the Bible's teaching about women, McClelland provides a detailed examination of Pauline passages, treating the apostle Paul as a "task theologian."

Because women's studies in America was pioneered by historians

and literary scholars, our chapters on history and literature have a great wealth of recent material to draw from and wide choices for concentration. Douglas W. Carlson chooses to examine the methodology of history—the way history is usually done—and presents in clear terms why Christians especially must not "fall prey to the tendency to ignore or devalue the past." His story of women in American history uses significant figures as reference points—from Anne Hutchinson to the Grimke sisters to "Rosie the Riveter," Carlson keeps us aware of particular people so we do not get lost in a welter of facts. Women as bearers of the image of God, persons of value who must receive just and fair treatment from their society and from those who interpret the past, motivate Carlson's involvement in women's history.

Whereas Carlson uses the image of God to argue the equal validity with men of women's experience in history, June Steffensen Hagen, author of "Reading with Feminist Eyes," uses that same concept to emphasize the uniqueness of women's experience as reflected in literature. She also delineates the various ways feminist perspectives appear in literary criticism today. Her story of changing ways of reading the novel *Jane Eyre* leads into a section on "girls' books and boys' books" and how those childhood reading patterns limit readers' ability to identify with others. Hagen's understanding of the Gospel is that the ministry of reconciliation requires identification across gender lines: she bases her whole discussion on a premise that literature can help us to love—first to love ourselves, and ultimately to love our neighbors as we love ourselves.

In the second literary chapter, readers will find Marilyn I. Mollenkott using an underlying commitment to full development of human potential as she surveys women poets in America and the achievements of Emily Dickinson. Mollenkott sees the restriction of another human being's creative possibilities as insulting to the Creator of all. Her ideas build from simple story and biography to unified close readings of Dickinson's poems of duplicity.

A similar theme of the danger of limiting God's good gift, human creativity, runs throughout James W. Terry's survey of women in music and art history in the Western tradition. Like Carlson in the American history chapter, Terry reviews what factors mitigate against women's achievements and how value judgments are made. Even though musical tradition was passed within families from fathers to sons, and women painters were closed out of classes drawing the nude, Terry finds astonishing the range and depth of women's accomplishments in both music and art. He explains the startling vision and the world of women such as Hildegard of Bingen, Clara

Schumann, Berthe Morisot and Georgia O'Keefe in a way that nonspecialists can understand.

Like the history discussion, the two other chapters on the social sciences—sociology and public policy—approach women's experiences and the models used to examine them with a highly empirical orientation. Winston Johnson, for example, in "Gender, Society, and Church," studies a range of topics germane to his field and to all of us today: changing gender role expectations in the United States; life changes of women as compared to men in American culture, especially participation in education, the economy, political life, and health; explanations for the differences between "masculine" and "feminine" and male and female; and a look at what the future holds regarding gender roles. Johnson reminds us of the interdependency of church and culture: "we do not operate as Christians in a social vacuum anymore than the early church did." Johnson concludes that for the Christian rank and authority must always give way to service.

The chapter on public policy sounds a call to action, summoning Christians first to become aware of oppression, second to provide relief for the oppressed, and then to work for systemic change. Sarah J. Couper looks at the feminization of poverty, including working women and domestic violence, suggesting throughout that like the Samaritan we must stop, notice, and aid; we cannot just "pass by."

The last chapter, "Encounter with Women's Spirituality," has a personal emphasis and asks the readers to read slowly and meditatively, to empathize with the struggles of a man trained in Christian ministry and education as he learns to "know through love" instead of through categories and analysis. Roger M. Evans reveals his early resistance to women's studies but also his willingness to change as he honestly confronts a new way of encountering himself, women, and the world. Readers must be willing to go through contexts, traditions, and temptations, even the Slough of Despond in order to reach with Evans the place of rest—actually the place of growth. Those who value the spiritual life will appreciate Evans's purpose: "to enter into [life], to learn to understand from the viewpoint of daily life and to comprehend it as others who inhabit it do, especially those who have been marginalized in our society. I have sought a perspective that would serve to deepen life with God."

We hope that after spending time with this text readers will realize that all nine authors share the same purposes.

Works Cited

Duke University, The Council on Women's Studies. Letter to Alumnae. Spring 1988.

Rich, Adrienne. "Taking Women Students Seriously." *On Lies, Secrets, and Silence: Selected Prose 1966–1978.* New York: Norton, 1979.

Ruth, Sheila. *Issues in Feminism: A First Course in Women's Studies.* Boston: Houghton Mifflin, 1980.

Schuster, Marilyn R., and Susan R. Van Dyne. "Curricular Change for the Twenty-First Century: Why Women?" *Women's Place in the Academy: Transforming the Liberal Arts Curriculum.* Edited by Marilyn R. Schuster and Susan R. Van Dyne. Totowa, N.J.: Rowman and Allanheld, 1985. 3–12.

Stevens, Bonnie Klomp, and Larry L. Stewart. *A Guide to Literary Criticism and Research.* New York: Holt, Rinehart and Winston, 1987.

Storkey, Elaine. *What's Right with Feminism?* UK: S.P.C.K., 1985. Reprinted, Grand Rapids: Eerdmans, 1986.

1

Theology and Feminism

David W. Diehl

When I began teaching theology courses in the late sixties, the term "feminist theology" was unknown. Some years later when I first heard the term I found the combination of "feminist" and "theology" rather peculiar. What did theology have to do with the secular women's liberation movement?

Was not feminism driving people away from the church whereas theology was seeking to involve people in the work of the church? I came to see that it is sometimes the other way around. At that time, however, theology and feminism seemed to me to have largely antithetical goals. But as I taught college students through the seventies and into the eighties, and as I observed the bright, self-confident woman I married, who has excelled in career and community service as well as in the home and has broken just about every negative stereotype about women, I have been constrained to take an interest in feminist concerns and how they have a bearing on theology.

In this chapter I intend to treat the relationship of theology and feminism by first defining the two terms and showing how their combination is not so peculiar. Then I will introduce the thoughts of some of the better-known feminist theologians. After that, I will develop a typology of five theological positions with respect to feminist concerns, and from this I will identify the main issues that have emerged from the interplay between theology and feminism— issues that have made feminist theology one of the most vital areas in the field of women's studies.

THE RISE OF FEMINIST THEOLOGY

Introduction: Some Terms

Theology is usually understood as the study of the knowledge of God—in particular, God's existence and nature and his works of creation, providence, revelation, and redemption. *Christian* theology is concerned with the knowledge of God as it is centered in Jesus Christ and his word in the Bible. There are different aspects of theology, such as biblical theology, which studies the teachings of the Bible in the perspective of biblical history; historical theology, which studies Christian teachings as they developed in Christian history; and systematic theology, which seeks to give a coherent account of the Christian faith in the *terms* and *context* of life and learning today.

Feminism according to *Webster's Third New International Dictionary* is "the theory of the political, economic, and social equality of the sexes" and the "organized activity on behalf of women's rights and interests." Feminist *theology*, then, is theology practiced from the perspective of the feminist theory of social equality. Feminist theology is therefore a type of systematic theology, as I defined systematic theology, insofar as feminist theology speaks of Christian or religious faith out of a particular context of contemporary life. Some would question, however, whether feminist theology is really systematic theology in the full sense as is Reformed theology, Thomistic theology, or neoorthodox theology. Does feminist theology have a total system of beliefs about God, humankind, sin, Christ, and salvation? Are we not, rather, talking about the application of Christian theology to women's rights and not about a distinct theology itself?

In answer to this question, feminist theologians point out that a person's social context influences his or her theology. Different social contexts may affect not only our views of how the Gospel *applies* to life but also our understanding of the very meaning of the Gospel and our understanding of God, to say nothing of our own self-understanding. Feminists contend that while traditional theology is practiced primarily from a male perspective, the female perspective also has something important to contribute. As Rosemary Radford Ruether says,

> The use of women's experience in feminist theology, therefore, explodes as a critical force, exposing classical theology, including its codified traditions, as based on *male* experience rather than on universal human experience. (*Sexism and God-Talk* 13)

Another way to understand the term "feminist theology" is to see it along with black theology and third-world theology as one of the types of liberation theology. Each type of liberation theology interprets the Bible and its central themes from the perspective of an oppressed group, whether it be the oppressed blacks suffering under white racism or the oppressed poor of South America. Each theology is an outgrowth of a social movement or conflict. Black theology grew out of the civil-rights movement of the fifties and sixties. Feminist theology grew out of a women's movement, precipitated by such books as Betty's Friedan's *Feminine Mystique* (1963) and Simone de Beauvoir's *Second Sex* (1949)—a movement that took significant form in 1966 with the founding of the National Organization of Women (NOW).

Women have always been a major force in the work of the church. However, theology was almost exclusively the province of men until the late sixties and early seventies. Since then a steady flow of books and articles on theology from a feminist perspective has appeared.

An early form of feminist theology appeared in an article written in 1960 by Valerie Saiving, entitled "The Human Situation: A Feminine View." In this article Saiving suggests that "one's sexual identity has some bearing on his [sic] theological views" (25). She illustrates this by showing how the differences between masculine and feminine experience can lead to differences in the doctrines of sin and redemption. For example, she speaks of contemporary, male-dominated theology as identifying sin with pride, will-to-power, exploitation, self-assertiveness, and the like; whereas in reality women's sinful temptations "are better suggested by such items as triviality, distractibility, and. . . in short, underdevelopment or negation of the self" (35, 37). This contrast drawn by Saiving may be oversimplified, but it illustrates the concern Christian feminists have that theology should express the Christian faith in a way relevant to women and not just to men.

The Revolutionary Path of Mary Daly

Perhaps the first major work written from this new perspective of feminist theology is Mary Daly's book *The Church and the Second Sex* (1968). Daly argues that the church has fostered a view of women as being inferior and that this has had much to do with the oppression of women. At this point Mary Daly was writing as a Roman Catholic and decried Thomas Aquinas's idea of the woman as a "defective male." Because of the Second Vatican Council she saw hope that the church was heading in a positive direction concerning women's equality (Daly ch. 3).

In 1973 Daly wrote *Beyond God the Father: Toward a Philosophy of Women's Liberation*. In this book we can see that she has moved in a more radical direction, far from mainstream Catholic theology. Her view is not just a matter of disliking the idea of God as Father; the book is a repudiation of just about everything in traditional theology because all of theology is guilty and condemned by association with the patriarchal culture of which it is a part. The doctrine of the Trinity and the eternal preexistence of Christ as the Son must go because they are part of a male-centered and male-dominated culture (*Beyond* 69–71). She rejects the doctrine of original sin because it is sexist and makes women the origin of evil (48, 49). Daly advocates that women must rename God, the world, and themselves according to their own experience as women, free of all male influence. She stresses the importance of naming as part of being human and as part of "the evolving spiritual consciousness of women" (8). In order to be free and authentic as women everything must be renamed in ways that are in contrast to the man-centered descriptions of biblical religion. Daly says that all nouns referring to God are inadequate and suggests it is best to call God "the Verb" (33–34). Furthermore she argues for an emerging sisterhood which by its anti-patriarchal nature must necessarily be understood as "Antichurch" (133).

When *Beyond* was published in 1973, Daly had not officially separated from the church, but her views of women's liberation were so radical that she had to speak of the evolving women's religion, which she advocated, in terms of opposition to the church in its traditional form. In *Gyn/Ecology: The Metaethics of Radical Feminism* (1978), Mary Daly's break with Christianity is complete. Here she is anti-Christian and anti-male, arguing for the superiority and separation of women into a new religious movement of lesbian radical feminists.

Some Theological Leaders

Rosemary Radford Ruether

Rosemary Radford Ruether, theologian at Garrett-Evangelical Theological Seminary, is one of the most prominent leaders in what may be called mainstream Christian feminism. While being committed to a thoroughgoing feminist position, she nevertheless is a committed Roman Catholic who dialogues with mainstream theologians. Her goal in feminism is the mutuality of women and men, not the separation and superiority of women, such as Mary Daly espoused. Ruether places her feminist concerns within the larger perspective of liberation theology in general and has written several books reflecting

this perspective. For example, *New Woman-New Earth: Sexist Ideologies and Human Liberation* (1975) examines the relationship of sexism with racism and other forms of social and economic oppression. For Ruether the feminist cause is important to human liberation as a whole because it points to a change of values from those of patriarchy—domination, possession, conquest, and accumulation—to the values of reciprocity and acceptance of mutual limitation (204–5).

Ruether's *Sexism and God-Talk: Toward a Feminist Theology* (1983) probably comes the closest of all feminist works to being a complete statement of systematic theology. In it she works her way through a feminist interpretation of the Christian doctrines of God, creation, anthropology, Christology, ecclesiology, and eschatology. This is significant because feminist theologians are often criticized for belaboring limited concerns and for not addressing the full range of subjects that Christian theology normally covers. Ruether seems to be attempting to rectify the situation.

Early in the book she identifies what she calls the "critical principle of feminist theology" and explains it as "the promotion of the full humanity of women." She further states,

> Whatever denies, diminishes, or distorts the full humanity of women is, therefore, appraised as not redemptive. Theologically speaking, whatever diminishes or denies the full humanity of women must be presumed not to reflect the divine or an authentic relation to the divine. . . . (*Sexism* 18–19)

Ruether frankly acknowledges that much of the Bible supports patriarchy and as such cannot be seen as revelatory or reflective of the divine. She believes, however, that the Bible contains "resources for the critique of patriarchy" and the pointing toward human liberation in all forms (22, 23). These resources are found in what she calls the "prophetic liberating traditions." These traditions oppose the oppression and evils of the existing social order throughout biblical history. Elsewhere she speaks of these traditions as essentially one tradition, calling it the "prophetic-messianic tradition." This tradition is characterized by a critical process "through which the biblical tradition constantly re-evaluates, in new contexts, what is truly the liberating Word of God. . ." (Ruether, "Feminist Interpretation" 117). Thus the biblical texts can be criticized and shown to be fallible, but they are criticized by a norm which the Bible itself gives (Ruether, *Sexism* 23). The norm is a self-criticizing process emerging in the prophets and culminating in Jesus. According to Ruether, "Jesus renews the prophetic vision whereby the Word of God does not validate the existing social and religious hierarchy but speaks on behalf of the marginalized and despised groups of society" (135–36).

Furthermore, Jesus presented his message of liberation according to the concept of servanthood.

> By becoming servant of God, one becomes freed of all bondage to human masters. Only then, as a liberated person, can one truly become "servant of all," giving one's life to liberate others rather than to exercise power and rule over them. (121)

Thus Jesus and the Bible help us to see the ultimate religious basis behind all true human liberation. Feminist theologians emphasize the need to use this prophetic vision of Scripture in the liberation of *women* in ways that even the Bible could not see or speak of (31– 33).

Ruether also explains that the modern application of the biblical liberation theme to women and other oppressed groups calls for the use of other sources beyond the Bible and traditional Christianity— e.g., resources from marginalized or "heretical" Christian traditions such as Gnosticism and non-Christian religions and philosophies, including Western liberalism and Marxism (21–22, 33–45). All of these can help us in universalizing the liberation message for all social contexts. Ruether's eschatology deemphasizes speculation about the afterlife and places emphasis on what can come to be here on earth.

Letty Russell

Another leader in mainstream feminist theology is Letty Russell, who teaches at Yale Divinity School. She was ordained a Presbyterian minister in 1958 and served as pastor of the East Harlem Protestant Parish for seventeen years. She is also a member of the Commission of Faith and Order of the National Council of Churches. In *Human Liberation in a Feminist Perspective: A Theology* (1974) she takes an approach similar to Ruether's, placing the problem of women's oppression in the larger context of the other forms of human oppression. The goal is the full humanity of both sexes and all the races and classes. She says,

> Feminist theology strives to be *human* and not just *feminine.* . . . Feminist theology today is, by definition, *liberation theology* because it is concerned with the liberation of all people to become full participants in human society. (19–20)

Furthermore, to be fully human in the Christian sense means to learn "servanthood," which does not connote inferiority or subordination but rather responsibility in love toward God and others. "Women and men are called by God in Jesus Christ to be both servants and apostles as representatives of the new humanity" (142).

In *The Future of Partnership* Russell argues that Christianity shows us how to be free from the hierarchical relationships of *domination* and to learn the model of partnership. The Trinitarian God is a relationship of mutual love and mutual laboring in the work of creation. Through Christ we come to be partners with God and with other human beings, sharing in "the work of caring for creation, setting the captives free and standing as witness for and with those who need an advocate" (34–35).

In her article "Authority and the Challenge of Feminist Interpretation," Letty Russell expresses herself very personally about the authority of Scripture in her life. She admits that she cannot hold to the traditional view of inspiration whereby everything that the Bible asserts must be considered true or right. She says,

> The Bible has authority in my life because it makes sense of my experience and speaks to me about the meaning and purpose of my humanity in Jesus Christ. In spite of its inconsistencies and mixed messages, the story of God's love affair with the world leads me to a vision of New Creation that impels my life. (138)

She seems to reflect the neoorthodox tradition when she says,

> Divine inspiration means that God's Spirit has the power to make the story speak to us from faith to faith. The Bible is accepted as the Word of God when communities of faith understand God to be speaking to them in and through its message. (141)

She further explains that communities of faith hear God speak when they engage in the twofold process of imaginative reflection on Scripture and liberating actions in church and society (141–43). This emphasis on the interplay of reflection and action is common in most liberation theologies.

In *Household of Freedom: Authority in Feminist Theology* Russell takes up the question of how all of God's people share authority in the sense of servanthood and partnership in fulfilling the will of God as "housekeeper of all creation."

Elizabeth Schüssler Fiorenza

Elizabeth Schüssler Fiorenza, the Krister Stendahl Professor of New Testament at Harvard Divinity School, takes a more radical approach to Christian feminism than does either Ruether or Russell. Unlike them, Fiorenza cannot find any tradition or prophetic theme throughout the Bible that can form the authoritative base for feminist theology. As Randy Maddox puts it, for Fiorenza "Scripture can function only as a source or prototype, not an unchanging norm for Christian feminist theology" (Maddox, "The Word of God and

Patriarchalism" 212). She sees the patriarchal bias as pervading the whole of Scripture.

What, then, is the norm for theology? Fiorenza answers with the concept of "women-church," which she explains as a "movement of self-identified women and women-identified men in biblical religion" ("The Will to Choose or to Reject" 126).

She says,

> The locus or place of divine revelation . . . is therefore not the Bible or the tradition of a patriarchal church but the *ekklesia* of women and the lives of women who live the "option for our women selves." It is not simply "the experience" of women but the experience of women (and all those oppressed) struggling for liberation from patriarchal oppression. ("Will to Choose" 128)

For Fiorenza, the Bible in itself is far from being the Word of God, the final authority for faith and practice. Yet the Bible remains the important source for the identity of women-church as a religious movement in history as well as today. Fiorenza explains that women-church existed in the earliest form of Christianity and stemmed from the liberating model that Jesus himself lived in his relation to women. But this women-church was soon repressed by the developing patriarchal structure of the established church and so survived in a very repressed and sometimes almost nonexistent form (*Bread Not Stone* ch. 4, 153, n. 20). But today women-church has come alive with the help of the larger women's liberation movement. The Bible, then, is the book of women-church insofar as it is the resource for the origin of women-church. But the Bible must be interpreted according to the norm of the *experience* of women-church—i.e., the experience of women struggling to be freed of patriarchal oppression.

Thus Fiorenza speaks of five elements or steps involved in feminist hermeneutics—i.e., five principles of biblical interpretation ("Will to Choose" 130–36). The first is a hermeneutic of *suspicion*—we must approach the Bible with caution, able to recognize its destructive, patriarchal elements. Second is the critical, evaluative step in which the biblical texts "must be tested as to their feminist liberating content." Third is the step of proclamation—proclaiming the message of liberation and speaking out against the church's use of patriarchal texts and concepts. Fourth is the need for remembrance and reconstruction of the stories and lives of biblical women who struggled against oppression. Here it is often necessary to read between the lines to recover the half-hidden truths about women-church in the Bible. Finally there is the hermeneutics of creative ritualization or the step of creative revisioning. "Women not only rewrite biblical stories but also reformulate patriarchal prayers and

create feminist rituals for celebrating our foremothers" ("Will to Choose" 135). In this fivefold process of interpreting Scripture the Bible is seen, not as the archetype for Christian truth, but rather as a "historical prototype." In other words, imperfect though it may be, the Bible is a point of historical departure, so to speak, that "provides women-church with a sense of its own ongoing history as well as Christian identity" (136).

For many Christian theologians there are at least two major criticisms of Fiorenza's position. First, it wipes out the authority of Scripture in any objective sense. Ruether and Russell found a core or norm within the Bible itself, but Fiorenza places the norm completely outside the Bible, namely, in the experience of women-church. She argues that the Bible originated from a community of faith and that the ongoing normativeness or relevance of the Bible must be decided by the community of faith in each generation. She rejects as hopelessly archaic the idea that the prophets and apostles of Scripture may have had special inspiration. The question then is, in what sense can Fiorenza's theology be called Christian once she has rejected the normativeness of Scripture in whole or in part?

The second criticism is that she has a very exclusive view of the church. Her view of "women-church" would seem to separate her church from much of Christ-centered Christianity. Her answer to this point is as follows:

> Just as we speak of the church of the poor, of an African or Asian Church, of Presbyterian, Episcopalian, or Roman Catholic churches, without relinquishing our theological vision of the universal Church, so we may speak of the church of women as a manifestation of this universal Church. (*Bread Not Stone* 7)

In spite of this answer it remains to be seen whether "women-church" will grow as part of the larger church or become a sect alienated from it.

Phyllis Trible

One more feminist theologian who should be considered in this section is Phyllis Trible. A theologian at Union Theological Seminary in New York, she has much more reverence for the Bible than Fiorenza has. As a specialist in biblical literature Phyllis Trible has been a leader among feminists in doing careful exegesis of Scripture to bring out woman's story and the positive themes of equality and liberation that are present in the biblical text itself.

In *God and the Rhetoric of Sexuality* (1978) Trible engages in a literary analysis of a selection of biblical texts relevant to feminism.

She calls her method of approach "rhetorical criticism," an approach that seeks the meaning of a text by viewing it as "a literary creation with an interlocking structure of words and motifs" (8). She begins with Genesis 1:27 and argues from the literary structure of this verse and its context that *man* as both male and female denotes equality and not hierarchy between the sexes (*Rhetoric* 12–19). She further points out that "male and female" becomes a key metaphor for the meaning of "image of God." Although God is beyond sexuality, the equality of male and female in the *image* of God provides a basis for investigating and proclaiming female metaphors for God in the Bible equally as valid as male metaphors (20–23). Trible proceeds to examine various little-known female metaphors to show that the fullness of God's character is best known through the variety of descriptions found in both sexes, e.g., mother (Isa. 66:13), midwife (Ps. 22:9), mistress (Ps. 123:2), and pregnant woman (Isa. 42:14). She also considers various texts on male/female relations such as the love poem in the Song of Songs, which portrays equality and mutuality of the sexes, and the story of Ruth and Boaz as studies of liberated women in a patriarchal culture (*Rhetoric* chs. 5–6). Similarly she has worked in numerous articles and in her recent book, *Texts of Terror*, to help men and women alike reclaim woman's story within the Bible.

Evangelicals and Feminism

Letha Scanzoni and Nancy Hardesty

The ground-breaking work within the evangelical camp is the book by Letha Scanzoni and Nancy Hardesty, *All We're Meant to Be*, which appeared in 1974. The authors go through the relevant texts of Scripture, showing the themes of equality and mutuality of the sexes. They approach the Bible from a high view of biblical authority. They try to show that equality is God's original plan and that though male domination came through sin, the New Testament message of redemption in Christ means restoration to freedom and equality among races, sexes, and classes of people. They argue for a nonauthoritarian understanding of "headship," and see the apostle Paul's injunction about women's silence in the church as a case of solving a problem of disorderliness in Christian gatherings and not a prescription against women teachers or ministers. The authors' aim is to present a biblical Christian view of women as full persons free to grow, learn, develop, and fully utilize their God-given talents and abilities in the home, the church, and the work world.

Paul Jewett and Virginia Mollenkott

Paul Jewett of Fuller Seminary wrote *Man as Male and Female,* which was published in 1975. It is a scholarly treatment of Scripture and Christian history on the nature of humankind as centered in the relationship of man and woman. Jewett rejects the hierarchical model of male and female in favor of a partnership model. He reaches a position about Paul the apostle that goes contrary to what most evangelicals would allow; he contends that while Paul caught the vision of the equality of the sexes in Christ, his teaching on women's subordination reflects a rabbinical bias inconsistent with the full application of the Gospel itself (119). Notwithstanding this controversial point, Jewett's book has done much to nudge evangelicals to reconsider the central teachings of Scripture on male/female relations. Virginia Ramey Mollenkott's *Women, Men and the Bible* (1977) takes a position similar to Jewett's on a qualified view of Pauline authority. Mollenkott says,

> I believe that Paul's arguments for female subordination, which contradict much of his own behavior and certain other passages he himself wrote, were also written for our instruction: to show us a basically godly human being in process, struggling with his own socialization; and to force us to use our heads in working our way through conflicting evidence. (104)

In *The Ordination of Women* published in 1980, Paul Jewett offers a reasoned rebuttal of traditional arguments against women in ministry and a defense of women's ordination based on the Christian model of equality and partnership of man and woman. More recently Mollenkott has written two other books on feminist theological themes: *The Divine Feminine* (1983), and *Godding* (1987). In the former she deals with the female imagery in the Bible with reference to God, such as God's giving birth, God as nursing mother, God as female homemaker, God as mother eagle and mother hen, etc. In the latter book Mollenkott develops the thesis that we should embody or incarnate "God's love in human flesh, with the goal of cocreating with God a just and loving human society" (*Godding* 2). She says,

> Godding is the very opposite of lording it over other people. . . God's presence is known in those relationships that are mutually sympathetic, helpful, interdependent rather than in hierarchical one-up, one-down relationships. (4)

Mollenkott, especially in *Godding,* takes an ecumenical stance that in some respects places her closer to mainstream feminists than to evangelical feminists.

Other Evangelical Feminists

Since the late seventies, an increasing number of evangelicals have written books and articles from a feminist perspective. Many of them, holding to a strict view of biblical inspiration, maintain the full authority of Paul's teachings while agreeing with Jewett and Mollenkott on the coequal partnership of men and women in the home and church. Some works of this type that deserve mention include:

Gilbert Bilezikian, *Beyond Sex Roles*

Mary J. Evans, *Women in the Bible*

Patricia Gundry, *Woman Be Free*

Alvera Mickelsen, ed., *Women, Authority and the Bible* (See especially articles by Richard Longenecker, Berkeley and Alvera Mickelsen, Walter Liefeld, and David Scholer.)

Aida B. Spencer, *Beyond the Curse: Women Called to Ministry*

Ruth A. Tucker and Walter Liefeld, *Daughters of the Church* (See especially chapter 11 on a survey of many writers and the appendices on various issues of Christianity and feminism.)

In addition to individual authors we should note the Evangelical Women's Caucus (with their newsletter *Update*) and the periodical *Daughters of Sarah,* both of which arose in the mid-seventies and have made evangelical feminists and their concerns visible in the conservative Protestant world.

THEOLOGICAL POSITIONS OF FEMINISM

Having looked at specific writers of feminist theology, I now want to present a typology of five general positions from theology with respect to feminism. The first two are nonfeminist views and will need a bit of elaboration, whereas the last three will be summarizations and categorizations of views already presented. The first three views are evangelical, holding to a high view of biblical authority. From this typology we can more clearly identify the major issues on theology and feminism, which I will spell out in the next section. (Note: my typology is partly influenced, with some differences, by Randy Maddox's article "The Word of God and Patriarchalism: A Typology of the Current Christian Debate." In each case I have given in parentheses a second name for these positions.)

Strict Hierarchicalist (Traditionalist)

Strict hierarchicalists hold that the Bible as the infallible Word of God teaches the hierarchical structure of man as leader and woman as

subordinate. This is a universal norm, ordained by God from the creation, as taught in Genesis and confirmed by Paul. "Head" in 1 Corinthians 11:3 and Ephesians 5:23 means "authority"; i.e., it indicates superior rank. Patriarchy is God's will for both the home and the church. The commands of 1 Corinthians 14:34 and 1 Timothy 2:12 about women's silence in the church are transcultural and thus apply today. Only men are allowed to be ministers or hold positions of authority in the church. Women may be involved in various types of service but are not to be elders or teachers of men. The patriarchal language about God in the Bible and church liturgy should be maintained. This position sees the feminist crusade for egalitarianism between the sexes as unbiblical and a product of modern secular humanism.

One of the fullest defenses of this position in recent years is Stephen Clark's *Man and Woman in Christ* (1980). Clark is primarily interested in the teaching of Scripture on male and female roles and its contemporary application, but he also seeks to support his views from the social sciences, arguing for basic differences in the sexes that justify different responsibilities between men and women. He argues for Christian communities that will follow the biblical pattern of life as an alternative to today's technological society. These communities will exhibit "brother-sister love" in Christ, but according to the biblical system of subordination of church members to the elders and wives to husbands. Women can serve as deaconesses, helping the elders in the work of the church, but they should not be teachers or overseers in the church. Specific application of these general principles can be applied according to local cultural considerations. (See especially chs. 22–24.)

Other works that support this hierarchicalist view include *New Testament Teaching on the Role Relationship of Men and Women*, by George Knight; *Women and the Word of God*, by Susan Foh; and *The Role of Women in the Church*, by C. C. Ryrie. Note that some advocates of this position are even stricter than Clark in that they do not allow women to be deaconesses.

Moderate Hierarchicalist (Liberated Traditionalist)

Moderate hierarchicalists hold that the Bible as the infallible Word does teach the hierarchical structure that places man over woman. They are more positive than strict hierarchicalists toward feminist concerns, however, for they see the Bible, and especially the New Testament, as teaching a moderate hierarchy in male/female relations and they emphasize the difference between this and the authoritarian type of patriarchy in Judaism. Accordingly, Christ's

attitude toward women was quite different from that of the culture of his day. Following Christ's lead, Paul taught that a man's headship (leadership) includes service to his wife and delegated authority— even a degree of mutual submission. Wives should help their husbands rule in the home, and women should help do the work of the church. According to the moderate hierarchicalist, women can be not only deaconesses but also teachers and ministers, provided that these leadership positions are subordinate to elders or ministers who are men.

A notable advocate of this position is Donald Bloesch, who elaborates his view in *Is the Bible Sexist?* Bloesch speaks against both patriarchy's characteristics of male domination and authoritarianism and feminism's reaction to *all* hierarchy. He suggests the alternative of "covenantalism" in which man and woman freely submit to the service of God as Lord, and do not lord it over each other. Nevertheless, there still remains a kind of subordination of wife to husband and a precedence of male leadership in the church, even though both men and women can be ministers. This male leadership is one of self-giving service and loving direction, not domination. Bloesch's view is thus a middle position between the traditionalists and the Christian feminists.

Ronald and Beverly Allen also espouse this position in their book *Liberated Traditionalism*. Although James Hurley is usually classified as a traditionalist, his substantial work *Man and Woman in Biblical Perspective* does convey some of the ideas of a moderate hierarchicalism.

Biblical Feminist (Evangelical Feminist)

According to biblical feminists, the Bible as the infallible Word does *not* teach patriarchalism as God's ideal. Genesis 1 and 2 teach the equality and mutuality of male and female. Genesis 3:16 is descriptive of the consequences of sin, not prescriptive of what should be. God revealed himself by means of a patriarchal culture but progressively worked his redemptive purpose to the end that patriarchy or any hierarchy of the sexes should be overcome. The social application of the Gospel, as exhibited by Christ and summarized by Paul (Gal. 3:28), leads to egalitarianism in the home, church, and society. Paul taught the principles of equality in Christ and mutual submission (headship meaning "source" not "authority") and supported women's place in church ministry (Rom. 16; 1 Cor. 11; Eph. 5). But he applied these principles in moderation in relation to existing customs for the sake and testimony of the Gospel. He commanded silence and submission for the untrained and the disorderly. Women are given all

the gifts and may be deacons, elders, ministers, and apostles. With changed customs today women in ministry should not be subordinate to any kind of male authority in the church.

This is the position of the evangelical feminists mentioned earlier (see "Evangelicals and Feminism" 34–36). Paul Jewett and Virginia Ramey Mollenkott are usually classified with biblical feminists, though they have a looser view of biblical authority than most of the evangelicals I mentioned and in some respects could be classified with the next position.

Mainstream Feminist (Reformist Feminist)

Mainstream feminists state that although the Bible contains the Word of God, it is not itself the infallible Word of God. Much of the Bible teaches or supports patriarchy, and insofar as it does, it should not be considered divine revelation. The Word of God can be found in the redemptive themes of Scripture or in the "prophetic-messianic tradition" that criticizes the oppression of the social order and points to human liberation. The Word is found especially in the person and egalitarian life of Jesus who brings redemption from all forms of sin, including patriarchalism. On the basis of the norm of Christ and the liberating vision of such texts as Genesis 1:27 and Galatians 3:28, Christians should work for the full liberation of women in all spheres of life, acknowledging their equal rights in the home, the workplace, and all ministries of the church. Language about God should use both male and female models or metaphors, though God is beyond both sexes. Inclusive language should be used in Bible translation and church educational and worship materials. Woman's story in the Bible needs to be redressed.

The theologians we examined who hold this position are Ruether, Russell, and Trible. They call themselves "reformist" feminists because they seek to work within the church and help reform its views about male/female relationships as well as religious authority. Others who espouse this position include Sallie McFague, Elizabeth Moltmann-Wendel, and Elizabeth Tetlow.

Radical Feminist (Revolutionary Feminist)

Radical feminism has two forms, one is Christian and the other is "post-Christian," though both are revolutionary in their approach to religion.

Radical Christian

According to this position, patriarchalism and androcentric bias pervade the Bible. Thus the locus of revelation cannot be seen in the Bible itself or any tradition within the Bible. Instead, the locus of revelation is in the experience of "women-church," a community of women-affirming Christians seeking liberation from patriarchal oppression. From the time of Jesus, women-church was present in primitive Christianity (though largely hidden behind the patriarchal pages of the New Testament) and is reemerging today as the manifestation of God's work of human liberation. This is the position of Elizabeth Schüssler Fiorenza.

Radical Post-Christian

According to this position, not only must biblical authority be given up, but also Christianity as a whole must be rejected and superseded if the liberation of women is to be realized. Women must engage in a spiritual revolution and rename God and the world according to their own radical religious experience that is totally free of men (who are inferior). The experience may include lesbianism and witchcraft. A better conception of the divine is the Mother Goddess. This, of course, is the view of Mary Daly, but other proponents include Naomi Goldenberg and Starhawk (see *Works Cited*).

ISSUES

Having seen the different views with respect to theology and feminism, we are now in a better position to examine the major issues involved. There are several that we should consider, some general and some more specific.

Normative Patriarchy

Perhaps the primary issue regarding theology and feminism concerns the question, "Does the Bible teach patriarchy as normative for all cultures?" Of the five positions I just identified, you will note that the first two and the last would answer yes, though the practical response of the last one is opposite that of the first two. The two forms of "traditionalism" agree that patriarchy in some sense is the biblical norm and that thus the feminist cause of egalitarianism should be opposed, whereas the radical feminist view, in agreeing that the Bible teaches patriarchy, says that the *Bible* should be opposed. Mainstream

or reformist feminism would give a yes-and-no answer to the question. Some parts of the Bible are strongly patriarchal whereas other parts point toward liberation. Thus the Bible is diverse and even conflicting in its teachings. The middle position, biblical feminism, answers the question with a no; that is, patriarchy is not God's ideal for all cultures, and the Bible as his Word does not teach that. God condescended to work his revelatory purposes through a patriarchal culture, but his ultimate standard is seen in the pristine creation and in the New Testament model of redemption. Genesis 1:26–28 and Galatians 3:28 state God's universal ideal.

Obviously, the different positions on patriarchy reflect different views about biblical authority as well as different views about what in the Bible is culturally limited and what is normative for all cultures. Many feel that egalitarianism of the sexes will eventually win out over patriarchy in the Christian church, just as the abolition of slavery won out in the nineteenth century. Social progress makes victory inevitable. Others argue that the patriarchy issue is not exactly parallel to the slavery issue, because slavery was not instituted by divine revelation whereas patriarchy was. This, of course, is the very issue in dispute, and it probably will continue to be for a long time in the evangelical church. It involves subissues such as whether Genesis 3:16 is descriptive or prescriptive, whether Genesis 2 teaches subordination or coequal partnership, whether or not patriarchy as ordained from creation is reaffirmed by Paul in 1 Corinthians 11 and 1 Timothy 2, and whether Galatians 3:28 teaches only spiritual equality in Christ or also social and sexual egalitarianism.

The Meaning of "Head"

Another issue, related to the first but having its own exegetical questions, is whether "head" in Paul's teaching (1 Cor. 11; Eph. 5) denotes, on the one hand, "authority" or "superior rank" or, on the other hand, "source" or the idea of the "originator and completer" of life (Mickelsen and Mickelsen, "What Does *Kephale* Mean in the New Testament?"). The former choice is compatible with the hierarchicalist view, whereas the latter is more compatible with the feminist themes of mutuality and partnership. At present scholars are in dispute over which meaning is best supported grammatically, historically, and contextually. Theological and social biases seem to get in the way.

Women Ministers

A third issue has to do with the ordination of women or women's full participation in church ministry. Strict hierarchicalists are, of

course, against it, while biblical feminists are for it. The second position, moderate hierarchicalism, seems to be gaining support in some evangelical circles as a compromise position. According to this position, women can be ministers, though the principle of subordination to male leadership in some way must be maintained. It is questionable how long this position can stand. Can the church go on asking women ministers to submit to male ecclesiastical authority purely on the basis of a certain interpreted biblical principle unless there is evidence to support it from the nature of male/female differences? The question of scientific evidence concerning gender differences by nature is an important one for both feminists and their opponents.

As David Basinger says:

> Most Traditionalists and the Egalitarians do clearly see a very strong connection between the *authority thesis*—the contention that God has ordained a preset gender hierarchy—and what I shall call the *inherent traits thesis*—the contention that men and women possess inherent (biologically-rooted) characteristics which make them best suited for leadership and support roles respectively. ("Gender Roles, Scripture, and Science" 245)

Thus traditionalists such as Stephen Clark seek support from the social sciences for gender differences in defense of male authority and leadership (*Man and Woman in Christ* ch. 17). If it turns out, however, that scientific study cannot support the preference for male leadership from the standpoint of what constitutes "good leadership" (Basinger 253), then it seems to me that the practice of women's subordination to men in the professions of church ministry will be on shaky ground. The whole question of patriarchy and of what God's ultimate intention was for man and woman from *creation* once again looms large.

Biblical feminists agree that Scripture conveys diverse messages about women in ministry. Some passages indicate women in various kinds of ministry (Acts 2:17; 18:26; Rom. 16:1–7; 1 Tim. 3:11), while other passages show restrictions (1 Cor. 14:34; 1 Tim. 2:12). But biblical feminists contend that the restrictions were not imposed because of something inherent in the nature of woman or because of God's universal intention. Rather, they argue that Paul restricts women's leadership for the sake of testimony in regard to the social norms of his day. If they are right, then it would seem *contrary* to Christ's law of love and Paul's teaching about the gifts for mutual edification in the church to restrict women in ministry today in view of the marked changes in social norms. Yet traditionalists still contend that the New Testament restrictions about women and

ministry are based on God's order from creation and not according to cultural factors. Thus the debate continues.

Inclusive Language

A fourth issue concerns inclusive language in Bible translation, hymnology, and church materials. An example of the use of inclusive language in the church is the *Inclusive Language Lectionary*, a selection of readings for the church year, produced by the National Council of Churches. This lectionary uses "God" in place of masculine pronouns referring to God, and uses "Father [and Mother]" instead of just "Father" when that name refers to God. It translates "Son of God" as "Child of God" and renders "Brethren" as "Sisters and Brothers," "Friends," or "Neighbors" (Tucker and Liefeld 425). Is this kind of thing good and needful in church materials? Feminists answer yes because in our culture traditional biblical language can convey an exclusively masculine view of God and a view of the church body as excluding or marginalizing women. On the other hand, traditionalists are often irate about references to God as female, seeing it as an affront to the very existence of biblical revelation.

In sorting our way through this issue we would do well to consider seriously the feminine metaphors and imagery referring to God in the Bible. They, too, teach us truth about the character of God, who is beyond our physical and gender limitations and distinctions. I believe it would be difficult to object to the following quote without getting into theological trouble:

> God, by any orthodox definition, transcends human masculinity and femininity. Therefore, even core terms like "Father" cannot reduce God to our concepts of manhood. If there is a problem with such terminology, it does not lie in the nature of God nor in the words of Scripture, but in any meaning we ascribe to them that goes beyond the biblical intention and restricts God to human categories. Correspondingly, metaphors that ascribe feminine characteristics to God should be recognized as descriptive instruments to help us understand the depths of God's character and care for us. Pagan deities were either masculine or feminine. God is infinitely greater than such categories. (Tucker and Liefeld 450)

In other terms, God is no more a man than a woman. God is Person, or God is the perfect personal being, whose fullness of personal life we reflect in diverse finite ways in our earthly masculine and feminine humanity. God's love, righteousness, and wisdom are revealed in "masculine" expressions of aggressive power, providence, and lordship. The same attributes are also revealed in "feminine" expressions

of enabling power, spiritual nurture, and friendship. We worship not only a transcendent and sovereign God but also an immanent and "relational" God (Maddox, "Toward an Inclusive Theology" 13–14).

Traditionalists, however, are generally agreed that since God has chosen to reveal himself primarily in masculine terms we should respect the language of biblical revelation and not change or add to it. The debate about inclusive language in Bible translation partly involves different translation theories, such as whether translation should be word for word or a "dynamic equivalent' in culturally relevant language.

The issue also relates to the revision of hymns. Should we respect the exact words of the hymn writers, or should we, for example, revise "Good Christian Men Rejoice" to make its language inclusive of both sexes? These challenges faced by Christian scholars have profound consequences in the practical life of the Christian community.

Before getting too far away from the subject of masculine and feminine imagery about God, I should mention that some feminists, particularly those of the mainstream and radical types, are opposed to *all* forms of hierarchy, and thus play down God's transcendence with a tendency toward pantheism. Yet biblical feminists are not necessarily against hierarchy, as such, but against hierarchy according to sex, race, nationality, or social class. Hierarchy according to experience or qualifications is another matter. While God as Friend is in and with us, God is also in some sense *above* us, just as a parent is above a child, or a conductor is "above" the members of a symphony orchestra. There are appropriate stations in life, and the voluntary subordination of creature to Creator is always appropriate.

The Cultural Factor in Biblical Interpretation

A fifth and final issue I wish to mention is a general one overarching all of the others. It has to do with the *cultural* factor in biblical interpretation. It should be familiar to us by now. We have seen it in such questions as, "Is patriarchy a universal ideal or a temporary stage in sinful, human history?" Or, "Are Paul's restrictions about women and ministry meant only for the culture of his time or for all cultures?" In other words, how do we distinguish between culturally directed applications of biblical principles and the transcultural biblical principles themselves? This is one of the giant questions of biblical hermeneutics today. Much has been written in attempts to answer this question. (See, e.g., Osborne, "Hermeneutics and Women in the Church" 337–52; Swartley, *Slavery, Sabbath, War and Women* 229–34; and Fee and Stuart, *How to Read the Bible for All Its Worth* ch. 4.)

Some people are not very comfortable with the distinction between the cultural and the transcultural, fearing that it is often used in a way that relativizes the authority of the Bible. Traditionalists perceive feminists as using the distinction as a ploy by which to reinterpret Scripture according to the standards of twentieth-century science and secular culture, thereby evading the absolutes of biblical teaching about men and women. I respond that Christians in every generation have interpreted Scripture through insights of science and of the culture of their times, and this is both good and unavoidable. The Bible teaches truth about how we are to live for God's glory in *this* world in which God has placed us. Thus to understand fully the truth of the Bible we must relate it to the larger truth *outside* of the Bible, the truth about God's creation and human life and history. That larger truth is progressively known both by formal scientific study and practical lived experience.

What evangelical Christianity objects to, of course, is the way some types of theology make the Bible just another part of God's truth through general human experience and do not recognize it as *special* revelation. In order to preserve the special revelational authority of the Bible, evangelicals often feel that they must oppose science where it seems to contradict Scripture. But as an evangelical myself, I believe that the old "Bible/science controversy" has been too long and too often misconstrued. The controversy is not between the Bible and science, for if the Bible is infallible and science is fallible, then there is no contest. The real controversy is between our fallible "theological" knowledge of Scripture as special revelation and our fallible scientific knowledge of creation as general revelation (cf. Basinger 247). Both revelations are God's infallible truth, and our knowledge of both is fallible and limited. But the two revelations are "mutually interpretive" and the theologian and the scientist need each other for a fuller and more accurate understanding of this twofold truth. We need to understand about the nature, content, and purpose of each revelation; for example, we need to understand that in special revelation God reveals the specifics of his historical redemptive purposes, whereas in general revelation he reveals specifics about the nature and laws of creation. (See Diehl, "Evangelicalism and General Revelation" 445– 50.) Then, understanding the mutuality of the revelations, we can learn how general revelation helps us to see what the Bible does and does *not* teach, say, concerning the relationship of the sun and the planets, or the age of the earth, or even the physical and social laws by which God has given form to our humanity.

What I am suggesting, therefore, is that evangelicals can give the authority of Scripture its full due as special revelation while being fully serious about a scientific study of creation as general revelation,

of which we, with our personhood and sexuality, are a part. I am
suggesting also that a right understanding of general and special
revelation can help us deal with these cultural issues about theology
and feminism. To be diligent students of both revelations in an
integrative and Christian way is to learn according to the principle of
what I call the "Christological progressiveness of the twofold revela-
tion" (Diehl 453–55). I believe this principle has worked somewhat
through the interplay of the theological and scientific enterprises to
effect real social progress in modern times. Thus I do not believe the
feminist movement is, per se, un-Christian, though some forms of it,
such as Mary Daly's, are. Through this principle we have overcome
slavery and made progress against racial prejudice. Through this
principle we have come to see that medieval ideas about women's
inferiority in the spiritual, intellectual, and even leadership areas are
false. Through this principle we might even come to the conclusion
that the apostle Paul, while seeming to apply the Gospel to his society
according to a kind of moderate hierarchicalism, would today, if he
were here, apply it more along the lines of biblical feminism.

In suggesting this, I am not trying to relativize Paul's authority. I
am distinguishing between principles and applications. The principles
of the Gospel have to do with faith in Christ and obedience to his law
of love, and thus they have to do with servanthood and appropriate
subordination to existing authorities for Christ's sake. Application of
these principles will vary in history, depending on what the existing
authorities are. We do not subordinate ourselves to people today quite
the way slaves did to their masters or subjects did to their kings. What
about the subordination of women to men in the kind of culture we
live in today? Might not our Christological progressiveness entail a
different application of the same gospel principles on the question?

Because these and other related issues have such far-reaching
implications, thoughtful Christians will need to read and discuss and
think and pray before deciding where *their* theological position about
feminism lies, and even after that, we must all be open to new truth.
Simplistic solutions to complex problems do not benefit the body of
Christ.

Works Cited

Allen, Ronald and Beverly. *Liberated Traditionalism*, Portland, Ore.: Multno-
 mah, 1985.
Basinger, David. "Gender Roles, Scripture, and Science: Some Clarifications."
 Christian Scholars Review 17 (1988): 241–53.
Bilezikian, Gilbert. *Beyond Sex Roles*. Grand Rapids: Baker, 1985.
Bloesch, Donald. *Is the Bible Sexist?* Westchester, Ill.: Crossway, 1982.
Clark, Stephen. *Man and Woman in Christ*. Ann Arbor: Servant, 1980.

Daly, Mary. *The Church and the Second Sex.* New York: Harper & Row, 1968.
_____. *Beyond God the Father: Toward a Philosophy of Women's Liberation.* Boston: Beacon, 1973.
_____. *Gyn/Ecology: The Metaethics of Radical Feminism.* Boston: Beacon, 1978.
deBeauvoir, Simone. *The Second Sex.* Translated by H. M. Parshley. New York: Knopf, 1953.
Diehl, David W. "Evangelicalism and General Revelation: An Unfinished Agenda." *Journal of the Evangelical Theological Society* 30 (1987): 441–55.
Evans, Mary J. *Women in the Bible.* Downers Grove: InterVarsity, 1983.
Fee, Gordon, and Douglas Stuart. *How to Read the Bible for All Its Worth.* Grand Rapids: Zondervan, 1982.
Fiorenza, Elizabeth Schüssler. *In Memory of Her.* New York: Crossroad, 1983.
_____. *Bread Not Stone: The Challenge of Feminist Biblical Interpretation.* Boston: Beacon, 1984.
_____. "The Will to Choose or to Reject." *Feminist Interpretation of the Bible.* Edited by Letty Russell. Philadelphia: Westminster, 1985. 125–36.
Foh, Susan. *Women and the Word of God.* Philadelphia: Presbyterian & Reformed, 1980.
Friedan, Betty. *The Feminine Mystique.* New York: Norton, 1963.
Goldenberg, Naomi. *Changing of the Gods.* Boston: Beacon, 1978.
Hurley, James. *Man and Woman in Biblical Perspective.* Grand Rapids: Zondervan, 1982.
Gundry, Patricia. *Woman Be Free.* Grand Rapids: Zondervan, 1977.
Inclusive Language Lectionary. The National Council of Churches. Atlanta: John Knox, 1983.
Jewett, Paul. *Man as Male and Female.* Grand Rapids: Eerdmans, 1975.
_____. *The Ordination of Women.* Grand Rapids: Eerdmans, 1980.
Knight, George. *New Testament Teaching on the Role Relationship of Men and Women.* Grand Rapids: Baker, 1977.
Maddox, Randy. "Toward an Inclusive Theology: The Systematic Implications of the Feminist Critique." *Christian Scholar's Review* 16 (1986): 7–23.
_____. "The Word of God and Patriarchalism: A Typology of the Current Christian Debate." *Perspectives in Religious Studies* 14 (1987): 197–216.
McFague, Sallie. *Metaphorical Theology.* Philadelphia: Fortress, 1982.
Mickelsen, Alvera, ed. *Women, Authority and the Bible.* Downers Grove: InterVarsity, 1986.
Mickelsen, Berkeley, and Alvera Mickelsen. "What Does *Kephale* Mean in the New Testament?" *Women, Authority and the Bible.* Edited by Alvera Mickelsen. Downers Grove: InterVarsity, 1986. 97–110.
Mollenkott, Virginia Ramey. *Women, Men and the Bible.* New York: Abingdon, 1977.
_____. *The Divine Feminine: Biblical Imagery of God as Female.* New York: Crossroad, 1983.
_____. *Godding: Human Responsibility and the Bible.* New York: Crossroad, 1987.
Osborne, Grant R. "Hermeneutics and Women in the Church." *Journal of the Evangelical Theological Society* 20 (1977): 337–52.
Ruether, Rosemary Radford. *New Woman-New Earth: Sexist Ideologies and Human Liberation.* Minneapolis: Seabury, 1975.

————. *Sexism and God-Talk: Toward a Feminist Theology.* Boston: Beacon, 1983.

————. "Feminist Interpretation: A Method of Correlation." *Feminist Interpretation of the Bible.* Edited by Letty Russell. Philadelphia: Westminster, 1985. 111–24.

Russell, Letty. "Authority and the Challenge of Feminist Interpretation." *Feminist Interpretation of the Bible.* Edited by Letty Russell, Philadelphia: Westminster, 1985. 137–46.

————. *The Future of Partnership.* Philadelphia: Westminster, 1979.

————. *Human Liberation in a Feminist Perspective: A Theology.* Philadelphia: Westminster, 1974.

————. *Household of Freedom: Authority in Feminist Theology.* Philadelphia: Westminster, 1987.

Ryrie, C. C. *The Role of Women in the Church.* Chicago: Moody, 1970.

Saiving, Valerie. "The Human Situation: A Feminine View." *Woman-Spirit Rising.* Edited by Carol Christ and Judith Plaskow. New York: Harper & Row, 1979. 25–42.

Scanzoni, Letha, and Nancy Hardesty. *All We're Meant to Be.* Waco: Word, 1974.

Spencer, Aida B. *Beyond the Curse: Women Called to Ministry.* Nashville: Thomas Nelson, 1985.

Starhawk. *The Spiral Dance: A Rebirth of the Ancient Religion of the Great Goddess.* New York: Harper & Row, 1979.

Swartley, Willard M. *Slavery, Sabbath, War and Women.* Scottdale, Pa.: Herald, 1983.

Trible, Phyllis. *God and the Rhetoric of Sexuality.* Philadelphia: Fortress, 1978.

————. *Texts of Terror: Literary-Feminist Readings of Biblical Narratives.* Philadelphia: Fortress, 1984.

Tucker, Ruth A., and Walter L. Liefeld. *Daughters of the Church.* Grand Rapids: Zondervan, 1987.

For Further Study

1. How has biblical feminism affected biblical interpretation and biblical authority in evangelicalism?

2. Do you think the evangelical churches should allow women to be ministers? Explain your answer. What do you think the evangelical churches' stand will be on this issue in the early twenty-first century?

3. Christian theology generally teaches that Christ both fulfilled the OT and changed things with respect to the OT. In what sense, if any, do you think Christ and his Gospel changed things regarding women?

4. Should the church use hymns and Scripture readings with inclusive language?

5. Which one of the five positions discussed in Part 2 do you view as being most compatible with a Christian liberal arts education, and why? (class debate)

Writing Suggestions

1. Which one of the five positions discussed in Part 2 is the position of your family or church? Which one is your own present position? Explain why you have or have not changed.

2. Where or how do you think God is working in the church today in the midst of the feminist-traditionalist debate?

3. How do you conceive of God in regard to masculine and feminine qualities? Do you think you need to change your view of God? Do you think you need to change your ideas of what is feminine and what is masculine?

Research Topics

1. A critical analysis of the feminist theology of one of the following: Rosemary Radford Ruether, Letty Russell, Elizabeth Schüssler Fiorenza, Paul Jewett, Virginia Ramey Mollenkott

2. Views of "headship" in the apostle Paul's theology

3. Pros and cons of women's ordination

4. Pros and cons of inclusive language in Bible translation

Shorter Reading List

Russell, Letty, ed. *Feminist Interpretation of the Bible.* Philadelphia: Westminster, 1985, chs. 9–11.

Swartley, Willard M. *Slavery, Sabbath, War and Women.* Scottdale, Pa.: Herald, 1983, ch. 4.

Tucker, Ruth A., and Walter L. Liefeld. *Daughters of the Church: Women and Ministry From New Testament Times to the Present.* Grand Rapids: Zondervan, 1987, ch. 11.

Longer Reading List

Clark, Stephen. *Man and Woman in Christ.* Ann Arbor: Servant, 1980.

Daly Mary. *Beyond God the Father: Toward a Philosophy of Women's Liberation.* Boston: Beacon, 1973.

Fiorenza, Elizabeth Schüssler. *Bread Not Stone: The Challenge of Feminist Biblical Interpretation.* Boston: Beacon, 1984.

Jewett, Paul. *Man as Male and Female.* Grand Rapids: Eerdmans, 1975.

Mickelsen, Alvera, ed. *Women, Authority and the Bible.* Downers Grove: InterVarsity, 1986.

Mollenkott, Virginia Ramey. *Women, Men and the Bible.* New York: Abingdon, 1977.

Ruether, Rosemary Radford. *Sexism and God-Talk: Toward a Feminist Theology.* Boston: Beacon, 1983.

Russell, Letty. *Human Liberation in a Feminist Perspective: A Theology.* Philadelphia: Westminster, 1974.

Scanzoni, Letha, and Nancy Hardesty. *All We're Meant To Be.* Waco: Word, 1974.

Trible, Phyllis. *God and the Rhetoric of Sexuality.* Philadelphia: Fortress, 1978.

————. *Texts of Terror: Literary-Feminist Readings of Biblical Narratives.* Philadelphia: Fortress, 1984.

2

The New Reality in Christ: Perspectives From Biblical Studies

Scott E. McClelland

THE ISSUE TODAY

> Suppose. . . that we might just as well pray to "Our Mother which art in heaven" as to "Our Father." Suppose . . . that the Incarnation might just as well have taken a female as a male form, and the Second Person of the Trinity be as well called the Daughter as the Son. Suppose, finally, that the mystical marriage were reversed, that the Church were the Bridegroom and Christ the Bride. All this, as it seems to me, is involved in the claim that a woman can represent God as a priest does. (Lewis 236–37)

It has been forty years since C. S. Lewis thus criticized the church of England when it first considered ordaining women as priests. Used to shock and restore churchmen to their sensibilities on the issue at the time, Lewis's ironic feminine terminology has a decidedly varied impact on evangelicals today. For some it continues to have the same force as when Lewis first wrote: the whole suggestion of such female imagery for God indicates the unnaturalness of admitting women to such positions. For others (indeed, their numbers have substantially increased), the imagery suggests a broadening of perspective, a rich inclusiveness that permits Christians to appreciate the full image of God.

As with Lewis and all other writers before him (including the biblical writers), we are all somewhat the products of our culture. Is Lewis's concern with female terminology based on cultural exclusions of women from full participation in most areas of life, as in the England of 1948? Has his argument lost some persuasive strength

because of cultural changes of our day and recent feminist movements? If there can be such changes in just forty years, what can we expect as we try to read the Bible, a book produced thousands of years ago in a *very* different culture?

Which culture has colored the biblical message most, the culture that produced it or the one that reads it? Possibly, it is in women's issues, more than any other social or theological debate, that we encounter culture's role in producing biblical texts, and our understanding of them.

How does all this talk of culture and change affect our understanding of women as cobearers of God's image? As a Christian man who simultaneously has many Christian sisters—to whom I am also, respectively, husband, son, father, pastor, and teacher—how do I read the biblical message? Why has God placed another human on this earth who resembles me so much, yet at the same time differs so greatly? How and why are we made this way? How should I relate to women? Does being female automatically place someone in roles different from mine and restrict her from others? These are some questions that women's studies raise. And these are the questions that we must first answer from a biblical perspective if we are people who seriously want to reflect God's design in our relationships.

At this point categories may help us clarify the boundaries of our discussion. Within evangelicalism two major sides have formed on the issue of women's roles. "Hierarchicalists" (or "traditionalists") assert that on the basis of their gender women may not hold certain positions within the Christian community. "Egalitarians" (or "biblical feminists") assert that regardless of gender all Christians can participate fully in ministry, regardless of roles.

HERMENEUTICS

We must discuss the issues governing the interpretation of this or any other issue in the Bible. For it is one's interpretive method that either helps uncover the meaning of the text as the author intended or leads to "reading in" an interpreter's preferred understanding. We should openly admit that each interpreter comes to a text already biased in many areas; therefore, we should immediately dispense with the myth of objectivity and allow the interpreter to wrestle with individual biases in one's field of understanding.

Helpful surveys have been undertaken to present the many hermeneutical approaches used in discussing women's studies. Scholer (407–20), Tucker and Liefeld (443–52), and Swartley (192–228) can

instruct readers in assessing the many options open in interpretation. These writers (esp. Tucker and Liefeld 401–41, and Swartley 150–91) survey several contemporary scholars' conclusions on the issue.

Perhaps the most important factor in biblical interpretation is the role of culture both for the biblical writer and for the interpreter. As implied above, the time in which a biblical revelation was given and written, and the time in which it was read somewhat color the meaning of a text. Yet the meaning is also somewhat "concretized," that is, it is made more understandable by its appearance in an earthly and human environment—by its involvement in a particular culture. That culture helps us build a frame of reference points by which to discern meaning (what Swartley calls the "missionary factor," 188). The culture also enables us to avoid the wholesale subjectivizing of texts that can lead to relativizing God's word (see recent warnings by Hafemann 129–44).

Grammatico-Historical Methodology

To discuss the many hermeneutical approaches would go beyond the scope of this work. Suffice it to say, the grammatico-historical method, which considers the insights of the grammar and history of the time a text was written, has the advantage of providing a somewhat agreed-to reference point among evangelicals from which to argue the meaning of texts (note Scholer, 412–20 for correctives to this model; see also Marshall's overview in New Testament Interpretation). The assumption that the word of God came first into a particular point in time and was intended primarily for its original recipients, is foundational both to an evangelical understanding of Scripture and to an understanding of the incarnation of Jesus Christ.

Working Principles

Two very readable introductions to the issue of biblical interpretation are Fee and Stuart's How to Read the Bible for All Its Worth (HTRTB) and a slightly more technical work by Fee, New Testament Exegesis for Students and Pastors. The latter gives a workable schematic chart by which interpreters may proceed through a selected portion of Scripture. What these and other works (cf. bibliography) generally emphasize are these interpretive principles:

1. The primary meaning of a text is what the original author intended and what the original readers could have understood.

2. Proper use of a text's context involves at least the following:

a. Due consideration of the genre (i.e., letter, gospel, history, poetry, etc.) and that genre's distinctive literary conventions.

b. Appreciation of the historical, cultural, political, and religious environment in which a text is written.

c. Study of words and grammar that most closely approximate the use of terms at that time (e.g., just try explaining the meanings of the words *cool* or *bad* to persons from the 1940s, 1960s, and 1980s!)

d. Positioning of the text relative to an author's argument, his combined body of works, and the overall direction of biblical revelation.

e. An understanding of the textual variations in any particular reading, and their possible bearing on the arrangement of words.

3. Clearer, more precise texts should be used to interpret less clear, ambiguous, or vague texts.

4. The relative worth of texts citing principles and those detailing particular historical or cultural situations must be discerned.

5. The words of Jesus and the new covenant's restoration take precedence over the particulars of old covenant patterns, especially when the new covenant fulfills the old (e.g., the sufficiency of Christ's sacrifice replaces or cancels the need for continued individual sacrifices, etc.)

Summary. We already interpret a text through our own cultural eyes as soon as we read the Bible—especially in translation. (Fee *HTRTB* 16ff.). Far from being the only method, and far from being foolproof, the grammatico-historical method does provide the most help for interpreting the Bible and for regarding the text seriously for what it presents itself to be—God's word in human words. However, let us allow that it is as much our own cultural biases, as it is the Bible itself, that governs our conclusions on biblical interpretation.

THE BIBLE'S TEACHING ABOUT WOMEN

In our discussion of the biblical evidence we must work through the major passages associated with the purpose and meaning of women in God's economy. Approaching the texts chronologically will

give us a feel for the contexts in which biblical statements are made. Such an approach will also allow us to be sensitive to the biblical contemporary culture and the contrasting position of the biblical authors to that culture on this issue.

Creation Accounts

Genesis 1

Our first task is to note what the original readers understood these traditions to mean. The traditional view of Mosaic authorship would place the formal codification of these materials not long after his lifetime. The culture of that time period was overtly patriarchal.

Thus, when we note that the initial account seems to place a very exacting association between the "image of God" and the expression of that image in flesh as both "male and female" (note Phyllis Trible's study of the poetic parallelism, 16–17), there seems every reason to believe that woman's image-bearing capabilities were in no significant way different from man's. In such a patriarchal culture, this passage must have been, as Paul Jewett said, "the first great surprise of the Bible" (33).

While there were ample biological differences evident at once, there appears to be no implication that one partner bore the "image of God" any differently than did the other. The use of plural expressions for "the Adam," leads to the inescapable conclusion of Aida Spencer: "The image of God is a double image" (21).

The cultural mandate that they should be cosovereign over the creation with God (Gen. 1:28) is expressly stated in the plural. There was to be no distinction in their reign, no original subordination of roles, at least in this account (Evans 12).

Genesis 2

Genesis 2 has been used by hierarchicalists as their touchstone. The creation of woman after man, woman as "taken out of man," woman named by the man, and woman created as a helper for the man, are all given as supports for God's original intention for woman's subordination to man. As Evans (14–17) and Spencer (23–29) argue, however, none of these notions necessarily leads to a hierarchical viewpoint; rather, they tend to focus again on the mutuality of the two sexes in their roles as cosovereigns. Furthermore, if priority of creation in the full account bespeaks superiority, then God's earlier creation of other life-forms would have to be considered in that hierarchy: animals preceded humans, yet they are not said to be superior. Even the apostle Paul's statement of man's precedent

creation (1 Cor. 11:8–9) does not precisely speak to this issue, especially since Paul uses the order of creation to help with a point in his argument that is not altogether clear (Fee, *First Corinthians* 492ff.) and may actually be simply expressing that woman's "source" is from man. Note that Paul quickly adds a point to assert the mutuality of man and woman (1 Cor. 11:11–12).

The essence of the message in Genesis 2 appears to be one of providing a "helper" for Adam, who in some unspoken way is incomplete without a woman. Far from giving us the impression of a self-sufficient male who is given a female for his own pleasure, or to have a close though inferior object to govern, the creation of the female provides the male with a completeness he lacks. The term in Hebrew for "help meet," or "fit helper," used here to describe the woman, leans much more toward the preciseness of the match: the newly created person fits the needs and the deficiency in the initially created person (Spencer 23ff.).

The message of Genesis 2 seems far more concerned (again, within a strict patriarchal context) to address the necessity of the female's place in the human arena. Thus it approaches the same declaration of the need for and the worth of *both* sexes in God's created order. While male-dominated culture might relegate females to secondary positions, God's original intention was for the woman to provide what the man lacked, and the man likewise to provide what the woman lacked, in mutually presenting the "image of God" incarnate (Jewett 24–40).

Once the equality of women and men is understood to be God's original intention for humanity, it becomes more overwhelmingly clear that the monogamous relationship between these two, wherein they physically, spiritually, and emotionally are united as one, in some measure appears to mimic the three-in-one relationship of God. Any undermining of the union of the human partners tends, in turn, to diminish appreciation of the nature of the Partners in the divine union.

The Fall of Humanity

Certainly it is Eve's participation in the Fall of humanity that supports much of the hierarchicalist teaching regarding the subordinate place of women. If it is reasoned that the creation established a dominant position for the male, and the female fell victim to pride in usurping that position, the Fall appears to give ample evidence of the female's incapability of leadership and/or self-assertiveness in crucial affairs such as this confrontation with the serpent.

Of most interest to this writer in the account of the Fall are two

major questions in the Fall scenario: (1) Why did the serpent, noted to be extremely crafty, approach Eve and not Adam (Gen. 3:1)? and (2) In Eve's answer to the serpent concerning God's prohibition, why did she add the injunction "you must not touch" the fruit (Gen. 3:3)?

In answering the first question, it is possibly because we are so used to the hierarchical approach that we immediately think in terms of the woman's weakness or greater gullibility as the reason why the serpent approached her and not Adam. Beyond this, Eve's added prohibition (cf. Gen. 2:17; 3:3) is normally associated with the woman's obsessive desire to have what God had forbidden her. A few examples will help.

H. Morris recognizes the added prohibition and describes it as being "purely the product of Eve's developing resentment" (111). He further describes the scene just prior to the act of disobedience: "As Eve, having allowed her mind and emotions to be influenced by the Satanic suggestions of doubt and pride, continued to gaze at the forbidden tree, its fruit seemed to become more and more beautiful and delectable all the time" (113). Clearly exegetical concerns have given way to dramatic license, and a most biased one at that!

H. G. Stigers characterizes the scene similarly: "Eve's reaction, instead of a flat rejection of the pernicious suggestion . . . is to temporize, to give expression to resentment against God's command by adding, '. . .neither shall you touch it' " (*Genesis* 74). John Calvin, however, observes the comment by an earlier writer, Peter Martyr, that the addition came because Eve was "anxiously observing the precept of God" (149). In other words, she was trying to obey *too hard!*

Yet is it likely that the reaction of a frustrated, anxious woman, especially one who, by her very nature is more easily deceived than her male counterpart, would be to add prohibitions to those she already so resents? Is it not *just as likely* (surely as likely as Morris's reconstruction) that it was Adam who added this injunction in the first abortive attempt by one human being to educate another?

Let us recall that it was prior to Eve's creation that Adam was given the original prohibition from God concerning the tree (2:17). For Eve to know the prohibition as well as she did, she must have been educated in its content. Either God specially revealed it to her or, in what would be most natural as a fitting interchange between the supposed cosovereigns of the creation, Adam would have taught her. In any event, it appears *just as likely* that Adam hedged the prohibition to Eve, attempting to stop her one step short of breaking the actual law. Later Judaism would become famous for placing such a hedge around the Law (note the practice of not uttering God's personal name, Yahweh, in an attempt not to break the third commandment).

Thus it can be understood to be *just as likely* for the serpent to

attack Eve because he knew that her inadequate education regarding the prohibition in the end would lead her to doubt the ultimate prohibition itself and to suspect that God really was hiding something of great value on the tree. In any event, Adam was located in close proximity to her during the entire conversation and appears not to hesitate for a moment in partaking of the fruit (Gen. 3:6; Spencer 30–34). The New Testament appears to hold Adam responsible for the entrance of sin into the world (Rom. 5:12–14; 1 Cor. 15:21–22). Rather than receiving blame for not asserting his supposed "headship" and, with it, ultimate authority/responsibility for what happens in his "family," it is *just as likely* he is responsible because he improperly taught God's word to Eve.

Effects of Sin

Crucial passages in regard to women's studies are the judgments on Eve and Adam for their disobedience against God's stated prohibition. Genesis 3:8–13 indicates the change in relationship that occurred because of disobedience. Their nakedness exposed, in both a physical and a spiritual sense, they now emphasized and cultivated through mutual blame their separation from the oneness God intended for them.

Genesis 3:15 indicates God's plan of redemption in crushing the serpent and the effects of his deception through the seed of the woman. Thus, far from being marginalized to the very recesses of humanity's worth, females would always be at the very center of God's process of reconciliation.

In the specified judgments against the sinning participants in the Fall we find the most debated issue regarding male/female relationships. The effect of sin on their relationship, specified in 3:16, has variously been interpreted as prescriptive (indicating God's will for what will happen), or descriptive (indicating what will happen, not necessarily God's will). In any case, the judgment introduced a new relationship that included the man's dominance of the woman, and a form of "desire" on the woman's part for the man.

Since Adam and Eve are both included in the judgment, where is the indication that one was more culpable in the Fall than the other? Adam's fault in "listening to his wife" (Gen. 3:17) is not specified. Most likely it is in the content of the listening—that is, following through with eating that which he knew to be prohibited that was at issue. In other words, it is not in the listening itself that Adam was at fault, for this would imply that men need not, and should not, listen to their wives at all!

Since verse sixteen is the first appearance of any reference to one

human "ruling" over another, and because this is associated with the consequence of the Fall, we are at least on safe ground in concluding that such a relationship was not associated with God's original intention. Hierarchicalists are surely grasping at preconceptions when they say that this "rule" carries with it only an additional negative aspect of an already intended governing structure (Knight 43; Clark 32, 35).

Summary. The creation and fall of humanity appears to have a centralized theme of missed opportunity and unfulfilled promise (likely this is a theme of the entire Bible prior to Christ's redemptive work). Rather than setting up a hierarchical governmental structure between the two co–imager-bearers of God, the divine intention appears to hold out the promise of mutuality and equal participation in the cultural mandate. It is in the judgment associated with the Fall that separation from God and alienation from the other human image-bearer of God is introduced. The judgment is not given without the hope of restoration, however. As in most of God's punishments found throughout Scripture, the coming work of the Messiah brings God's *shalom* to the disrupted unity of creation. The promise of Genesis 3:15, in this writer's view, severely, and lovingly, restricts and temporalizes the judgments that follow. Restoration to oneness, not hierarchicalism, is the goal of redemption.

The Place of Women in the Biblical World

Old Testament: Paradoxical Treatment

The Old Testament gives evidence for a somewhat greater appreciation of the woman in Israel relative to surrounding nations. Israel's strict moral code probably had much to do with subduing a full-fledged oppression of its female members. Richard N. Longenecker distinguishes two spheres in Jewish society, each alternatively governed by men and women. The public sphere belonged to the men, while the private sphere, the home, was basically governed by women until, and unless, conflict would arise (Longenecker "Authority" 65). This distinction may have contributed to what appears to be a special acknowledgment of the dignity of motherhood and its influence in Israelite society (Nicole 1176).

Thus such texts as Exodus 20:12; Deuteronomy 21:18–19; Proverbs 1:8; 6:20; and 10:1 gave equal worthiness to mothers and to fathers to be honored, and to govern the affairs of their children. Other texts described protective measures especially designed for widows and slave women who were normally targets for abuse in many surrounding cultures (e.g., Exod. 22:22; Deut. 14:29; 21:10–14;

24:17–19). In Sabbath regulations sons and daughters were treated alike (Exod. 20:10) and crimes against women were treated very seriously (e.g., Lev. 20:10; Deut. 22:20–24).

Women such as Miriam, Deborah, Hannah, Huldah, Ruth, and Esther were participants in the struggle for Israel's survival and were honored for their contributions. Groups of women were also remembered for parts they played in the religious and moral life of the nation (2 Sam. 14:1–20; 20:14–22; Prov. 14:1), and for holding official positions of leadership (Exod. 38:8; 1 Chron. 25:5–6; Ezra 2:65; Neh. 7:67; Ps. 68:24–25). Such examples readily indicate to those who take notice, that the confinement of women to the private sphere was quite arbitrary (Prov. 31:16, 24; cf. Evans 29–31).

Feminine illustrations for the nature of God and for the personification of wisdom abound in the Old Testament (e.g., Exod. 16:4–36; 17:1–7; Num. 11:12; Ps. 36:8; Hos. 11:4 et al.; Prov. 8; see also Spencer 121–31). Trible cites such illustrations, as well as Israel's corporate personality and the equality implicit in the Song of Songs, to show that images that emphasize feminine aspects of God are present in various Old Testament authors and time periods (Trible cited by Swartley 153–54; cf. Evans 21–24).

Yet for all these positive assertions, the Mosaic Law contained certain regulations that were ultimately used to discriminate against women as a group. These discriminating measures included the sign of the covenant placed on men only (circumcision), the prohibition of women to be part of the priesthood (possibly as a contrast to other nations), special purification measures after birth and during menstruation, the listing of a woman as part of her husband's possessions (Exod. 20:17), the prohibition of women to initiate divorce, and the fact that fathers were permitted to sell their daughters as slaves (not as prostitutes, however).

While each of these restrictions alone can be seen to have a mildly positive overtone relative to the contemporary culture, the cumulative effect appears to have further widened the gap between the sexes. From the fourth century B.C., accelerated by contact with Hellenism, Jewish attitudes began to mirror those of gentile lands that were definitely misogynist. An example of these attitudes is found in the Apocrypha: "From garments cometh a moth and from a woman the iniquities of a man. For better is the iniquity of a man than woman doing a good turn" (Ecclus. 42:13–14; cf. 1 Enoch on Gen. 6:1ff.; Sirach 25:24 et al.).

Summary. The culture of the Old Testament time period was quite androcentric; patriarchal models of the government of nation and households abound throughout it. While many of the texts reveal

a better lot for women in Israel than in most other cultures, the effect of the Fall can clearly be seen in the oppressiveness of male domination over women, the unfounded positions regarding women as sexual temptresses, and in the severe restrictions of women in regard to public life and education (Spencer 50–54).

We can also see the resultant depreciation of the position of women in the eyes of their Jewish brethren in the numerous rabbinic references to both the lack of necessity and the foolhardiness of educating a woman. Rather than learning from the Old Testament examples of the women who had ability to learn, lead, and speak in the public arena, rabbinic Judaism paralleled the gentile world's concern for the relegation of women to the home, away from contact with the public sphere. Women's conversing with men, whether it was for education in the Torah or merely for passing the time of day, was viewed with horror and incurred censure (Evans 33–37).

In this repressive society the Word became flesh.

Jesus' Ministry and Women

All commentators note Jesus' very open attitude toward women. For his time, Jesus' association with women could hardly be observed to be anything short of scandalous. So characteristic was Jesus' openness toward women that in spite of the patriarchal culture of his day, the Gospels, written thirty years and more after his ministry, continued to reflect this attitude (Swindler 183).

Jesus allowed women to follow him as disciples (Mark 15:41; Luke 8:1–3). He spoke openly in public to them, including even a Samaritan woman (John 4). He involved himself in ministering to their needs. For those who were often held to be of less worth than men (Ecclus. 42:9–14), Jesus dealt with a considerable number of women:

- Peter's mother-in-law, Matt. 8:14–15 (Mark 1:29–31; Luke 4:38–39);
- The daughter of Jairus; the woman with a hemorrhage (even though allowing her to touch him made him "unclean"), Matt. 9:18–26 (Mark 5:21–43; Luke 8:40–56);
- The widow of Nain and the woman identified as "a sinner," Luke 7;
- The woman with an "awkward disability"; Jesus called her a "daughter of Abraham" (a term of endearment found nowhere else in biblical or rabbinic literature), Luke 13;
- The woman "caught in adultery"; Jesus rejected the double standard of the time regarding sexual practices and forgave her (Swindler 182), John 7:53–8:11 (if authentic).

Besides being prominent at Jesus' birth (note the care by angels to announce to Mary what would happen, Luke 1:26–38), women were involved in the recognition of him as Messiah (Anna, a prophet, Luke 1:36–38) and were witnesses to his death and resurrection. He conversed with them on theological topics (Syrophoenician woman, Matt. 15:21–28; Samaritan woman, John 4; Mary and Martha, John 11; cf. Spencer 60–62) and he commended their faith (widow and her mite, Mark 12:41–44; Luke 21:1–4; "daughter of Abraham," Luke 13; woman with hemorrhage, Matt. 8 et al.).

In all these ways, Jesus showed that women were not to be restricted in their quest for faith in God. It was the women in Jesus' life who proved to be the most faithful and the most persistent in following him and in responding to the extraordinary dimensions of his ministry.

Hierarchicalists wish to point out that Jesus did not speak to the status of women in Judaism per se, and they take from that the understanding that Jesus approved of the status quo (Zerbst 60–61, Clark 251). Quite to the contrary, however, Jesus acted toward women and men alike in ways that completely changed their relationships with one another. In breaking down the many culturally imposed restrictions regarding contact between law-abiding Jewish men and women, Jesus put into place those qualities of acceptance that would, ultimately, lead to the abolition of such restrictions. His actions spoke very loudly.

Further, it does not help the hierarchicalists to argue that Jesus did not appoint women as disciples or apostles. Indeed, the logistics of women becoming full-time disciples and traveling with males around Palestine would have been impossible and would have scandalized and obscured Jesus' true mission. The Twelve most likely were a reconstitution of the tribes of Israel—only males would be appropriate symbols for this (E. and F. Stagg 129). However, women did follow Jesus in groups, and to use any other term for them than disciples is begging the question. Women were not in the inner circle—only three men were—but they did constitute the first witnesses to the resurrection while those in the inner circle were in hiding.

The issue of not appointing women apostles is a problematic one because the debate about the definition of the term, its general lack of use in the Gospels, the continuity between disciples and apostles, and the nature of the office in the early church are all issues that are not fully resolved in New Testament study. As we will see, there is evidence that women may well have been involved in many leadership capacities, including that of apostle, in the early church. Nowhere, however, are we told that the lack of women in these positions constituted policy, or retained an appropriate order of

authority. Conclusions drawn from silence are tenuous at best. A similar criticism could be made against gentile participation in leadership (Stagg 255), but since most hierarchicalist commentators are gentile leaders, this argument has not been seriously considered.

It may well be said, then, that Jesus brought a remarkably new approach to all human beings in his ministry. He displayed the love of God to both sexes while not being drawn into endorsing any contemporary social, economic, or political categories. His mission was bigger than all that. As we will see in the Pauline analysis of his redemption, Christ "makes all things new" (Tucker and Liefeld 45–48).

New Testament: A New Creation

We will want to analyze the Pauline passages concerning women that have been at the center of the biblical studies debate. However, before moving into those issues, we need to survey the territory of the New Testament to see what, if any, effect Jesus' attitude toward women had on the first-century church.

The institution of the church after the outpouring of the Holy Spirit on Pentecost (Acts 2) is a monumental moment in God's salvation history. The prophets Joel (2:28–32), and Jeremiah (31:33–34), and others looked forward to that moment with utmost hope for the renewal of Israel. Yet their prophecies also indicate an expansion and a new formation of the covenant in which they operated. Indeed, with the coming of the Spirit and the internalization of the Law in the hearts of believers, an eschatological ("last days") event occurred in human history.

With this event a new reality began, one that radically altered the nature of contemporary relationships and roles because such roles were products of the Fall of humanity and that Fall became powerless in Christ (Bilezikian 422). As the apostle Paul specified concerning this time, worldly or cultural orientations must be rejected in favor of the new reality: "Therefore, if anyone is in Christ, he is a new creation; the old has gone, the new has come!" (2 Cor. 5:17).

The announcement of a new creation, a new covenant, indicated that reconciliation in Christ does not simply rebuild the old relationships between men and women but also ushers in a foretaste of the completeness that is to come. The new reality is of a completely different sort than the old. Even those hierarchicalists who argue for a superiority of rank, or role, for males based on the creation order must see that the newness envisioned here in Paul brings all persons into an equalized relationship with one another. The only existence we can

claim in the new reality is an existence that is built on Christ. No other distinction is worthy of continuance into this newness.

If such a reading of the direction of reconciliation is justified, we would expect to see such a newness being put into practice in the new community of faith. The only time such practices should be halted would be, as in the ministry of Jesus, when issues pertaining to individual practices are in danger of obscuring the overall salvation appeal of the Gospel. It has often been noted with regard to the issue of slavery (a close parallel to the issue of women, see Swartley) that Jesus and Paul never spoke directly against the practice. Yet it has also been accepted that they refrained from doing so, not because they accepted the practice, but because they knew that the infusion of the Gospel into the lives of human beings would result in the demise of that practice.

As we look at the practices of the early church we see a striking contrast between the treatment of women and the opportunities afforded them within the church in the generally misogynist culture of the Hellenistic world:

• The Holy Spirit is poured out on men and women equally (Acts 2 indicates presence of women with men in worship prior to the outpouring);

• Baptism, as the initiatory rite of the new covenant, is open to both women and men;

• Women actively participate in public prayer and prophecy (Acts 2:18; 21:9; 1 Cor. 11:5);

• Many women are listed as coworkers with Paul's missionary enterprise. Ten of twenty-nine people named in Romans 16 are women; they are commended with terms similar to those used for men; Phoebe is described as a deacon; and likely a Junia is numbered among the apostles; Priscilla is mentioned, along with her husband, as an influential teacher of Apollos (Acts 18:18–19, 26);

• Mutuality of marital and sexual relations is unparalleled in Hellenistic culture (1 Cor. 7);

• Businesswomen such as Lydia and Chloe were influential supporters of Paul's ministry (Acts 16; 1 Cor. 1).

Whatever else may be said about the evidence given above, the picture is one of increased participation of women in the very mainstream of church life. Not relegated any longer to the domestic sphere alone, they now participate in advancing the Gospel because they are corecipients of the Spirit of God. A new creation has dawned within the old; it will revolutionize the contemporary sphere, but it also has the difficult task of doing this from the inside out. The real challenge, then, is to retain the principles of this new creation, while

attempting to gain acceptance within the more restrictive old creation.

PAULINE PASSAGES ON WOMEN

When we analyze the Pauline material, it becomes quite obvious where the difficulties lie. Paul appears to give contradictory indications about what he wishes the church's attitude toward women to be. One set of texts (i.e., Gal. 3:28; 1 Cor. 7; Rom. 16) appears egalitarian, while the other set (1 Cor. 11; 14; "house rules" in Ephesians and Colossians; 1 Tim. 2:11–15) appears hierarchicalist. Clearly, we must either find a way to harmonize this material or accept the fact that the leading New Testament author contradicts himself (such is the conclusion of R. Jewett, "Sexual Liberation" 64–69; Betz 200; this might also be called a "development" of Paul's thought).

Galatians 3:28

There is neither Jew nor Greek, slave nor free, male nor female, for you are all one in Christ Jesus.

New Testament scholars have generally treated Galatians 3:28 as one of the most impressive statements regarding the reality of life in the new covenant. Called the "Magna Carta of the New Humanity" (Longenecker, *New Testament Ethics* 30), it has been widely believed to be a Pauline quotation of an early Christian baptismal formula (Longenecker 31; Bartchy 58; Betz 184–85). It appears only in the women's issue that hierarchicalists are reluctant to allow this text to be one starting point in Paul's overall principle regarding the new reality in Christ (Ryrie 76; Knight 1; 4–11; Clark 138).

Clearly, the passage is meant to be the climax to Paul's discussion concerning the need to abolish all differences of attitude and practice between Jewish believers and Gentile believers. The other couplets ensure that the newness in Christ should be seen to be an exhaustive and not a limited newness. To make this point strictly in the context of the Galatian problems, he need not have included the other pairs. Yet for Paul there must have been an inseparable linkage of these couplets as descriptive of the new clothing put on in Christ. Paul may have consciously undercut the unfortunate prayer uttered by Jewish males, who thanked God that they were blessed that they could learn the Torah since they were neither "a Gentile, . . . an uneducated man, . . . a woman" (Palestinian Talmud; which may have been influenced

by a gentile parallel: Greeks were glad not to be "a beast, . . . a woman, . . . a barbarian"; Spencer 64, n.1)

Klyne Snodgrass effectively shows that this principle of equality was meant to be interpreted not only in a soteriological sense but also in a social sense. He exclaims that "Galatians 3:28 is the most socially explosive text in the New Testament, and, given its due, it will confront and change our lives and communities" (Snodgrass 167–68). He goes on to detail how this statement not only stands as the hinge of Paul's argument against the relegation of Gentiles in Galatia to a lower status, but also is "his basic summary of what it means to be a Christian" (173).

Significant in our analysis of Galatians 3:28 is the care that Paul has taken (or, the care originally taken by the author of this baptismal formula) to show that sexual differences are not obliterated in Christ, only the consequences attached to those differences in the fallen culture are obliterated. While Paul shows the complete elimination of differences between those in the position of being Jews *or* Gentiles, slaves *or* free, he changes the conjunction slightly in the instance of male *and* female. This means that while obvious sexual distinctiveness remains, "valuation or status based on the difference is rejected" (Snodgrass 177).

Taken as a point of departure, Galatians 3:28 stands as an affirmation of the restored oneness of the created order through the work of Christ (cf. Rom. 10:12–13; 1 Cor. 7:17–27; 11:11–12; 12:13; Col. 3:9–11 et al.). The image of clothing, found here, covered all the culturally associated marks of distinction. In effect, the nakedness of the Fall in Genesis 3 is covered by the clothing of Christ in Galatians 3 with the effect of restoring innocence and mutuality among all persons. Added to all of that is the newness found in Christ, which profoundly affects each sex's ability to reflect the image of God since each carries God's own Spirit within.

Paul's other emphasis, so often repeated with reference to the body of Christ, as to the dependency of all believers on one another's spiritual gifts (Rom. 12; 1 Cor. 12), gives further credence to the principle of newness, restoration of oneness, and inclusion of all as the marks of the new covenant. As Longenecker writes, "The cultural mandate of the gospel lays on Christians the obligation to measure every attitude and action toward others in terms of the impartiality and love which God expressed in Jesus Christ, and to express in life such attitudes and actions as would break down barriers of prejudice and walls of inequality, without setting aside the distinctive characteristics of people" (*New Testament Ethics* 34).

Summary. We must agree with those who see Galatians 3:28 and

passages like it, as the starting point for our analysis of Paul's view as to the role and status of women in the church (Gasque 189; Bruce 190). The principle enunciated here is at the very center of the entire gospel proclamation of reconciliation in Jesus Christ. It affirms the basic equality of all as sinners saved by the grace of Christ's finished work on the cross. It demonstrates, in the most tangible forms, the striking difference the "new creation" (2 Cor. 5:17) makes us recipients of that grace, and it points forward to the ultimate restoration of all things to the God who is "no respecter of persons" (e.g., Deut. 1:17; 10:17; 16:19; 2 Chron. 19:7; Luke 20:21; 1 Tim. 5:21).

Restrictive Passages

In turning to those passages where some restrictions seem to be made by Paul on the practices of women in the early church, we want to be careful to note a characteristic of all Pauline literature—it is occasional in nature. Paul is a "task theologian" (Fee, HTRTB 46) and, as such, must be interpreted with a careful eye toward the occasion and purpose of his writing.

Our procedure, then, will be to analyze each restrictive passage, with an attempt to distinguish what is clear from what is unclear. The distinctions will be useful in helping us understand possible reasons why Paul seemingly slowed down the process of mutuality in Christian practice in some of his congregations.

1 Corinthians 11:1–16

Context: On the heels of chapters 8–10, which include Paul's missionary strategy ("I become all things to all men in order to save some," 9:22), this passage continues the discussion of the need to restrict liberties for the sake of the gospel message in some practical areas of the Corinthian church's patterns of worship (ch. 11).

Clear points:
1. Women could pray and prophesy at some gatherings of the membership.
2. The *manner* in which the women did these things was at issue, not the fact that they were doing them.
3. Paul gives instructions for the women to give proper regard for "head covering."
4. While making a distinct appeal to women only, Paul indicates the interdependency of men and women "in the Lord."

Unclear points:
1. What lack of "head covering" was involved? Is Paul referring to veils or to proper hair arrangement (tied up vs. loose)?
2. What does Paul mean by "head" (Greek *kephalē*)?
3. What problem was there in the situation that would cause believers to interpret a particular head covering to be proper or disgraceful?
4. What part do the angels play in this?

Analysis: Using the clear points of this passage, we may infer that Paul continues to insist that Christians give proper attention to cultural conditions in order not to give offense in representing the Gospel (note his discussion on hair length and propriety during corporate meals). At issue in 1 Corinthians 11 is that some women, in exercising their right to participate in the worship service, had transgressed a cultural line in regard to proper "head covering."

Some Corinthian women apparently felt that the best solution to the problem posed by Paul was the eradication of all sexual distinctions. This became manifest through their rejection of sexuality in marriage (1 Cor. 7), in their shaving of their hair (the issue here), and in their inappropriate behavior within the church assembly (ch. 14). In each of these areas, rather than asserting a little freedom and having Paul respond with a word to keep them in their place, these women asserted a sexless reality that negated God's original created intentions (for a discussion of the major options here, see Fee, *First Corinthians* 491–530). Paul enjoins them to restrict their freedom as an accommodation to those who might consider such actions disgraceful toward the men in the congregation, inappropriate in regard to the issue of "headship," and offensive to angels.

Finally, I agree with those who hold the view that *kephalē* most likely denoted "source of life," "origin," or "prominent one." While authority might be a derivative aspect of any one of these terms, it is not a necessary one, nor is it the best with regard to Paul's linkage here. Recent studies, particularly the one by C. Kroeger, have affirmed the idea of "source" behind the Greek term (Kroeger, "The Classical Concept of 'Head' as 'Source'"; also B. and A. Mickelsen; see W. Grudem for an opposing view).

1 Corinthians 14:33–36

Context: In the midst of a discussion concerning spiritual gifts (chs. 12–14) Paul is exhorting the Corinthians to understand the priority of prophecy over that of tongues-speaking and the need to restrict both gifts for propriety during a worship service. Further, the

immediate context calls on the church to be mindful of proper procedures in judging prophecy.

Clear points:
1. Paul forbids women to speak (Greek: *lalein*) in the assembly.
2. His reason for the restriction is propriety.
3. They are to learn in submission, as the Law says.
4. They are to seek answers to questions from their husbands.

Unclear points:
1. How can this restriction be reconciled to the apparent allowance for prayer and prophesying in 1 Corinthians 11?
2. How does the textual evidence, showing that many manuscripts place these passages (vv. 34–35) after verse 40, affect the legitimacy of the passage?
3. Is this injunction for all women or only for those who are married?
4. Does *lalein* connote any kind of speech, or a particular kind (such as babbling; cf. Nicole 1178)?
5. Does the injunction refer to all assemblies of the church?
6. What "Law" is cited here, since there is no such injunction in the Mosaic Law? (Liefeld, "Women, Submission and Ministry in 1 Corinthians" 149).

Analysis: There are many more unclear than clear points here. The context might well give us the proper understanding of this problem because the issue involved is that of propriety with regard to the judging of prophecies (an important feature of early church worship). This amounted to a type of mutual teaching in assessing, and possibly correcting, pronouncements made by others.

Since the context seems to indicate the presence of nonbelievers in the assembly (vv. 23–25), the passage may refer to a different service than that of 1 Corinthians 11 (which may have only service in the home in mind as opposed to what 14:23 implies is the whole church together). Paul may be appealing to the fact that it was highly improper for women in Hellenistic and Roman cultures to "reveal" themselves in speech, as would be the case if women were judging some men's prophetic utterances. Thus "the Law" may be a reference to the cultural practices of the Corinthians (cf. the Oppian Law; see Liefeld 141).

Many more scholars are reassessing the textual evidence and deciding that this is a marginal gloss and not an original part of the text (most recently Fee, *First Corinthians* 699–710). Paul's uncharacteristic appeal to the Law makes this an even greater possibility, along

with the apparent contradiction of 1 Corinthians 11. In any event, it is highly unlikely that Paul is contradicting himself. If we do not accept the view of a marginal gloss, it would seem that propriety is again the issue. Women were to restrict their speech in this circumstance, since it was culturally inappropriate, and since, if judging prophecy was in view specifically, uneducated women would not allay but only increase the already confused situation (vv. 33, 40).

1 Timothy 2:9–15

Context: In the midst of encouraging and instructing Timothy on how to conduct the affairs of the church at Ephesus, Paul has to help Timothy combat the effect of false teachers who have infiltrated the congregation. The passage at issue, along with 1 Timothy 5:11–15 and 2 Timothy 3:6–7, indicates that young women were especially susceptible to the new teachings (Bartchy 73–74; Spencer 91). Some have suggested that the false teaching may have been characteristic of the religious environment of Ephesus with its matriarchal emphasis (Scholer "1 Timothy 2:9–15" 199, n.19; Kroeger, "1 Timothy 2:12: A Classicist's View" 226ff.).

Paul's intent in 1 Timothy appears to be to call a halt to the deteriorating situation by showing his support for Timothy, while exhorting the church to take defensive measures against the heresy (Scholer, "1 Timothy" 199). Thus, the injunctions are designed to address a particular number of problems found at Ephesus and may not necessarily be normative.

Clear points:
1. Both men and women are enjoined to proper behavior.
2. The value of injunctions and encouragements regarding the adornment of women and the preservation of the woman in childbirth are equal to those regarding teaching and having authority.
3. The injunction against teaching and authority are coupled with an emphasis on the need for women to be "quiet" (repeated in vv. 10–11).
4. Paul bases these instructions on the order of creation and the deception of Eve into sin.

Unclear points:
1. What was the nature of the false teaching that disturbed the Ephesian church?
2. Why did Paul use the rare term *authentein* to indicate what he forbids women to exercise over men?

3. What significance is there to the use of *oude,* which is a close connective, instead of *kai,* which is the typical "and" indicating a conjunction of two equal nouns?
4. Is Paul's argument regarding both the order of creation and Eve's responsibility for the Fall a normative interpretation of the biblical events or an ad hoc argument designed only for that context?
5. Is there any more normative value to the injunctions concerning teaching and authority than to the statements about adornment, childbirth, or instructions to widows (5:14, "I want [them] to get married")?

Analysis: This is an extremely difficult passage, as the unclear points above show. We must begin by taking the nature of this epistle seriously as a response to a contemporary situation and not as a church-order manual. In most cases Paul is attempting to redress some wrongs and some overemphases of the situation. We might expect that some of his measures are fit for an emergency situation rather than for an ideal one.

The injunctions Paul places on women have been variously interpreted, but the fact remains that this is the only passage in Scripture that could actually be used to forbid total participation by women in ministry. Yet, the injunctions are based on what appear to be some shocking arguments that reveal either an author other than Paul (since he cites Adam as the one responsible for sin's entrance into the world elsewhere [Rom. 5; 1 Cor. 15]) or Paul's use of selective arguments to counteract specific false teachings (cf. Scholer, "1 Timothy" 200).

Further, it is not quite clear what Paul is forbidding, since the simple idea of "authority" is found continuously throughout the Pauline epistles by his use of the term *exousia* rather than the rare *authentein,* which has negative connotations of a domineering style usually associated with acts of violence. Also, the use of the connective *oude* supports the view that a specific type of teaching, that which was domineering over men, was in debate here. Presumably, such a style of teaching would be inappropriate for men as well as women to use. However, women believers were just becoming acclimated to the freedom in Christ to learn and reflect on theological matters, and they would still need a time of apprenticeship before presuming to teach others.

The passage seems to prove too much, since Priscilla's work with Apollos was not condemned, but commended. The passage disallows all teaching by women—in Sunday schools, missionary work, seminaries, publications, etc. It gives no guidelines for implementation,

such as specifying the age when a boy can no longer be taught by a woman or the subject matter that is forbidden. Presumably, all female Christian-school teachers or even public-school teachers are in violation of this provision!

Let us be cautious in assigning to this passage the normative force so often given to it by traditionalists. The cultural background is ripe with pagan religious practices in Ephesus that emphasized the feminine aspect of deity to the exclusion of the masculine in many cases. The very selective argumentation by Paul that appears to counteract his stated principles elsewhere and parallel passages that appear to indicate the need for restrictions for the sake of propriety (Titus 2:4–5) should temper our universalizing these restrictions outside very similar contexts. There are too many unclear points for us to be completely sure about what Paul is specifically restricting.

At any rate, as many have noticed, his restriction is stated in the present tense: "I am not allowing" Did local conditions dictate Paul's statements here? Would alleviation of the heresy or the maturation of women in the faith call for a lightening of the provision? We believe the principles enunciated in a text such as Galatians 3:28 must find expression in the church when the historical particulars, such as those confronted in these passages, were removed.

1 Corinthians 7; Ephesians 5:21–33; Colossians 3:18–19

Paul seems to consistently teach respect and submission by men and women toward one another to an extent not encountered in the Hellenistic world. In sexual relations, Paul says that husband and wife are to submit to one another as Christ submitted his own interests to those of his lover, the church.

It is probably true that in Paul's time wives had less authority in the household than did husbands. Yet Paul's suggestion of any other arrangement would have placed an undue stress on the normal relationships of that day and thus would have brought Christian marriages under unnecessary criticism by the culture. Overall, in relations between wives and husbands, women and men, slaves and owners, the Gospel liberated individuals to an equal standing before God, without insisting on a societal revolution to confirm that reality. Such an insistence would only have muddied the waters and obscured the Gospel's true power to ultimately, versus temporally, liberate the human person through reconciliation with God.

Summary. W. Ward Gasque sums up the difficulties in reconciling the texts discussed above with Galatians 3:28, and other inclusive texts: "The answer is rather simple: the danger for the church in Paul's day lay in the exact opposite direction from the church in our

day; that is, there was the danger that it might press the principle of Christian freedom too far" (Gasque 191).

Paul was always faced with announcing a new reality of life to a fallen world. This announcement admittedly would not be welcomed by those perpetuating differences in status and role, with themselves at the top; such people practice oppression and suspicion toward others (John 11:48).

"Idol Meat": A Parallel Case?

The epistle that most clearly shows Paul's way of walking the tightrope in the midst of this collision of the new and old realities, is 1 Corinthians. In the Corinthian church the principles of the Gospel's freedom were used far beyond legitimate bounds of propriety and righteousness. The Corinthians were moving too far too fast and, as Fee points out, were overly influenced by a "spiritualized eschatology" (Fee 11) that failed to consider the impact the Gospel's newness would have on the contemporary culture. As newcomers to the Gospel, they tended to blend it inappropriately with contemporary views within Hellenism. Thus, in many issues, Paul had to move carefully through an uncharted middle ground that, while not denying the liberating power of the Gospel in principle, avoided linkage with any contemporary Hellenistic views and gave proper direction to how the new reality in Christ should be structured.

Therefore, similar to the way "the weak" are treated in the discussion of meat offered to idols in 1 Corinthians 8–10, Paul would prefer that the social implications of the Gospel take full and appropriate effect within the church. "The strong" were to proceed with great restraint in order not to push the weaker members of the body into areas in which they were uncomfortable and in which they would be susceptible to past pagan influences. The principle, then, clearly given in the example of Paul's rejection of pay for preaching the Gospel (1 Cor. 9), is to be careful not to allow any contemporary issue or controversy to impede the progress of the Gospel and its mission to save as many as possible (1 Cor. 9:19, 22).

In the Corinthian situation, those who are strong are obviously on a better theological footing than the weak, yet they still have not fully understood Jesus' command that such a position requires one to be a "servant of all." The strong are right in principle, but they need to love the weak members of the body so as not to push them too far. However, Paul never commends the weak for their weakness. He asserts that their weakness is caused by a lack of knowledge (8:7). The obvious intention of his long argument about "idol meat" in these chapters and the need to stop judging each other on such matters

(Rom. 14), clearly shows that the weak are not to remain that way! Paul gives every indication that with time and understanding of the Gospel, the strong will not push the weak beyond their capacity, and the weak will integrate the new reality of the Gospel much more into their own lives.

Paul, Propriety, and Women

As with the issue of meat offered to idols, the matter of the participation of women in the full life of the church ran up against many cultural taboos and misogynistic viewpoints. The use of women in sacred prostitution, the great restriction on women's public endeavors, the Jewish association of women with seduction and gullibility all served to make women's full embracing of the new reality in Christ that much more difficult. Paul's clearly enunciated principle of equality (Gal. 3:28) was evidently modified *only* when either the manner or the type of participation in church life had negative cultural implications (1 Cor. 11; 14), or when a specific heretical problem involving women was involved (1 Tim. 2).

A major factor in all these passages is that women were to be instructed in order to counteract the difficulties they confronted at that time (1 Cor. 14:35; 1 Tim. 2:11). The lack of education for women in those days is certain, so calling on untrained women to teach, have authority, or judge prophecies was only asking for more difficulties than the church could afford. The principles of equality and mutuality had to be realized through care and concern for those who, through societal restrictions, had not been allowed to fulfill their potential. The church was to work toward that fulfillment.

Similar to "the weak" in the Corinthian church, women were to be encouraged to guard the priority of expanding the Gospel while also implementing its life-changing principles. When full implementation of such principles could be obtained, without compromise of the Gospel, Paul endorsed change. Paul's charge to Philemon, a slave-owner, concerning Onesimus, his slave, speaks to this change: "Take him back no longer as a slave, but more than a slave, a beloved brother, especially to me, but how much more to you, both in the flesh and in the Lord" (Philem. 16).

Paul had grasped the future. He knew what effect the Gospel of Christ would have on the fallen culture around him. He was careful to place his priority on pressing home the need to be "in Christ" in order that the new reality found in Christ could take effect and cause a "new creation." While he anxiously pressed forward, moving as fast as was possible for him in that day, he knew that God had time to bring these effects of the Gospel to pass. For Jews and Gentiles, the time for

discrimination on the basis of race before Christ had passed; for slaves and free, the time for discrimination on the basis of social standing had passed; for women and men, the time for discrimination on the basis of gender had passed. "There is neither Jew nor Greek, slave nor free, male nor female, for you are all one in Christ Jesus" (Gal. 3:28). We accept the passing of the first two of these discriminations as part of the new reality in Christ. Why, then, do we retain our male/female discriminations?

Works Cited

Bartchy, S. Scott. "Power, Submission, and Sexual Identity Among the Early Christians." *Essays on New Testament Christianity: A Festschrift in Honor of Dean E. Walker*. Edited by C. Robert Wetzel. Cincinnati: Standard, 1978.

Betz, Hans D. *Galatians*. Hermenia: A Critical and Historical Commentary on the Bible. Philadelphia: Fortress, 1979.

Bilezikian, Gilbert. "Hierarchist and Egalitarian Inculcations." *Journal of the Evangelical Theological Society* 30, no. 4 (December 1987): 421–26.

Bruce, F. F. *The Epistle to the Galatians*. Grand Rapids: Eerdmans, 1982.

Calvin, John. *Commentaries on the First Book of Moses Called Genesis* vol. 1. Grand Rapids: Eerdmans, reprint 1948.

Clark, Stephen B. *Man and Woman in Christ*. Ann Arbor: Servant, 1980.

Evans, Mary J. *Women in the Bible*. Downers Grove: InterVarsity, 1983.

Fee, Gordon D. *New Testament Exegesis for Students and Pastors*. Philadelphia: Westminster, 1980.

_____. *The First Epistle to the Corinthians*. The New International Commentary on the New Testament. Grand Rapids: Eerdmans, 1985.

Fee, Gordon D., and Douglas Stuart. *How to Read the Bible for All Its Worth*. Grand Rapids: Zondervan, 1982.

Gasque, W. Ward. "Response" (to Klyne Snodgrass). In *Women, Authority, and the Bible*. Edited by Alvera Mickelsen. Downers Grove: InterVarsity, 1986.

Grudem, Wayne. "Does KEPHALE (Head) Mean 'Source' or 'Authority over' in Greek Literature? A Survey of 2,336 Examples." *Trinity Journal* n.s. 6 (1985): 38–59.

Hafemann, Scott. "Seminary, Subjectivity, and the Centrality of Scripture: Reflections on the Current Crisis." *Journal of the Evangelical Theological Society* 31 no. 2 (June 1988): 129–44.

Jewett, Paul K. *Man as Male and Female*. Grand Rapids: Eerdmans, 1975.

Jewett, Robert. "The Sexual Liberation of the Apostle Paul." *Journal of the American Academy of Religion* March supplement, Abstract 132, #55, (1979).

Knight, George W. III. *The New Testament Teaching on the Role Relationship of Male and Female with Special Reference to the Teaching/Ruling Functions in the Church*. Grand Rapids: Baker, 1977.

Kroeger, Catherine C. "1 Timothy 2:12: A Classicist's View." *Women, Authority, and the Bible*. Edited by Alvera Mickelsen. Downers Grove: InterVarsity, 1986.

————. "The Classical Concept of 'Head' as 'Source.'" *Serving Together: A Biblical Study of Human Relationships*. Edited by G. Gabelein Hull. New York: Macmillan, 1987.

Kroeger, Richard C., and Catherine C. "Women, Ordination of." *Evangelical Dictionary of Theology*. Edited by W. A. Elwell. Grand Rapids: Baker, 1984.

Lewis, C. S. "Priestesses in the Church?" *God in the Dock: Essays on Theology and Ethics*. Edited by W. Hooper. Grand Rapids: Eerdmans, 1970.

Liefeld, Walter. "Women, Submission and Ministry in 1 Corinthians." *Women, Authority, and the Bible*. Edited by Alvera Mickelsen. Downers Grove: InterVarsity, 1986.

Longenecker, Richard N. *New Testament Ethics for Today*. Grand Rapids: Eerdmans, 1984.

————. "Authority, Hierarchy and Leadership Patterns in the Bible." *Women, Authority, and the Bible*. Edited by Alvera Mickelsen. Downers Grove: InterVarsity, 1986.

Marshall, I. Howard, ed. *New Testament Interpretation: Essays on Principles and Methods*. Grand Rapids: Eerdmans, 1977.

Mickelsen, Berkeley and Alvera. "What does KEPHALE Mean in the New Testament?" *Women, Authority, and the Bible*. Edited by Alvera Mickelsen. Downers Grove: InterVarsity, 1986.

Morris, Henry. *The Genesis Record*. Grand Rapids: Baker, 1976.

Nicole, Roger. "Women, Biblical Concept of." In *Evangelical Dictionary of Theology*. Edited by W. A. Elwell. Grand Rapids: Baker, 1976.

Ryrie, Charles R. *The Place of Women in the Church*. New York: Macmillan, 1958.

Scholer, David M. "1 Timothy 2:9–15 and the Place of Women in the Ministry." *Women, Authority, and the Bible*. Edited by Alvera Mickelsen. Downers Grove: InterVarsity, 1986.

————. "Feminist Hermeneutics and Evangelical Biblical Interpretation." *Journal of the Evangelical Theological Society* 30 no. 4 (November 1987): 407–20

Snodgrass, Klyne. "Galatians 3:28: Conundrum or Solution?" *Women, Authority, and the Bible*. Edited by Alvera Mickelsen. Downers Grove: InterVarsity, 1986.

Spencer, Aida B. *Beyond the Curse: Women Called to Ministry*. Nashville: Thomas Nelson, 1985.

Stagg, Evelyn and Frank. *Women in the World of Jesus*. Philadelphia: Fortress, 1978.

Stigers, Harold G. *A Commentary on Genesis*. Grand Rapids: Zondervan, 1976.

Swartley, Willard M. *Slavery, Sabbath, War, and Women*. Scottdale, Pa.: Herald, 1983.

Swindler, Leonard. "Jesus Was a Feminist." *Catholic World* 212 (January 1971): 177–83.

Trible, Phyllis. *God and the Rhetoric of Sexuality*. Philadelphia: Fortress, 1978.

Tucker, Ruth A., and Walter Liefeld. *Daughters of the Church: Women and Ministry From New Testament Times to the Present*. Grand Rapids: Zondervan, 1987.

Zerbst, Fritz. *The Office of Woman in the Church: A Study in Practical Theology*. Translated by A. G. Merkens. St. Louis: Concordia, 1955.

For Further Study

Discussion Questions

1. Discuss the role of culture in the meaning of words or ideas. For example, imagine explaining the terms "cool" or "bad" to a person living in the 1940s, 1960s, and today. Are there differences in meaning? Why? Try thinking of other terms or concepts that have been equally "culturally conditioned." Have we conditioned any biblical passages by our own cultural patterns? (Discuss 1 Corinthians 11:13–15 or 1 Timothy 2:9.)

2. Discuss the assertion by Klyne Snodgrass that Galatians 3:28 is "the most socially explosive text in the New Testament." How important is this text in your own understanding of what it means to a Christian? How should this text be applied to relationships within our communities and throughout the world?

3. Discuss the author's presentation of the "restrictive passages," especially 1 Timothy 2. Should these texts continue to have normative force for the teaching of the church concerning women today? Why or why not? Does the presentation of the "idol meat" case help you in your understanding of how these texts should be applied today?

Writing Suggestions

1. List the similarities and differences between the creation accounts found in Genesis 1 and 2 regarding the nature of the relationship between men and women. Why do you think two accounts were provided? Can these be harmonized, and if so, how?

2. Give your own views concerning the two questions asked by the author regarding the fall of humankind. Research at least three other commentators on the issue to broaden your discussion.

Research Topics

Serious students of the Bible will want to read and compare in a number of commentaries the various texts discussed in this chapter.

Shorter Reading List

Evans, Mary J. *Woman in the Bible: An Overview of all the Crucial Passages on Women's Roles.* Downers Grove: InterVarsity, 1983.
Mickelsen, Alvera, ed. *Women, Authority, and the Bible.* Downers Grove: InterVarsity, 1986.

Spencer, Aida B. *Beyond the Curse: Women Called to Ministry.* Nashville: Thomas Nelson, 1985.

Swartley, Willard M. *Slavery, Sabbath, War, and Women.* Scottdale, Pa.: Herald, 1983.

Tucker, Ruth A., and Walter L. Liefeld. *Daughters of the Church: Women and Ministry From the New Testament Times to the Present.* Grand Rapids: Zondervan, 1987.

Longer Reading List

Bilezikian, Gilbert G. *Beyond Sex Roles: A Guide for the Study of Female Roles in the Bible.* Grand Rapids: Baker, 1985.

Clark, Stephen B. *Man and Woman in Christ: An Examination of the Roles of Men and Women in Light of Scripture and the Social Sciences.* Ann Arbor: Servant, 1980.

Daly, Mary. *Beyond God the Father: Toward a Philosophy of Women's Liberation.* Boston: Beacon, 1973.

Fiorenza, Elizabeth Schüssler. *In Memory of Her: A Feminist Theological Reconstruction of Christian Origins.* New York: Crossroad, 1983.

Foh, Susan. *Women and the Word of God: A Response to Biblical Feminism.* Grand Rapids: Baker, 1981.

Gundry, Patricia. *Woman Be Free! The Clear Message of Scripture.* Grand Rapids: Zondervan, rev. ed. 1988.

Jewett, Paul K. *Man as Male and Female.* Grand Rapids: Eerdmans, 1975.

Knight, George W. III. *The New Testament Teaching on the Role Relationship of Men and Women.* Grand Rapids: Baker, 1977.

Scanzoni, Letha, and Nancy Hardesty. *All We're Meant to Be: A Biblical Approach to Women's Liberation.* Waco: Word, 1974.

Stagg, Evelyn and Frank. *Woman in the World of Jesus.* Philadelphia: Fortress, 1978.

Trible, Phyllis. *God and the Rhetoric of Sexuality.* Philadelphia: Fortress, 1978.

3

Discovering Their Heritage: Women and the American Past

Douglas W. Carlson

HISTORIOGRAPHY AND METHODOLOGY

Limitations of Traditional History

"History," said one cynic, "is the tricks we play on the dead." Historians grow accustomed to such deprecations of their subject, knowing full well that people often consider their efforts useless or futile. Nevertheless, they continue their work of reconstructing the past, convinced of its importance for understanding the present.

However, they also recognize the limitations of their efforts. In the nineteenth century, a movement appeared, associated with German historian Leopold von Ranke, to make history an objective science by simply laying out the facts of history "to tell how it actually happened." The story would tell itself and the "meaning" of history would be clear. With the maturation of the discipline in the twentieth century, however, historians have surrendered such lofty ground, recognizing that the "facts" are rarely the entire story and that historians are partisan and not necessarily neutral observers. They participate in and are shaped by geographical location, national heritage, class, gender, and an era, all of which affect their perspective.

The result is that the historical story is always incomplete, and may indeed seem all too often like tricks played on the dead. Moreover, we are learning that the dead are not the only victims of the incomplete story. Women, present as well as past, have suffered from history's subterfuges and omissions. Composing more than half of any population, women have been well-nigh invisible in written history.

Historian Carol Berkin tells of sitting at her desk writing an article explaining women's history when her young daugther gleefully approached with the latest issue of a favorite magazine. Inside was the picture of a male face, which, if turned upside down, became a female face. Berkin realized that the picture illustrates the problem of women in history. They are usually invisible because the perspective is turned to the man's face (Berkin 35). How would history look if we turned the picture the other way?

At first we wouldn't see very much at all. The study of history requires records of the past. Records have most often been written documents, whether clay tablets from the library of Assyrian emperor Assurbanipal in the eighth century B.C., or your grandmother's letters buried in the attic. Historical events for which no records exist are for all practical purposes lost to posterity. Incomplete records mean an incomplete history, a difficulty historians often face particularly when studying more remote eras. The problem is immediate when studying women's history, however, because the focus has always been on the male world. Historians often have to hunt to find the records to tell women's story.

You might ask before this goes too far, why bother studying the past at all? We live in the present and plan for the future. The past is gone and cannot be changed. Our age is not an age that cultivates historical consciousness. American culture is particularly present-minded, and history for us is most often simply a garnish to decorate the present. Each time we move a commemorative holiday to the nearest Monday in order to create a three-day weekend we are saying that the extended weekend, not the commemoration, is the important event. Unfortunately Christians also fall prey to the tendency to ignore or devalue the past, when in fact, we should recognize its great significance. We know that God is Creator of time and history and that history is not a meaningless or endless series of random events, but rather it has purpose and direction and will culminate in Christ's return. The very essentials of our faith are not disembodied esoteric theological truths; instead they come to us incarnate as people and events in time and history. Much of God's written revelation to us is the history of his dealings with humankind; his calling out a chosen people and leading them to a promised land. Most importantly in the Incarnation, God became flesh in "the fullness of time." If the historical events of Christ's death and resurrection had not occurred, the apostle Paul reminds us, then our faith would be worthless.

God's revelation gives us insight into the significance of history. In addition to helping us discern the larger sweep of human events, history has a more personal significance for individuals as members of a family, an ethnic group or a nation. Historical understanding is

valuable because it helps us know who we are. It does so by telling us where we came from and how we got here, a way of saying that our identity is wrapped up in our history. In the book of Exodus, on the eve of the Passover, God ordered the Israelites to commemorate the event with a feast—an ordinance that would forever celebrate the memory of what was about to take place. Parents were to tell their children the story of God's deliverance of his people, and the recounting would help solidify their sense of identity as a chosen people. Today the popularity of genealogy—tracing one's family history—testifies to the desire of people to extend their sense of identity by establishing links with the past.

Searching for a "usable past" is how historians describe the appeal to history for a record that will illuminate, enhance, and give meaning to the present. The emergence of black studies, which blossomed along with the civil rights movement in the 1960s, is one example of that kind of search. Finding the records, reconstructing the lives of their ancestors in Africa and the New World—as slaves and free people—affirmed for blacks their existence and importance. The book *Roots* was perhaps the most well-known example. These studies have taught us much about black experiences in America including slavery, emancipation, segregation, discrimination, and in recent decades, a renewed commitment to realize for black citizens the promise of America. The study of the black experience has raised and sometimes answered for black Americans questions about their place and their contribution to American history. The establishment of a national holiday as affirmation of the significance of Martin Luther King, Jr. has been especially important for black Americans. Black history affirms black identity.

Women's history, in the same way, affirms women's identity. But how has history treated women? What is the problem with traditional history in relation to women? Simply put, it has left them out. Women have been reduced as Gerda Lerner, a pioneer in women's history, says to "marginality," (xxii) or worse, invisibility. The male world is the point of reference for traditional history; thus females become peripheral. The angle of vision has left women out of the picture. The usual way of doing history has been incomplete; traditional history has offered very little to women that would affirm their identity. In terms of the search for a usable past, the landscape for women has proven barren.

What explains the neglect of women in history? One strong force has been the operative definition of what constitutes history.

> Historians' neglect of women has been a function of their ideas about historical significance. Their categories and periodization

have been masculine by definition, for they have defined significance primarily by power, influence, and visible activity in the world of political and economic affairs. Traditionally, wars and politics have always been a part of "history" while those institutions which have affected individuals most immediately—social relationships, marriage, and the family—have been outside the scope of historical inquiry. (Gordon, Buhle, and Dye 75–76)

Since the lives of most women have fallen into these latter categories, their history has not been written. If history focuses on change over time, great events like wars and politics (masculine categories) have marked its milestones. By comparison, the lives of women, focused in the home and on child rearing, appear to remain the same. The real changes affecting them and the changes they have affected, remain unexplored and when women have been involved in "the public sphere," their role there has often been overlooked. Until the angle of vision is altered to include women's experience, women will remain invisible (Gordon, Buhle, and Dye 75–76).

We explored why history is important to Christians. But why is *women's* history important to Christians? Why should those of us who claim the name of Christ learn women's story? Christian scholars should be characterized by a high level of honesty and integrity because we study the Creator's universe, and we seek to tell the truth, and as much as is humanly possible, we seek to tell the whole story. We recognize our shortcomings. We see things imperfectly and will never get them entirely right. Nevertheless, it is a high calling to deepen our understanding of God's creation and we pursue it with all the integrity we can muster.

As Christians we take *people* seriously. History is about people. God became human to redeem people. While we recognize that there are impersonal movements and forces that affect events, and that individuals are largely shaped by their environment, we disagree with those who consider these influences ultimate or completely determinative. Theologians speak of the doctrine of the *imago Dei*; human beings are made in the image of God. The image of God distinguishes us from the rest of creation and makes individual people important. Despite the forces that shape us, Scripture says that we are, each one of us, ultimately accountable for what we do. Bearing God's image involves awesome responsibility. Women bear that image as much as men, and the reconstructing of the human story, if done with a desire to honestly tell the whole story, should include that half of God's image-bearers who were previously excluded.

The issue of identity becomes important once again, especially in the realm of church history. If the history of the Christian past is one that excludes women, what sense of identity can we expect them to

have with it? Recent scholarship has begun to uncover evidence of times and places in the Christian tradition when in fact women's experience has been both affirmed and influential. Hence the writing of women's history can be for Christians the redressing of omissions and a step toward wholeness for women by allowing them to establish a deeper identity with their religious tradition.

Development of Women's History

Women's history has developed as a distinct field only in the last twenty years. In 1970 no formal doctoral training on the subject was available in America and only a handful of women would have called themselves women's historians. Today more than a thousand men and women historians deal almost exclusively with women's history, and most history departments in major universities have at least one specialist in women's history. What brought about this dramatic change?

The emergence of women's history reflects the larger change of the emergence of women in public life. The twentieth century has witnessed dramatic changes for American women. They have gained the vote and joined the work force in unprecedented numbers, a phenomenon spurred by the demands for labor during World Wars I and II. Accompanying this increase of women in the work force was an expansion of their occupational aspirations beyond the areas traditionally open to them. Education also has been democratized to allow women to pursue more educational training, including advanced degrees. From 1930 to 1970 only 12–15 percent of new Ph.D. degrees in history were granted to women. Today women receive 33 percent of new Ph.D.'s in history the percentage continues to rise. Historians, like other people, want to study and read about topics that relate to their own experiences. Now that women have joined the profession in significant numbers, the history of women has emerged as a serious field of the discipline (Norton, "Is Clio a Feminist?" 1). In addition, the women's movement of the 1960s and 1970s played a role in focusing both public attention and the attention of historians on issues related to women in American society.

The study of women's history has evolved through several phases. The first phase, spurred in large measure by the concerns of the women's movement, focused on the oppression or victimization of women at the hands of men, what one historian has called the "cataloging of injustices" (Berkin 36). It tended to focus on the patriarchal society of the nineteenth century, including such things as the subordinate legal status of women, the imposition of domesticity, or bizarre male-imposed treatments for "female complaints." It is not

surprising that women's history began with a focus on the subordination of women. Black history also began with a reconstruction of the history of oppression of the black race.

The victimization of women, however, was not an adequate picture of women's history. While it documented women's subordinate status, it portrayed women as essentially passive, as acted upon. It allowed no sense of women initiating, of women acting, of women shaping their own lives. The female experience has been more than victimization.

Hence, a second phase of women's history emerged which was compensatory, asserting the accomplishments of women in the larger society. This phase is often called "contribution history." Highlighting the accomplishments of notable women or "women worthies" is one manifestation of this type of history. In 1971 a three-volume work entitled *Notable American Women 1607–1950* was published. It presented brief sketches of the lives and accomplishments of 1,359 American women. Only the wives of American presidents were included because of the reputation of their husbands—all others were included on the basis of their own merit (James, *Notable American Women* 1:xi).

Browsing through these volumes one encounters women of significant accomplishment in many fields, women whose efforts have usually not been accorded adequate recognition in traditional history. One example is Elizabeth Blackwell (1821–1910), who became the first woman to graduate with a medical degree. Born in England, she came with her family to America when she was a child. From the first, her decision to study medicine was met with opposition and hostility. Her applications to the leading medical schools in the Northeast were rejected. She was finally accepted at rural Geneva College in western New York in 1847, because the students, to whom her application was referred, thought her application a joke. Despite ostracism and scorn from students and the community, she persisted and was awarded her degree in 1849.

During the 1850s she practiced in New York City, serving poor women in a tenement district. In 1868 she helped to found the Women's Medical College of the New York Infirmary, giving women access to good medical training. She returned to England the next year, where she spent the rest of her life. There, in 1871, she helped form the National Health Society. She lectured extensively on hygiene and preventative medicine before these were commonly emphasized by the medical community and she helped pave the way for medical training for other women (James, *Notable American Women* 1:161–65).

Contribution history also identifies roles that women have played

collectively in society, for example, the role of women in reform movements. In both the abolition movement and the temperance crusade before and after the Civil War, women participated actively and their contributions to these crusades have been included in the history of the movements. Similarly, women began to play important roles in the history of the church, not only in the usually prescribed role of domestic spiritual influence on husband and children, but also in the public sphere of revivals and religious reforms. The important role of women across the wide spectrum of religious activity in American history is now beginning to be acknowledged.[1]

Contribution history has enhanced women's history by demonstrating that women's experience is more than victimization and subordination. It points out that women have participated and played key roles in important movements in the American past. Thus contribution history serves to incorporate women into the mainstream of the American story—it begins to put women in the picture of history.

However, some women's historians have said that contribution history only puts women in a picture for which men have drawn the frame. It presents women once again in male-defined categories; the criteria for inclusion come from the male-dominated world. In the introduction to Notable American Women, the editor explains that "the subjects chosen were necessarily women whose work in some way took them before the public" (James 1:xi). A sense that this was still an inadequate formulation for explaining woman's experience has given rise to a third phase of women's history: focusing attention on a women's world, a "women's sphere" distinct from that of men. Gender, like race and class, has become a category for analyzing history. This third phase coincides with a recent trend in the writing of history, to turn away from a focus on wars and politics—the "great events," heroes and villains of history—in order to reconstruct the experience of common people, history from the "bottom up" as it is sometimes called. This new social history has told us much about the life of common people in various eras of history—their fears, aspirations, and the ways they responded to the world they lived in.

"Women's sphere" has become the characteristic term for the study of women's history. While its use as a construct for studying history is fairly recent, the notion of women living in separate worlds dates back at least to Alexis de Tocqueville. Linda Kerber notes that in Democracy in America, Tocqueville's classic study of American society published in 1835, he observed that for the married woman

[1] See the three volumes entitled Women and Religion in America edited by Rosemary Radford Ruether and Rosemary Skinner Keller in "Works Cited."

"the inexorable opinion of the public carefully circumscribes [her] within the narrow circle of domestic interests and duties and forbids her to step beyond it" (Kerber, "Separate Spheres" 10). Tocqueville's image of a "circle of domestic life" suggests boundaries limiting the choices open to women (10). When historians went looking for a model by which to study women's experience on women's terms, the notion of a "separate sphere" seemed well-suited, and much of recent women's history utilizes the concept.

The scheme has been used to characterize several aspects of women's experience. In an early article (1966) entitled "The Cult of True Womanhood," Barbara Welter explored the ideology imposed upon middle-class white women, which stated that the true woman's place was in the home, and the qualities which should characterize her were domesticity, piety, purity, and submission. While we recognize these as laudable characteristics, Welter saw the separate sphere as a boundary limiting the experience and expression of women as part of the legacy of subordination. Those who dared to move beyond the circle of domestic life ran the risk of social condemnation. On the other hand, a separate women's culture held possibilities for creation of a supportive world of collective identity, as demonstrated in Nancy Cott's *The Bonds of Womanhood* (1977), that explored the middle-class culture of white women in early nineteenth-century New England. From the diaries and letters of these women, Cott analyzed the categories of work, domesticity, education, religion, and sisterhood, and found a shared understanding of the domestic life of women that provided a basis for friendships and a network of emotional support.

Study of the experience of women through the construct of a separate sphere has proven to be a useful tool. For one thing, it provides a means for moving women's history from the periphery to center stage. Within the male-dominated categories of traditional history, women's experience generally remains marginal. However, separate spheres provide a model by which to focus on the female experience. Another issue raised by the separate spheres approach is periodization. Do the traditional labels for eras of American history— the Revolutionary Era, the Age of Andrew Jackson, the Progressive Period—relate to the history of women? Are they meaningful in explaining women's experience? Historians are now relabeling some of the eras of American history using titles like Preindustrial and Industrial America to explain the economic changes that occurred between 1750 and 1850. If we are going to write a history of women in America, what new labels will emerge? The outlines are not yet clear, but that which is a useful term to describe the traditional public sphere may or may not speak to the nature of women's experience. For

example, the labels preindustrial and industrial do bear on women's experience in terms of the removal of economic production from the home. (The family's economic production came from the home.) This change marked an important watershed for American women, more so than the establishment of American political independence or the election of a certain president. Similarly the use of birth control in the late-nineteenth and early-twentieth centuries, and with it the voluntary reduction of family size, marked an important alteration in women's life cycles that is not reflected in the labels used to describe the history of that era.

On the other hand, the separate sphere approach contains potential pitfalls. If women's historians isolate the female experience too completely from the male sphere, they risk losing the sense of context in which it occurs and remain isolated from the mainstream. As it now stands, women's history is still all too often slighted or ignored. Large history departments have their women's historians, but in the mainstream, in survey courses in Western civilization and American history, a survey of texts reveals that the female experience remains marginal.

Ultimately, what do those sensitive to women's history hope for? Gerda Lerner envisions a new universal history that will synthesize women's history and traditional history (which, to remind us again, is the story of half the population). Such a reconstructed past would have a rich texture, not only analyzing the male and female worlds, but also analyzing their interaction, thus covering much of the human experience. We can hope for a continuing evolution of historical study of women, from the beginnings of articulating subordination, to exploring a separate female world, to integration of that world with the other reconstructions of the human past. For as Lerner says, "only a history based on the recognition that women have always been essential to the making of history and that *men and women* are the measure of significance, will be truly a universal history" (Lerner, *The Majority Finds Its Past* 180).

HISTORICAL SURVEY OF WOMEN IN AMERICA

Demographic Overview of Women in America: 1600 to 1970

Now it is time to ask, what have the efforts of women's historians produced? What have we learned about the experience of women in American history? While a good bit of work as been done, and new

studies are pouring off the presses, much remains to be told. There are still significant gaps in our understanding. Nevertheless a picture is emerging, and our task here is to bring its broad outlines as well as some specific examples into focus.

As we said earlier, history presents an angle of vision, a perspective, and a historian usually picks one particular way to look at a historical issue. Factors like race, ethnic background, and class, in addition to gender are important elements to consider when talking about people in society, and these factors are relevant to women's experience in America. Hence we should admit at the outset that most of this survey will focus on white, middle-class women. That is not to suggest that the experience of other women—black and Native American women for example, or rich or poor women—is not important. Their story also needs to be told and integrated into the larger picture. To say we will focus on white middle-class women is simply a reflection of the fact that the white middle class has been the dominant group in the female population as it has in the male, and most historical research on women to date has focused on that dominant group.

Let us begin our overview with a broad generalization. The history of women in America can be summarized as the female half of the population living within expectations defined by the male half of the population. Much of women's history to date has highlighted women comfortably living out their lives within, but often bumping up against, the boundaries of those expectations. Many women seem not to have thought about the boundaries or who defined them; others have felt the limitations very keenly and have challenged them. Over the course of three-and-a-half centuries in America, the circumstances, the realities of life for women have changed substantially. The definitions of women's roles, however, have been altered much more slowly.

We begin with a comparison of some vital statistics of demographic and family patterns in the colonial era with those of recent times. Even though the lives of most women have revolved around the home and the family, statistics on life expectancy, marriage, childbearing, and changes in life cycle between the colonial era and recent times offer stark contrasts. Once English settlement was well established on the North American continent, living conditions were among the best in the world for that era. By the eighteenth century the life expectancy at birth for a white female was about forty years. Sixty-six out of every hundred women born could expect to live to age twenty; and thirty of them would live to age sixty-five. By contrast, the life expectancy of a white female born in 1970 had risen to seventy-six years. Ninety-eight out of every hundred could expect to

live to age twenty, and eighty-three would reach age sixty-five. The major portion of the increase in life expectancy came after 1880. Women born today can expect to live almost twice as long as their colonial counterparts (Wells 22).

The marriage age (averaging between twenty and twenty-three years) of white women has remained fairly constant since the eighteenth century. Similarly the marriage rate has remained fixed; nine out of ten women who live into their twenties do marry. Childbearing patterns have changed dramatically, however. The average eighteenth-century married woman who lived through her childbearing years gave birth to seven children. Today the average number of children per married woman has dropped to two. The decline in the birth rate began after 1800, and evidence suggests that limits on family size were made by choice despite little knowledge of birth control (Wells 19–20).

These statistics reflect only a few of the demographic patterns uncovered by historians and sociologists. But what do they tell us about the changes in the life patterns of American women? Not only do American women live much longer today, but their lives are significantly different. A child born in the twentieth century will probably have fewer siblings than her colonial counterpart, and there will be a greater age difference between twentieth-century siblings. Consequently the modern girl has the opportunity for more attention from her parents, and as a result of a longer life cycle she is also less likely to lose a parent through death while she is still a child.

Within a year or two of marriage in her early twenties, the colonial woman began bearing and rearing children, a process that continued throughout the remainder of her life, for she was likely to die while young children were still at home. Contrast that scenario with the woman of today, whose twenty-year childbearing and child rearing responsibilities represent a significantly smaller portion of her life. The modern woman contemplates three decades of adult life outside of those responsibilities we often think of as her traditional role. Moreover, since she is now likely to outlive her husband by several years, she faces the prospect of widowhood (Wells 26–27).

Taken together, these statistics suggest dramatic changes over time in the female life cycle. Contemplating our current society and the altered circumstances which reduce the amount of time and energy women give to the traditional responsibilities of home and children, we see how they provide a historical context in which to understand the movement by women to extend their experiences beyond "the circle of domestic life."

Colonial America

In the late-sixteenth and early-seventeenth centuries, when England began to stake a claim to a portion of the New World, the homeland established permanent settlements of transplanted English citizens. Consequently English women were always in demand in the colonies. The Spanish and French, by contrast, were more interested in the conquest of the native inhabitants and the exploitation of the wealth and resources readily available and did not emphasize settlements with wives and families from Europe. Despite the intention to establish European-style communities in the English colonies, the sex ratio was imbalanced in favor of males, at least throughout the seventeenth century. Colonial authorities recognized the need for females in the colonies and made a variety of efforts to import them. Some came over on an agreement to be sold as wives. Others, convicted of petty crimes in England, were simply sent over by the government. Still others were kidnapped in England and sold in America. Perhaps the largest number came over as indentured servants, an arrangement where a woman agreed to work for a fixed number of years (usually four to seven) in exchange for passage to America. At the end of the indenture she was free, and usually married. Indentured servitude was, incidentally, a vehicle by which many men also gained passage to America.

The New World setting to which a woman came was a re-creation of the patriarchal family structure of Europe. Colonial American society is referred to as traditional or premodern, meaning before industrialization and the growth of commercial capitalism. The household was the woman's sphere, with housekeeping and child care her responsibilities. Her economic contribution to the family unit during the colonial period, however, was probably greater than in later eras because she assumed responsibility for food preparation and cloth production. In the days before refrigeration, commercial food preparation, and modern-day appliances, the processing and preserving of food was done in the home, including salting, smoking, drying, and pickling. Moreover, unless a family lived in a city and had the financial means, the woman of the house had to spin yarn, weave cloth, and sew clothes. She often worked in the fields along with her husband, and tended a vegetable garden. In this setting the economic contribution of the wife/mother to the family unit approximated that of the husband/father.

While woman's life was limited to the domestic sphere, that sphere encompassed a very significant portion of the concerns of the entire family. Opportunities for activities outside the home were rare for women, especially in rural areas. Organized communal gatherings

such as quilting bees and church functions became special occasions, eagerly anticipated. The church was an acceptable arena for female participation, and church activities, as well as religious revival, manifested in the Great Awakening of the mid-eighteenth century, included a social as well as a spiritual dimension. If life for women was circumscribed, it was nevertheless full, and the evidence suggests that women poured themselves into efforts for the welfare of their families.

Outside the home, however, the lives of women were officially very limited. Legally a married woman had few rights and was in fact invisible; her status was sometimes referred to as "civil death." Coverture was a term used in British common law to describe how a married woman was screened by her husband from legal recognition. She had no right to property, including any that she brought to the marriage (her husband assumed ownership), she could not sign a contract, she had no title to her own earnings, and in a legal separation she had no right to the children. Blackstone's *Commentaries* of 1765, which became the standard textbook for law students in America, stated that "the husband and the wife are one person in law; that is, the very being or legal existence of the woman is suspended during her marriage, or at least, is consolidated into that of her husband" (Schneir 72). Her legal interests were considered to be represented by males associated with her. Colonial churches were unified in upholding the legal subordination of women, affirming that limitations of mind and body—related to the sin of Eve—determined women's place as subordinate.

The model of woman's subordinate place was imported from Europe to America with the settlers, yet the historical evidence suggests that it was not always strictly observed. Local records of the colonies reveal instances where married women owned property, ran businesses, and controlled earnings (Riley 16–19). Perhaps the environment of the New World, in which a woman's economic contribution was so crucial, served to lessen the power of Old World ideologies.

A significant issue historians have debated is the status of women in colonial America compared to their counterparts in the nineteenth century. One argument has been that, despite the prevailing ideology and legal codes, the colonial era represented a kind of "golden age" of status for women from which they declined in the nineteenth century. This interpretation was first put forward by Elizabeth Anthony Dexter in *Colonial Women of Affairs* in the 1920s. In colonial America, runs the argument, women were scarce, they made a greater economic contribution to the family than was true later, and sex roles seem not to have been as rigid as they later became. Taken together, these

arguments suggest that women had greater status, decision-making authority, and ability to determine their own lives, including choice of spouse, than was true in the nineteenth century when the sex ratio was balanced, women's role was more rigidly defined as domestic, and the economic significance of the home had been reduced.

Scholarship of recent years has challenged the accuracy of all three of these assertions. When women were scarce the marriage age dropped into the high teens, making it unlikely that women were exercising choice of spouses. The records of property claims after the Revolution indicate that women were unfamiliar with family land holdings and income, thus casting doubt on the assertion that they were participating in the economic decisions of the family. The same records indicate significant difference in content between the claims of men and women, thus suggesting that roles or spheres were in fact clearly defined. Discussion of a "golden age" persists nonetheless, perhaps because of its appeal as a backdrop to the changes affecting women in the nineteenth century.[2]

Anne Hutchinson

The experience of one particular woman illustrates the pressure on women to conform to prescribed roles and the tensions aroused in the community when they did not. Anne Hutchinson (1591–1643) was a colonial woman of uncommon intellectual ability and assertiveness. Usually the incident involving her is treated principally as a religious controversy in early colonial New England. But seen from the perspective of women's history, it illustrates important dynamics between genders in Puritan Boston (Koehler 55–78).

Anne Hutchinson arrived with her husband in the Massachusetts Bay Colony in 1634, to a community established for the expressed purpose of being a city on a hill, a model Christian society for the rest of the world to emulate. The essence of the Puritan community was obedience to civil and moral law based on the Old Testament and overseen by the clergy. According to Puritan theology, obedience to these laws was necessary preparation for the coming of grace and was a sign that conversion had taken place. Hence social harmony, order, and conformity, as defined by the clergy, were of utmost importance to the community. Anything less threatened the entire social fabric and the fate of the mission.

In 1636 Anne Hutchinson began having mid-week meetings in her home to review the previous Sunday's sermon with other women

[2] Carol Ruth Berkin and Mary Beth Norton, *Women of America: A History* (Boston: Houghton Mifflin, 1979) 40–42. See also Norton, "The Evolution of White Women's Experience in Early America," *American Historical Review* 89 (1984): 593–619.

who may have missed the service. Soon, however, she began to add interpretation. She taught that to require outward conformity to the law in order to receive grace was to preach salvation by works. She also asserted that the Holy Spirit, dwelling in the redeemed individual, would instruct as to what to believe and how to act. Her teaching, called antinomianism, undermined the need for strict conformity, authoritative magistrates, and rigid laws. Her interpretation posed a challenge to the entire structure of the Puritan community. Between 1636 and 1638 she was called before the clergy and the magistrates several times to account for her behavior. The records of these exchanges show her to be their intellectual equal.

The doctrines she was teaching galled the clergy enough, but what also bothered them was that she was acting beyond her role. During an interrogation in November 1637 Governor John Winthrop accused her of holding a "meeting and an assembly in your house that hath been condemned by the general assembly as a thing not tolerable nor comely in the sight of God nor fitting for your sex" (Koehler 64). Another interrogator, Hugh Peter, also accused her of stepping beyond the bounds prescribed for her, "you have stept out of your place, you have rather bine [sic] a Husband than a Wife and a preacher than a Hearer; and a Magistrate than a Subject" (Koehler 64).

Clearly it was more than the doctrine she was teaching that upset the authorities because there were men in Massachusetts sympathetic to antinomianism who did not incur the same measure of wrath. Hutchinson defended herself ably on several occasions with knowledge, wit, and sarcasm that infuriated the authorities who interrogated her. When she was finally badgered into an incautious comment, she let loose with a torrent of accusation against them, precisely what they wanted. She was labeled a heretic and banished from the colony. She went to a new settlement on Narragansett Bay in Rhode Island, where she lived until her husband died in 1642. With her six children she then moved to the Dutch colony of New Netherland. The following year the entire family, with the exception of the youngest daughter, was killed in an Indian attack.

Looking at this incident from the perspective of women's history we see not only a theological controversy, but also an expression of female discontent. In a religiously oriented society which prized rigidity in both doctrinal orthodoxy and patriarchal social structure, antinomianism offered a theological vehicle for expressing a measure of rebellion against the system. The Spirit of God, claimed Hutchinson, had revealed himself to *her* directly, and with that assertion of personal religious experience, she was expressing her personal independence and a measure of equality. The vehemence of the establishment's response testifies to the threat they perceived (Koehler 78).

Other women besides Anne Hutchinson challenged the authority structure at this time; she, however, was the most dramatic instance. She and others acting beyond their appropriate sphere were accused of being under the influence of Satan, and of fulfilling wild sexual lusts; they were ultimately labeled witches (Koehler 68, 73–74).

Revolutionary Times and Abigail Adams

The American Revolution is appropriately acknowledged as a turning point in American history. But what was its impact on women? Historians have engaged in lively discussions of this question. If the event is viewed as a significant advance in the political development of America, one writer has argued that for women it presented only the illusion of change. In the years before and after the Revolution, with the coming of industrialization and commercial capitalism, the socioeconomic importance of the home declined, meaning for women, a deterioration of their position.

For all of its rhetoric about freedom, equality, and the dignity of the individual, the Revolution offered little improvement in the legal status of either blacks or women. In the enthusiasm of the times, thoughtful women pondered the legal restrictions binding them. One such woman was Abigail Adams (1744–1818), daughter of a respected Massachusetts clergyman, wife of the second president, and mother of the sixth. She exemplified the limited choices of women in that, despite her family background and the eventual position she achieved, she never in her life had the opportunity to attend school. In a letter often quoted, Abigail admonished her husband John, who was attending the Second Continental Congress in March 1776:

> in the new Code of Laws which I suppose it will be necessary for you to make, I desire you would Remember the Ladies and be more generous and favourable to them than your ancestors. Do not put such unlimited power into the hands of the Husbands. Remember, all Men would be tyrants if they could. If perticuliar care and attention is not paid to the Laidies, we are determined to foment a Rebelion, and will not hold ourselves bound by any Laws in which we have no voice, or Representation. (Rossi 10–11)

Needless to say her plea went unheeded and her husband responded to her with affectionate condescension:

> As to your extraordinary Code of Laws, I cannot but laugh. We have been told that our Struggle has loosened the band of Government every where. That Children and Apprentices were disobedient—that schools and Colledges were grown turbulent—that Indians slighted their Guardians and Negroes grew insolent to their Masters. But your Letter was the first Intimation that another Tribe more

numerous and powerful than all the rest were grown discontented. This is rather too coarse a Compliment but you are so saucy, I wont blot it out. (Rossi 11)

If the Revolution did not offer women legal benefits, some historians have argued that it did provide expanded opportunities in the public sphere. As men went off to war, women assumed more responsibility for running farms and businesses. Women also had opportunities to serve the war effort. Some did so individually, like Mary Ludwig Hay McCauley, better known as Molly Pitcher, who aided her husband's Continental army unit by cooking and nursing, and took over his place at the cannon when he fell during the Battle of Monmouth. Others participated collectively in organizations like the Daughters of Liberty, which distributed anti-British propaganda. The war also created ambiguities about women's political and legal status: on the one hand they were in theory politically and legally invisible, on the other they participated in highly political activities during the conflict. Could a married woman be tried for treason? For openly treasonous actions, the answer was yes, though in most cases she remained under the legal cover of her husband. If the conflict did not alter the definition of female participation in public life, the circumstances of the Revolution, nonetheless, created opportunities for expanded activity outside the home.[3]

Republican Motherhood

Historians are generally agreed on one important change that the Revolution brought to women's role inside the home: a new definition of the task of motherhood. During the years from independence to the writing of the Constitution, there was much public discussion of republicanism, the ideology upon which the new nation was founded. Americans were keenly aware (and proud) that they had done something unprecedented in human history: they had established a sizable nation on the fundamental tenets of individual liberty and the guarantee of rights for all citizens. (The modern reader is immediately struck by the limited initial reach of these guarantees, extending as they did mainly to white male citizens.) The promise of the New World was to be realized in America where the people had established a *novus ordo seclorum,* a new order for the ages.

Amid the euphoria, the founders pondered serious questions, like how could they insure that this experiment in liberty would endure.

[3] For discussion of the impact of the revolution of women see Mary Beth Norton, *Liberty's Daughters: The Revolutionary Experience of American Women, 1750–1800* (Boston: Little, Brown, 1980), and Linda K. Kerber, *Women of the Republic: Intellect and Ideology in Revolutionary America* (New York: Norton, 1980).

They read a good deal of history, including that of the republics of ancient Greece and Rome, analyzing their sources of strength and the causes of their downfall. What emerged from their study was the ideology of republicanism. Successful republics, where people ruled themselves, required a virtuous, intelligent, and independent citizenry, characterized by personal integrity and commitment to the common good above personal concerns. George Washington was esteemed first in the hearts of his countrymen because of his reputation for integrity and his personal sacrifice for the cause of public service. Such were the citizens of a successful republic.

The new philosophy affected women in two ways. The first was an expansion of educational opportunity. Education for women in the colonial era had been mostly for upper-class women, and it consisted of preparation for marriage. Training in fashion, music, and needlework for a life as a decorative ornament for a husband seemed shallow and inconsequential in a new era when the body politic required strong independent citizens.

> Because it seemed appropriate for women in a republic to have greater control over their own lives, "the *dependence* for which women are uniformly educated," was deplored. The Republic did not need fashion plates; it needed citizens—women as well as men—of self-discipline and of strong mind. (Kerber, *Women of the Republic* 203-4)

In the years after independence local communities and states began to provide for a wider segment of the female population an education that included much of the traditional curriculum offered to boys. Confident and capable women were the goal, though this aim did not represent an opening of the public sphere to women, but rather represented an expansion of the realm of the domestic sphere—the home came to be viewed as one of the chief means of instilling moral principles and public virtue in the rising generations. Republican Motherhood, the imparting of personal and public qualities of good citizenship to her daughters and especially to her sons, became the patriotic, social, and moral contribution of the American woman. One graduate of a female academy illustrated in her parting comments that she had captured the vision of the potential of Republican Motherhood:

> A woman who is skilled in every useful art, who practices every domestic virtue . . . may, by her precept and example, inspire her brothers, her husband, or her sons, with such a love of virtue, such just ideas of the true value of civil liberty . . . that future heroes and statesmen, when arrived at the summit of military or political fame,

shall exaltingly declare, it is to my mother I owe this elevation. (Kerber, *Women of the Republic* 229)

The new ideology invested in a woman a profound civic responsibility to be performed within the domestic circle. In so doing it imparted to her greater responsibility than had the domestic sphere of the colonial era. The responsibility of mother was not simply for the family, but for the nation as well.

The Nineteenth Century

At the very time the home was being invested with greater ideological significance its economic importance was declining. The change was due in large measure to the effects of industrialization and the rise of commercial capitalism taking hold in America. Among the consequences was the removal from the home of several economic functions. As the men of the family took jobs in factories and related businesses, the principal means of subsistence for the family was now pursued away from the home. Moreover, the primary economic tasks that women customarily performed, food production and processing as well as cloth production, were also largely removed from the home. For lower-class women who needed to make an economic contribution to the household, the changes often meant going out into the labor force. For middle-class women the changes meant more leisure time, which many filled by joining the wide variety of reform activities popular at the time.

The True Woman

The ideology that the woman's place was within the domestic circle was never proclaimed more loudly or persistently than during the nineteenth century. One cannot spend much time in the popular literature of those years without encountering repeated statements of the proper behavior of the "true woman." Precisely during an unsettling time of rapid changes, when traditional norms and values give way to new ones, traditional verities are most loudly reaffirmed. In the midst of so much flux, says Barbara Welter, "one thing at least remained the same—a true woman was a true woman wherever she was found" (Welter 152).

What were the qualities of this creature? Four cardinal virtues characterized her: piety, purity, submissiveness, and domesticity. Americans considered religion a pillar in the structure of a republican civilization, and a woman was assumed to have a special gift for piety. Her mission as a wife and mother was to impart religious teaching and piety to her family. Purity was as important as piety, for if she lost it, a

woman lost her special place. In the popular fiction of the day, a loss of virtue often led to mental derangement. A woman should work valiantly to retain her virtue, especially in light of the fact that men, of more sensual nature, would inevitably assault it. Ultimately, if she was successful in retaining her virtue, men would be grateful to her for saving them from themselves (Welter 154–56).

Social change in dress was sometimes denounced as an attack on woman's virtue. In a story in the magazine *The Ladies' Wreath* in 1852, a young woman expressed her appreciation for the new style, the bloomer, a loose-fitting trouser worn under a skirt, which allowed greater freedom of movement and was healthful and attractive, yet still modest. Her male professor warned her, however, that trousers are in fact, "only one of the many manifestations of that wild spirit of socialism and agrarian radicalism which is at present so rife in our land." Sufficiently warned, the woman retracted: "If this dress has any connexion with Fourierism or Socialism, or fanaticism in any shape whatever, I have no disposition to wear it at all . . . no true woman would so far compromise her delicacy as to espouse, however unwittingly, such a cause" (Welter 157).

Submissiveness, however, was the most feminine virtue; it was part of the order of the universe. Woman "feels herself weak and timid. She needs a protector," said one male author in 1854. "Woman despises in man everything like herself except a tender heart. It is enough that she is effeminate and weak; she does not want another like herself" (Welter 159). Submission was held to be a natural characteristic of women, a quality not appropriately found in men. One physician concluded, presumably after sufficient observation, that "woman has a head almost too small for intellect but just big enough for love" (Welter 159–60). The nature of her love was to be submissive, passive, and responsive, all as an object of the subject, her husband.

Domesticity was the fourth of the cardinal virtues that characterized a true woman. Her rightful place was by the hearth, within the home, where she performed her great task of nurturing Christian behavior and belief. "The domestic fireside is the great guardian of society against the excesses of human passions" (Welter 162). The home was to be an oasis, an escape from the crass and materialistic world of the factory and the marketplace. The atmosphere at home was to be such that husbands and sons would not go elsewhere for a good time. Creating this environment was the wife's responsibility.

The Christian who reads this may be inclined to respond that these are Christian virtues. Indeed. The problem in the nineteenth century was *application*. All of God's people are called to submission, (to God and to one another), as well as to personal piety and purity.

But in the ideology of the true woman, a double standard prevailed; the virtues applied only to females. Women were to remain pure; men were by nature sensual and could not be expected to be pure. The women bore the responsibility for the spiritual tone of the family; the men were tainted by the world and could not bear that responsibility. As one reads the syrupy platitudes characterizing the true woman, the high calling announced for her begins to sound oppressive, like a male rationalization for their own wandering from the truth; the pedestal upon which she was placed had a chain.

We should mention once again, however, the significance of the true woman ideology. It articulated a sharply defined social norm of the ideal woman that was widely discussed and commonly accepted. But at the same time, we should add, it was of limited application. The standard was not applied to blacks, immigrant women or other women of the working class. That they did not measure up to these norms did not seem to bother anybody. Moreover, as the historical record makes clear, many of those for whom it *was* intended pursued endeavors well beyond its boundaries. Perhaps it was the nature of the dramatic changes overtaking American society, and the uncertainties that accompanied them, that explains the insistent and incessant affirmation of one reliable constant—the true woman.

Religion and Reform Movements: Abolition, Temperance, Suffrage

The greater amount of leisure time of middle-class women afforded opportunities for them to pursue activities outside the home, and there were many activities for women to pursue. Religious activities were an acceptable outlet for women's energies for three reasons. One reason for this was a woman's presumed natural religiosity. Another was that female participation in religious endeavors has always been accepted. And finally, religion was prominent in nineteenth-century America. The six decades before the Civil War witnessed another wave of religious revivals known appropriately as the Second Great Awakening. In both city and countryside, in the North, South, and West, the revival meeting became a common religious expression of American culture, one that continued in the years after the Civil War.

One important feature of nineteenth-century revivalism was the doctrine of perfectionism, preached by Charles Grandison Finney, the best-known of the revival preachers, as well as others. Finney taught that spiritual conversion ought to be followed by a process of transformation leading to human perfection. Christians in turn were to attack the evils of society in order to bring in the kingdom of God. The result would be not only personal perfection but also a perfect

society. During these years the unique blend of republican political ideology and perfectionist religious doctrine proved an explosive mixture that fueled a multitude of reform movements. Temperance and abolition were among the best known reform movements, and women comprised a large portion of the grass-roots support. Almost every city and small town had female benevolent and reform societies. At first these efforts were related to the church. They included mission societies, Bible and tract distribution, and Sunday school societies. Because of the church affiliation, women's participation in reform societies was deemed an acceptable extension of their sphere. Soon, however, the reforms began to take on a life of their own, separate from the church. An accurate picture of the ferment of reform in this era must include the efforts of the individual women and groups who provided much of the rank and file support for these crusades.

Women who initially came to the antislavery movement did so from the tradition of pietistic female benevolence. Abolition propaganda denounced the moral evil of slavery. However, the nature of abolitionism evolved beyond benevolence into politics. The more radical wing of the movement, led by William Lloyd Garrison, argued the moral equality of all human beings, denounced as evil those institutions (including the government and church) that tolerated slavery, and called for its immediate abolition. The antislavery movement provided activist women with an ideology, a methodology, and the occasion for dealing with their own discontent. The ideology included a vision of equality and independence for all human beings and a denunciation of institutional oppression. The methodology was the spreading of their ideas to other women, challenging them to envision a new set of gender relations (DuBois 291–92, 299–300). The occasion was when they found themselves excluded from participation in abolition meetings led by men.

Angelina and Sarah Grimke

Angelina Grimke (1805–1879) was a leader among female abolitionists. Born into a prominent social family in Charleston, South Carolina, in 1805, she was troubled by the institution of slavery even before the abolition movement began. "That system must be radically wrong," she wrote in her diary in May 1829, "which can only be supported by transgressing the laws of God." She moved north and by the mid-1830s became involved in antislavery agitation. In 1836 she wrote "An Appeal to the Christian Women of the South," an abolition pamphlet that, by virtue of her prominent southern name, caused a great stir and brought her much criticism. Soon she and her sister,

Sarah (1792–1873), were speaking at antislavery meetings attended by men as well as women throughout Massachusetts.

For a woman to speak in "mixed" or "promiscuous" meetings was a taboo in that era, and in 1837 the clergy of the Congregational Church in Massachusetts issued a letter, read in every pulpit, denouncing their behavior, though not mentioning the Grimkes by name. Angelina responded in a pamphlet defending her right to speak out and insisting that women should be allowed to participate in making the laws by which they were governed. In 1839 the two sisters, along with Theodore Dwight Weld, whom Angelina married, compiled from southern newspapers an abolition document entitled *American Slavery As It Is*, which Harriet Beecher Stowe used extensively as source material for *Uncle Tom's Cabin*.[4]

Growing resentment of limitations on their activities among reform-minded women like the Grimkes led to the founding of a women's rights movement at Seneca Falls, New York, in July of 1848, where a gathering of about 300 people, including some 40 men, adopted a Declaration of Sentiments and Resolutions. Modeled after the Declaration of Independence, the statement called for equality of rights for women. Among the resolutions was one reflecting discontent with their subordinate status in the reform causes of the day:

> Resolved, therefore, That, being invested by the Creator with the same capabilities, and the same consciousness of responsibility for their exercise, it is demonstrably the right and duty of woman, equally with man, to promote every righteous cause by every righteous means; and especially in regard to the great subjects of morals and religion, it is self-evidently her right to participate with her brother in teaching them, both in private and in public, by writing and by speaking, by any instrumentalities proper to be used, and in any assemblies proper to be held (Schneir 82)

The movement's leaders announced a series of reforms to eliminate women's inferior and dependent status, but the main focus of their efforts became the franchise. At their national convention in 1856 the delegates resolved "that the main power of the woman's rights movement lies in this: that while always demanding for woman better education, better employment, and better laws, it has kept steadily in view the one cardinal demand for the right of suffrage: in a democracy, the symbol and guarantee of all other rights" (quoted in DuBois 305).

Subsequent history revealed that the vote was not the envisioned panacea, but in the context of nineteenth-century American society,

[4]Edward T. James, ed., *Notable American Women, 1607–1950: Biographical Dictionary*. 3 vols. (Cambridge, Mass.: Belknap, 1971) 1: 97–99. For additional information on the Grimke sisters see Gerda Lerner, *The Grimke Sisters from South Carolina: Pioneers for Women's Rights and Abolition* (New York: Schocken, 1971).

in light of women's legal and political invisibility, suffrage symbolized visibility, it conferred legitimacy and significance in the body politic. To the extent that it posed a measure of female autonomy, it challenged in a fundamental way the gender relations of society. That is why it was accorded so much significance (DuBois 307–8). Women's rights leaders were disappointed following the Civil War when suffrage was granted to former slaves by the Fifteenth Amendment, but not to women, despite their significant contributions to the war effort. The first breakthroughs in female suffrage came in western territories; in 1869 the Wyoming Territory gave women the vote, followed by the Utah Territory the next year. The desire to attract women to western territories and states was one reason these regions granted female suffrage.

By the end of the century, despite the failure to win nationwide suffrage, women's participation in the public sphere had increased significantly. College education was available to more women after the Morrill Act in 1862 underwrote land grant colleges as coeducational. Certain professions such as nursing, teaching, librarianship, and social work were considered female professions. By 1890 about four million women worked for pay outside the home—approximately one out of seven. Most of those who worked, however, labored at low-paying unskilled jobs. Women's participation in reform crusades was more widely accepted than before the Civil War. The Women's Christian Temperance Union was perhaps the most important reform organization of these years, involving thousands of women across the nation. Frances Willard (1839–1898) led the WCTU for twenty years from 1879 until her death in 1898.

Frances Willard

Willard was raised in the Midwest, and even though she graduated from a college for women, her education was sporadic—she spent less than four years in formal schooling. During the 1860s and 70s she worked in several schools, most of them Methodist, including the Evanston (Illinois) College for Ladies of which she was appointed president. In 1874 she became involved in temperance work in Illinois, and in 1877 she spent a short term as director of women's meetings for evangelist Dwight L. Moody and accepted the presidency of the WCTU in 1879. Under her leadership the organization grew to national prominence on behalf of the cause of prohibition. Alcohol was deemed a blight on the land, posing ruin to society and family. The slogan, "for God and Home and Native Land," became well known as did the white ribbon badge, symbol of the purity of the home. A feminist as well as a prohibitionist, Willard led the

organization to take up other reform issues like labor reform, prostitution, and health and hygiene, despite resistance from a conservative constituency. Her efforts on behalf of reform led the state of Illinois, upon her death, to place a statue of her in the nation's Capitol (James 3: 613–19).

The Twentieth Century

As the twentieth century began, the sphere of activity open to women had expanded significantly beyond the domestic circle of the "true woman." The changes were the result of new social and economic circumstances combined with the determination or need of some women to take advantage of them. The focus of the women's rights movement was still on suffrage, but the movement had changed significantly. The campaign had grown in stature from radical fringe to moderate reform.

The initial efforts for women's rights, dating from the 1848 Seneca Falls Convention, had included a radical denunciation of women's subordination and assertions of women's equality with men. The demands of the radical feminists to eliminate all barriers between the activities of the sexes would have amounted to a sweeping change of the nineteenth-century social order. Included in their attacks were the widely venerated institutions of marriage, the family, and the church as the sources of women's oppression. The laws of the day in relation to marriage and the family, and the church's support of those laws gave substance to the criticism. But as long as these more radical voices were heard prominently within the movement, opponents could label it a fringe element, and its chances of success were slight. In 1890, two wings of the movement, one more radical and one more conservative, joined together to form the National American Woman Suffrage Association to focus their efforts unitedly on the vote (Chafe 4–12).

Over the years the rationale women used for demanding the vote changed significantly in response to new circumstances. Initially they argued their equality with men and that justice entitled them to the vote as a constitutional right. However, by the turn of the century, women were putting forward arguments of expediency—that middle-class white women's votes would offset (presumably ill-informed) black and immigrant votes, or that women's moral superiority was needed at the ballot box to insure the success of the reforms for social and economic justice (Kraditor 43–74). The counterbalance argument, that white women would offset black and immigrant votes, indicated that even reformers participated in the prejudices of the day. The moral superiority argument for the vote indicated a return to the

notion of distinctiveness between women and men. It was precisely because of women's particular moral qualities by which they organized and ran the home that they should be included in the electorate. Political life needed that same benevolent influence. Politics, said WCTU president Frances Willard, was simply "enlarged housekeeping." And who was better prepared for the task than women? Turn-of-the-century suffragists skillfully exploited the domestic argument to offset the criticism that women's rights threatened marriage and the home (Chafe 12–16). Women's efforts in the reforms of the Progressive period such as prohibition (Frances Willard and the WCTU), and social work (Jane Addams and Hull House), indicated the kind of contribution women could make.

By World War I, having won a place as one of the reforms of the Progressive era, women's suffrage was no longer seen as a radical movement. A carefully crafted campaign of lobbying, begun in 1915 and coordinated by Carrie Chapman Catt of the National American Woman Suffrage Association, won suffrage victories state by state and national support in Congress. President Woodrow Wilson endorsed the women when they gave their support for his war policies. The additional factor of women's home-front contribution to the war effort led to the adoption of the Nineteenth Amendment in 1919. At the time of its approval, thirty-nine states allowed women the vote in at least some elections.

With the passage of the suffrage amendment, the women's rights movement lost its momentum. Some leaders believed that, having gained the vote, the major victory had been won. Further reform could be accomplished through the ballot box. Others believed that the same kind of concerted effort should now be directed toward other specific reforms. But which was most important: legal reforms? economic reforms? greater educational opportunity? No consensus on priorities emerged and the movement splintered. In fact, although women worked in all of these areas, the movement decentralized and became less visible.

But what about the great victory of suffrage? What was its impact? Prior to its enactment, both advocates and opponents envisioned enfranchised women as a potent voting block. In the early 1920s, politicians showed their awareness of the potential of this new force and passed new bills that aided women. One issue pressed by women's groups was the Sheppard-Towner bill that called for federal money for maternity- and infant-care health clinics. The fact that 250,000 infants died each year in America was offered as an argument in favor of the bill. Opponents claimed that this governmental intervention would weaken the family. Despite hesitance to allocate federal money for social programs, Congress was sensitive to the

pressure of the new female voters, and the bill passed in 1921 (Chafe 27–28). Then in 1922 Congress passed the Cable Act that guaranteed citizenship for a woman independent of her husband.

By the late 1920s, however, the situation had changed and Congress was no longer willing to pass women's reform legislation. The political climate had become more conservative under the Republican administrations of the decade, but more importantly it was clear to Congress that women did not vote as a block. They voted like the males around them, reflecting the variables of class, race, ethnicity, region, and religion. The vision of voting women transforming American society was a mirage.

The Emerging Woman

Suffrage was an important symbol, however, of the emergence of women from the domestic sphere. The popular image of women in the 1920s also supported that conclusion. During the decade of the twenties America was introduced to the flapper: the bobbed-haired, short-skirted, Charleston-dancing, cigarette-smoking young woman who gave the illusion that women were liberated. Moreover, it was now believed that women had a choice to be either a career woman or a homemaker. The realities of the 1920s, however, indicated that suffrage did not guarantee economic opportunities. Jobs were in fact available, but careers were hard to find. Despite the new image of the young working woman there was not a great increase in the percentage of working women in the 1920s. Up to 1910 the number of women who worked had risen to about 25 percent, and that figure remained relatively stable until World War II (Chafe 55). Moreover, the wage differentials between men and women were marked. In 1939 male teachers, for example, earned an annual salary of $1953 while female teachers earned $1394 for the same work (Chafe 61). One of the justifications for paying women less was the long-standing, erroneous belief that while men worked to support families, women worked for supplemental income, for "pin money," or worked only until they married. However, studies during the 1920s and 30s by the Women's Bureau, a lobby group, found that about 90 percent of working women did so out of economic need, and that one out of four working women provided the main income for the family (Chafe 63). Nonetheless, the myth of pin money persisted, and the prevailing attitude toward women was still that their place was in the home.

The Depression of the 1930s brought strong pressure on women to get out of the scarce job market. Working women meant unemployed men. During the decade, twenty-six states introduced legislation to prohibit married women from working. A study of fifteen

hundred school systems conducted by the National Education Associ-
ation in 1930–31 found that 77 percent of them refused to hire
married women, and 63 percent fired teachers who subsequently
married (Chafe 108). If the marketplace was hostile to economic
equality for women during the Depression, the New Deal of the
Roosevelt Administration opened new doors of opportunity. The relief
and welfare agencies of the New Deal required staffs of experienced
social workers, and social work was considered a women's profession.
Also, some New Deal programs aided women. The Social Security Act
of 1935 provided federal funds for health care for mothers and
children. (The money appropriated by the Sheppard-Towner Act had
been terminated in 1929.) And the Fair Labor Standards Act of 1938
established hour and wage standards for all workers in interstate
commerce, including women.

During the decades of the twenties and thirties, a potential
conflict between the two roles—career woman and homemaker—did
not surface because the roles rarely coincided. Most career women
were single. In 1920 only 12.2 percent of professional women were
married. The norm for middle-class women who worked was to do so
when young and single. Upon marrying they left the work force for the
home. Poor white as well as poor black women faced a conflict
because they were forced to take on both roles, and, separated from
the middle-class majority by class or race, they remained isolated and
were not the subject of public discussion (Berkin and Norton 278).
However, for the majority, the tradition of married women being in
the home prevailed and the tensions of balancing work and domestic
roles did not arise.

War and Woman-power: "Rosie the Riveter"

Then came World War II. Following Pearl Harbor and a nation-
wide mobilization for the war effort, six million women entered the
work force. Previously they had been discouraged from working, but
now they were recruited by the federal government. One pamphlet put
out by the secretary of war stated that the department "must fully
utilize, immediately and effectively, the largest and potentially the
finest single source of labor available today—the vast reserve of
woman-power" (Chafe 147). To encourage women's participation, the
federal government allocated funds for day care facilities. During the
war the number of females in the work force rose from 25 percent to
36 percent. Not only did women have unprecedented opportunity to
work but they took jobs in heavy industry, challenging the stereotypes
of women's capabilities. The aircraft industry offers a dramatic
illustration. In the first two years of the war, women's participation in

the industry rose from 4,000 or 1 percent to 310,000 or 39 percent (Chafe 140). "Rosie the Riveter," the symbol of the women who assembled the planes, became a familiar image on billboards and posters, a heroine of the war effort.

Perhaps the most important was the profile of the new working woman. "Rosie" was married and over thirty-five. By the end of the war married women composed almost half of the female work force (Chafe 144–45). World War II represented a dramatic societal change by throwing open to women economic opportunities previously denied them. Out of need, patriotism, or both, women responded in large numbers. Whether or not this represented permanent change in economic opportunity for women could not be known until the restoration of a peace-time economy. The answer was quick in coming.

When the war ended and the boys came home, there was great pressure for women to step aside and let the returning veterans take the jobs that were, by popular consensus, theirs. Women were encouraged to quit or were simply forced out in order to make room. The government, fearful of a return to prewar depression and (male) unemployment, cut off funds for day care in 1946. Many women, however, after experiencing high wages and economic mobility, did not want to return home and fought, though usually unsuccessfully, to keep their positions. Large numbers of women were forced out of war-time positions normally considered men's work; however, many found jobs as office workers in the burgeoning postwar economy. Despite the return to peacetime, the percentage of women in the labor force did not decline significantly from the war-time high.

The Working Mother

The 1950s presented a paradoxical picture of women. On the one hand, more women were working outside the home than ever before. On the other, the ideology of domesticity revived. Marriage and homemaking were clearly the ideal. Sixty percent of women who went to college in the fifties dropped out of school to get married and begin the "baby boom." As the postwar consumer-oriented economy grew, and the exodus to the suburbs began, the role of homemaker expanded. As new technologies made it easier to get sparkling dishes, cleaner clothes, and shinier floors, housewives had more leisure time. They took up gardening, decorating, and the PTA, as well as the transportation of children to swimming and music lessons. But increasingly, when children started school, mother went to work.

Working mothers brought the two roles of women into conflict, and during the late 1940s and 1950s a literature emerged debating

woman's role in society. One side argued that a woman's place was biologically determined to be in the home raising children. The thrust of the argument was that the feminist drive to compete with men was not only against woman's nature, but was responsible for neurotic and delinquent children, and alcoholic and impotent husbands. Another side argued that social roles and expectations are as much learned as biologically determined, and to narrow a woman's sphere to the home was to thwart her potential and increase her discontent.[5] The debate, as we know, continues.

Why have mothers gone to work since World War II? Why the change in patterns? At least two answers have been given. Betty Friedan, in *The Feminine Mystique*, said that women in suburbia were unfulfilled, chasing the ideal they had been taught—the feminine mystique—that happiness and contentment were found entirely in catering to husbands and children. They were joining the work force as an escape from an overly confining suburban existence. Whatever the merits of Friedan's argument, it struck a chord among many women, and the book is usually cited as the opening bell of the women's movement of the 1960s and 70s. Historians suggest a more mundane explanation for why mothers have gone to work. The middle-class lifestyle to which Americans have become accustomed requires two incomes. In the inflationary economy after World War II, providing the family with health care, college, and social opportunities has increasingly required more than one income (Berkin and Norton 281). Ideology defers to lifestyle.

Woman with Rights

In the 1960s a new women's rights movement emerged, affirming the analysis of Friedan and taking its cues from the social atmosphere of the decade, the expectations raised by President John Kennedy, the civil-rights movement, and the turmoil over the Vietnam War. Young, college-educated women gained experience in these events, and like their counterparts more than a century earlier, reacted against the limitations and inequalities they encountered because they were women. Although trained for careers, they found many positions still closed to them; in the positions they did obtain they faced discriminatory salary scales and limited advancement opportunities. Women of the 1960s had greater access to birth control than any generation before them and knowledge of the world's population crisis led them to make conscious choices about parenting. Marriage received more

[5] For a discussion of this literature, see William H. Chafe, *The American Woman: Her Changing Social, Economic, and Political Roles, 1920–1970* (New York: Oxford University Press, 1972), ch. 9.

emphasis as a relationship and less as a necessary economic arrangement. In short, many women felt they had more options open to them than earlier generations, and they resented limitations placed on their participation in the public sphere. Since the 1960s, notable firsts have been achieved by women. Sally Ride and Christa McAuliffe participated in America's space program. Geraldine Ferraro was the first woman to run for the vice presidency. Sandra Day O'Connor was the first woman appointed to the Supreme Court. Once again, women's attempts to expand their boundaries have sparked much discussion and controversy as the recent history of the Equal Rights Amendment demonstrated. Discussion of women's proper role continues to be part of the debate.

The Contemporary Woman

A brief survey of women's history provides a context and perspective in which to understand our present era. We have seen how women's experience has changed over time—in life expectancy, in childbearing patterns, and in role expectations and opportunities both inside and outside the domestic sphere—and how women have responded. Women face circumstances today that are vastly different from those two, or three, or even one hundred years ago. Many of these changes relate to what social scientists call modernization, the emergence of industrialized, democratic nation-states, with great emphasis on individuals, and the accompanying effects on society and social structures. In most instances the changes brought by modernization have been celebrated as evidence of human progress—the creation of widely distributed material wealth, victories against disease, communication and transportation breakthroughs, and democratically run governments. The changes and the new opportunities progress affords have generally been hailed as beneficial—at least when pursued by men. But when women have sought expanded opportunities, opportunities that can be seen as logical consequences of new realities in and out of the home, the result has often been controversy and opposition. Women have been accused of exceeding the bounds of their role.

As we contemplate history and contemporary society, Christians are forced to confront matters of gender. We affirm the value of each individual—male and female, throughout history and in our own society—as a bearer of the image of God. We look back at the record of earlier eras and affirm as just and fair the extension of the rights of women to hold property, to receive education, to vote. We understand better their statements and actions knowing something of the circumstances they have faced. As we confront gender matters in our

society, we have an opportunity, indeed an obligation, to learn from our study of women's experience in American society, in order to understand better and participate intelligently in the resolution of issues concerning women today.

Works Cited

Berkin, Carol Ruth. "Clio in Search of Her Daughters/Women in Search of Their Past." *Interpreting the Humanities.* Princeton: Woodrow Wilson National Fellowship Foundation, 1985. 35–47.

Berkin, Carol Ruth, and Mary Beth Norton, eds. *Women of America: A History.* Boston: Houghton Mifflin, 1979.

Chafe, William H. *The American Woman: Her Changing Social, Economic, and Political Roles, 1920–1970.* New York: Oxford University Press, 1972.

Cott, Nancy F. *The Bonds of Womanhood: "Woman's Sphere" in New England, 1780–1835.* New Haven: Yale University Press, 1977.

Dexter, Elizabeth Anthony. *Colonial Women of Affairs.* Boston: Houghton Mifflin, 1924.

DuBois, Ellen Carol. "Women's Rights Before the Civil War." *Feminism and Suffrage: The Emergence of an Independent Women's Movement in America, 1848–1869.* Ithaca: Cornell University Press, 1978. Reprinted in *Our American Sisters: Women in American Life and Thought.* Edited by Jean E. Friedman and William G. Shade. Lexington, Mass.: Heath, 1982. 291–316.

Friedan, Betty. *The Feminine Mystique.* New York: Norton, 1963.

Gordon, Ann D., Mari Jo Buhle, and Nancy Schrom Dye. "The Problem of Women's History." *Liberating Women's History: Theoretical and Critical Essays.* Edited by Berenice A. Carroll. Urbana: University of Illinois Press, 1976. 75–92.

James, Edward T., ed. *Notable American Women, 1607–1950: A Biographical Dictionary.* 3 vols. Cambridge, Mass.: Belknap, 1971.

Kerber, Linda K. *Women of the Republic: Intellect and Ideology in Revolutionary America.* New York: Norton, 1980.

————. "Separate Spheres, Female Worlds, Woman's Place: The Rhetoric of Women's History." *Journal of American History* 75 (1988): 9–39.

Koehler, Lyle. "The Case of the American Jezebels: Anne Hutchinson and Female Agitation During the Years of Antinomian Turmoil, 1636–1640." *William and Mary Quarterly* 3d ser. 31 (1974): 55–78.

Kraditor, Aileen S. *The Ideas of the Woman Suffrage Movement, 1890–1920.* New York: Norton, 1981.

Lerner, Gerda. *The Grimke Sisters from South Carolina: Pioneers for Women's Rights and Abolition.* New York: Schocken, 1971.

————. *The Majority Finds Its Past: Placing Women in History.* New York: Oxford University Press, 1979.

Norton, Mary Beth. *Liberty's Daughters: The Revolutionary Experience of American Women, 1750–1800.* Boston: Little, Brown, 1980.

————. "The Evolution of White Women's Experience in Early America." *American Historical Review* 89 (1984): 593–619.

————. "Is Clio a Feminist?" *New York Times* (13 April 1986). Sec. 7:1+.

Riley, Glenda. *Inventing the American Woman: A Perspective on Women's History*. Arlington Heights, Ill.: Harlan, 1987.

Rossi, Alice S., ed. *The Feminist Papers: From Adams to de Beauvoir*. New York: Columbia University Press, 1973.

Ruether, Rosemary Radford, and Rosemary Skinner Keller, eds. *Women and Religion in America*. Vol. 1, *The Nineteenth Century*. New York: Harper, 1982.

————. *Women and Religion in America*. Vol. 2, *The Colonial and Revolutionary Period*. New York: Harper, 1983.

————. *Women and Religion in America*. Vol. 3, *Nineteen Hundred to Nineteen Sixty-Eight*. New York: Harper, 1986.

Schneir, Miriam, ed. *Feminism: The Essential Historical Writings*. New York: Vintage, 1972.

Wells, Robert V. "Women's Lives Transformed: Demographic and Family Patterns in America, 1600–1970." *Women in America: A History*. Edited by Carol Ruth Berkin and Mary Beth Norton. Boston: Houghton Mifflin, 1979.

Welter, Barbara. "The Cult of True Womanhood: 1820–1860." *American Quarterly* 18 (1966): 151–74.

Wilson, Joan Hoff. "The Illusion of Change: Women and the American Revolution." *The American Revolution: Explorations in the History of American Radicalism*. Edited by Alfred Young. DeKalb, Ill.: Northern Illinois University Press, 1976. Reprinted in *Our American Sisters: Women in American Life and Thought*. Edited by Jean E. Friedman and William G. Shade. 3d ed. Lexington, Mass.: Heath, 1982. 117–36.

For Further Study

Discussion Questions

1. List the women you have been introduced to in your previous study of history. Were they "women worthies"? How were they characterized?

2. To what extent has history as you have studied it offered a "usable past," affirming a sense of identity to women?

3. What women have you encountered in the history of the Christian church? To what extent has the story of church history accurately reflected the role women have played?

4. Do you think that the changes in society and family life brought about by industrialization and modernization justify changes in definitions of men's and women's roles? Why or why not?

Writing Suggestions

1. Think of a woman who has had significant influence on your spiritual life and write a description of that influence.

2. Make a list of ten important women in American and/or world history and describe why they were important.

Research Topics

1. What links, if any, existed between the leaders of the early women's rights movement and other antebellum reform efforts? What was the relationship of these women to the church?

2. How and why have the wars of America affected the status of women in American society?

3. How does the history of labor legislation affecting women compare with that designed principally for men? Were women offered the protection of such legislation before, after, or at the same time as men? If there was a difference, how do you explain it?

4. How was the ideology of the American Revolution viewed by women of that era?

Shorter Reading List

Berkin, Carol Ruth. "Clio in Search of Her Daughters/Women in Search of Their Past." Interpreting the Humanities. Princeton: Woodrow Wilson National Fellowship Foundation, 1985. 35–47.

Gordon, Ann D., Mari Jo Buhle, and Nancy Schrom Dye. "The Problem of Women's History." *Liberating Women's History: Theoretical and Critical Essays.* Edited by Berenice A. Carroll. Urbana: University of Illinois Press, 1976. 75–92.

Kerber, Linda. "Separate Spheres, Female Worlds, Woman's Place: The Rhetoric of Women's History." *Journal of American History* 75 (1988): 9–39.

Lerner, Gerda. "The Majority Finds Its Past." *The Majority Finds Its Past: Placing Women in History.* New York: Oxford University Press, 1979. 160–67.

Norton, Mary Beth. "Is Clio a Feminist?" *New York Times.* 13 April 1986. Sec. 7:1 +.

Longer Reading List

Berkin, Carol Ruth, and Mary Beth Norton, eds. *Women of America: A History.* Boston: Houghton Mifflin, 1979.

Carroll, Berenice A., ed. *Liberating Women's History: Theoretical and Critical Essays.* Urbana: University of Illinois Press, 1976.

Chafe, William H. *The American Woman: Her Changing Social, Economic, and Political Roles, 1920–1970.* New York: Oxford University Press, 1972.

James, Edward T., ed. *Notable American Women, 1607–1950: A Biographical Dictionary.* 3 vols. Cambridge, Mass.: Belknap, 1971.

Kerber, Linda. *Women of the Republic: Intellect and Ideology in Revolutionary America.* New York: Norton, 1980.

Lerner, Gerda. *The Majority Finds Its Past: Placing Women in History.* New York: Oxford University Press, 1979.

Norton, Mary Beth. "The Evolution of White Women's Experience in Early America." *American Historical Review* 89 (1984): 593–619.

Riley, Glenda. *Inventing the American Woman: A Perspective on Women's History.* Arlington Heights, Ill.: Harlan, 1987.

Ruether, Rosemary Radford, and Rosemary Skinner Keller, eds. *Women and Religion in America,* Vol. 1: *The Nineteenth Century* (1982); Vol. 2: *The Colonial and Revolutionary Period* (1983); Vol. 3: *Nineteen Hundred to Nineteen Sixty-Eight* (1986). New York: Harper.

Scott, Anne Firor. *Making the Invisible Woman Visible.* Urbana: University of Illinois Press, 1984.

4

Reading With Feminist Eyes

June Steffensen Hagen

THE SONG OF DAUGHTERS IS DIFFERENT FROM THAT OF SONS

Recall how disconcerting it is when you can't tell if the person you're talking to over the telephone is a man or a woman. Or imagine what it would be like to meet new people if we were all decked out in large paper bags that hid all our maleness or femaleness. As very young children we learn the difference between "he" and "she," and we find out which one we are. Before race, before nationality, and even before language, society's pink and blue syndrome prevails. We learn to deal with ourselves as either male or female and that's how we are trained to deal with each other. Fashion changes—pants on women, longer hair on men, earrings on both, or cultural changes in work patterns such as women driving eighteen-wheel trucks and men teaching kindergarten—all take some getting used to because they shift the boundaries of the old categories and make us uncomfortable. Gender is the fundamental category of human relationships.

That gender matters in our everyday lives is so basic a truth that we rarely need to put it into such blunt words, yet surprisingly enough only recently has gender begun to be analyzed as a significant part of literature. Feminist scholars and critics contribute to that analysis. It is the purpose of this chapter to make explicit what has been taken for granted and to explain how and what reading with feminist eyes entails. We will do this in what I intend to be a natural, nontechnical way—by means of story. After some initial thoughts on the unique-

115

ness of female experience and its relatively limited representation in literature, especially in the novel, we shall consider "their story": the story of today's critics and scholars who use feminist approaches in their work. In the third major section I'll tell "my story," an extended example of how I read a major novel, Charlotte Brontë's *Jane Eyre*, in the past and how that reading changed as I recognized "her story," Jane Eyre's story, a story by a woman about a woman.

The final section will be "your story, our story." What were your early reading patterns? Did they fit the usual "boys' books, girls' books" division? Did you identify with characters across gender lines? If you did, what did you gain? If you did not, what did you lose? And how does such identification or lack of it affect you now? At the end of the chapter we'll examine our current book lists, our future reading, and most importantly, why the faithful Christian reader may need new reading habits.

Limited Female Representation in Literature

Some maintain that literature is gender-proof, or a least should be treated so. Underlying that stand may be an unconscious wish to continue the pattern we've had before in which women readers have been taught that the male experience in the books they read is objective; it is a *universal* experience. Female experience is less universal, we are told, and attempts to present it as applying to all people are doomed to failure. Man is the measure of all things and "man" is supposedly generic. I submit, however, that when novels written by men are examined closely, we find that instead of presenting universal experience, they actually present a male view of the world. For example, most female characters in novels written by men fall into stereotypes that fail to give women readers a person truly like themselves with whom to identify. Annette Kolodny, Professor of Literature at Renssalaer Polytechnic Institute, identifies the most personally distressing of these as "whores, bitches, muses, and heroines dead in childbirth" (144). Often women readers feel somehow abnormal or left out completely because they themselves don't fit those stereotypes. One of the common denominators of these stereotypes has been that women use sexual power as their only way of influencing others. Lee Rosenblum Edwards, a literary critic at the University of Massachusetts, Amherst (who was valedictorian of my 800-member high school class in 1958), found that in college she struggled mightily. Her knowledge of herself as a person of great intellectual power, and as a woman, conflicted with the images of women in the books she was required to read and in the way she was being taught to think about "femininity." Edwards writes: "My peers

and my professors . . . apostrophized Molly Bloom [a very sensuous character in James Joyce's novel *Ulysses*], the Wife of Bath, or Cleopatra as the epitome of eternal femininity. But if Molly Bloom was woman, what was I?" (229). Perhaps Edwards should have studied more books written by women, we think to ourselves; maybe they would have provided better role models. But then we remember that thirty years ago (and still today for that matter), books written by women were not a part of the standard literary curriculum, though women have been publishing for at least two hundred years and have regularly produced well-written, widely read books—especially novels. From *Frankenstein* to *Uncle Tom's Cabin* to *The Awakening* to *The Color Purple*, the books have been there. But rarely in literature courses. (The exceptional inclusion of Jane Austen or George Eliot only proves the rule.) Elaine Showalter, Professor of English and Humanities at Princeton University, was one of the first literary scholars to ask major public questions about why college classes omitted books written by women. She described in 1970 what the female student, the "prime consumer" of the literary curriculum, might encounter:

> In her freshman year she would probably study literature and composition, and the texts in her courses would be selected for their timeliness, or their relevance, or their power to involve the reader, rather than for their absolute standing in the literary canon. Thus she might be assigned any one of the texts which have recently been advertised for Freshman English: an anthology of essays, perhaps, such as *The Responsible Man*, "for the student who wants literature relevant to the world in which he lives," or *Conditions of Men*, or *Man in Crisis: Perspectives on the Individual and His World*, or again, *Representative Men: Cult Heroes of Our Time*, in which the thirty-three men represent such categories of heroism as the writer, the poet, the dramatist, the artist, and the guru, and the only two women included are the Actress Elizabeth Taylor, and The Existential Heroine Jacqueline Onassis.
>
> Perhaps the student would read a collection of stories like *The Young Man in American Literature: The Initiation Theme*, or sociological literature like *The Black Man and the Promise of America*. In a more orthodox literary program, she might study the eternally relevant classics, such as *Oedipus*; as a professor remarked in a recent issue of *College English*, all of us want to kill our fathers and marry our mothers. And whatever else she might read, she would inevitably arrive at the favorite book of all Freshman English courses, the classic of adolescent rebellion, *Portrait of the Artist as a Young Man*. ("Women and the Literary Curriculum" 855)

After also evaluating upper level courses, Showalter concludes, "Women students will . . . perceive that literature, as it is selected to be taught, confirms what everything else in the society tells them: that the masculine viewpoint is considered normative, and the feminine viewpoint divergent" ("Women and the Literary Curriculum" 856). Assessments such as Showalter's have effected considerable change in the literary curriculum since 1970. Professors have begun to include women writers in courses, while at the same time special courses on the female literary tradition and topical courses such as images of women have sprung up. In addition, women's studies programs offering degrees from the bachelor's through the Ph.D. now exist at many colleges and universities to help overcome previous limitations and to expand the frontiers of knowledge.

Uniqueness of Female Experience

What are some of the differences between male and female experience that we might see reflected in literature written from a female viewpoint? No one denies that differences between the sexes exist, though sometimes while we assert "Vive la diffèrence," we also minimize that variation in our zeal and say, "Oh, we're basically all the same—human beings, all—so let's not make a big deal out of differences." That's an understandable attitude, based perhaps on a theology of our common creation in the image of God, but proponents of this view forget that we were created *male and female* in God's image. They also tend to ignore or minimize what general human knowledge is beginning to teach about distinctive psychological development—our relationships with others; our sexual patterns throughout the life cycle; and our cultural connections, especially language, utilization of space, and day-to-day living. Female experience in all these areas is unique.

Psychological development for women apparently depends on different conceptions of self and relationships than it does for men. Patrocinio Schweickart, Associate Professor of English at the University of New Hampshire and a specialist in reading theory, summarizes some of the latest "very interesting speculations about [such] differences in psychological studies":

> The works of Jean Baker Miller, Nancy Chodorow, and Carol Gilligan suggest that men define themselves through individuation and separation from others, while women have more flexible ego boundaries and define themselves in terms of their affiliations and relationships with others. Men value autonomy, and they think of their interactions with others principally in terms of procedures for arbitrating conflicts between individual rights. Women, on the other

hand, value relationships, and they are most concerned in their dealings with others to negotiate between opposing needs so that the relationship can be maintained. (54–55)

One result of these differences is that separation from the mother is a more complicated task for girls than it is for boys. In becoming men, young boys move away from the female more distinctly, with less confusion. (How boys separate from *fathers* is a subject well-studied in both psychology and literature.) For girls, the problem is how to separate from the mother, how to be an autonomous person in the wider world, while still knowing that she needs to become a "connected" adult like the mother, that is, a woman. Literature is long on mother-son separation stories since the time of D. H. Lawrence's *Sons and Lovers* (1913) but short on mother-daughter separation stories. If "the song of daughters is different from that of sons," as poet Stanley Kunitz claims it is, don't we limit ourselves by hearing only one song? (36). Toni Morrison's Pulitzer-prize winning novel *Beloved* clearly signals a movement toward more fictionally examined mother-daughter relationships—and wider readership for them.

Our relationships within a family are also sex-related. Women are *always* daughters, *sometimes* wives, mothers, nieces, aunts, great-aunts, grandmothers, and granddaughters. They are *never* sons, husbands, fathers, nephews, uncles, great-uncles, grandfathers, or grandsons. Kinships like these are vital to much fiction, so literature written from a female perspective about families would differ from that written from a male perspective. Fictional staples like the tyrannical father, wayward son, erring daughter, sustaining mother (or oppressive mother, on the negative side) might figure in dissimilar ways in the songs of daughters.

Friendships among women make life companionable for half the human race. Think of those "best friends" of early teen years—and if you're male, think of how you sometimes secretly envy the quality of friendships women seem to sustain so easily. What effects do friendship differences have in male/female love relationships and, especially, on marriage? Novels and other kinds of literature that depict female friendships can give men the chance to experience how the other half lives. Such reading also gives women the pleasure of seeing their valued human intimacy taken seriously in a work of art. But if we read only about Huck and Jim, Queequeg and Ishmael, the "friends" in James Dickey's *Deliverance*, or war buddies in stories about Vietnam, we are not getting the full picture. We need Anne Shirley and Diana Barry, Jane Eyre and Helen Burns, Meg and Jo March, Celie and Shug Avery, Sula and Nell as well. Now that

television has given us Cagney and Lacey as well as Kate and Allie and the matchless Laverne and Shirley, novels, too, are recognizing "best friends." "Despite their late blooming," novelist Margaret Atwood writes, "women's friendships are now firmly on the literary map as valid and multi-dimensional novelistic material" (39).

Parts of the life cycle are shared among men and women: the struggle for self-identity, especially in the college years, early career choices, mid-life, "empty nest," retirement, and death of parents. Although these stages of life cut across gender lines, the tensions of each stage, the decision-making processes, and the internal struggles may differ. For example, a woman does not experience the death of her mother in the same way a man experiences the death of his father, and vice versa.

On the other hand, the female sexual life cycle—the onset of menstruation, childbearing, nursing, menopause—is strictly female. We have learned much about the male sexual life cycle through literature (and some may think that since Phillip Roth's *Portnoy's Complaint* we have learned more than we might care to know!), but only rarely, at least until recently, has the female life cycle been depicted by those who know it intimately: women.

Let me give one personal example. As an avid reader throughout my early years, my sense of self and of the world was formed to a great extent by what I read. Of course, I also had direct experience along the way, "real life" as it's called, but for new things, I had to rely on what others said, what I saw around me, and what I read. At the age of thirty I gave birth to a child, a new experience for me. Little was actually said in my society about the salient details of that major experience. I had also seen little of it: I did remember the pictures from *Life* magazine, the ones deemed so shocking in the 1950s because they showed an actual birth, but on the other hand I never saw the birth of little Ricky on *I Love Lucy*. My high school and college biology texts had diagrams but no pictures. Furthermore, I was a city girl, so farm animal births were foreign to me, also. Even the house cats we had in Brooklyn were male so I never went through a pregnancy and birth with them either. But what about novels? Surely in all those books I must have read about labor and childbirth. Yes, I had—but never from the point of view of the woman. I had read about the experience as observed by obstetricians, by friends, and by husbands standing behind, but never had I read about the birth experience as observed by the birth-giver herself. In *Tristram Shandy*, an eighteenth-century novel by Laurence Sterne, I had suffered the long wait in the downstairs drawing room with Walter Shandy, Dr. Slop, and Uncle Toby—while Mrs. Shandy labored upstairs. I had sorrowed with Frederic Henry in Hemingway's *A Farewell to Arms*

when he learns that Catharine Barkley and the baby are dead. While reading Hardy's *Tess of the D'Urbervilles* I had surmised that between Tess's seduction and her nursing the baby in the hayfield she must have borne the ill-fated child named Sorrow, but I never read about the birth because Hardy skipped it. Even *The Good Earth* uses an impersonal third person narrator so that O-lan's struggle to give birth in the field is distanced from the reader. Don't get me wrong, though. As a sensible twentieth-century woman I did read the Lamaze natural childbirth book and I knew the basic facts. But I did not know them imaginatively, I did not know them with that important part of me nurtured by literature. How could this significant event be so absent in my reading?

Not by coincidence at all, but by more careful planning, I had another generative experience that same year: I wrote an extended work of literary scholarship and criticism, a doctoral dissertation on the 1842 *Poems* of Alfred Tennyson. And I did so, again, without literary example, without ever having read a novel in which a woman did that sort of writing and even without having read a full book of literary criticism by a woman. Neither my life's work nor woman's sexual life cycle had been depicted from a female point of view.

Women's cultural experience—their language, natural groupings, day-to-day lives, as well as their artistic expressions—are not the same as men's. Although we are not yet sure what all the differences are, we do know that women's culture has not been a major part of normal reading experience. We know ships and whaling in American literature; do we know sewing circles and quilts? Do we think of pioneers and farmers as being only male, as in, "The pioneers and their wives crossed the prairies in covered wagons." (Weren't the wives *also* pioneers?) Does the centrality of courtship and marriage in Jane Austen's books diminish her fiction in our eyes because these are "women's concerns"? Why so? Isn't marriage as important as sailing down the Mississippi on a raft? Isn't the drawing room as wide a world as the foxhole? Furthermore, isn't Jane Eyre being locked in the Red Room as much a picture, a universal picture, in fact, of childhood oppression as is that of David Copperfield pasting labels on shoe polish bottles? Do those by now well-documented differences in conflict resolution and in childhood games, i.e., jumping rope versus marbles, suggest that men and women are trained into antithetical ways of relating to the world? If so, aren't both ways equally important to know about, to read about? They are, if we value the whole creation as God created it, and if we intend to look on that creation and say, "It is good."

Since about 1750 great numbers of women have been writing and publishing. We have, therefore, more than two hundred years of

created and recorded female experience to draw on, with more being produced every day. It is as though the last two decades of literary criticism have released a flood of creativity that has been kept in check for a long time. Women's symbols, myths, language, relationships—their lives—are now more available to us in literature than ever before. More importantly they are as available to men as to women.

However, availability is only the beginning. We also need eyes capable of new vision. The following discussion on how gender matters in literary criticism examines the lenses we must use for such revisioning of our books and ultimately of ourselves and our world—making conscious the unconscious.

FEMINIST CRITICS: THEIR STORY

For a general reader, or even a college-educated one, literary studies may seem esoteric and jargon-laden, certainly far removed from what people do when they choose a book to read on the subway on their way to work. Nonetheless, literary scholars and critics are important to all of us. Scholars function as bibliographers, textual experts, editors, biographers, and publishing and literary historians. Critics become the interpreters of those works that have been discovered and published. They also study the writing and reading processes. Both kinds of literary midwives most often teach composition and literature courses in colleges. Their activities as scholars and critics and teachers affect how and what the educated population reads, for they discover and gather together books written in the past, they reveal something about their authors, they deepen our understanding and enjoyment of literary art, and they ultimately push us on to a deeper understanding of ourselves *and* others. The result is that real understanding—standing in another's shoes—brings compassion.

Feminist perspectives have changed literary study to the point where the recently completed Modern Language Association study of doctoral programs in English reported that "87% of the departments surveyed ranked [feminist criticism] as having the greatest impact on their curriculum" (4). Yet such concerns are not for specialists only; any serious reader can come to appreciate feminist perspectives.

How to Focus the Critical Eye

Here is a step-by-step approach to the general field of literary studies and to the impact of feminist thought and method. The chart

LITERARY STUDIES

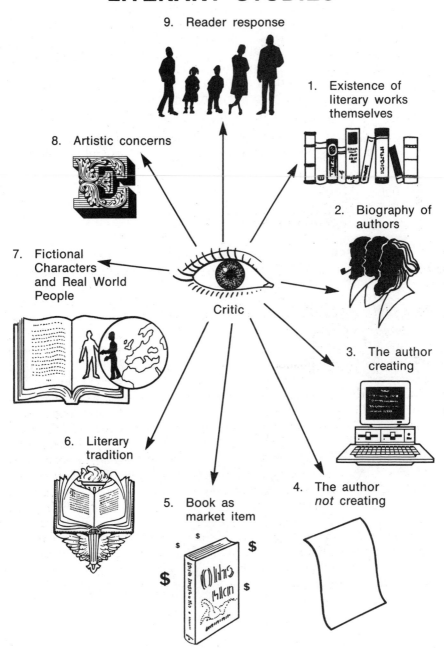

9. Reader response

1. Existence of literary works themselves

8. Artistic concerns

2. Biography of authors

7. Fictional Characters and Real World People

Critic

3. The author creating

6. Literary tradition

4. The author *not* creating

5. Book as market item

Figure 1 Literary Studies

(figure 1) places you, the reader, the critic, the "eye," in the middle. The rays from the center lead to the various places on which your eye can rest, the points around the circle labeled 1–9, that constitute literary studies. We will ask, first, what it is that people look at when they do such a study. What do they consider? Where does their attention go? What do they talk and write about? Along with answering these questions we will make connections between these traditional focuses and the current innovative feminist emphases in each. Gender is one of our lenses for seeing; it is something between the eye and the object that helps us focus. We see through gender, we see through race, we see through class, we see through economic status, we see through faith, we see through many, many lenses, although sometimes darkly. Using such lenses wisely helps us see "the object as in itself it really is" (Arnold 258).

Existence of Literary Works

One of the primary things a literary scholar does is to discover works. What has been written? What has been published? By whom? When? Where? One would think that after hundreds of years of serious literary sleuthing that all the bibliographies would be complete, that we would have vast stacks of lists of what has been written, and what has been published; but we do not. Oh, we have some lists, but they are incomplete ones; mainly we have lists of what men have written. Scholars are still compiling basic listings of writings by women as well as ferreting out material still secluded in grandmothers' attics. That we still don't know much about women's writing may be more a reflection on the selection, reviewing, canonizing, and teaching procedures than it is on the "intrinsic" value of the literature. Editor Nina Baym of the new *Norton Anthology of English Literature* that has "a commitment to women's writing," explains that "what's considered good and what isn't is historically flexible" (quoted in Kolbert 116).

In *How to Suppress Women's Writing*, Joanna Russ summarizes the forces at work through the years that have pushed women's writing back into the attics or beat it back from serious critical attention once published. What was it like to have such patronizing things said about one's writing, about oneself?

> She didn't write it. (But if it's clear she did the deed . . .) She wrote it but she shouldn't have. (It's political, sexual, masculine, feminist.) She wrote it, but look what she wrote about. (The bedroom, the kitchen, her family, other women!) She wrote it, but she wrote only one of it. ("*Jane Eyre*, poor dear, that's all she ever . . .") She wrote it, but she isn't really an artist, and it isn't really art. (It's a thriller, a

romance, a children's book. It's sci-fi!) She wrote it, but she had help. (Robert Browning, Branwell Brontë. Her own "masculine side.") She wrote it, but she's an anomaly. (Woolf. With Leonard's help . . .) She wrote it BUT. . . . (front cover)

Strident as they are, such voices have not prevailed. However, the buried, the suppressed, the forgotten, and even the "listed under the wrong author" now speak up. Some of these newly discovered or newly revalued works of fiction, marked up rather than down, include Rebecca Harding Davis's *Life in the Iron Mills*, Charlotte Perkins Gilman's "The Yellow Wallpaper," Kate Chopin's *The Awakening*, Louisa May Alcott's *Work*, Elizabeth Gaskell's *North and South*, Olive Shreiner's *Story of an African Farm*, Susan Glaspell's "A Jury of Her Peers," and Jean Rhys's *Wide Sargasso Sea*. The last can be read as a companion to *Jane Eyre:* the story told from another character's perspective. Bertha Mason, the mad wife imprisoned by her husband in the earlier novel, here speaks first person from her beginning as a young bride in the West Indies to her confinement in an English attic.

Recent discoveries include dozens, even hundreds of readable, revelatory diaries, journals, letters, memoirs, and autobiographies. Many were written by unassuming women with no thought of publication: they simply wanted to record their lives, perhaps for their children and grandchildren or even just for themselves. Others looked for a wider audience. Because literary scholars have retrieved these communications and prepared them for print, and because readers seem hungry to know more about the lives of common folk, women and men today can have an interior view of female identity denied previous generations. Who will forget Harriet Jacobs after having read her slave narrative? And are we not enriched to hear for the first time *female* voices from the Kansas frontier in Joanna L. Stratton's *Pioneer Women*?

In addition to taking us across historical and geographical lines, such reading also moves us across economic and racial barriers. Major new resources for the study of writing by black women, for example, include *The Schomburg Library of Nineteenth-Century Black Women Writers*, a scholarly edition of poetry, fiction, journalistic writing, essays, and personal narratives in thirty volumes published by Oxford University Press in 1988. As Eric J. Sundquist writes in his review, "This magnificent project will dramatically change the landscape of Afro-American literature and American cultural history" (15).

Biography of Authors

The critical eye next focuses on biography. Biographers who take a feminist perspective recognize that gender locates their subjects

within strongly conceived patterns of society, that those patterns are part and parcel of family life as well as professional authoring life, and that people write within them. Helene Moglen's biography of Charlotte Brontë, for instance, has challenged traditional biographies that at times ignored such patterns.

Moglen questions how family relationships affected Brontë's production of novels and her "self conceived." She notes the importance of the death of Mrs. Brontë, who had borne six children in seven years:

> The actual effect which their mother's death had upon the children's lives—the way in which it touched their minds—is nowhere recorded. But one feels the naïveté of the critics and biographers who have brushed those effects aside, observing that the children were too young and had known their mother too little to have been much moved by the event. The fact that Charlotte speaks only once of Mrs. Brontë in her copious correspondence and journals does not confirm the idea that the memory of her death and dying was so trivial that it could be easily dismissed, but rather suggests that it was so painful that it had to be repressed. (21)

Moglen makes us wonder, too, how it mattered to Charlotte Brontë that all her father's aspirations for his children were pinned on his one son, Branwell, an alcoholic who suffered during his brief life from self-doubt, vacillations of purpose, and dramatic, violent outbursts common to many sufferers of that disease, and who finally drank himself to an early death. Moglen also delves into the possibility of unconscious "sexual power games" being played out by M. Heger, the male teacher Charlotte Brontë fantasized into her novel *The Professor*. Moglen asks: "How unique was Brontë's response? To what extent was her infatuation, accepted for so long at face value, simply another manifestation of the sexual politics pervasive in Victorian society: more insidious because it was socially validated?" (70). Most biographers such as Moglen have addressed in their studies of nineteenth-century women the important issue of marriage: the degree to which it was mandatory, the obstacle that husband and children presented to a professional writer, the need for us to understand these powerful tensions. Thus, even for established authors such as Charlotte Brontë feminist scholars have significant biographical interpretation to do, offering new insights, challenging old assumptions, noticing the formerly ignored detail. And for the lesser-known women writers in the past or women writers today, we can expect more biographies with full attention to gender issues.

The Author Creating

Literary studies also encompass the author creating. After all, that is why we are interested in the lives of these people in the first place, why the biographies get written. New approaches are emerging from those scholars and critics sensitized to the subtle influences of gender experience on creativity. Carolyn G. Heilbrun, Professor of English at Columbia University and past president of the Modern Language Association (who also writes the Kate Fansler mystery novels under the pen name "Amanda Cross"!) compares in her book how the psychological circumstances, the identity needed for the creation of literature, may vary between women and men. Why have many women novelists of the past had trouble developing fully human and achieving women characters in their works of fiction? Why are the male characters often more convincingly drawn, more authentic, and more fulfilled people than their female counterparts? Mary Ann Evans, who adopted the pseudonym George Eliot in order to have her writing accepted in the mid-nineteenth century, tried very hard in *Middlemarch* and *The Mill on the Floss* to create fully developed women characters. Yet many readers feel that Eliot failed to give Dorothea Brooke or Maggie Tulliver the self-actualization she managed for herself. Why this holding back, this bowing to convention? In her work on Mary Shelley's novel *Frankenstein*, critic Ellen Moers raises important questions about the relationship between Shelley's psychological state in the midst of the various pregnancies, and the births and deaths of children which surrounded her creation of "the monster." Mary Poovey, Heilbrun, Gilbert and Gubar, and others, including pioneers Patricia Meyer Spacks and Ellen Moers, all take as their vital critical activity theories of female creativity.

The Author Not Creating

Of no less interest is how gender relates to the author not creating—that is, if we address this phenomenon with something beyond discussions of writer's block or anal fixations. In *Silences* Tillie Olsen compiled statements from the many women writers who first struggled desperately to write at all and then continued to struggle all their lives to keep writing:

> Compared to men writers of like distinction and years of life, few women writers have had lives of unbroken productivity, or leave behind a "body of work." Early beginnings, then silence; or clogged late ones (foreground silences); long periods between books (hidden silences); characterize most of us. (178)

Right now as I type this quotation I look over my machine at a quotation from James Russell Lowell: "In creating, the only hard thing's to begin." Reading Olsen's book makes me think that Lowell is probably wrong when it comes to women trying to write: for anyone, male or female, it's hard to begin to be sure—but for women it's especially hard to continue. Just consider the practical restrictions on many women's creative energies. For instance, women responsible for small children may have neither the stamina nor free, uninterrupted time for writing. (At nap time, most people who care for children nap right along with their charges!) Also, women with a vocation other than that of homemaker—and that's the majority in America today—average more than three-quarters of the housework, in spite of supposedly "sharing" such chores with husbands.

In her classic feminist essay *A Room of One's Own*, Virginia Woolf argued that for a woman to do creative work she needs £500 a year and a room of her own. The first guarantees freedom from care, from drudgery, from the fragmentation of having to respond to everyone else's physical needs. (With such money one could hire both nursemaid and housekeeper.) And with a room of her own a woman has privacy and personal space and quiet. I imagine Woolf was thinking of the traditional Victorian house which often had one room set apart just for study, reading, and writing. But "the library" was not where the wife presided. "The library" was used by the male head of the household for reading the newspaper and smoking cigars after dinner—and for hiding away from the incessant distractions of the large family he had so willingly fathered. When I ask my students which room in the modern house belongs to the woman, they usually answer, "the kitchen." How do you write the Great American Novel at the same counter where you cut up the stringbeans for supper? Or, if you're a painter, do you set up your acrylics and easel right there on top of the dishwasher? Woolf's conditions for female creative achievement remain surprisingly relevant though house design has changed. In short, Jane Austen may have been able to write impeccable novels in the middle of a busy family living space, but let's face it—Jane Austen was exceptional!

Book as Market Item

A traditional focus for literary study is the practical world of the book as a market item: publishing, marketing, sales, reviews, profit and loss, continuing editions, etc. Publishing history for women reveals two recurring problems: 1) getting a book published under one's own name; and 2) getting a fair reading for that book.

Because of bias against women's writing, many books written by

women were first published anonymously, pseudonymously, or with false attribution. Research into early women writers suggests their real frustration at having to be known as "Anon." instead of "Aphra Behn" or "Anne Finch." Using a pen name, either a male pen name or one of ambiguous sexuality, such as Charlotte Brontë's choice of "Currer Bell" and her sisters' choices of "Ellis" and "Acton Bell," only compounds the distress of hidden identity. In some cases, as in that of "George Eliot," even after Mary Ann Evans' real name was known, the pen name continued to be used in personal address. Occasionally, creative works by women were published under false attribution. Authorship was given to, or in some cases, stolen by, brother, father, husband, friend, lover. John Stuart Mill's feminist essay *The Subjection of Women* may be in large part the work of his wife Harriet Taylor Mill. Some of the music of Clara Schumann has been attributed to her husband Robert Schumann, and who knows how much music composed by Fanny Mendelssohn appeared before the public with her brother's name listed beneath it? Scholars today wonder what may be the psychological effects of having to disguise one's identity and to deny one's creative productions, to deny, in effect, that those works had a mother.

Reactions to disguised authors' styles provide glimpses of sexual bias. A figurative plain brown wrapper for a book was as disconcerting to nineteenth-century reviewers of *Jane Eyre* as a literal brown paper bag hiding Charlotte Brontë in person would have been. One reviewer writes with more authority than sense: "For power and thought of expression, we do not know its rival among modern productions It is no woman's writing . . . no woman could have penned the 'Autobiography of Jane Eyre' The tale is one of the heart, and the working out of a moral through the natural affections; it is the victory of mind over matter" (ERA, 14 November 1847, quoted in Evans 364). Another reviewer guesses correctly, "for our part, we cannot doubt that the book is written by a female, and, as certain provincialisms indicate, by one from the North of England." So far so good—Brontë was a Yorkshire woman. But then he throws in a however, "however—throughout there is masculine power, breadth and shrewdness, combined with masculine hardness, coarseness, and freedom of expression" (*Christian Remembrancer*, April 1848, quoted in Evans 365). Our final judge exhibits such "masculine shrewdness": "The leading characteristic of the novel . . . and the secret of its charm, is the clear, distinct, decisive, style of its representation of characters, manners, and scenery; and this continually suggests a male mind" (E. P. Whippel, *North American Review*, October 1848, quoted in Evans 366). This repeated equation of good style/powerful style with maleness, especially when presented in its own often phallic language,

convinces this reader, at least, that we cannot look to nineteenth-century reviewers like this for unbiased judgment or even serious discussion. Whatever the real differences are between men's and women's style, language, and daily culture will be up to twentieth-century scholars and critics in women's studies to analyze. Such analysis has barely begun.

Literary Tradition

With publishing and reviewing roadblocks set in front of aspiring women writers, one is amazed that they wrote at all. Something sustained them. Was it a sense of their own tradition?

In general, influences on a writer, specifically the influence of other authors, reveal a great deal about where writers learn their art; whom they are imitating, whom departing from, whom extending, whom responding to. What other works in the literary tradition influence women writers? Are they the same poems, plays, novels, and essays that influence male writers? If men and women writers read the same books, are they challenged by the same or different parts of them?

Major scholars and critics today specialize in locating and studying women's literary tradition. Elaine Showalter led the way in 1977 with *A Literature of Their Own: British Women Novelists from Brontë to Lessing*. She notes that the line in the English novel for women writers may be Burney, Austen, Edgeworth, the Brontës, Bradford, Eliot, Woolf, and Lessing, the minor as well as the major; this challenges the "universality" of the Defoe, Richardson, Fielding, Dickens, Trollope, Hardy, and Conrad male tradition. Showalter finds that "when we look at women writers collectively we can see an imaginative continuum, the recurrence of certain patterns, themes, problems, and images from generation to generation" (11). It may well be that the richness of literary production by women today, especially in the novel, poetic, and personal narrative forms, depends on this tradition. One result of recovering literary history for women is that the aspiring young female writer of today finds herself more firmly located in a noble profession. Thirty years ago the young woman who wanted to be a poet, reports Jane Marcus, "had on hand Sappho, Emily Dickinson, and Amy Lowell" (63), whereas today she also knows Behn, Finch, the reconstituted Barrett Browning and Christina Rossetti, as well as a veritable cornucopia of contemporaries: Sexton, Plath, Brooks, Rich, Levertov, Rukeyser, Kumin, Sarton, Shange, and Giovanni to name only some. Women fiction writers and playwrights also enjoy a creative climate much improved by the rediscovery of the female tradition in literature.

Feminist literary criticism which concentrates on the female tradition goes by the term Showalter coined; "gynocriticism." The focuses we've looked at thus far (numbers 1–6), lend themselves to that approach. However, another branch of feminist literary criticism has evolved side by side with gynocriticism. This branch, the study of images of women in literature, and reader response, includes literature written by men as well as by women. Although my model does not do justice to the complexity of these fields—and remember, we are trying to avoid the esoteric and jargon-laden—it does provide at least three focuses for feminist vision of literature produced by both sexes, (numbers 7–9 on the chart). A tenth field, literary theory in itself, presents a more tangled skein than this one chapter could untangle and thus I have not even listed it. Those wishing to know more should read *The New Feminist Criticism*, edited by Elaine Showalter, or *Feminist Literary Theory: A Reader*, edited by Mary Eagleton.

Fictional Characters and Real World People

Fitting together fictional characters and real world people and situations, sometimes called "stereotypical criticism," requires the skills of literary scholars and critics cognizant of sociology, psychology, and history, as well as literature. Such people ask: "How does the world created within this text mesh with or fit the world outside, the real world?" "Have uncalled-for distortions of reality been passed off as reality?" (They would say "uncalled-for" distortions because not all writing is in the realistic mode—works of the imagination often employ symbols, myths, fantasies, even completely made-up worlds in order to tell their particular truth.) Characters created by men, such as Daniel Defoe's Moll Flanders, may be subject at times to misunderstanding on the part of general readers. Many have felt that Moll's callous treatment of her children may have been a reflection of Defoe's misunderstanding or maligning of mothers or even some more far-reaching misogyny on his part. But feminist interpretations have restored some of Defoe's stature as a fine realistic novelist. Miriam Lerenbaum in "Moll Flanders: 'A Woman on Her own Account'" defends Defoe's portrait by social-historical methods:

> All the evidence provided by her own words, as well as those of her contemporaries and the scientists and historians of our own period, suggests that Moll is neither unnatural, culpable, nor unfeminine in her indifference to her children, certainly not by the standards of her own period, and probably not even by the standards of ours. (109)

Lerenbaum also finds Defoe's depiction of Moll's anxiety over her mid-life changes psychologically astute and cause enough for Moll's

straying into a devious path, in her case a criminal one. Revisionist readings like this recognize that some male writers may be able to fit female character and real world together very well, just as female writers often create deeply imagined and realistic male characters. (I think of Tertius Lydgate in George Eliot's *Middlemarch* as such.) We know more about men, on the whole, so it's easier to make such statements about fictional men than about fictional women. Until our knowledge of the real world of women catches up to our knowledge of the real world of men, we would do well to read literature warily, acknowledging our ignorance. To correct at least part of our ignorance we can use scholarly books such as *What Manner of Woman: Essays on English and American Life and Literature*, edited by Marlene Springer, along with our big anthology. Chapters on "The Portrayal of Women by Chaucer and His Age," or "Praising Virtuous Ladies: The Literary Image and Historical Reality of Women in Seventeenth-Century England," or "Combat in the Erogenous Zone: Women in the American Novel Between the Two World Wars" allow even the nonexpert to engage in stereotypical criticism.

Artistic Concerns

Feminists in literary studies today continue to use all the traditional emphases we are familiar with from our literature courses: style, characterization, voice, plot, theme, setting, language, symbolism, archetypes and myths, genre, and structure. But they do so without the rigid emphasis on viewing "a literary work as an autonomous object that is not to be interpreted and evaluated either in the context of the author's life or in the context of the reader's own ideas and beliefs" (Stevens and Stewart 19), an emphasis of the New Criticism or formalism they were most likely trained in. Looking beyond individual literary works to wider groupings has resulted in one of the most important critical studies of the last twenty years: Sandra M. Gilbert's and Susan Gubar's revolutionary *The Madwoman in the Attic: The Woman Writer and the Nineteenth-Century Literary Imagination*. Their preface explains how their first discoveries led to a very wide examination of artistic concerns, including the whole symbolic pattern of confinement and enclosure that is crucial to interpreting much fiction written by women, including *Jane Eyre*:

> This book began with a course in literature by women that we taught together at Indiana University in the fall of 1974. Reading Emily Dickinson, Virginia Woolf, and Sylvia Plath, we were surprised by the coherence of theme and imagery that we encountered in the works of writers who were often geographically, historically, and psychologically distant from each other. Indeed, even when we

studied women's achievements in radically different genres, we found what began to see a distinctively female literary tradition, a tradition that has been approached and appreciated by many women readers and writers but which no one had yet defined in its entirety. Images of enclosure and escape, fantasies in which maddened doubles functioned as social surrogates for docile selves, metaphors of physical discomfort manifested in frozen landscapes and fiery interiors—such patterns recurred throughout this tradition, along with obsessive depictions of diseases like anorexia, agoraphobia, and claustrophobia. (xi)

Later in their book Gilbert and Gubar develop theories of dominant and muted stories; they also illuminate the tense relationships between women writers and their literary "forefathers" in such a way that as tired a subject as John Milton's influence becomes fascinating new material.

Setting is another traditional artistic concern that benefits from eclectic feminist criticism. In *Communities of Women*, for example, Nina Auerbach, Professor of English at the University of Pennsylvania, analyzes novels set within groups of women from which men, through forces of war or less violent circumstances have been excluded, including *Pride and Prejudice, Little Women, The Prime of Miss Jean Brodie, The Bostonians*, and others. What do such settings contribute? Are these novels different from or similar to male bonding stories about battles or baseball?

In later books such as *Woman and the Demon: The Life of a Victorian Myth*, Auerbach examines male-created stereotypes that are so intense they have become almost mythic. She demonstrates how women as angel or demon, old maid, or fallen idol, all being stereotypes with negative connotations, actually mask masculine fear and awe of women's power.

Most recently theorists interested in gender difference in literature have begun to study language. French feminist theorists concentrate here, as do other critics highly influenced by "the institutes and seminars of the Neo-Freudian psychoanalyst Jacques Lacan, the deconstructionist philosopher Jacques Derrida, and the structuralist critic Roland Barthes" (Showalter, *New Feminist Criticism* 9). Some French feminists, building on the biological and cultural differences between men and women, postulate a uniquely female writing, *l'ècriture feminine*.

Reader Response

Readers schooled in artistic concerns usually are well aware that literature has designs *in* it. What we may not suspect is that often

even the most innocuous-seeming literature has designs *on* us! Furthermore, we sometimes forget that as people whose lives already have patterns in them, we bring to our reading preconceived grids or matrixes. Reader-response critics analyze exchanges between reader and text, asking: "How significant are the differences between readings? What prompts readers to read as they do? What do the differences between readings imply about the process of reading?" (Flynn & Schweickart xii). Feminist critics active in the reader-response field pursue these opening questions to an underlying one: "If readers differ in their approaches to texts, how much of this difference can be attributed to gender?" (Flynn & Schweickart xii).

The reader-response approach, like most in literary studies, can be taken overtly either in theory or in practice, though both activities are always informing each other and working together beneath the surface. For our purposes here, that is for students of an introductory women's studies book, rather than for advanced students in literature, the practice side must be emphasized.

Judith Fetterley's book *The Resisting Reader* is "must" reading for anyone interested in how people respond to well-known short stories and novels. But it is particularly important for any woman who has felt left out when reading the canonized works of American literature. Fetterley begins forcefully, "Literature is political" (xi). And she continues in the same way, "American literature is male" (xii). Specifically, "The major works of American fiction constitute a series of designs on the female reader; all the more potent in their effects because they are 'impalpable'" (xi).

Fetterley attempts to teach women, first, how to be "resisting" rather than "assenting" readers, how to read all literature *as women*. Through a series of chapters treating well-known fiction by Washington Irving, Sherwood Anderson, Nathaniel Hawthorne, William Faulkner, F. Scott Fitzgerald, Henry James, and Norman Mailer, she next encourages a revisioning akin to what Adrienne Rich, the famous American poet, called for when she said, "Re-vision—the act of looking back, of seeing with fresh eyes, of entering an old text from a new critical direction—is for us more than a chapter in cultural history; it is an act of survival" (19). By providing a survival kit, as it were, Fetterley intends to promote better critical dialogue between men and women:

> The consequence, in turn, of this re-vision is that books will no longer have to be read as they have been read and thus will lose their power to bind us unknowingly to their designs. While women obviously cannot rewrite literary works so that they become ours by virtue of reflecting our reality, we can accurately name the reality

they do reflect and so change literary criticism from a closed conversation to an active dialogue. (xxii–xxiii)

Naming the reflected reality even when it is a painful one, occupies Fetterley in her case study of teaching Susan Glaspell's understated short story, "A Jury of Her Peers." She found that once men have allowed themselves to read the story of domestic violence, they will easily recognize its point, though they may not like it. "Male violence against women and women's retaliatory violence against men constitute a story that a sexist culture is bent on repressing, for, of course, the refusal to tell this story is one of the major mechanisms for enabling the violence to continue" (Fetterley, "Reading about Reading" 154). Our newspapers can give us the facts: "About a third of American families experience domestic violence, according to the family research laboratory at the University of New Hampshire in Durham. At least 1.8 million women are assaulted by their husbands every year and more than 1.6 million children are abused by parents" ("Students Tackle Issues of Violence"). Literature, in this case, literature written by women intent on reflecting the feeling of those facts, can help us identify with the oppressed and spur us on to societal change.

Feminist critics in general, and in particular the more generative thinkers such as Fetterley, Showalter, Auerbach, Gilbert, and Gubar, are admittedly engaged in trying to change readers and thus change the world. They do not view literary criticism as some sort of ivory-tower retreat surrounded by the thin air of objectivity. They maintain that literary criticism has always been socially motivated and directly connected to the perspectives of the critic. The difference is that feminist critics admit up front what their perspectives are. They work overtly at "exposing sexism, elucidating feminist ideals, and thereby contributing to the liberation of society. . ." (Stevens and Stewart 75). Such efforts are far from futile utopianism. In fact, many readers report positive, life-changing effects from reading with feminist eyes.

In the next section, "My Story and Jane Eyre's," I hope to show how at least one person's reading was dramatically changed for the better by a consciousness newly sensitized to feminist interpretations of literature. In "Your Story, Our Story," the last section, I will argue that Christian readers have a special responsibility to read literature written by women.

BY A WOMAN, ABOUT A WOMAN: MY STORY AND JANE EYRE'S

In the middle of a Victorian literature class a few years ago, in one of those epiphanies teachers learn to expect and certainly to treasure

as we go about our strange, intriguing work, it dawned on me that I was definitely a different reader of *Jane Eyre* at age forty-four than I had been when I taught it last, at age twenty-four, and read it first, at age fourteen.

Girls first read *Jane Eyre* in early adolescence. For many it is their first real literary, adult novel. From talking with students and friends I gather that the novel often gets rereadings, sometimes many such. One friend, a thirty-three-year-old with a master's degree in social work, said to me when she heard I was doing this study:

> "Oh, *Jane Eyre*—I've read it six or seven times at least, the first time in my early teens. I don't know why it was such a favorite—it drew me like a magnet. When I finished it each time I felt vicariously like I had completed a great struggle myself."

When I suggested to her that Jane successfully resolved the dilemma of being fully independent yet being fully loved and able to love in return, my friend replied: "Yes, of course, that's it: Jane managed to do what I wanted to do. But I never realized that until you said it just now."

Like most readers, my friend had read *Jane Eyre* with great interest, great identification with the heroine, great emotional involvement; but she did not know until much later what may have caused that power. I read that way myself at fourteen. Lost in the romantic story, anxious to find out if Jane ever got to marry Mr. Rochester, I recall my frustration with the whole Marsh End episode and the lackluster Rivers family. "What is all this doing here, slowing the story down?" I asked myself.

For a fourteen-year-old girl, Jane's orphanhood, isolation, mistreatment by the Reed family and, on the more upbeat side, solacing herself with her intense friendship with the dying Helen Burns and her crush on Miss Temple also prove engrossing. Not as important as the Rochester romance, of course, but still vital. As far as I can tell, no fourteen-year-old reader ever thought that Jane was *not* the main character.

By looking back over the criticism I had available to me through the years, I can trace the critical field in which I read the novel, a field that at first gave little attention to the muted story beneath the dominant one and that at times even marginalized the dominant story.

William Peden, in the introduction to the Modern Library hardcover edition of Jane Eyre I bought in the early 1950s with my own money, all $1.95 of it, spends six pages on the gloomy biography of all the Brontës and only four pages on the novel. Peden seems surprised by the novel's success with readers, given its "gothic elements."

Robert B. Heilman's fine essay, "Charlotte Brontë's 'New Gothic,'" on the other hand, coming in the late 1950s and included in one of the first paperback anthologies of literary criticism about the Victorian period, treats that Gothic accomplishment seriously and well. Yet Heilman calls Brontë "Charlotte" throughout his essay. But in his other book *The Magic in the Web*, does he call Shakespeare "William"? In the case of Charlotte Brontë, it sounds as though Heilman respected the novels and patronized the author.

Mark Schorer, in the introduction to the Riverside edition of 1959 (my graduate school text), treats the novel very perceptively in so many ways that it is almost shocking to find him lapsing into a snide tone:

> English fiction is full of governesses, but perhaps none is so famous as plain little Jane Eyre, who vindicates the purity of her humble breed and at the same time releases and realizes a thousand of its gaudy dreams. One may hope that some day a not overly solemn social historian will undertake a study of the place of the governess in British culture. (v)

Why does Schorer hope for a "not overly solemn social historian"? Is it because females such as governesses—and perhaps seamstresses such as Grace Poole, or housekeepers such as Mrs. Fairfax, or emotionally disturbed wives such as Bertha Mason—are worthy of only fleeting, bemused attention? Such a remark made about David Copperfield or Jude Fawley or Oliver Twist would be incomprehensible to us, but Schorer's comment is acceptable when he thus trivializes Jane's plight. Schorer also assumes an occasionally arrogant tone. For example, he sums up what he calls Charlotte Brontë's "unenthusiastic marriage to her father's curate," with the line, "it may be presumed that she never recovered from Edward Rochester" (xvii).

Nevertheless, Schorer does pose a vital question: "[*Jane Eyre*] was an instant triumph and has remained one, especially with female readers, ever since. Why?" What he calls its weaknesses, such as Jane's need for women role models, the presence of the maniac in the attic, and Jane's inheriting the fortune and finding her family before she is able to return and marry Rochester—these things, which Schorer calls "silly, feeble parts" (x–xi), turn out to be the very ones feminist critics in the 1970s and 1980s see as key. These are the parts of the book that concentrate a powerful effect on readers.

Another impression received by female graduate students in the mid-1960s from both critics and teachers was that somehow in earlier, impassioned adolescent reading, we had identified with the wrong character. *Jane* is not the important person after all; *Rochester* is!

Thus we should analyze his dilemma, we should shudder at the implications of his blindness and of his having been maimed, Freudian symbols of his emasculation, no doubt the ultimate threat for a male character and for the *presumed* male reader.

As a *female* reader, but one studying for achievement in the male academic world, I listened carefully to my tutors and I read earnestly, trying to square my actual reading experience of *Jane Eyre* with what they said it ought to be. Not to have done that would have meant the usual dismissal of female judgment. Carolyn Heilbrun delineates this process in *Reinventing Womanhood*:

> In the . . . academic [world], the point of view that women commit themselves to with conviction is likely to be labeled by the dominant men as "trivial," or insubstantial. It is placed, by assumption, outside the mainstream, the major discipline, and allowed to continue, if at all, only along the minor channels and canals that constitute the tributary waterways. (164–65)

I wanted to be mainstream. Therefore I looked at this novel as being part of the Gothic tradition, or a commentary on the Brontë family biography, or on "Charlotte's" sexual repression, or a social change document, or a fascinating study of a man's problem. In short, I denied my own convictions, my own reading experience; I fit in just fine.

And I didn't read *Jane Eyre* again for twenty years. Why bother? The generative power of the novel was gone for me. It had been effectively defeminized. Only recently has that destructive action been realized to be emotionally equivalent to being emasculated.

I continued to read criticism, however, and in the next two decades I began running into material that gradually opened my eyes to an old vision, one glimpsed in my first reading, but blocked out later by the dominant readers around me: The novel *Jane Eyre* is by a woman, about a woman. It deals primarily with female problems. It even comes from a female tradition of novel writing. Charlotte Brontë, I came to understand, wrote "in absolute and passionate awareness of the disabilities under which women, and particularly gifted women, struggle for a place to put their lives" (Heilbrun, *Towards Androgyny* 78). Thus by all rights, *Jane Eyre* could have been included in Jerome Buckley's 1974 book, *Season of Youth: The Bildungsroman from Dickens to Golding*. After all, like *Great Expectations, David Copperfield, The Ordeal of Richard Feverel, The Way of All Flesh, Jude the Obscure, Sons and Lovers*, and *Portrait of the Artist as a Young Man*, all of which are included, *Jane Eyre*, too, is "a novel of growing up and finding one's place in the world." But since Buckley emphasizes the hero's loss of a father and struggle to attain "the gentlemanly ideal," neither of which are vital to Brontë's governess,

by definition he excluded *Jane Eyre*. Buckley's book is really "The *Male* Bildungsroman from Dickens to Golding," but like many critics, Buckley assumes that what is male represents all that is human and what is female never represents anything that is human.

I further realized that Rochester is only the central character of the Thornfield episode. In fact, each section has a different male figure who restricts Jane: John Reed, the sadist; Brocklehurst, the pious oppressor; Rochester, the master; and St. John Rivers, the self-annihilator, the emotion-killer (Gilbert and Gubar 351).

Finally, in 1979, while reading *The Madwoman in the Attic* by Sandra M. Gilbert and Susan Gubar, I stumbled upon a paragraph that summed up the new/old vision of Brontë's book:

> [Jane's] story, providing a pattern for countless others, is . . . a story of enclosure and escape, a distinctively female Bildungsroman in which the problems encountered by the protagonist as she struggles from the imprisonment of her childhood toward an almost unthinkable goal of mature freedom are symptomatic of difficulties Everywoman in a patriarchal society must meet and overcome: oppression (at Gateshead), starvation (at Lowood), madness (at Thornfield), and coldness (at Marsh End). Most important, her confrontation, not with Rochester but with Rochester's mad wife Bertha, is the book's central confrontation, an encounter . . . not with her own sexuality but with her own imprisoned "hunger, rebellion, and rage," a secret dialogue of self and soul on whose outcome . . . the novel's plot, Rochester's fate, and Jane's coming-of-age depend. (338–39)

My revisionist reading of *Jane Eyre* depended, too, on Elaine Showalter's book *A Literature of Their Own*, as well as Maurianne Adams's article "*Jane Eyre:* Woman's Estate." These four critics, Gilbert, Gubar, Showalter, and Adams, provided the critical field for my third encounter with the novel, at age forty-four. The best way to outline this experience is to use the five geographies of the novel as the structure, selecting one or two crucial points in each.

In the first chapters of *Jane Eyre*, the fact that Jane is a ten-year-old *girl* and her terrible circumstances are reflective of common female childhood difficulties is central. She suffers from confinement, a sense of physical inferiority, enforced silence, exclusion from the family circle, bewilderment, submission, and fear of abuse. She says, "Accustomed to John Reed's abuse, I never had an idea of replying to it; my care was how to endure the blow which would certainly follow the insult" (Brontë 8). It takes her a long time to rebel against the abuse, and then it takes great agonizing before she can make the judgment "Unjust! Unjust!" even to herself; and then more struggle before she gives the facts to an outside adult. "John Reed knocked me down," she reports to the surgeon, "and my aunt shut me up in the

red-room" (20). Fear, endurance of suffering rather than the reporting of it, guilt—this pattern is that of the abused girl, the battered woman. Finally, Jane, unlike many victimized women, is able to say in effect, "He hit me: I am not to blame." Also, when "Resolve," as she calls it, finally rises in her, she says it "instigated some strange expedient to achieve escape from insupportable oppression—as running away, or, if that could not be effected, never eating or drinking more, and letting myself die" (12). There they are, the female remedies—escape, anorexia, suicide.

Jane's confinement in the red room in chapter two also turns out to be a powerfully evocative matrix of symbols. One of the most potent of these is, I think, the onset of menstruation. Here is Jane, age ten, cut off from help and solace and explanation, confronting her own blood. There is no mother or sister or girlfriend to tell her what is happening, what the pain is, why she is bleeding. Somehow, though, she knows she cannot leave Gateshead until she becomes a woman. The terror of the red room captures that experience plus other aspects of female sexuality and is recapitulated in the confrontation with Bertha Mason. Bertha's fury toward Rochester, expressed in corpulent, florid, even passionate excitement, results in more blood-letting. After seeing the spectre of Bertha, whom she describes as purple-faced, and red-eyed, with a lurid visage flaming over hers, Jane faints, "for the second time in my life—only the second time—I became insensible from terror" (250). The nightmares and visions of the red room are with Jane at Thornfield, the mirror horrors recur, the dreams of mother and death and the ghastly images of marriage intensify. The abuse and physical and emotional pain of Gateshead, then, are only Jane's *initiation* into women's realities. There is more to come.

At Lowood School, the second locus, the starvation motif reappears, but now it is institutionalized and combined with other attempts to subdue the specifically female flesh: the brown shapeless dresses hide any shapely bodies, the rough haircuts detract from potential beauty, the cold walks reduce any passions or rebellions. Helen Burns' religious acquiescence won't serve long for Jane's model—and neither will Miss Temple's kindness combined with capitulation to unjust authority, though both do sustain her for a time. It is Miss Temple's leaving to get married that prompts Jane's first real feminist cry:

> I tired of the routine of eight years in one afternoon. I desired liberty; for liberty I gasped; for liberty I uttered a prayer; it seemed scattered on the wind then faintly blowing. I abandoned it and framed a humbler supplication; for change, stimulus; that petition, too, seemed swept off into vague space; "Then," I cried, half-desperate, "grant me at least a new servitude!" (74)

All her prayers are actually granted, but in reverse order: first, the new servitude at Thornfield, then the stimulation of Marsh End, and finally, the liberty at Ferndean.

At Thornfield, the third story section—literally so when we learn how important the attic level of the house is—Jane rejects Rochester's proposal that because she can't legally be his wife, she ought to at least be his mistress. In the past I had assumed from my reading that her decision came on conventional moral grounds, but with my new critical field, other passages pointing to much more significant reasons emerged. Jane says early on, "Wealth, caste, custom inter-vened between me and what I naturally and inevitably loved" (221) and also, "I am no bird; and no net ensnares me: I am a free human being with an independent will" (223) she exclaims to Rochester. Jane refuses Rochester because by becoming his mistress she would be by position inferior to him—that's what he said he had felt of his past mistresses. And Jane asserts, "I care for myself" (279). She values herself enough to avoid an unequal union. She also cares for herself enough to know that she needs time and distance in which to understand all the emotions symbolized in the confrontation with Bertha Mason—the rage, the violence, the passion—and to find ways of successfully merging them into her mature self. Until Jane has mastered herself and has the full independence of life represented outwardly by a sphere of work, a place of her own, financial independence, and her own family to give her a social place in the world and a loving community, she cannot live with Rochester.

All of these needs, it turns out, are met at Marsh End. Jane's sojourn with the Rivers family, Diana, Mary, and St. John, the part of the novel I had been so impatient with when I was young, turns out to be not an interruption in the story but rather absolutely essential for completing Jane's journey toward self-worth and authentic living.

Jane is nursed to physical health by the Rivers, who, it is revealed, are her cousins. She receives a legacy that guarantees financial independence. She gets a teaching job and lives in her own cottage. Diana and Mary become the female friends on an equal basis that she had longed for. Moreover, Jane's experiences with her own feelings allow her to eventually understand that St. John Rivers, so apparently selfless in his motivation, in truth has major difficulties with a spiritual ambition that makes him insensitive to the feelings of others. The images that she uses to describe her state of mind as she struggles with St. John's appeals to her are evocative of earlier sections of the novel, but now she recognizes her condition: "Oh, I wish I could make you see how much my mind is at this moment like a rayless dungeon," and "My iron shroud contracted round me" (355). When she finally rejects St. John's insistent demands for a loveless

marriage for missionary respectability, Jane's true need for liberty is foremost in her mind and her emotional health assured: "If I join St. John," she says to herself, "I abandon half myself . . . As his sister, I might accompany him—not as his wife." And at last she tells him outright, "I am ready to go to India, if I may go free" (356). But instead of going to India, she hears Rochester calling for her—and she returns to him.

In the final location, Ferndean, in which Jane is reunited with the now blinded, maimed, and wifeless Rochester, I sense in my reading these days that Jane is not somehow giving up her newfound freedom for more servitude but rather experiencing growing freedom. Rochester himself has suffered and has lost his interest in demanding servitude from others. As Heilbrun points out, "We today begin to see that Rochester undergoes, not sexual mutilation as the Freudians claim, but the inevitable sufferings necessary when those in power are forced to release some of their power to restore those who previously had none" (*Towards Androgyny* 59). Rochester has experienced freedom from the egoism which previously restricted his growth. Thus, far from being that capitulation on Charlotte Brontë's part that earlier critics had suggested, Jane's marriage with Rochester is really the culmination of her development: she has achieved both autonomy and love, and the person she loves has learned how to love her. I've heard that situation called fantastic wish-fulfillment, but is it? Don't we all know a few people, at least one or two, who are both autonomous and who love and are loved in return? Were our adolescent hopes for Jane's happiness so incredibly unrealistic after all? I think not.

My third reading of *Jane Eyre*, then, was substantially changed by feminist insights. I have an answer now for the question Schorer raised in 1959 about why *Jane Eyre* is such a triumph, especially with female readers.

BOYS' BOOKS, GIRLS' BOOKS, AND CHANGE FOR THE FAITHFUL READER

After having considered my experience with the novel *Jane Eyre*, it is now your turn to examine your personal patterns in reading fiction. The following is essentially reader response criticism (#9 on the chart of Literary Studies). It depends on "reading researchers [who] have contributed empirical data on gender-related similarities and differences among developing readers" (Flynn, "Gender and Reading" 267). Elizabeth Segel's fascinating article, " 'As the Twig Is Bent . . .':

Gender and Childhood Reading," first encouraged me to this approach.

Here are some questions for you to answer, followed by comments on what the usual patterns are. Each of you is an individual, of course, so you may depart from the norm, but chances are most readers of this book will find themselves mirrored.

Your Story

1. List the novels important to you in your early reading years, ages 10–16.

Comment: These days such lists often include for boys *Tom Sawyer*, *The Hobbitt*, *The Hardy Boys* series, *The Sugar Creek Gang* series, *The Lion, the Witch and the Wardrobe*, and the *Black Stallion* books. In the past male readers may have delved more into the *Tom Swift* series and classics such as *Twenty Thousand Leagues Under the Sea*, *The Three Musketeers*, *Treasure Island*, and *David Copperfield*.

For today's girls the list often includes *Little Women*, *Anne of Green Gables*, the *Little House on the Prairie* series, the *Nancy Drew* series, plus other syndicate-produced teen series sold through school book orders (for example, *Canby Hall*). Years ago female readers devoured *A Tree Grows in Brooklyn*, *Rebecca*, *Gone with the Wind*, and perhaps *Jane Eyre* and *Wuthering Heights*.

According to the book trade, teachers, librarians, and the young readers themselves such books are either "boys' books" or "girls' books." The definitions are simple: a boys' book has a male main character; a girls' book has a female main character.

The socializing intention of boys' books has been to encourage growth to manhood through increasing autonomy. Especially in vogue in the twentieth century is the "good bad boy," Tom Sawyer and Huck Finn being late nineteenth-century forerunners, who resists adult authority, specifically female domestic authority, and eventually finds success in the public male world where females do not count. The socializing intention of girls' books, in contrast, seems to have been to encourage what one researcher calls "growing down rather than growing up"—moving away from childhood delight in noisy independence and action to the gradual acceptance instead of the young woman's quiet subservience and confined adulthood (Pratt 14).

2. Did you know at the time that you were reading boys' books or girls' books? Did you regularly cross over and read the opposite type?

Comment: Before about age nine or ten, most boys and girls read both kinds of books. After that boys read almost only boys' books. However, "girls [are] avid readers of boys' books from the start" as well as being readers of girls' books (Segel 175). Since boys for the most part read only in the one category—and girls will read in the boys' category—a library or school with limited funds tends to buy at least twice as many boys' books as girls' books. Publishers respond to this situation by issuing books in about those same proportions. Until fairly recently these forces worked together to limit the existing accessibility of books with female main characters. In the 1960s several very popular books broke this rule: Scott O'Dell's *Island of the Blue Dolphins* (1960), Louise Fitzhugh's *Harriet the Spy* (1964), and Madeleine L'Engle's *A Wrinkle in Time* (1962). Boys read these books with female protagonists with as much enthusiasm as girls did. When one young boy in sixth grade was asked, " 'Can you remember any books about girls that you enjoyed?' He replied, 'No [pause], . . . except *A Wrinkle in Time*,' then he quickly added, 'But she wasn't 'really the main character' " (Segel 182). Librarians and publishers declared these novels exceptional and made no major adjustments in their proportions for publishing and buying. In the 1980s, however, as a result of pressures from feminists, publishers are now issuing about the same number of books in each category. Yet the forces of past experience and socialization remain strong: the old taboo still holds sway, controlling what young boys read. In fact, when it comes to gift giving, Segel observes, "most adults would never think of giving a boy a book about a girl" (182).

3. What were the losses and gains from your pattern of childhood reading?

Comment: It may be that some of the caring qualities often attributed naïvely to women's "nature" may actually come from women's early training in sharing the lives of those different from themselves, from being "able to enter stories that exclude them," from identifying with male characters in fiction. On the other hand, the chronic male complaint "I just don't understand women" reflects a reality compounded by lack of training through cross-gender reading identification. In short, men may not know as much about women as women know about men! (That this repeats a pattern in which slave knew more about master than master knew about slave should not be missed.)

Women are ultimately limited in their reading, not by their own choices, which, as we've noted, are often wide-ranging, but rather by the increasingly male-centered books we are assigned to read and

discuss from high school on into college. Our being omitted or marginalized or stereotyped in fiction just as we know our whole sex to have been in historical, political, cultural, and religious life, leaves us without literary role models and tends to increase women's problems of self-esteem and self-assertion.

The limitations of sex-restricted reading are also harmful to boys, especially in our time:

> The boys' book-girls' book division, while it depreciated the female experience and so extracted a heavy cost in feminine self-esteem, was at the same time more restrictive of boys' options, of their freedom to read (all the exotic voyages and bold explorations notwithstanding), than of girls'. The fact that girls could roam over the entire territory of children's books while most boys felt confined to boys' books didn't matter much when girls' books were for the most part tame socializing tools geared to perfecting and indoctrinating young ladies, and virtually all the "good books" from a child's point of view were accessible to boys. But now that many girls' books . . . are enthralling and enriching stories, boys are the losers. The greater pressure on boys to confine themselves to male-typed reading and behavior, though stemming from the higher status of males, is revealed to be at heart a limitation—one obviously related to all the constraints that preserving the traditional male role imposes. We can only speculate about the ramifications of this fact. In a society where many men and women are alienated from members of the other sex, one wonders whether males might be more comfortable with and understanding of women's needs and perspectives if they had imaginatively shared female experience through books, beginning at childhood. At the least, we must deplore the fact that many boys are missing out on one of fiction's greatest gifts, the chance to experience life from a perspective other than the one we were born to—in this case, from the female vantage point. (Segel 182–83)

Most often readers approach fiction in order to see their own experience reflected or clarified and to gain a sense of the life of the other, be it the other sex, nationality, class, race, or period of time. Additional major pleasures come from fiction, of course, such as seeing the world presented in ordered form, hearing language well-used, escaping from the humdrum known into the exciting unknown; but I believe the search for knowledge of the self and the other motivates us the most. The boys' books, girls' books syndrome as well as a predominately male literary tradition holds us back from both this knowledge and these pleasures.

Our Story

The stories of this chapter thus far—theirs, mine, hers, yours—may encourage us to move beyond our former reading patterns, to make all human experience conveyed through literature "our story." We might start by asking, "How many books on my list of recent reading were written by women? How many included female characters who were not stereotypes? Moreover, how did I read those books? Did I take advantage of feminist perspectives on literature? Did I wear my gender-sensitive lenses while reading and thus move toward "seeing the object as in itself it really is?" (Arnold 258).

The faithful Christian reader has special responsibilities, far-reaching, yet intimate, which require such reading.

Consider, for one, the whole mission of the church: "to restore all people to unity with God and each other in Christ" (*Book of Common Prayer* 855). This ministry of reconciliation requires that we break down sinful patterns of domination and oppression, "strive for justice and peace among all people, and respect the dignity of every human being" (305). Wide reading of literature written by both men and women, done critically and sensitively, helps equip us intellectually for such actions.

The faithful Christian must also respond to Christ's summary of our basic responsibilities. If we heed the call to "love the Lord your God with all your heart, with all your soul, with all your mind, and with all your strength" (Mark 12:29, 30), we cannot limit ourselves to literature only by and about men, for loving God suggests, among other actions, offering praise for all God's wonderful works, including the creation of human beings in God's image, human beings created female and male. How can we praise that which we do not know? Furthermore, the embodiment of human life, its being lived in distinctively male or female flesh, is not to be lamented—it is to be celebrated. That celebration is enhanced as we become, as it were, the flesh of the other, as we do incarnational reading.

The second part of Christ's summary of the Law, "Love your neighbor as yourself" (Mark 12:31), calls us to overcome at least three blocks: ignorance, selfishness, and lack of self-love, the first two of which Susan Gallagher comments on so well in her section on reading as the Christian vocation in *Literature Through the Eyes of Faith*. The last block, lack of self-love, it seems to me, is more characteristic of women than of men. Reading literature written by women and employing feminist perspectives as we read help women and men toward the Law's fulfillment in different ways. For the most part, women benefit by increased self-esteem, the capacity to love themselves by finding a mirror of their own experience in art. When they

no longer feel themselves to be unworthy creatures, they become capable of loving others. Men on the whole, become capable of loving when they have shared the life of the other and practiced extending to others the same love they have been taught to give themselves.

St. Paul explains to the Philippians that his capacity for finding God's resources in himself in all circumstances came in part from his wide range of human experience, "I have been very thoroughly initiated into the human lot with all its ups and downs—fullness and hunger, plenty and want" (Phil. 4:12 NEB). In order to say that truthfully, St. Paul must have broken out of the limitations of his own maleness and participated as well as he could in female life. *His* reading opportunities for doing that were limited; ours are not.

For all of us, men and women alike, the Christ at our door whom we are called to serve in human, particular, reconciling ways—with a cup of water, with food, with companionship—may be female. We must know her well, celebrate her creation, identify with her. Moll Flanders, Tess Durbeyfield, Elizabeth Bennet, Hester Prynne, Martha Quest, Mattie Silver, Celie, Jane Eyre, Bertha Mason, Mrs. Ramsay, Dorothea Brooke, Meg and Jo March—these and other fictional women expand our knowledge, sharpen our sympathies, entice us into finding our own lives by losing our ignorance and selfishness and self-depreciation. Reading books written by women will not in and of itself make us ministers of reconciliation, for only God's love shed abroad in our hearts can do that, but reading can make us open to love.

Works Cited

Adams, Maurianne. "*Jane Eyre:* Woman's Estate." *The Authority of Experience: Essays in Feminist Criticism.* Edited by Arlyn Diamond and Lee R. Edwards. Amherst: University of Massachusetts Press, 1977.

Arnold, Matthew. "The Function of Criticism at the Present Time." *Lectures and Essays in Criticism. Complete Prose Works of Matthew Arnold, Vol. 1.* Edited by R.H. Super. 11 vols. Ann Arbor: University of Michigan Press, 1962.

Atwood, Margaret. "That Certain Thing Called the Girlfriend." *New York Times* 11 May 1986: Sec. 7:1+.

Auerbach, Nina. *Communities of Women: An Idea in Fiction.* Cambridge, Mass.: Harvard University Press, 1978.

_____. *Woman and the Demon: The Life of a Victorian Myth.* Cambridge, Mass.: Harvard University Press, 1982.

Benstock, Shari, ed. *Feminist Issues in Literary Scholarship.* Bloomington: Indiana University Press, 1987.

Book of Common Prayer, The. New York: The Church Hymnal Corporation, 1979.

Brontë, Charlotte. *Jane Eyre.* Edited by Richard J. Dunn. New York: Norton, 1971.

Buckley, Jerome Hamilton. *Season of Youth: The Bildungsroman from Dickens to Golding.* Cambridge, Mass.: Harvard University Press, 1974.

Diamond, Arlyn and Lee R. Edwards, eds. *The Authority of Experience: Essays in Feminist Criticism.* Amherst: University of Massachusetts Press, 1977.

Eagleton, Mary, ed. *Feminist Literary Theory: A Reader.* London: Blackwell, 1986.

Edwards, Lee R. "Women, Energy, and *Middlemarch.*" *Massachusetts Review* 13:1–2 (1972): 223–38.

Evans, Barbara, and Gareth Lloyd Evans. *The Scribner Companion to the Brontës.* New York: Scribner, 1982.

Fetterley, Judith. *The Resisting Reader: A Feminist Approach to American Fiction.* Bloomington: Indiana University Press, 1978.

————. "Reading about Reading: 'A Jury of Her Peers,' 'The Murders in the Rue Morgue,' and 'The Yellow Wallpaper.'" *Gender and Reading: Essays on Readers, Texts, and Contexts.* Edited by Elizabeth A. Flynn and Patrocinio P. Schweickart. Baltimore: Johns Hopkins University Press, 1986.

Flynn, Elizabeth A. "Gender and Reading." *Essays on Readers, Texts, and Contexts.* Edited by Elizabeth A. Flynn and Patrocinio P. Schweickart. Baltimore: Johns Hopkins University Press, 1986. 267–88.

Flynn, Elizabeth A., and Patrocinio P. Schweickart, eds. *Gender and Reading: Essays on Readers, Texts, and Contexts.* Baltimore: Johns Hopkins University Press, 1986.

Gallagher, Susan, and Roger Lundin. *Literature Through the Eyes of Faith.* San Francisco: Harper & Row, 1989.

Gilbert, Sandra M., and Susan Gubar. *The Madwoman in the Attic: The Woman Writer and the Nineteenth-Century Literary Imagination.* New Haven: Yale University Press, 1979.

Heilbrun, Carolyn G. *Towards a Recognition of Androgyny.* New York: Harper & Row, 1973.

————. *Reinventing Womanhood.* New York: Norton, 1979.

Heilman, Robert B. "Charlotte Brontë's 'New Gothic.'" *Victorian Literature: Modern Essays in Criticism.* Edited by Austin Wright. New York: Oxford University Press, 1961. 71–85.

Jacobs, Harriet A. *Incidents in the Life of a Slave Girl, Written by Herself.* Edited by Jean Fagan Yellin. Cambridge, Mass.: Harvard University Press, 1987.

Kolbert, Elizabeth. "Literary Feminism Comes of Age." *New York Times* 6 December 1987: Sec. 6:110+.

Kolodny, Annette. "Dancing Through the Minefield: Some Observations on the Theory, Practice, and Politics of a Feminist Literary Criticism." *The New Feminist Criticism: Essays on Women, Literature, and Theory.* Edited by Elaine Showalter. New York: Pantheon, 1985. 144–67.

Kunitz, Stanley. "The Poet's Quest for the Father." *New York Times* 22 February 1987: Sec. 7:1+.

Lerenbaum, Miriam. "Moll Flanders: 'A Woman on Her Own Account.'" *The Authority of Experience: Essays in Feminist Criticism.* Edited by Arlyn Diamond and Lee R. Edwards. Amherst: University of Massachusetts Press, 1977.

Marcus, Jane. "Still Practice, A/Wrested Alphabet: Toward a Feminist Aesthetic." *Feminist Issues in Literary Scholarship.* Edited by Shari Benstock. Bloomington: Indiana University Press, 1987. 79–97.

Modern Language Association Newsletter (Summer 1987).

Moers, Ellen. *Literary Women: The Great Writers.* Garden City, New York: Doubleday, 1976.

Moglen, Helene. *Charlotte Brontë: The Self Conceived.* Madison: University of Wisconsin Press, 1976.

Olsen, Tillie. *Silences.* New York: Delacorte Press, 1979.

Peden, William. Introduction. *Jane Eyre.* By Charlotte Brontë. New York: Modern Library, 1950.

Poovey, Mary. "My Hideous Progeny: Mary Shelley and the Feminization of Romanticism." *PMLA* 95:3 (1980): 332–47.

————. *The Proper Lady and the Woman Writer: Ideology as Style in the Works of Mary Wollstonecraft, Mary Shelley, and Jane Austen.* Chicago: University of Chicago Press, 1984.

Pratt, Annis. *Archetypal Patterns in Women's Fiction.* Bloomington: Indiana University Press, 1981.

Rich, Adrienne. "When We Dead Awaken: Writing as Re-Vision." *College English* 34 (1972): 18–30.

Russ, Joanna. *How to Suppress Women's Writing.* Austin: University of Texas Press, 1983.

Schomburg Library of Nineteenth-Century Black Women Writers, The. Edited by Henry Louis Gates, Jr. 30 vols. New York: Oxford University Press, 1988.

Schorer, Mark. Introduction. *Jane Eyre.* By Charlotte Brontë. Boston: Houghton Mifflin, 1959.

Schweickart, Patrocinio P. "Reading Ourselves: Toward a Feminist Theory of Reading." *Gender and Reading: Essays on Readers, Texts, and Contexts.* Edited by Elizabeth A. Flynn and Patrocinio P. Schweickart. Baltimore: Johns Hopkins University Press, 1986. 31–62.

Segel, Elizabeth. " 'As the Twig Is Bent . . .': Gender and Childhood Reading." *Gender and Reading: Essays on Readers, Texts, and Contexts.* Edited by Elizabeth A. Flynn and Patrocinio P. Schweickart. Baltimore: Johns Hopkins University Press. 1986. 165–86.

Showalter, Elaine. *A Literature of Their Own: British Women Novelists from Brontë to Lessing.* Princeton: Princeton University Press, 1977.

————, ed. *The New Feminist Criticism: Essays on Women, Literature, and Theory.* New York: Pantheon, 1985.

————. "Women and the Literary Curriculum." *College English* 32:8 (1971): 855–62.

Spacks, Patricia Meyer. *The Female Imagination.* New York: Knopf, 1975.

Springer, Marlene, ed. *What Manner of Woman: Essays on English and American Life and Literature.* New York: New York University Press, 1977.

Stevens, Bonnie Klomp, and Larry L. Stewart. *A Guide to Literary Criticism and Research.* New York: Holt, Rinehart and Winston, 1987.

Stratton, Joanna L. *Pioneer Women: Voices From the Kansas Frontier.* New York: Simon & Schuster, 1981.

"Students Tackle Issues of Violence." *New York Times* 30 June 1988: C11.

Sundquist, Eric J. "A Great American Flowering." *New York Times* 3 July 1988: Sec. 7:1+.

Woolf, Virginia. *A Room of One's Own.* 1928. Reprint. New York: Harcourt Brace Jovanovich, 1981.

For Further Study

Discussion Questions

1. Boys' Books, Girls' Books—
 a. List the novels important to you in your early
 reading years, ages 10–16.
 b. Did you know at the time that you were reading
 boys' books or girls' books? Did you regularly cross
 over and read books written for the other sex?
 c. What were the losses or gains from your pattern of
 childhood reading?

2. Discuss the absence or presence of women writers in the
 literature courses you have taken in high school or college.

3. How might the Bible be different if it had been written by
 women? (Discuss a particular book—for example, Exodus, Job,
 Song of Songs, Mark, or Acts.)

4. Why are Harlequin romances popular? Can such books be
 compared *in any way* to male pornographic literature? Consider
 here comparative male and female desires for escape, fantasy,
 and titillation.

Writing Suggestions

1. Read a short story by a woman and write a personal response
 that reflects whether you are a female or male reader.

2. a. Write a description of one of your own experiences that you
 would consider uniquely female or uniquely male.
 b. Write a description of one of your own experiences
 that you would consider unaffected by gender.

Research Topics

Develop your own reading program and research the works of
contemporary women authors.

Short Story Writers: Nadine Gordimer, Grace Paley, *Women &*
Fiction, *Women & Fiction 2*, and *New Women and New Fiction*,
edited by Susan Cahill.

Novelists: Alice Adams, Margaret Atwood, E. M. Broner, Louise Erdrich, Paula Fox, Gail Godwin, Mary Gordon, Maxine Hong Kingston, Alison Lurie, Toni Morrison, Bobbie Ann Mason, May Sarton, Muriel Spark, Alice Walker

Poets: Gwendolyn Brooks, Maxine Kumin, Adrienne Rich, Muriel Rukeyser, May Sarton, Anne Sexton

Mystery Writers: Amanda Cross (pen name of Carolyn Heilbrun), Agatha Christie, P. D. James, Dorothy Sayers, Josephine Tey

Personal Narrative Writers (autobiographies and journals): Maya Angelou, Madeleine L'Engle, May Sarton, Kate Simon, Susan Toth

Playwrights: Caryl Churchill, Irene Fornes, Lillian Hellman, Beth Henley, Marsha Norman, Ntozake Shange, Wendy Wasserstein

Shorter Reading List

Adams, Maurianne, "*Jane Eyre:* Woman's Estate." *The Authority of Experience: Essays in Feminist Criticism.* Edited by Arlyn Diamond and Lee R. Edwards. Amherst: University of Massachusetts Press, 1977.
Fetterley, Judith. "Reading about Reading: 'A Jury of Her Peers,' 'The Murders in the Rue Morgue,' and 'The Yellow Wallpaper.'" *Gender and Reading: Essays on Readers, Texts, and Contexts.* Edited by Elizabeth A. Flynn and Patrocinio P. Schweickart. Baltimore: Johns Hopkins University Press, 1986.
Olsen, Tillie. *Silences.* New York: Delacorte, 1979.
Segel, Elizabeth. "'As the Twig Is Bent . . .': Gender and Childhood Reading." *Gender and Reading: Essays on Readers, Texts, and Contexts.* Edited by Elizabeth A. Flynn and Patrocinio P. Schweickart. Baltimore: Johns Hopkins University Press, 1986. 165–86.
Showalter, Elaine. "Women and the Literary Curriculum." *College English* 32:8 (1971): 855–62.
Tischler, Nancy M. *A Voice of Her Own: Women, Literature, and Transformation.* Grand Rapids: Zondervan, 1987. Chapters 1 and 7.

Longer Reading List

Diamond, Arlyn, and Lee R. Edwards, eds. *The Authority of Experience: Essays in Feminist Criticism.* Amherst: University of Massachusetts Press, 1977.

Fetterley, Judith. *The Resisting Reader: A Feminist Approach to American Fiction.* Bloomington: Indiana University Press, 1978.

Flynn, Elizabeth A., and Patrocinio P. Schweickart, eds. *Gender and Reading: Essays on Readers, Texts, and Contexts.* Baltimore: Johns Hopkins University Press, 1986.

Gallagher, Susan, and Roger Lundin. *Literature Through the Eyes of Faith.* San Francisco: Harper & Row, 1989.

Gilbert, Sandra M., and Susan Gubar. *The Madwoman in the Attic: The Woman Writer and the Nineteenth-Century Literary Imagination.* New Haven: Yale University Press, 1979.

Heilbrun, Carolyn G. *Reinventing Womanhood.* New York: Norton, 1979.

Moers, Ellen. *Literary Women: The Great Writers.* New York: Doubleday, 1976.

Russ, Joanna. *How to Suppress Women's Writing.* Austin: University of Texas Press, 1983.

Showalter, Elaine. *A Literature of Their Own: British Women Novelists from Brontë to Lessing.* Princeton: Princeton University Press, 1977.

————, ed. *The New Feminist Criticism: Essays on Women, Literature, and Theory.* New York: Pantheon, 1985.

Spacks, Patricia Meyer. *The Female Imagination.* New York: Knopf, 1975.

Springer, Marlene. *What Manner of Woman: Essays on English and American Life and Literature.* New York: New York University Press, 1977.

5

"That One Talent Which Is Death to Hide": Emily Dickinson and America's Women Poets

Marilyn I. Mollenkott

Now say, have some women worth? Or have they none? Or had they some, but with our Queen is't gone?

(Anne Bradstreet)

We care little for any of the mathematicians, metaphysicians, or politicians who, as shamelessly as Helen, quit their sphere. Intellect in women so directed we do not admire, and of affection such women are incapable.

(Rufus Griswold)

And I was afraid, and went and hid thy talent in the earth. . . . Thou wicked and slothful servant. . . . Take therefore the talent from him. . . . And cast. . .the unprofitable servant into outer darkness. . . .

(Matthew 25:25–30 KJV)

What do colonial poet Anne Bradstreet, nineteenth-century-man-of-letters Rufus Griswold, and the gospel writer Matthew have in common? They all raise the issue of human potential; and they reach different conclusions about it as well. Bradstreet's approach, half-mocking, half-serious, suggests the absurdity of the question she poses. Griswold is dogmatic about "women's place" and the freak-ishness of those who leave it for various professions. And Matthew relates a parable that strongly teaches that not to use the gifts of God is to receive terrible condemnation. It was this parable that provided the impetus for John Milton's sonnet, alluded to in my title, written after the onset of his blindness, in which the speaker acknowledges

that to hide his talent is to experience death.[1] The development of human potential, then, has implications not only for this life but also for the next.

Women's studies is primarily a matter of human potential, of the freedom to realize and develop the good gifts that God has given to each of us, no matter what skin color, family background, level of intelligence and ability, or, of course, gender. It is also a matter of the obstacles that get in the way of that potential. Those obstacles can be of two kinds. The first kind, external or social, refers to whatever it is in our social structures (whether bias, prejudice, or superstition) that tries to prevent this realization, to block the "inalienable rights" endowed by our Creator. The second kind, internal or personal, refers to what we impose on ourselves through fear, lack of confidence, insecurity, or lack of awareness. Each of us struggles on both these fronts, and we therefore have to address the obstacles from these two angles. We have to eliminate the external blocks, but we also have to address the internal ones; people need to have faith in themselves.[2] Whatever works to build up that faith is modeled after the servant-hood of Christ: he was the "redeemer"; his work was "at-one-ment"; he was a person who built bridges. And he accomplished redemption on the cross, but he also emphasized redemption in relationships; that is, loving, caring servanthood, a healing not only of physical problems but of psychological, emotional, and spiritual ones as well. The Bible tells us that love casts out fear, that God has given us a sound mind, *not* the spirit of fear. Our focus in this chapter, then, will be on human potential, what militates against it and what nurtures it. Notice the metaphors. I use the word *militate* because to stop human development is an act of violence; and I use the term *nurture* because to foster growth is life-giving.

We will concentrate first on the issue of human potential in the experience of American women poets from colonial times, the seventeenth and eighteenth centuries, to the 1980s, to try to discern

[1]Milton wrote the sonnet on his blindness (#19) before he had completed any of his major poetry. In it he questioned how he could do the writing that he believed God had called him to do without his vision. He concluded that true service is not a matter of what is accomplished, but rather one of being willing to serve no matter what the circumstances or consequences. John Milton, *Complete Poems and Major Prose*, ed. Merrit Y. Hughes (New York: Odyssey, 1957), 168.

[2]In *Women of Crisis*, Robert and Jane Coles tell about a little black girl who was being integrated into a southern school during the civil-rights crisis of the 1960s. After confronting the angry mobs who cursed her, threatened violence and even death, she was admonished to forgive her persecutors as Christ had done. She answered, "but . . . Jesus was a man." Later she explained why she objected. "If you're a man, you can be nice to your enemy, and get away with it. If you're a woman, you probably *have* to be nice to your enemy, but you may not get away with it." Obviously she had both kinds of obstacles to overcome. Robert Coles and Jane Holowell Coles, *Women of Crisis: Lives of Struggle and Hope* (New York: Delacorte/Seymour Lawrence, 1978). 3.

what kinds of obstacles they confronted both in their society—their readers, editors, and critics—and in themselves—their conformity to or rejection of what their historical context told them. Even more significant, we will consider what these obstacles did to shape the kinds of poetry they wrote. Then we will look at the life and poetry of Emily Dickinson as a microcosm of those issues and forces, in order to see how attitudes toward women in general and as artists in particular were major factors in the kinds of subjects she treated, as well as the way in which she wrote about them.

A GIFT OF SIGHT

Before we consider Emily Dickinson and America's women poets from the perspective of human potential, I would like to relate a story I found in *Daughters of Sarah*, a journal published by evangelical women. This is a tale about personal blindness and lack of self-confidence, about a person with a limited view of herself, and about social bias toward the single woman. Think of the loaded terms we have for a person like this. We call her "spinster" (Emily Dickinson is often referred to this way), a term that defines her by her function in society and that has a pinched sound to it. Or we call her "old maid"; note the prejudice about age as well. Ironically, she can be twenty-seven and still be an old maid. Think of the overtones of sterility, sternness, rigidity, prudishness, and lack of value. We evangelicals have another unique term for a single woman; we call her an "unclaimed blessing," as if because she is not married, she is not really a blessing, a potential one perhaps, but one no one wanted. It is a demeaning phrase, as if she were an item sitting on a shelf, waiting for life to begin, waiting for someone to choose her so that life could happen.

I would like you to consider this story and the implications for your life. Consider the following questions about it. First, does the incident in the story relate to anything you have experienced? If so, what experience? Second, could you have seen your experience from a different perspective? Third, what insight did you gain from the story? How did it change your thinking? How could it change your behavior?

A Gift of Sight: A Christmas Fable

It was the best Christmas gift that I have ever received and, perhaps, will ever receive. I suppose that I have journeyed through about the same number of bleak and empty Christmases as you have, dirty rain-splattered evenings when the shining strength of

faith alone makes the heart glad. This one I sat alone as happens at times to us who have not taken or been taken in marriage. I had my memories as we all do. And these were sweet and bittersweet. You know how they are. It should have been a joyful Christmas for it was on a Monday night, and Sunday had given me candlelight and choirs, and their loveliness nearly drowned out the usual tired message about "Christmas/Easter Christians."

What marred it was Freddy hitting Artie on the nose. Of course, Artie probably jabbed Freddy first with his elbow which is his way. He has been a noted elbower since the second grade. Mary had been whining and Rhonda sick and Freddy and Sammy began to pester Chloe, who shoved Sammy, and while I was separating them, I suppose Artie did his famous elbow performance on Freddy, who I had in one hand beside me while with the other I was parting Sammy and Chloe, for Freddy squealed and squirmed out of my grasp and let Artie have it point blank. Well, then there was a furor, and Ms. Matthews left her class and helped me calm it all down, taking Freddy in custody so I could conduct Artie to the kitchen and wash him off. When I came back Rhonda had thrown up and Chloe was crying and Sammy was gone. Freddy was giggling and holding his nose, and that imp Artie began to giggle, too. And it was only 10:30. I had 15 minutes more to atone, I guess, for my sins. The lesson had completely broken down. The spirit of the day was in shambles.

Ms. Punumba, the Superintendent, said not to be sad or upset about it, these things happened. But still I came home and cried a little. I suppose I wanted to be a success, so it is probable that my pride was hurt. Still, it had disgraced the sanctity and nobility of the day. The children were so small-minded, not merely childlike but childish—puerile in the worst sense, nasty little beasts, perverse as children sometimes are—seemingly more perverse on this day than on others.

So it was with discouragement that I faced what was to prove a further disappointment. Christmas day dragged on with its wearying drizzle, never raining hard, until the night came murking up, all but the heavy, polluted smell that the city has on a close night.

I took myself to bed thanking God that this was not all I could expect from life. And so I went to sleep.

And what about the gift I mentioned? Christmas had come and gone—ragged and dulled and empty.

The gift came that night in a dream.

One moment I was in my bed and the next I was on a broad highway in a beautiful valley. The sun was in my eyes, bright all around. I was traveling and a beautiful strong woman was beside me, keeping pace.

I did not feel the need to speak and instead let the wonder of the place enchant me. We traveled on, we two silent companions. And

she with graceful step was every way the definition of an Amazon. She was lithe, tall, with silver hair caught back for working or for war. She held a stave not for support and strode like a strong gazelle—a warrior queen. At last upon a gentle rise we stopped and saw across a placid sea an alabaster temple set with emerald, ruby, azure, and pearl. There were beautiful youths about the steps, an obvious guard, women and men together, themselves lithe limbed and mighty.

At last the Queen spoke. "Gaze long, Virginia. This is why you were summoned."

"Why?" I asked faltering.

"To gaze on them."

"They are so beautiful."

"Not so. They are ugly, nasty, and brutish. It is the love of the Father that is beautiful and has made them beautiful. Do you see that woman near the last pillar?"

"Yes, she is so lovely."

"Her name is Rhonda . . ."

I felt faint.

". . . and Chloe and Samuel."

I turned to her in shock.

"Do you know me, Virginia?"

"No . . .I . . ."

"I am you in the sight of God."

I awoke and sat up in the close night. I was crying now—for joy. These children—myself—there was a meaning in our struggle. Beyond the veil of failing human sight a vision saw what we would be with the bright, clear sight of the Father of lights. Praise God. (Spencer 8–9)

Now that you have read the story, notice how it reveals Virginia's blindness about her life as well as about the lives of the children she is teaching. She judges them on appearance only, just as she judges herself primarily because of external conditions. On that basis they are "nasty little beasts," and her life is a failure. In other words, she judges them the way that society judges her (perhaps one of the meanings of "judge not that ye be not judged"). And what the dream tells her is that she must look beyond the surface, to see them and herself in terms of their potential, to see the way that God sees, "beyond the veil of human sight."[3] In this vision the children were beautiful and she was a strong, poised, and confident woman. She

[3] Robert Browning's poem "Rabbi Ben Ezra," written in the nineteenth century, states a similar theme. The Rabbi looks back on his life in his old age and tries to assess the success or failure of it. He concludes: "All I could never be / All men ignored in me, / This, I was worth to God, whose wheel the pitcher shaped." Robert Browning, *Poems of Robert Browning*, edited by Donald Smalley (Boston: Houghton Mifflin, 1956), 286.

learned that both she and the children were progressing toward that beauty and strength, and she learned to see with new eyes, to value others as God values them, and to value herself as God values her. To me the story speaks loudly of the need to change our perceptions of ourselves and others and of the condition in which we live. And it also says that it is not enough to give people social status and external freedom; they must have a sense of their worth intrinsically if they are to be full human beings and reach their potential. Thus we come to the parable of the talents. The reason the servant buried the gift or talent was fear, lack of vision. The results were awesome: accusations of wickedness and sloth, loss of the gift, and banishment. The issue of human potential is crucial.

A TALE OF CONFINEMENTS

The two kinds of obstacles to human growth and development that we have been considering appear clearly in the history of America's women poets. We turn now to that history and consider it from these two perspectives: on the one hand, external barriers; that is, bias from the audience, whether readers, critics, or publishers; and on the other hand, internal barriers; that is, fear, doubt, or lack of vision or confidence. The experience of woman as poet from about 1650 to the present is a history of confinements "to a large extent," according to Alicia Ostriker, "the inhibition of ambition, acquiescence in definitions created by others, self-defeating divisions between head and heart" (16). Not all women succumbed, however. There is also a great deal of power, "wit, grace, and technical skill" on the part of those who did not just "submit" but who were able to "subvert" the "dominant culture" (*Ostriker 16).

Colonial Period

We begin with the colonial period (including both the seventeenth and eighteenth centuries).

In the seventeenth century women who read, wrote, and thought were often considered dangerous. One case in point was Ann Hopkins, the wife of a Hartford-upon-Connecticut governor, who upon losing "her reason" (Ostriker 17), was taken to Boston for medical help. According to John Winthrop, one of her critics, the cause of her illness was too much reading and writing of books. This problem could have

*All Ostriker references are to *Stealing the Language: The Emergence of Women's Poetry in America* (Boston: Beacon, 1986) unless otherwise noted. —ed.

been avoided if she had "attended her household affairs, and such things as belong to women" rather than becoming enmeshed in "such things proper for men, whose minds are stronger." If Ann Hopkins had stayed "in the place God had set her," he says, she might have "kept her wits" (Winthrop 2:225).

In addition to the concern that reading, writing, and thinking unbalanced women was the fear that women's interest in reading and writing took them away from their real work which was the care of the home. This fear led Anne Bradstreet's brother-in-law, John Woodbridge, who published her poems in 1650, to assure the audience that the poetry was "the fruit but of some few hours, curtailed from her sleep and other refreshments" (Bradstreet 3). The reader need not worry, therefore; this work was done only in her spare time and did not rob the family of her attention.

Women also had to be careful to be "humble" about their work. Anne Bradstreet, for example, referred to her poems as "ill-formed offspring of my feeble brain" in "The Author to Her Book." Using the metaphor of an imperfect child, she wrote,

> At thy return my blushing was not small,
> My rambling brat (in print) should mother call,
> I cast thee by as one unfit for light
> Thy visage was so irksome in my sight.
>
> (221)

Although critics speculate that this kind of statement by the poet was not serious, there is an element of truth in it. Why did she find it necessary to resort to such a metaphor even if it was a semi-joke?

Furthermore, women's poetry in the seventeenth century was supposed to be about "womanly" topics: home, children, and so forth. But Bradstreet wrote on such unfeminine subjects as physiology, the history of civilization, natural history, politics, and the heroism of Queen Elizabeth, as well as on more personal topics such as fear of death in childbirth, her children, and love and friendship for her husband. In one poem, she charmingly refers to her offspring in natural terms: "I had eight birds hatched in one nest, / Four cocks there were, and hens the rest" (232ff.). Thus Bradstreet managed to write about both public and private matters.

She was also very important to the development of women's poetry in that she points to certain dominant characteristics that would surface repeatedly in later women's work. The lack of power for women and their secondary social status, which would require a "meek poetic persona," are two examples of those dominant characteristics. Another is the fact that many women poets would be published only because of others' efforts, and still another is the

tendency of women poets to assert then retract what they said. Her work also expresses a distaste for dualistic, hierarchical thinking and for "vertical metaphor"; she prefers horizontal images of relationship or mutuality (in women's poetry hierarchy is generally associated with pain and death, whereas mutuality is associated with happiness).[4] Bradstreet also began the tradition of poems of women's identification with nature and animals (Ostriker 21–22).

Moving on to the eighteenth century, we find that poetry by women wanes for about one hundred years. One significant woman to emerge from the silence was Phyllis Wheately, the first black woman poet in America, who was encouraged by her "master" to write, to show that, "Negroes, black as Cain, / May be refin'd, and join th' angelic train" (48). One of her favorite themes was the celebration of a mythological heroine, a topic that was to appear in the writing of many other women poets as a kind of escape valve. Her poem "Niobe in Distress for Her Children Slain by Apollo" has certain autobiographical elements—the sense of helplessness and the fact that Wheately was taken from her own mother (Ostriker 22–23).

During the late eighteenth century, especially revolutionary times, and as the result of the struggle for freedom from England, women wrote patriotic poetry and hence were involved socially and politically. One such poet, Mercy Warren, wrote to John Adams to ask if women could write political satires. Adams encouraged her, and she wrote farces in defense of liberty. One such, "a mock-heroic celebration of the Boston Tea Party" (Ostriker 24) called "The Squabble of the Sea Nymphs," shows that she took Adams's advice to "let the censure fall where it will" (quoted in Fritz 107–8) to heart:

> The fair Salacia, victory, victory sings,
> In spite of heroes, demi-gods, or kings,
> She bids defiance to the servile train,
> The pimps and sycophants of George's reign.
>
> (205)

Another notable eighteenth-century poet is Ann Eliza Bleecker who also wrote satire, although less pointedly than Warren. Her work was written primarily to amuse friends rather than for personal fame as a poet. In several pieces of delicious satire, Bleecker goes after a widow goose looking for a new husband as well as other social types and occasions. But she especially deserves mention because of the

[4] See Carol Gilligan, *In a Different Voice: Psychological Theory and Women's Development* (Cambridge: Harvard University Press, 1982) for a fascinating study of the latest research on women's moral development and how it is different from men's. Gilligan shows that men perceive danger in relationships, whereas women associate danger with competition, personal achievement, and "hierarchical construction of human relationships" (42-45).

poems written after her daughter's death, which were "the first in America about personal tragedy" (Ostriker 24). In them she questions God but later submits to his will and praises him for keeping her from suicide.

The first woman to earn her living from her pen was Susanna Rowson, creator of the best seller *Charlotte Temple*. A versatile woman, Rowson was also an actress, a playwright, an editor, and a poet. Her rousing drinking songs were, according to her biographer, not fit for a lady; her later work was, however, more sedate. In one of her plays, *The Slaves of Algiers, or, a Struggle for Freedom*, women who are the captives of pirates say they believe in liberty: "woman was never formed to be the abject slave of man . . . I feel that I was born free, and while I have life, I will struggle to remain so," says the slave who has been taught these principles by an American. Then in a classic case of saying something but then quickly retracting it, a trait that dominates women's poetry, Rowson has an imaginary audience of women who misunderstand what they have heard:

> She says that we should have supreme dominion,
> And in good truth we're all of her opinion,
> Women were born for universal sway,
> Men to adore, be silent, and obey.

Rowson is quick to correct this "misunderstanding":

> To bind the truant, that's inclined to roam,
> Good humour makes a paradise at home.
> To raise the fall'n—to pity and forgive,
> This is our noblest, best prerogative.
> By these, pursuing nature's gentle plan,
> We hold in silken chains—the lordly tyrant Man.
> (73)

Rowson insists in several poems that women must be self-sufficient and purposeful, not idle and silly. In one of her best pieces, "Women as They Are," she exposes several types of women:

> the dizzy beauty; the dull-witted housewife who can cook but do nothing else . . . the "accomplished belle" who sings, dances, and flirts in French and whose husband will find her a "fluttering insect" and want to kill her; the weeping novel reader; the screaming shrew. (Ostriker 26)

Finally, Rowson turns the light to men who find the satire amusing and lays some of the responsibility for these types at their feet. She tells them that if they do not want these kinds of wives, they should "treat us, scorning custom's rules, / As reasonable beings, not as fools" (*Poems* 115).

With the exception of Anne Bradstreet, these women have been forgotten. It is possible to have taken a course in American literature, yes, even to have taught one for many years, and not to have come across them. And even Bradstreet gets short shrift from certain admirers as well as from detractors. For example, John Berryman, in a tribute poem, *Homage to Mistress Bradstreet*, writes about her "abstract didactic rhyme" and "proportioned, spiritless poems" (n.p.). More damaging is the opinion of Moses Coit Tyler, a critic of colonial literature, who calls her work "lamentable rubbish" (1: 283) and that of Charles Eliot Norton, a Bradstreet editor, who writes that her poetry had "no grace and charm of spontaneous lyrical utterance" (xx). Even the critics who like her praise her later work that is personal rather than the earlier poetry that is not, thus giving way to the bias that women should write on personal subjects rather than more philosophical, objective ones.

In any event, Ostriker says that historians of American literature have thus far missed the point. Bradstreet was

> astonishingly original: a woman who as a philosophical poet takes all knowledge as her province and interprets it from a distinctly female point of view, who as a lyric and meditative poet offers a model of emotional and spiritual struggle concluding in success and who finds in her biological role a poetic authority unavailable to her brethren. (27)

Nineteenth Century

Nothing in the colonial period compares, however, with the double bind of the nineteenth century, the double message that was given to woman: to climb onto her pedestal and to jump off it at once. On the one hand, reformers were asking women to become involved— to be useful, serious, and self-respectful; on the other hand, the growth of wealth and the emergence of the middle class required women to be idle as a sign of prosperity, and to be the keepers of the new refinements brought about by that wealth. As Rufus Griswold put it,

> We need in woman the completion of our own natures; that her finer, clearer, and purer vision should pierce for us the mysteries that are hidden from our senses, strengthened, but dulled, in the rude shocks of the outdoor world, from which she is screened by her pursuits, to be the minister of God to us. (13–14)

To put this new trend into historical context, we see that whereas women in the seventeenth century were often involved in serious work—printing, blacksmithing, shopkeeping, and midwifery—in the

nineteenth such opportunities decreased, especially ones in the newly established medical profession. Work in the home in earlier times involved crafts and skills like candlemaking, shoemaking, and animal husbandry, but with the growth of cities and industry, such work was removed from the home. With that change came a significant loss for women of such useful kinds of work. Later, in the eighteenth century, woman's role was also subordinate, but now as a necessity for the wheels of society to turn smoothly. One shocking element of this period was the publication of a handbook for married women entitled *The Lady's New Year's Gift, or Advice to a Daughter* that from 1688 to 1765 was so popular that fifteen editions were printed in America. The advice on "how to live with a husband" recognizes that he might be unfaithful, dumb, weak, even a drunkard, and offers guidelines for such circumstances. But, most important, the woman must give the appearance of not being in control even if she were forced to be:

> You must be very dextrous, if when your Husband shall resolve to be an Ass, you do not take care he may be your Ass; but you must go skillfully about it. . . . In short, the surest and most approved method will be to do like a wise Minister to an easy Prince; first give him the Orders you afterwards receive from him. (quoted in Cott 77–82)

Such realism about domestic relationships was not part of the nineteenth century. Instead woman became sentimentalized, idealized into a totally unselfish creature with no shred of self-interest in her. In retrospect we see here the cult of "the True Woman" (Ostriker 29). One journal for women, *The Ladies Magazine* (1830), paints a portrait of such a perfect specimen:

> See, she sits, she walks, she speaks, she looks—unutterable things! Inspiration springs up in her very paths—it follows her footsteps. A halo of glory encircles her, and illumines her whole orbit. With her, man not only feels safe, but is actually renovated. For he approaches her with an awe, a reverence, and an affection which before he knew not he possessed.[5] (quoted in Douglas 46)

Thus began the myth of male wickedness and female purity—the sentimentalizing of woman. Men were by their very nature more wicked because of their greater intelligence, their greater energy, and their tendency to action; women, on the other hand, were naturally "more religious, more submissive, more physically frail, and more sexually pure" (Ostriker 30). Women were intended for the more

[5] For a penetrating and eye-opening study of the great differences between the myth of nineteenth-century women and their actual living conditions, see Mabel Collins Donnelly, *The American Victorian Woman: the Myth and the Reality* (New York: Greenwood, 1986).

passive, private role of love in contrast to man's more aggressive social role. Such easy dichotomies hark all the way back to Aristotle, who defined two spheres of life: the public or realm of freedom, and the private or realm of necessity. The nineteenth century loved this idea. How easy it then was to relegate man to the sphere of freedom and woman to that of necessity. Certainly men believed this to be "naturally" true, and most women believed it, too. Thus, the twin obstacles to human growth rose up huge and suffocating: the external one of prejudice and the internal one of lack of self-awareness.

What happened to women's poetry in such a climate? Most important, since woman was a creature above the brutal and harsh sphere of man, her poetry must not deal with the difficulties and struggles of the real world. No, she must write about her protected sphere of the home. The key word was "elevated" (Ostriker 30); her work must be elevated above real life. Gone was the philosophical emphasis of a Bradstreet or the satiric point of a Rowson. It was now the woman poet's function to divert the reader from the harsh realities of politics, philosophy, and business. Women who dared not follow this requirement were castigated; Rufus Griswold went so far as to say that they were "hermaphroditic disturbers of the peace" (29). Further, the woman poet must be modest, not seeking for fame, writing spontaneously from the heart in a natural and refined way. Ostriker sums up the atmosphere well:

> In sum, what the genteel tradition demanded of the ladies was that they bare their hearts, gracefully and without making an unseemly spectacle of themselves. They were not to reveal that they had heads, let alone loins. They were not to demonstrate ambition. They were not to lecture on public issues or to speculate on philosophical or religious ones. A woman able to sing in this cage was respectable. A woman who tried to sing outside it was a whore . . . or a monster. (31)

Such expectations of and strictures on women poets achieved the desired effects. Women poets, for the most part, retreated from the public sphere and the closest they got to writing about issues was poetry about the suffering of the less fortunate. Women also wrote about home or about nature as inspiring or about love and death, but only in vague terms, rarely with any degree of realism. Thus the culture that women were to guard became feminized, sentimentalized, and divorced from real life. According to Ostriker, the "sentimentality is a result of authors' pretending not to know, not to feel, what they do know and feel" (33).

Recently, however, certain critics have argued that the tension between the submissiveness imposed by society and the assertiveness

needed to be a writer often resulted in very powerful results. The poet had to find ways around the limitations imposed by society (Emily Dickinson, for example, is such a writer). Women did this by writing about certain ambiguous topics. One such is the poem about the bird that is free, alternately admired then rejected by the speaker; another is the poem of sanctuary, in which withdrawal is portrayed not as relief but rather as an escape from pain; or the poem of a death wish, in which the tomb is a haven; or poems in which poetry is equated with suffering. In other words, these women had to find very subtle, even devious means of presenting their true thoughts and feelings while satisfying what was required of them by critics, readers, and publishers.

Two such poets are Maria Brooks and Frances Osgood, writers whose poems betray a struggle between surface conformity and hidden feelings.

Maria Brooks produced a poem in which an evil angel falls in love with a woman and proceeds to kill off several of her potential bridegrooms. She is finally just about to go off with him when she is rescued by her "true love." *Zophiël* was ostensibly about the triumph of good over evil—even Griswold was very enthusiastic—but its themes of sexuality, violence, the killing of several males, and a celebration of fame and ambition suggest other concerns by Brooks. On the surface it was "fine," but below that are some rather daring elements (Ostriker 35).

The other poet worth noting for the same reasons is Frances Osgood, who wrote about love as limiting, restricting, a kind of woman's prison:

> Return with those cold eyes to me
> And chill my soul once more
> Back to the loveless apathy
> It learn'd so well before! (quoted in Ostriker 36)

In another work she describes a mother praying for the death of her children and her own death as well. According to Ostriker,

> All these poems maintain the proprieties of pure feeling and woman's loving self-effacement. That the commitment to love expected of a woman may destroy her identity, and that women may feel conflicting emotions—including rage and guilt—about the children as well as the men they love, was not something Osgood's age was ready to acknowledge. (37)

Twentieth Century

With the coming of the twentieth century, social conditions began to improve somewhat for women. America began to reconsider

their "role," and the idea of two distinct and separate realms for men and women was beginning to subside. Because of social trends such as post—Civil War economic development, opportunities for women were increasing. The result was a new freedom for women's writing, which tended to fall into two major approaches: the intensely personal lyric and the more experimental, intellectual, nonpersonal poetry.

The first approach or group consisted of very personal, lyrical poets. Writers such as Sara Teasdale, Edna Millay, and Louise Bogan wrote about love relationships but not in the nineteenth-century sentimental way. Physical and emotional passion were now a part of love. Yet, significantly, suffering was still very prevalent in the depiction of this experience. There was still "a problem of feminine rebellion defeated by masculine authority" in many of these poems (Ostriker 45). Imagery of walls, suggesting frustration and isolation, also appeared, as in Elinore Wylie's lines in which the speaker tells a bricklayer how to construct her wall:

> Full as a crystal cup with drink
> Is my cell with dreams, quiet and cool. . .
> Stop, old man! You must leave a chink;
> How can I breathe? *You can't, you fool!* (14)

In other words, all was still not well. Rather than passively accept their lot, however, many of these poets defied it. That note of defiance increased as the century progressed.

What is also disturbing about these poets is that they still remain neglected for the most part despite their contribution. As Ostriker estimates, "these women composed the first substantial body of lyric poetry which is worth anything in the United States." It is, she argues, work comparable in quality to the lyrics of the previous four centuries of English literature (46). I must admit that I am guilty of neglecting them as well, despite many years of college teaching and a particular interest in poetry. I need to reread and rediscover the works of these women.

Perhaps one major reason for this neglect is that the modern male poets were writing primarily about the decline of western civilization—the loss of religious faith, the waning of traditional values, and the disappearance of God. Major male poets like T. S. Eliot, Ezra Pound, Robert Frost, and so forth were wrestling with how to find something to hold on to in this void. Ostriker argues that for women poets who had negative associations to traditional beliefs and values, this loss was probably a welcome change (46–47). Sandra Gilbert and Susan Gubar, in their recent work, *No Man's Land: The Place of the*

Woman Writer in the Twentieth Century,[6] also argue convincingly that "modernism" is different for men and women. What is more, they assert that modernism is a product of the battle between the sexes (xii). What will be the effect on thinking people of the thesis of their study? How will it change the way that we look at the development of our century? Is it the case that the struggle to shape the "new woman" is just as important for the development of modernism and the modern world as the loss of faith, Darwinism, Freudianism, and so forth? They cite Samuel Hines and Theodore Roszak as two of the few contemporary thinkers who admit the connection between the battle of the sexes and the other characteristics of modernism (21ff.). We may have to completely rethink what modernism is and what forces provoked it. What is startling is that now that I have read their study, I am beginning to see how correct they are—that the truth of what they say has always been right under our noses but completely ignored. And my experience has been that of a woman who has studied at a major metropolitan university, supposedly at the forefront of what has been happening on the literary and ideological scene.

Another reason for the neglect of these personal poets is the negative treatment they received from male critics. One of the most egregious examples of bias is the evaluation of Edna St. Vincent Millay by John Crowe Ransom:

> She is an artist. She is also a woman. No poet ever registered herself more deliberately in that light. She therefore fascinates the male reviewer but at the same time horrifies him a little too. He will probably swing between attachment and antipathy. . . .

Then after arguing that women are best suited for love, Ransom offers the view that "Man distinguishes himself from woman by intellect." Woman, on the other hand, "is indifferent to intellectuality." Ransom then goes on to show how Millay lacks "intellectual interest"; she has a "deficiency in masculinity." (We note the subtle equation of intellect and maleness.) Her best work is personal in nature, he concludes (76–78, 103–5).

As if to counter this charge that woman is not intellectual, a second group of poets tried to be deliberately intellectual, to leave out the personal and the emotional. These poets were more experimental and, above all, impersonal. Writers such as Amy Lowell, Gertrude

[6] Sandra M. Gilbert and Susan Gubar, *No Man's Land: The Place of the Woman Writer in the Twentieth Century*, Vol. 1 (New Haven: Yale University Press, 1988). This is the first of a three-volume series called *The War of the Words*. The reader should be advised that the material dealt with in this study may be disturbing and is aimed at a mature audience. Volumes 2 and 3 are yet to be published.

Stein, and Marianne Moore formed this group. A good example of this kind of cerebral poetry is Moore's poem called "Marriage" that criticizes the whole institution: "Men have power / and sometimes one is made to feel it," she writes. Later, she describes Adam as experiencing "a solemn joy / in seeing that he becomes an idol." But even more cutting is the view from Eve who says that

> Men are monopolists
> Of "stars, garters, buttons
> and other shining baubles"—unfit to be the guardians
> of another person's happiness. (62–70)

Moore also often writes about animals in a shell or camouflage of some kind, which Ostriker interprets as a kind of mask or disguise, a sort of self-portrait (52).

Criticism of the institution of marriage is not confined to poets of the early twentieth century. A contemporary writer who is familiar with the biblical tradition has produced a series of short poems based on the book of Genesis, in which she exposes with a certain wit and playfulness the anguish of women in a patriarchal system. *Eve and Adam, Etc.* by Irene Genco, as yet unpublished, catches some of those concerns. Consider, for example, this one:

Story

> Adam told Eve
> GOD created them
> for company.
> Satan told them
> HE did it for an audience.
> Eve laughed,
> poked Adam in the ribs.

The portrayal of Eve here as slightly mischievous, playfully challenging the accepted way of thinking about things is a mild but pointed attempt to say that Eve may be physically and emotionally bound by the "system," but intellectually she retains a certain freedom.

Or, notice this one:

Socratic Method

> "Really? You've never tasted
> apples?" Satan asked. "Didn't
> you know they could raise
> your I.Q.?"
> "Really?" Eve murmured, raising
> an eyebrow.

In this poem Eve appears to be the target of the satire, accepting the spurious logic of the tempter. But the last line is ambiguous; is Eve raising the eyebrow with interest or with scorn? Either interpretation is possible.

Much more to the point is this next one:

Genealogy

God begat Adam,
Adam begat Cain,
Cain begat Enoch,
Enoch begat Irad,
Irad begat Mehujael,
etc., etc.
(Eve & a bunch of anon. women
got to be mothers.)

Here Genco again uses humor to expose a painful situation: the underplaying of women's contribution to the history of humanity, the primacy of the male and the secondary status ascribed to women.

One of the most effective of these little poems is very much directed toward the institution of marriage:

Roles

The play opened in Paradise.
Eve played herself,
Adam played himself.
When the show went on the road,
Eve played the Jewish Mother
And Adam played God.[7]

Implications of the destructive effects of the Fall in line four—the "show" taking to the road, cast out of Paradise; the stereotypes and easy dichotomies of separate spheres for men and women; and especially the suggestion of despotism and even blasphemy on Adam's part in the last line—all playfully and wittily suggest the pain and struggle of women and a relationship gone awry since Eden.

To return to the second group of modern women poets, their work is deliberately analytical, brilliant, and cerebral; and whereas the male writers of the day could openly struggle with the problems of the changing times, these women "veil their critique of culture behind a dazzle of stylistics" (Ostriker 53) and word play. They deliberately suppress the feelings.

[7] Irene Genco, Eve & Adam, Etc. The poems are quoted here by kind permission of the author.

What becomes clear in examining both these approaches or groups—the one personal and emotional, the other impersonal and intellectual—is that each one has a problem. Those who wrote primarily from the heart were in their way as lopsided as those who wrote primarily from their minds. The result is a dichotomy, a divided poetic voice in which the head and the heart are not working in harmony but rather are separate from each other; surely not a healthy state of affairs.

There is yet a third group of modern women writers. This group is one of political interests: poets who spoke out on social issues particularly in the 1930s and 1940s, and who were leftist in their political philosophy. Gwendolyn Brooks, the later Millay, and Babette Deutsch, to name a few, picked up the note of social protest from the folk ballads of the nineteenth century and carried it into the twentieth.

During the 1940s and 1950s women poets continued to struggle with male bias and dominance of the literary world. One writer, Jane Cooper, recounts an experience at the Iowa Writer's Workshop in which she was told by a classmate that "to be a woman poet is a contradiction in terms" (quoted in Ostriker 56). To add to woman's struggle, in the 1950s and 1960s women's magazines celebrated the delights of being a wife and staying in the home as the best option for women. One result was that in 1959 a smaller percentage of women were in college and the professions than had been in 1929.

More recently, several brilliant poets have emerged on the scene. Such writers as Adrienne Rich, Sylvia Plath, and Anne Sexton, to name only a few, have made a powerful impact and have gained in stature and importance. What is most significant is that these writers "portray explicitly female experience as if it were exactly as universal as men's experience" (Ostriker, *NY Times* 28). This poem by Adrienne Rich, for example, contrasts the imagination of a woman with her actual life, which comes off as much less satisfying. The tigers in the needlepoint that she sews are energized, unafraid, and powerful, while Aunt Jennifer suffers from the inhibitions of her marriage and remains circumscribed by the "ordeals she was mastered by":

Aunt Jennifer's Tigers

Aunt Jennifer's tigers stride across a screen
Bright topaz denizens of a world of green.
They do not fear the men beneath the tree;
They pace in sleek chivalric certainty.

Aunt Jennifer's fingers fluttering through her wool
Find even the ivory needle hard to pull.

The massive weight of Uncle's wedding band
Sits heavily upon Aunt Jennifer's hand.
When Aunt is dead, her terrified hands will lie
Still ringed with ordeals she was mastered by.
The tigers in the panel that she made
Will go on striding, proud and unafraid. (Rich 18–30)

Ostriker believes that the last twenty-five years in women's poetry in America constitute a movement in literature equal in importance to romanticism or modernism (NY Times 28). Very significantly, this poetry avoids the split between intellect and feeling, mind and passion. It is integrated work and therefore very powerful (Ostriker, NY Times 30). Women's poetry of the last few decades is a force to be reckoned with.

"TELL ALL THE TRUTH BUT TELL IT SLANT"[8]: EMILY DICKINSON

We now turn to a writer who is perhaps not only the greatest woman poet in America but who is also ranked by some people as the greatest American poet. Emily Dickinson commands our attention because her life and work epitomize in an extraordinary way the kinds of obstacles and concerns that women poets through the centuries have faced. What were those barriers?

To review, they include the first kind of block to the development of human potential, the kind resulting from external bias about women as artists. One notion was, for example, that women are by nature not intellectual, that rigorous working of their minds had physically as well as emotionally negative effects on their constitutions. In 1905 a doctor who was lecturing made the following statement about such activity: "hard study killed sexual desire in women, took away their beauty, brought on hysteria, neurasthenia, dyspepsia, astigmatism, and dysmenorrhea." Earlier, in a textbook for obstetricians dated 1848, this statement appeared: "She [woman] has a head almost too small for the intellect but just big enough for love" (quoted in Donnelly xii). It followed, then, that woman's natural sphere was the home and nothing must distract her from the care of her household and family. However, if a woman insisted on writing or on cultivating her mind, the parameters of her work were again circumscribed. She must do her craft with humility, not seeking for fame or power; she must write about subjects "appropriate for

[8] Thomas H. Johnson, ed. The Complete Poems of Emily Dickinson (Boston: Little, Brown, 1960). All poems by Dickinson are taken from this edition.

women"—home, husband, and children—not about philosophical, theological, moral, or social issues. Only topics of a personal nature were fit for a lady to write about. Later, in the nineteenth century, women were expected to provide escape from the harsh realities of the industrial revolution, not only in the home but also in the poetry they produced. The myth of the perfect woman—more religious, more submissive, more physically frail, more sexually pure—required that women poets produce work elevated from the dust and heat of manufacturing and laissez-faire business practices in order to divert the reader and provide an alternative to real life.

Another barrier faced by women poets was the negative reception they received from male reviewers and critics. In some cases even those who professed to be admirers demonstrated repugnance for the lack of intellect, the sentimentality, and even the femininity of these poets. Hence, ironically, women were criticized for writing in the manner and about the subjects that society required of them.

What of the internal hurdles women poets had to try to scale? Many of them accepted the dictates of society and its critics. For the most part they did write poetry devoid of intellectual content and focused on feminine subjects of hearth and home. Occasionally when a few did tackle more philosophical issues, they learned to state and then withdraw what they had stated. They did, for example, express (but in subtle ways) their distaste for hierarchical thinking and structures and their preference for mutual, more horizontal social arrangements. But these assertions were hastily withdrawn or covered up. They learned to couch their feelings of limitation in poems about mythological heroines or about the suffering of those less fortunate than they were. Their efforts to deal with universal subjects like love and death were often ineffective and lacking in realism. Eventually they were more successful when able to find devious means to portray their true thoughts, resulting in a tension between surface conformity and hidden meanings: themes of male death, sexuality, violence, love as a prison, the wish for death, the captive bird set free, the tomb as a release or haven from earthly care, the difficulties of marriage—all these subjects were introduced but carefully couched in such a way that a conventional reader could miss the full implications. Women also occasionally split their feelings from their intellect and wrote poetry devoid of one or the other. A group of very personal, lyrical poets in the twentieth century deliberately left out any intellectual content. At the other extreme, another group wrote poetry that deliberately left out feeling and cultivated only intellect. Both groups lacked balance. Furthermore, in the twentieth century, women poets found themselves unable to lament the decline of Western civilization as many male poets were doing; after all, the prejudice and strictures

they suffered from were part of that ethos. Therefore, to them, its passing may have been a welcome change. Also, their tendency not to view social and philosophical trends in the same way as major male poets led to neglect or negative treatment from male critics who said they were not intellectual enough.

Personal Qualities

As we look back, therefore, at the difficulties encountered by women poets in American culture, we begin to understand more about Emily Dickinson. How was this great American poet influenced by her nineteenth-century milieu, and how did she, in turn, shape her life and creative work in light of her context? We will now attempt to answer these questions.

What is it that makes Dickinson such a powerful and unique poet? What has attracted so many critics and biographers to her work and person, especially when in her lifetime she was almost completely ignored? Even those few people who knew of her work then reacted negatively and with confusion to what she had produced. It was only after her death that her writing found an audience, and even then, well-intentioned family members and friends who prepared it for publication corrected and fixed it to make it more acceptable. Not until 1955 did Thomas H. Johnson publish the Harvard variorum edition of her complete poems.

Surely one unique quality about her is the extent of her intellectual development. Dickinson received an excellent education, rare for a young woman of her day. Biographer Cynthia Wolff tells us, for example, that she had more training in mathematics and science than is now given to the average American boy. Her schooling was greatly affected by the ideas of Edward Hitchcock, the president of Amherst College, who saw to it that the latest scientific knowledge was available in the Amherst schools. His special emphasis on the relationship between science and religion, on natural and general revelation as an indication of the ways in which God operates in the universe, insured the best scholarship in science and mathematics. For Hitchcock the Bible or special revelation was in harmony with natural law (342–43).

In addition to the sciences, this young scholar at Amherst Academy and later Mount Holyoke Female Seminary (which subsequently became a college) studied liberal arts subjects—Latin, French, German, geography, history, classics, Bible, English literature, rhetoric, and "mental philosophy." This rigorous education had a tremendous impact on her poetry. "Emily Dickinson's formal education," writes Helen McNeil, "went far beyond anything available to any

British woman writer until almost the turn of the century (and then to very few)" (39). Fortunately, her father, Edward Dickinson, provided her with an education equal to that of her brother Austin. However, for various reasons, Edward did take Emily out of Holyoke after one year.

Not only was she intellectually developed, she was also emotionally developed. Her letters as well as her poems reveal a woman of great warmth, insight, sensitivity, and awareness of her own feelings and those of others. Although her life was physically restricted—she seldom ventured away from the family home—she had a wide circle of friends with whom she carried on a voluminous correspondence, for whom she had great affection, and to whom she gave of herself.

Dickinson's utter independence of spirit certainly is another intriguing quality. That she produced almost eighteen hundred poems without an audience, with very little encouragement, without critical evaluation, or even without a literary friendship such as Gerard Manley Hopkins[9] enjoyed is truly remarkable. It also raises the question, what kept her going? How could such artistic isolation be so productive? Related to this independence is the surprising fact that her isolation was a choice, not a sentence; she had, her letters reveal, many friends and several male admirers, even an offer of marriage. Yet she preferred the life of a recluse. Ironically, this kind of retiring, reticent personality is what women poets were supposed to have. According to Ostriker, "in adopting the persona of the shy recluse, delicately afraid of strangers, too sensitive for the marketplace, Dickinson did precisely what the ideal poetess was supposed to do" (38).

And, finally, what may be her most attractive quality is her boldness as a writer. At a time when women were considered to be by nature sentimental, unable to face life honestly, too delicate for the raw truth about things, Dickinson shows herself to be tough-minded. She does not sentimentalize or gush over such topics as love, marriage, or death. Rather, she explores these subjects by facing them squarely. In her context, "there were," writes Wolff, "these tacit stipulations: women's work must be relentlessly domestic and emotional; a female author must make *no claim for herself as a serious intellectual*; women might write and publish only so long as they did not also presume to *think*." Writing for a woman must not be "a strong-minded endeavor" (175). Dickinson gives her own view: "Tell all the Truth but tell it slant."

[9] Hopkins, her British contemporary, also remained ignored and unpublished in his lifetime, but he had three poet-friends with whom he corresponded, to whom he sent copies of his poems, and from whom he received criticism, encouragement, and sometimes, ironically, bafflement as well.

Family Life—and Death

We have seen some of the distinguishing qualities of this poet: what of the woman and the family in which she lived? How did her home life affect her poetic and spiritual development?[10] To begin, we get an inkling of her relationship to her father and mother in her letters:

—My Mother does not care for thought—and Father, too busy with his Briefs—to notice what we do—He buys me many Books—but begs me not to read them—because he fears they joggle the Mind. They are religious—except me—and address an Eclipse every morning—whom they call their "father" (letter to T.W. Higginson, 23 April 1862, Johnson and Ward, 2: 404).

Here we get clues about the domineering yet preoccupied father and the passive and nonintellectual mother.

Edward Dickinson was a very busy, financially ambitious man who spent most of his time in the practice of law and money-making ventures and very little time with his family. Emily once wrote of him, "My father seems to me often the oldest and oddest sort of foreigner" (Sewall 70–71). He was seldom at home and even when there had his focus elsewhere. His daughter loved him but felt a certain awkwardness with him, too. Donnelly contends that Dickinson's father was much more important than her mother because he "represented power" (21). It was the case, she points out, that in Victorian times the "bond between father and daughter was much closer than between husband and wife" (22). And because a father was not subject to death from childbirth as were mothers, he seemed to be stronger and more reliable (22). To the Victorian daughter the father was a kind of king in his household and he commanded her loyalty (26).

Emily's father made a negative impact on her life in other ways also. For one thing Edward Dickinson was a believer in the letter of the law without the spirit. McNeil says that he believed in "conserving the Union (of the United States) without subjecting any of its institutions to moral scrutiny." He was a man who focused on the exterior without the interior, "the rule of law . . . no longer complemented by a complex and questioning Puritan conscience" (50). This kind of legalism appears in his daughter's poetry in imagery of a father or Master or God who is more shell than substance. "The

[10]Cynthia Wolff, the biographer who also worked as a guide at the Dickinson Homestead in Amherst, tells us that it is the woman that visitors are most interested in. They know and appreciate the poetry, but it is the woman they ask most questions about. Cynthia Griffin Wolff, *Emily Dickinson* (New York: Knopf, 1987), 3.

father never doubts or is divided" (McNeil 51). Nevertheless, Dickinson expressed her love for her father in her letters but emphasized his austerity: "I always ran Home to Awe when a child" (Johnson and Ward, 2: 517). A further result of this legalistic attitude is that the house ruled by such a father can seem like a tomb. Imagery of confinement and entombment shows up in several of Dickinson's poems. "This," writes Wolff, "was a house of isolation, a house where the children's independence could be maintained only if easy intimacy and spontaneous affections were sacrificed. Vinnie [Emily's sister] describes in the end a fortress of terrible loneliness" (44).

Dickinson's mother was not only not intellectual, she was also quiet, undemonstrative, and prone to tears and illnesses. As the years passed, she became more and more sickly. Apparently she did not have a close relationship with any of her children, so that even though she was at home the children turned instead to each other for emotional support. Emily wrote about her, "mother lies upon the lounge or sits in an easy chair. I don't know what her sickness is, for I am but a simple child" (Letter to Mrs. J. G. Holland, 20 January 1856, Johnson and Ward, 2: no. 324). Prone to toothache and swollen jaws, Dickinson's mother was also the object of mild ridicule from her daughter: "Teething didn't agree with her, and she kept her bed, Sunday, with a face that would take a premium at any cattleshow in the land" (Letter to Louise and Frances Norcross, October 1863, Johnson and Ward, 2: no. 286). Yet when the mother eventually became an invalid, Dickinson cared for her and the relationship deepened. After her mother's death, Emily wrote, "We were never intimate Mother and Children while she was our Mother—but . . . when she became our Child the Affection came" (Letter to Mrs. J. G. Holland, December 1882, Johnson and Ward 2: no. 792).

What is significant about these parents is that while both were evidently loved, it had to be from a distance, since both were not capable of intimacy with their children. Hence Dickinson turned to her writing for comfort. According to Wolff, "words became her refuge and her one great love" (65). What is also important is that Dickinson's mother did not provide a role model for her daughter. This fact left Emily free to pursue her interests in her own way. The lack of a model became, ironically, an opportunity for freedom. And Dickinson's father, who valued her brother and his writings but who ignored Emily's, kept his daughters near him, so that they never married. Thus, he provided them with freedom from wifehood and motherhood, a fact that left Emily with time and energy to pursue her craft. He also left her to her own devices by being so distracted with his affairs.

But Dickinson was able, paradoxically, to turn her limitation into

freedom—her father's remoteness along with her liberty from the requirements of wifehood and from the dangers of childbirth, which were in her age very great[11] allowed her the chance to pursue her own interests. Hence she was able to use her circumscribed existence as an opportunity to write her poetry and to incorporate into that work themes of isolation, restriction, and confinement. Margaret Homans believes that Dickinson remained unmarried in order to preserve her autonomy (176). In the light of what her world expected of a married woman in terms of utter subservience to her husband, Dickinson chose to remain alone. It is a pity that she had to choose this alternative in order to have the freedom, the time, and the energy to give expression to her genius.

Perhaps far more damaging and insidious was the effect that her home life had on her religious and spiritual development. Dickinson probably formulated her view of God on the basis of her relationship to her father. Edward Dickinson, figure of love and detachment, provider yet dictator of imperatives for the running of the house from which he was frequently absent, builder of the family fortune yet cold and detached emotionally from his wife and children—this was her experience. And it was, as with most people, the framework for her view of God. She "never trusted the idea of God the Father," writes McNeil (59). Her poems about God are full of imagery of mistrust, sometimes anger, and certainly remoteness. "At best Dickinson's Father was an absent presence, teasingly withdrawn" (McNeil 59). Consequently she never relied on him fully. Like her own father, God did not respond:

> Of course—I prayed—
> And did God care?
> He cared as much as on the Air
> A Bird—had stamped her foot—
> *P 376

Like her own father, God was "the mingling of absence and law" (McNeil 60). He was "Burglar, Banker, Father" (P 49) in one poem.

Especially difficult for Dickinson was the loss of loved ones to death. Some readers have found her to be obsessed with this subject.

[11] Cynthia Wolff describes the awesome dangers of childbirth in Dickinson's day: "In 1828 it would have been difficult to find a woman in Amherst who could contemplate childbirth without fear. When men married, they took on additional financial responsibilities . . . however, marriage catapulted women into the midst of life's most awful mysteries—pain, mutilation, and possible death. Birth control was not available during the early nineteenth century in New England, and every married woman faced the possibility of a series of unplanned pregnancies, each one of which threatened an agonizing extinction" (45).

*All of the poems by Emily Dickinson are taken from *The Complete Poems of Emily Dickinson*, edited by Thomas H. Johnson. —ed.

Yet we need to understand that in her day women were expected to be the caretakers of the sick and the dying. "It seems," writes Wolff, "almost a birthright of females at that time to become intimately acquainted with mortality" (49–50). At a time when there was no nursing profession, the women of a household provided care. Dickinson tended her own mother in death. She also experienced several painful losses of friends and family members from 1878 to 1884 that only served to drive her further from God. Instead of finding comfort, she expressed anger:

> Of God we ask one favor,
> That we may be forgiven—
> For what, he is presumed to know—
> The Crime, from us, is hidden—
>
> P 1601

Her attitude toward Christ was less harsh; she even identified with his suffering. But she had trouble completely trusting him, because he was, after all, doing the work of his father. Therefore, she remained for most of her life skeptical and ambivalent about the Christian faith so tied in to her family.

In many ways, then, the home life of Emily Dickinson was crucial in shaping her personal development as well as her poetic vision.

Poetry of Duplicity

Having examined some of the characteristics of the life and home that Dickinson had to cope with as a daughter and a woman and the paradoxical way that she was able to turn limitations into opportunities for personal growth and freedom, we now turn to her poetry. How does her work reveal her ability to surmount some of the obstacles encountered by women poets in America? How does her experience as a poet epitomize that of other women poets of her day as well as of those who preceded her?

The most recent scholarship on Dickinson responds to these questions with a recurring idea: the key to her work is duplicity. The ambiguity of poets of the nineteenth century who preceded her was heightened or intensified in her poems, says Ostriker, into duplicity (38). This term has negative overtones of cunning, deception, or double dealing. Yet in applying the terms to Dickinson's work what is intended is not so much that she made an attempt to deceive as it is to indicate her realization that language has a doubleness to it, that it is ambiguous and therefore to a certain extent, slippery. That is, a statement may have several meanings or interpretations, thus, in a

way, making all language deceptive. This brief poem by her is an example.

> To die—without the dying
> And live—without the Life
> This is the hardest Miracle
> Propounded to Belief.
>
> P 1017

The terms here are obviously double and triple: what does *die* mean in line one, and what does *Life* mean in line two? And how do we resolve the paradoxes: how can one die without dying, and how can one live without life? The poem has almost the quality of a riddle. We have to think of the multiple meanings of the key words in order to solve it. The effort takes much concentration; and even when we think we have discovered the meaning, the terms continue to reverberate and shift.

Language also has what Homans calls a "fictive" (166) element, a quality of fiction or metaphor to it. It has not only literal but also connotative and figurative components. Consider the statement of a person arriving home late during a rainstorm: "I'm starved and soaked; it's raining cats and dogs out there, and if I don't get a bite to eat, I'll die." This is admittedly an obvious example and perhaps an extreme case. But the point is that the person making such a declaration is using language in a fictive way, and the listener knows enough not to take the statement literally.

Apparently Dickinson understood the deceptive and figurative nature of language thoroughly, its quality of revealing and concealing meaning. It was her genius for exploring and presenting that duplicity that contributed to her greatness and enabled her to epitomize the dilemma of the woman poet in America.

Perhaps the concept of duplicity is clearer if we consider it in connection with her poems. Dickinson was aware that a woman writing poetry faced a double bind. "On the one hand," writes Wolff, "she could become a strong poet only if she was assertive and used language forcefully; on the other hand . . . the mores of Amherst did not condone assertiveness and outspokenness in women" (170). She must be powerful and, at the same time, appear not to be. In the following poem she confronts the issue of women's role as passive and men's as active, and the problem that this bias creates for the woman artist.

> I would not paint—a picture—
> I'd rather be the One
> It's bright impossibility
> To dwell—delicious—on

And wonder how the fingers feel
Whose rare—celestial—stir—
Evokes so sweet a Torment—
Such sumptuous—Despair—

I would not talk, like Cornets—
I'd rather be the One
Raised softly to the Ceilings—
And out, and easy on—
Through Villages of Ether—
Myself endued Balloon
By but a lip of Metal—
The pier to my Pontoon—

Nor would I be a Poet—
It's finer—own the Ear—
Enamored—impotent—content—
The License to revere,
A privilege so awful
What would the Dower be,
Had I the Art to stun myself
With Bolts of Melody!

P 505

Here Dickinson contrasts the active, creative painter, musician, and poet with the passive observer, listener, and reader. In each stanza the speaker appears to prefer the passive, expected role to the more assertive one. She further identifies herself as female in the last stanza by associating the word *dower* with herself, a reference to the dowry or property a bride takes into a marriage. It may also be a gift given to a wife by her husband. Yet at the same time that she is choosing the role of audience, observer, she is, of course, producing a poem. Obviously, she is embracing the role of poet while pretending to repudiate it. And even more telling is the fact that if she has embraced the role of creator, then *she* is the one whose work evokes the "rare—celestial—stir," "sweet Torment," and "sumptuous—Despair" in stanza one. The contradictory terms suggest or reinforce the contrariness of the entire poem. Likewise, in stanza two, she would also be identified with the one who elevates the listener "softly to the Ceilings" and sends her like a "Balloon" out into the air of the village. Most important, however, is the acknowledgment in the last stanza that to exert such power, the "Art to stun myself / With Bolts of Melody" as a woman is to call into question "the Dower," the economic gift of a wife to a husband. Perhaps she is implying that to be a powerful writer is to drive away the possibility of marriage, the expected passive role—"Enamored—impotent—content—" of the wife in relationship to her husband. Thus, the whole poem by its very

existence and by its deviousness, its quality of duplicity, challenges the idea of woman as incapable of creative energy and power. Homans cites Derrida's term *phallogocentrism* to describe the theory that man is by nature creative and at the center of the universe, while woman is the outsider, the "other" (37). In her poem Dickinson refutes this idea, but she does so in an ironic way, a way that Wolff calls "comedic . . . tongue-in-cheek" (171–72). In this piece, as well as others, Dickinson had to find a way out of the dilemma she faced, and she did so by using language differently. "She reverses and undermines the usual meanings of words and questions some of the structures of language that had always remained ordained, and that must support phallogocentrism," writes Homans (36), who also argues that her "doubleness in language is a way of negating hierarchical thinking" (166).

Gilbert and Gubar take this argument one step further in asserting that Dickinson's work reflects the tendency of women poets to write about achieving victory over men in "The War of the Words," not through direct, physical confrontation, but rather by devious means or by accident (67). After all, agrees Wolff, "language . . . was a far subtler weapon than a hammer" (170). Perhaps this is the motive behind such poems as

> I took my Power in my Hand—
> And Went against the World—
> 'Twas not so much as David—had—
> But I—was twice as bold—
>
> I aimed my Pebble—but Myself
> Was all the one that fell—
> Was it Goliath—was too large—
> Or was myself—too small?
>
> P 540

If anything, in true Dickinson fashion, the attempt at heroics brings a mixed result: the attack is very brave but the obstacles are formidable, and she is honest enough to admit no easy victory.

Or consider this one:

> I rose—because he sank—
> I thought it would be opposite—
> But when his power dropped—
> My Soul grew straight.
>
> I cheered my fainting Prince—
> I sang firm—even—Chants—
> I helped his Film—with Hymn—
>
> And when the Dews drew off
> That held his Forehead stiff—

> I met him—
> Balm to Balm—
>
> I told him Best—must pass
> Through this low Arch of Flesh—
> No Casque so brave
> It spurn the Grave—
>
> I told him worlds I knew
> Where Emperors grew—
> Who recollected us
> If we were true—
>
> And so with Thews of Hymn—
> And Sinew from within—
> And ways I knew not that I knew—till then—
> I lifted Him—
>
> P 616

A more difficult poem to interpret, this one has the speaker at first elated over rising while her opponent sinks. But then she is perplexed to discover not joy at his losing but rather concern for his dying. The poem from stanza two to the end concerns the victor's attempt to console the loser. If this work is about victory over men, it displays a rather wise understanding that to defeat the enemy is also to defeat oneself in a way that no one wins a war. The welfare of one gender is linked to the welfare of the other. The exploitation and subordination of women has been a tremendous loss for men as well as for women, and the militant attack on men by women is a hollow victory. Still, the battle goes on.

Dickinson's duplicity surfaces in other ways, too. She deals with some of the same issues other women poets have treated but always with a certain ambiguity that suggests the difficulty of the problem. She attempts to speak frankly but also to couch that speech in a way that is double or hides the truth.

For one thing, she managed to repudiate the "cult of true womanhood" so prevalent in the nineteenth century among middle- and upper-class women, the notion that women were the curators of refinement and culture. At a practical level, she got her sister Vinnie to do all the housework, allowing herself the time, privacy, and energy to write. But she also mocked the notion of the woman poet as dangerous or deranged in the following poem:

> Much Madness is divinest Sense—
> To a discerning Eye—
> Much Sense—the starkest Madness—
> 'Tis the Majority
> In this, as All, prevail—

> Assent—and you are sane—
> Demure—you're straightway dangerous—
> And handled with a Chain—
>
> P 435

Here she manages to reverse the usual viewpoint of madness and sanity, raising the question as to what constitutes each. Perhaps sanity is only what the majority deems it to be, and to disagree with the status quo is to be labeled mad. It is clear that the speaker stands with the minority; her "madness" is "divinest sense"; her eye is discerning.

To the notion that women poets must not face life squarely, that they are too delicate for reality, she counters that the truth must be dealt with and spoken but in a way that the reader is able to handle; not wielded like a blunt instrument, but softened on the edges by indirection, by the fictive quality that we spoke of before.

> Tell all the Truth but tell it slant—
> Success in Circuit lies
> Too bright for our infirm Delight
> The Truth's superb surprise
>
> As Lightning to the Children eased
> With explanation kind
> The Truth must dazzle gradually
> Or every man be blind—
>
> P 1129

It is not only women that she speaks of here; all of humankind must receive the truth "With explanation kind," so that "The Truth must dazzle gradually." Using the metaphor of light for truth, she understands that to know the whole too quickly, to see all of the light suddenly is dangerous to the sight. Better gradual exposure than the shock, the blindness, caused by too much light/truth at once. And the paradox here—blindness can come from too much light too soon as well as from no light or ignorance—is especially powerful.

Even the subject of marriage gets a realistic treatment from Dickinson. In a time when women were supposed to be utterly obedient to their husbands' every wish; when they were considered to be possessions, not allowed to vote or to own property; when they had very few legal, social, or marital rights, she depicts the relationship as one in which the woman chooses to give herself. She weighs her decision as if it were a business transaction in which she as well as her mate might stand to take a loss on the investment. Emphasizing the element of risk in relationship, Dickinson explores the ambiguous nature of such an agreement with a calculating eye, almost in the way a financial analyst might evaluate the purchase of stocks and bonds.

I gave myself to Him—
And took Himself, for Pay,
The solemn contract of a Life
Was ratified, this way—

The Wealth might disappoint—
Myself a poorer prove
Than this great Purchaser suspect,
The Daily Own—of Love

Depreciate the Vision
But till the Merchant buy—
Still Fable—in the isles of Spice—
The subtle Cargoes—lie—

At least—'tis Mutual—Risk—
Some—found it—Mutual Gain—
Sweet Debt of Life—Each Night to owe—
Insolvent—every Noon—

P 580

The last stanza is especially shocking in that the risk is mutual, not a lopsided pact in which the woman is at the mercy of her husband. The fact that each one owes a "Sweet Debt" nightly and is bankrupt the next noon is also rather bold for a creature who is supposed to be above even mentioning the sexual reality of marriage.

The notion that a woman poet must have great humility, be self-effacing, and not seek for fame or power is also treated with a certain deviousness by Dickinson. One of her most intriguing poems is this one, full of "quintessential duplicity" (Ostriker 39).

I'm Nobody! Who are you?
Are you—Nobody—Too?
Then there's a pair of us!
Don't tell! they'd advertise—you know!

How dreary—to be—Somebody!
How public—like a Frog—
To tell one's name—the livelong June—
To an admiring Bog!

P 288

At first we see "Nobody" accepting her insignificance in the world of somebodies, joining with "you" in a kind of conspiracy of silence. Then in the second stanza Nobody judges the emptiness and foolishness of being "Somebody," making the comparison between social status and a frog croaking to an "admiring Bog." It is sweet revenge, a rejection of power and the successful public life. However, according to Ostriker, another interpretation is possible. What if

Nobody and the sympathetic reader join forces, become superior to Somebody, and steal his audience. He will be left croaking to no listeners, minus his status. "The issue, of course, is power," she writes; Dickinson has managed to make "a virtue of deprivation" (40). And what is also so devious about the poem is that it means both: Dickinson did prefer the private life, but she also yearned for an audience and the power that comes with recognition and acceptance.

Proof that she desired both is especially evident in this next poem, in which a note of resignation to the fact that she would not be published in her lifetime appears. She knew that her work was not acceptable from the negative reception of a few trusted friends who read it. Her letters, in which she expressed her deepest thoughts and feelings, did receive responses; her poetry would go unanswered.

> This is my letter to the World
> That never wrote to Me—
> The simple News that Nature told—
> With tender Majesty
>
> Her Message is committed
> To Hands I cannot see—
> For love of Her—Sweet—countrymen—
> Judge tenderly—of Me
>
> P 441

Evidently Dickinson accepted this fact and chose not to seek publication. She would not make the necessary concessions. She would not do the things required of a woman poet in her time. Ostriker says she would have been "a fool" to publish under these circumstances (42). Her privacy gave her the freedom to say what she believed in the manner she chose no matter how different from the expectations of the mid-nineteenth century. Yet the poem is ambiguous. It also indicates the assumption of an audience and asks the "Hands I cannot see" to "Judge tenderly" the poetry she wrote. She must have had an intuition that one day her work would see the light, would be made public.

Dickinson's treatment of nature was also daringly different from what a woman was supposed to do. According to Homans, women poets of the nineteenth century had a unique problem in writing about nature. Nature was always portrayed as feminine by male poets. Hence women were identified with nature as men were not and found it difficult to write about it. This, she argues, is what probably discouraged Emily Brontë and Dorothy Wordsworth from being poets of the caliber of Dickinson. One must see nature as other, as object, in order to be able to write about it. Dickinson had to find a way out of this dilemma. She did this by her duplicity, by using words in unusual

ways, by exploring the ambiguities of them (36–37). "A Narrow
Fellow in the Grass" accomplishes this feat by using a male speaker,
thus challenging the idea that woman as poet cannot relate to nature
well because of gender identity.

> A narrow Fellow in the Grass
> Occasionally rides—
> You may have met Him—did you not
> His notice sudden is—
>
> The Grass divides as with a Comb—
> A spotted shaft is seen—
> And then it closes at your feet
> And opens further on—
>
> He likes a Boggy Acre
> A Floor too cool for Corn—
> Yet when a Boy, and Barefoot—
> I more than once at Noon
> Have passed, I thought, a Whip lash
> Unbraiding in the Sun
> When stooping to secure it
> It wrinkled, and was gone—
>
> Several of Nature's People
> I know, and they know me—
> I feel for them a transport
> Of cordiality—
>
> But never met this Fellow
> Attended, or alone
> Without a tighter breathing
> And Zero at the Bone—
>
> P 986

It is a neat trick; Dickinson beats the male poets at their own game.

Much more powerful, however, is her apparent rejection of the
idea that nature is always feminine; she sees it rather as a phenome-
non of color, motion, and energy. In the following short but dynamic
poem, nature is not sentimentalized or feminized; it is charged with
energy that captures the sight; the hummingbird described is not
trivialized but celebrated for its brilliant colors and movement.

> A Route of Evanescence
> With a revolving Wheel—
> A Resonance of Emerald—
> A Rush of Cochineal—
> And every Blossom on the Bush
> Adjusts its tumbled Head—
> The mail from Tunis, probably,

An easy Morning's Ride—

P 1463

If we compare this treatment of nature with a poem by Words-worth, we can see the difference.

I Wandered Lonely as a Cloud
(1807)

I wandered lonely as a cloud
That floats on high o'er vales and hills,
When all at once I saw a crowd
A host, of golden daffodils;
Beside the lake, beneath the trees,
Fluttering and dancing in the breeze.

Continuous as the stars that shine
And twinkle on the milky way,
They stretch in never-ending line
Along the margin of a bay:
Ten thousand saw I at a glance,
Tossing their heads in sprightly dance.

The waves beside them danced; but they
Outdid the sparkling waves in glee:
A poet could not but be gay,
In such a jocund company:
I gazed—and gazed—but little thought
What wealth the show to me had brought:

For oft, when on my couch I lie
In vacant or in pensive mood,
They flash upon that inward eye
Which is the bliss of solitude;
And then my heart with pleasure fills,
And dances with the daffodils.[12]

Wordsworth's delicate and sensitive lyric is sentimental, its imagery rather quiet and even demure. Although it reveals a sensibility in tune with nature and an exuberance for its beauty, it lacks the dynamism and intensity of Dickinson. In fact, given the stereotypes about women poets, it seems more likely that the poem was written by a woman.

Even greater contrast is evident in Dickinson's "Blazing in Gold" poem, in which this maverick poet has the audacity to depict the usually male sun as female. Here is no sentimentalized treatment of the sun. It is characterized by energy, color, and motion as it sets and

[12] William Wordsworth, *Selected Poems and Prefaces*, edited by Jack Stillinger (Boston: Houghton Mifflin, 1965), 191.

its light intensifies, transforms what it touches, and then disappears. She gives it the quality of a magician or circus performer, a "Juggler of day."

> Blazing in Gold and quenching in Purple
> Leaping like Leopards to the Sky
> Then at the feet of the old Horizon
> Laying her spotted Face to die
> Stooping as low as the Otter's Window
> Touching the Roof and tinting the Barn
> Kissing her Bonnet to the meadow
> And the Juggler of Day is gone
>
> P 228

Just as Dickinson is, the sun is a trickster, secretly performing its transforming work. But she does not ignore its power, too, describing it as "Leaping like Leopards to the Sky." And the gold and purple suggest kingship, as does the use of leopard spots which in the Near East also symbolize royalty. "This wildcat from the Orient, arching through the sky, makes a flashing simile for the sun's daily journey," writes Charles Anderson (36).

In addition to her unconventional treatment of nature, Dickinson showed her uniqueness and deviousness in her satiric strain. She was apparently very impatient with human blindness and delusion and used her skill with language to unmask it on many occasions.

Ideas of progress, for example, get short shrift in several poems, like this one in which we are never told outright what it is she is criticizing. The clues in the poem lead us to deduce what she is describing, but even then it is not altogether clear that she is totally rejecting of her subject.

> I like to see it lap the Miles—
> And lick the Valleys up—
> And stop to feed itself at Tanks—
> And then—prodigious step
>
> Around a Pile of Mountains—
> And supercilious peer
> In Shanties—by the sides of Roads—
> And then a Quarry pare
>
> To fit its Ribs
> And crawl between
> Complaining all the while
> In horrid—hooting stanza—
> then chase itself down Hill—
>
> And neigh like Boanerges—
> Then—punctual as a Star

> Stop—docile and omnipotent
> At its own stable door—
>
> P 585

Obviously this is a locomotive, depicted as a horse (originally trains were dubbed "iron horses"); it is noisy, insatiable, nosey, and condescending (peering superciliously "In Shanties—by the sides of Roads—"). But it is also powerful, "punctual as a Star," and obedient. It is as if she cannot decide whether she likes this fellow or not. She is devious also in a mixed review of modern progress in technology.

More subtle yet is the satiric treatment in this poem about members of her own sex. Gentlewomen, part of the genteel tradition, did not impress her with their refinement. She exposes their condescending ways even more harshly than she does those of the locomotive. These women are not machines; they should know better.

> What Soft—Cherubic Creatures—
> These Gentlewomen are—
> One would as soon assault a Plush—
> Or violate a Star—
>
> Such Dimity Convictions—
> A Horror so refined
> Of freckled Human Nature—
> Of Deity—ashamed—
>
> It's such a common—Glory—
> A Fisherman's—Degree—
> Redemption—Brittle Lady—
> Be so—ashamed of Thee—
>
> P 401

Although she refers to them as soft and cherubic, and associates them with plush or velvet and a star—all good, positive things—she unmasks their problem with little sympathy. Their convictions are "Dimity," suggesting a fragile, superficial quality, and their horror of "freckled" or mixed human nature is also unacceptable. The last stanza is particularly cutting, ending with a warning that God may also be ashamed of them. The softness of stanza one ends in the brittleness of the conclusion in her condemnation of these contemporary Pharisees.

Dickinson's treatment of death is also not sentimental. Like other nineteenth-century women poets, she often portrays death as a sanctuary. Yet at other times she depicts it as frightening, the terrifying, unknown border between this life and the next. Her poems about the loss associated with death are especially poignant and filled with pathos. But one poem on the subject in particular, beautifully

crafted and haunting, reveals her duplicity very well. It is one in which she associates death with courtship, the figure of death personified as a gentleman caller who takes the speaker for a very pleasant carriage ride.

> Because I could not stop for Death—
> He kindly stopped for me—
> The Carriage held but just Ourselves—
> And Immortality.
>
> We slowly drove—He knew no haste
> And I had put away
> My labor and my leisure too,
> For His Civility—
>
> We passed the School, where Children strove
> At Recess—in the Ring—
> We passed the Fields of Gazing Grain—
> We passed the Setting Sun—
>
> Or rather—He passed Us—
> The Dews drew quivering and chill—
> For only Gossamer, my Gown—
> My Tippet—only Tulle—
>
> We paused before a House that seemed
> A Swelling of the Ground—
> The Roof was scarcely visible—
> The Cornice—in the Ground—
>
> Since them—'tis Centuries—and yet
> Feels shorter than the Day
> I first surmised the Horses' Heads
> Were toward Eternity—

P 712

The association of death with love was not new; the English metaphysical poets of the seventeenth century frequently linked the two. What is intriguing here is that she gives us the stages of death in terms of an encounter between a man and a woman and dresses the woman in clothing that could be associated with marriage, "Gossamer, my Gown— / My Tippet—only Tulle." Is she suggesting that marriage for a woman is in effect a kind of death, a process in which a woman proceeds from the pleasantness and harmlessness of courtship to the loss of her identity as she matures through life and finally enters her tomb? Read this way the poem becomes disturbing, to say the least.

In her work as a poet Dickinson also managed to avoid the trap of splitting off intellect from feeling. In one of her best poems she uses

the traditional idea of human maturation as comparable to the ripening and harvesting of vegetation, in this case fruit. In the process, she catches the feeling of the idea that God judges the heart and it is God who decides when the harvest time has come.

> A Solemn thing within the Soul
> To feel itself get ripe—
> And golden hang—while farther up—
> The Maker's Ladders stop—
> And in the Orchard far below—
> You hear a being—drop—
>
> A Wonderful—to feel the Sun
> Still toiling at the Cheek
> You thought was finished—
> Cool of eye, and critical of Work—
> He shifts the stem—a little—
> To give your Core—a look—
>
> But solemnest—to know
> Your chance in Harvest moves
> A little nearer—Every Sun
> The Single—to some lives.
>
> P 483

What is especially notable and powerful here is the way that Dickinson shows the speaker as personally involved in as well as describing the process and making the connection. The paradox of maturation as a state to be embraced but also shunned—it leads to "the Orchard far below," the grave—is also very effective. But the ambiguity becomes strongest in the view of the harvester; the Maker is the one who gave the gift of life in the first place, yet his approach— "Cool of eye, and critical of Work"—is awesome, terrible. With each day, the "chance in Harvest moves / A little nearer," and when he gives the signal all life ceases. It is no wonder that the word *solemn* in stanza one becomes *solemnest* in stanza three. Dickinson was a wordsmith; she must have known that *solemn* means sacred; it also means grave.

Dickinson's God is not only the awesome harvester of souls, he may also be the most devious of all beings. She often presents him as one who toys with humanity, who delights in confounding his children. In this next poem, he is depicted as a joker, a dabbler in the game of hide-and-seek, a distant tease who half reveals, half conceals himself from the "gross eyes" of humanity.

> I know that He exists.
> Somewhere—in Silence—

He has hid his rare life
From our gross eyes.

'Tis an instant's play
'Tis a fond Ambush—
Just to make Bliss
Earn her own surprise!

But—should the play
Prove piercing earnest—
Should the glee—glaze—
In Death's—stiff—stare—

Would not the fun
Look too expensive!
Would not the jest—
Have crawled too far!

P 338

The problem is that the players in the game are not equal; the human player is at a distinct disadvantage. This game, this "fond Ambush," could end in death; could cost a life. Then, "Would not the fun / Look too expensive!" The notion that God could be trifling with humanity, that he makes us work to find him, only to retreat to "Somewhere— in Silence" is certainly no laughing matter.

It is evident that Emily Dickinson is not a writer who dealt with only personal matters as women poets were supposed to do, yet in dealing with such universal and philosophical subjects as creativity, truth, love, nature, spiritual blindness, death, and God she was able to treat them with her unique, personal vision and stamp. And far from the requirement that women must write poems of escape from reality, she faced the harsh truth of life squarely, with a determination not to gloss over or sentimentalize it. For clear understanding of the subtle ways in which human beings are often separated from each other not by physical barriers but by delicate and intangible fear, mistrust, or misunderstanding, it would be difficult to find a more powerful expression than this poem:

I had not minded—Walls—
Were Universe—one Rock—
And far I heard his silver Call
The other side the Block—

I'd tunnel—til my Groove
Pushed sudden thro' to his—
Then my face take her Recompense—
The looking in his Eyes—

But 'tis a single Hair—
A filament—a law—
A Cobweb—wove in Adamant—
A Battlement—of Straw—

A limit like the Veil
Unto the Lady's face—
But every Mesh—a Citadel—
And Dragons—in the Crease—

P 398

The contrast between the solid physical barriers that can be overcome in stanzas one and two and the far more difficult hair and filament and cobweb of stanza three make the point well. Tunneling through rock to reach the beloved's face is far easier than trying to get past the fortress and dragons in the mesh of the lady's veil in the last four lines. A law is much more formidable than a rock.

Just as in her personal life Dickinson overcame social and familial bias and limitation, using, for example, her father's absence and indifference and her mother's passivity and remoteness as an opportunity to pursue her calling, so in her poetry she used language ambiguously, enabling her to say what society and family would have frowned on; her deviousness hid her real intent and meaning. In this way she reveals perfectly the dilemma of the woman poet and makes an art of duplicity. Her way of handling limitation and bias was the pen; with it she eluded the confinement of her home and of her century. Thus her life was itself a paradox—outwardly she played the role of obedient daughter and spinster, dabbler in the art of writing; secretly her cache of poems grew and confronted the very world she seemed to conform to. She was able to submit to and defy that world at the same time. Only after her death was the powerful extent of her challenge to the obstacles that women poets faced revealed. We see something of her secret energy and exuberance and vision in her attitudes toward other women writers of her day. Contrasting the outwardly conforming life of women with the power they could achieve as writers, she spoke of Elizabeth Barrett Browning and George Sand, the French writer. As women they were "Poor children!" As writers, they were "Women, now, queens, now!" (Johnson and Ward 2: 376).

A VISION OF HUMAN POTENTIAL

This chapter has been about human potential, about the gifts of God that are entrusted to each one of us and which we must have the

freedom and the commitment to develop, unlike the unwise servant in the parable. It is also about the frustration of human potential with regard to women's poetry in general and Emily Dickinson in particular, about the obstacles they faced and the strategies they devised in order to overcome them. The implications are clear. We need to eliminate from our culture whatever does violence to the realization and development of the gifts of God. We also need to catch a vision of our potential, to see ourselves and others in terms of what we can become, having the faith and courage to go forward rather than holding ourselves back because of fear and doubt.

Perhaps the most fitting way to conclude is with one of Dickinson's poems that sums up beautifully all that we have been considering. It is about a gentian, a lovely purple flower that blooms in cold weather, but that tried to be something else, a rose that blooms in summer. Whether through lack of vision or timidity or fear that it was not acceptable, the gentian violated its own nature and beauty. Thus, it gave in to internal barriers to growth, and the result was failure.

> God made a little Gentian—
> It tried—to be a Rose—
> And failed—and all the Summer laughed—
> But just before the Snows
>
> There rose a Purple Creature—
> That ravished all the Hill—
> And Summer hid her Forehead—
> And Mockery—was still—
>
> The Frosts were her condition—
> The Tyrian would not come
> Until the North—invoke it—
> Creator—Shall I—bloom?
>
> P 442

The first stanza also indicates that those who observed this mistake were not very helpful: "all the summer laughed" in derision. Could this be a symbol of the external barriers that the gentian faced, the scorn of society? That coupled with the wrong climate or conditions made the humiliation worse. But times change and with the coming of the cold, the gentian bloomed gloriously. The conditions were right: it "ravished" the hill, a term suggesting the giving of great happiness and enjoyment. The whole world benefited from this beauty. The blooming stopped the "Mockery" of stanza two. In stanza three Dickinson says "The Frosts" were the right environment for the gentian. Is she saying that not every flower blooms in the same way and at the same time, that we need to validate the unique experience of the one that "blooms" differently? It is a plea for tolerance and

acceptance. The cold could also suggest hardship to the rose but comfort to the gentian. We are not all the same. Women's poetry and men's poetry—all contribute; each has its unique beauty and experience to convey. The rest of stanza three refers to a "Tyrian" and the "North," perhaps alluding to the Tyrol or alpine region of Austria. *Tyrian* also refers to a purple dye associated with ancient times, perhaps suggesting the longevity of the problems of prejudice, failure of vision, and loss of potential.

Finally, the speaker ends with a question that is a kind of prayer for God to give assent to the "blooming" process. She has already acknowledged God as creator in line one. Now she waits for the benediction, the blessing or approval from God to go ahead. Dickinson understood that without this approval the flower would be nothing. She ends with a plea for the potential to be realized. For that to happen, however, the external barriers must be removed—human beings must respect and value and support one another; and the internal barriers must be removed—human beings must not hide their talents but use and develop them to the fullest potential. They must be able to say, Creator—I *shall*—bloom!

Works Cited

Anderson, Charles. "The Modernism of Emily Dickinson." *Emily Dickinson: Letter to the World.* Washington, D.C.: Folger Shakespeare Library, 1980.

Berryman, John. *Homage to Mistress Bradstreet.* New York: Farrar, Straus & Cudahy, 1956.

Bradstreet, Anne. *The Works of Anne Bradstreet.* Edited by Jeannine Hensley. Cambridge, Mass.: Harvard University Press, 1967.

Browning, Robert. *Poems of Robert Browning.* Edited by Donald Smalley. Boston: Houghton Mifflin, 1956.

Coles, Robert, and Jane Holowell Coles. *Women of Crisis: Lives of Struggle and Hope.* New York: Delacorte/Seymour Lawrence, 1978.

Cott, Nancy F., ed. *Root of Bitterness: Documents of the Social History of American Women.* New York: Dutton, 1972.

Donnelly, Mabel Collins. *The American Victorian Woman: The Myth and the Reality.* New York: Greenwood, 1986.

Douglas, Ann. *The Feminization of American Culture.* New York: Knopf, 1977.

Fritz, Jean. *Cast for a Revolution: Some American Friends and Enemies.* Boston: Houghton Mifflin, 1972.

Genco, Irene Haupel. *Eve & Adam, Etc.* Unpublished Poems.

Gilbert, Sandra M., and Susan Gubar. *No Man's Land: The Place of the Woman Writer in the Twentieth Century.* New Haven: Yale University Press, 1988. Vol. 1 of *The War of the Words.* 3 vols.

Gilligan, Carol. *In a Different Voice: Psychological Theory and Women's Development.* Cambridge, Mass.: Harvard University Press, 1982.

Griswold, Rufus. "Frances Sargent Osgood." *The Memorial: Written by Friends of the Late Mrs. Osgood.* Edited by Mary Hewitt. New York: George Putnam, 1851.

Holy Bible. Matthew 25:25–30. King James Version.

Homans, Margaret. *Woman Writers and Poetic Identity.* Princeton: Princeton University Press, 1980.

Johnson, Thomas H., ed. *The Complete Poems of Emily Dickinson.* 3 vols. Boston: Little, Brown, 1960.

Johnson, Thomas H., and Theodora Ward, eds. *The Letters of Emily Dickinson.* 3 vols. Cambridge, Mass.: Harvard University Press, 1958.

McNeil, Helen. *Emily Dickinson.* New York: Pantheon, 1986.

Milton, John. *Complete Poems and Major Prose.* Edited by Merrit Y. Hughes. New York: Odyssey, 1957.

Moore, Marianne. *Complete Poems.* New York: Macmillan, 1967.

Norton, Charles Eliot. Introduction. *The Poems of Mrs. Anne Bradstreet (1612–1672). Together with Her Prose Remains.* n.p.: The Duodecimos, 1897.

Ostriker, Alicia Suskin. "American Poetry Now Shaped by Women." *New York Times* 9 Mar. 1986: Sec. 7:1+.

———. *Stealing the Language: The Emergence of Women's Poetry in America.* Boston: Beacon, 1986.

Ransom, John Crowe. *The World's Body.* New York: Scribner's, 1938.

Rich, Adrienne. "When We Dead Awaken: Writing as Re-Vision." *College English* 34 (1972): 18–30.

Rowson, Susanna. *Miscellaneous Poems.* Boston: Gilbert & Dean, 1804.

———. *The Slaves of Algiers, or, a Struggle for Freedom.* Philadelphia: Wrigley & Berriman, 1804.

Sewall, Richard B., ed. *The Lyman Letters: New Light on Emily Dickinson and Her Family.* Amherst: University of Massachusetts Press, 1965.

Spencer, William David. "A Gift of Sight: a Christmas Fable." *Daughters of Sarah* November 1976: 8–9.

Tyler, Moses Coit. *A History of American Literature During the Colonial Times.* 2 vols. New York: Putnam, 1897.

Warren, Mercy. *Poems, Dramatic and Miscellaneous.* Boston, 1790.

Wheatley, Phyllis. "On Being Brought from Africa to America." G. Herbert Renfro. *Life and Works of Phyllis Wheatley.* Washington, D.C., 1916. Miami: Mnemosyne, 1969.

Winthrop, John. *Winthrop's Journal: "History of New England," 1630–1649.* Edited by James Kendall Hosner. 2 vols. New York: Scribner's, 1908.

Wolff, Cynthia Griffin. *Emily Dickinson.* New York: Knopf, 1987.

Wylie, Elinore. *Collected Poems.* New York: Knopf, 1966.

For Further Study

Discussion Questions

1. See the questions within the chapter, page 157, on "A Gift of Sight." Answer them.

2. What are the major issues or problems in the tradition of women's poetry in America? How did the poets involved cope with them?

3. How did Emily Dickinson's home life affect her spiritual and poetic development?

4. In what ways does Emily Dickinson's poetry reveal the dilemma of the American woman poet? How does this question apply to her life experience as well?

5. Is it probable that women who have believed social prejudice about themselves have been their own worst enemies?

6. Are there subjects that women poets should not write about?

Writing Suggestions

1. What external barriers to your own development have you experienced either in your family, church, school, or employment? Tell how you were or were not able to overcome them.

2. What internal barriers to your development do you struggle with? Tell how you have achieved small victories over these limitations.

3. Write a brief essay about a woman in your life who contributed to your personal growth or achievement of your potential. How did she enable you to grow?

4. What barriers to human potential do you see as still existing in our culture? For women? For men?

5. Attempt to write a brief poem in the vein of Genco's *Eve & Adam, Etc.*

Research Topics

1. Choose one of the poets mentioned in section two of the chapter as the subject of a brief research paper (5–10 pages). Write on (1) her strengths or weakness as a poet; or (2) the way her writing either accepts or rejects bias about women artists; or (3) her growing or declining literary reputation; or (4) her contribution to the tradition of women's poetry in America.

2. Choose a poem by Dickinson that is not discussed in the chapter and explicate it as revealing her "duplicity."

3. Make a case for the struggle to achieve the "new woman" as a major factor in the development of the modern world.

Shorter Reading List

Anderson, Charles. "The Modernism of Emily Dickinson." *Emily Dickinson: Letter to the World.* Washington, D.C.: Folger Shakespeare Library, 1980. 35–43.

Gross, Robert A. "Turning Inward in Amherst." *Emily Dickinson: Letter to the World.* Washington, D.C.: Folger Shakespeare Library, 1980. 11–15.

McNeil, Helen. "The House of the Father." *Emily Dickinson.* New York: Pantheon, 1986.

Ostriker, Alicia. "American Poetry Now Shaped by Women." *New York Times.* 9 Mar. 1986: Sec. 7:1+.

Rich, Adrienne. "When We Dead Awaken: Writing as Re-Vision." *College English* 34 (1972): 18–30.

Sewall, Richard B. "Emily Dickinson, Writer." *Emily Dickinson: Letter to the World.* Washington, D.C.: Folger Shakespeare Library, 1980. 17–20.

Walker, Alice. "In Search of Our Mothers' Gardens." *In Search of Our Mothers' Gardens.* New York: Harcourt Brace, 1984. 230–43.

Longer Reading List

Donnelly, Mabel Collins. *The American Victorian Woman: The Myth and the Reality.* New York: Greenwood, 1986.

Homans, Margaret. *Women Writers and Poetic Identity.* Princeton: Princeton University Press, 1980.

Johnson, Thomas H., ed. *The Complete Poems of Emily Dickinson.* Boston: Little, Brown, 1960.

Johnson, Thomas H., and Theodora Ward, eds. *The Letters of Emily Dickinson.* 3 vols. Cambridge, Mass.: Harvard University Press, 1958.

McNeil, Helen. *Emily Dickinson.* New York: Pantheon, 1986.

Moers, Ellen. *Literary Women: The Great Writers.* New York: Doubleday, 1976.

Ostriker, Alicia Suskin. *Stealing the Language: The Emergence of Women's Poetry in America.* Boston: Beacon, 1986.

Perrine, Laurence. "What Is Poetry?" *Sound and Sense.* 7th ed. New York: Harcourt Brace Jovanovich, 1987. 3–16.

Wolff, Cynthia Griffin. *Emily Dickinson.* New York: Knopf, 1987.

Woolf, Virginia. *A Room of One's Own.* New York: Harcourt Brace Jovanovich, 1957.

6

Absence and Presence in the History of the Arts

James W. Terry

"The fact is, there have been no great women artists, so far as we know . . ." (Hess and Baker 5). And there have been no great women composers of the stature of Bach or Beethoven, so far as I know.

If that assertion seems like sealing off a room before at least peeking in the window, have no fear. It leaves open for investigation much more than can be addressed in this chapter. Coming to an understanding of the "why" of the stated fact is topic enough for at least one volume. Scores of fascinating biographies, critical studies, and even historical novels are waiting to be written about good women artists and composers. Hundreds of volumes are needed to give the significant works of these creators a viewing or hearing. The Christian, especially, who understands humans as being created by God, and who views human creativity as one facet of every individual's imaging of God, is doubly responsible for unbiased assessments.

ABSENCE AND PRESENCE

The major part of this chapter will introduce you to several significant women creators and highlight a few of their works. But first I want to speak briefly to the lack of a significant female presence in the fields of painting and music. What can a feminist view of the arts teach us about the evolution of historical-studies disciplines in the arts? What can it show us about the training of artists over the

centuries that will help us appreciate some of the unique problems faced by women painters, sculptors, composers, and performers?

One factor to consider is that in their early stages musicology and art history developed an isolationist methodology. Scholars in these fields more often than not studied major works as the creations of supermen who appeared in society at different times. They attached almost no significance to the sociology of the arts (Bowers and Tick 3). These scholars were undoubtedly aware of artistic dynasties like Bosch (fifteenth-century Dutch painter) and Bach (eighteenth-century German composer), both of whom were at least third-generation artists. But this was considered only a secondary factor in the shaping and developing of the descendants' talent. The genius of the individual was heralded as the prime force that drives a person to create masterpieces. He was seen as ". . .unique, godlike—bearing within his person since birth a mysterious essence, rather like the golden nugget in Mrs. Grass's chicken soup, called Genius" (Hess and Baker 7). And it was assumed that this nugget, like hemophilia, is operative only in males.

Another factor to consider is the expectation level of patrons. The church, as the major patron of the arts from the time of Emperor Justinian (sixth century) until the sixteenth century (and even longer in Roman Catholic countries) turned again and again to the families of skilled craftsmen to design its buildings, carve its statuary, create its mosaics, paint its altar pieces and frescoes, and compose motets and settings for its Mass. That these creators were usually male is a result of sociology, not talent. Trades were passed from father to son; a daughter bore sons to carry on the trade of her father-in-law, who in all likelihood practiced a trade different from her father's. For example, a sister of Johann Bach would have grown up in the same rarefied musical atmosphere as the famous composer, an environment where music had been a way of life for generations. As a young teenager, however, she could have been married to a man two or three times her age who was perhaps a blacksmith looking for someone to run his household, mother his children from an earlier marriage, and provide him with conjugal rights. The thought that she might have or take the time to seriously develop any musical talent would not enter the head of any male member of her community, and could not even take root in her own mind. Thus daughters were regularly deprived of the opportunity to build on successive generational conditioning to a particular area of creativity. An awareness of these factors of expectation and opportunity is basic to our understanding regarding the lack of a woman's presence in the ranks of the great artists.

A corollary question raised by Linda Nochlin is why there have been no great artists from the aristocracy (Hess and Baker 9). It is

certainly not lack of interest or opportunity for training that can be blamed. Indeed, many women and men from the noble class were fine amateur artists and musicians. But they were not expected to be more than amateurs, nor did the demands of their social class allow them time for serious development of creative talents. Exactly the same holds true for women.

Not only have scholars given too much credence to the genius explanation of creativity, they have also reinforced and perpetuated the myth by studying only the creations of the supermen. The focus is on the analysis of great works, using relatively few models to define form and style. This leads to a concentration on the most innovative examples from a period, and has automatically eliminated most women's works from consideration, since women have not been leaders in style change (Bowers and Tick 3). Again this is not due to any lack in the female mental capacity. Rather, it is due to the exclusion of women from educational opportunities and professional positions. Women were not permitted to draw from nude models, male or female, in major public academies before 1890. Even after that, in many academies, the model had to partially drape for female students. Keep in mind that men had been drawing from female models for centuries. (A similar sense of confused modesty is still with us today in the man-physician woman-patient and woman-physician man-patient situations.) Thomas Eakins, one of the greatest American painters of the nineteenth century and a teacher at the Philadelphia Academy in the 1880s, found out how strong this double standard of propriety was. When he removed the loin cloth from a male model during the course of an anatomy lecture to a class of women art students, he was dismissed from the Academy staff.

These restrictions may not seem significant to us, but from the Renaissance through most of the nineteenth century realistic recreating of the human form on canvas was one of the most prized skills in painting. Students developed this skill in a formalized program of study, beginning with copying from drawings, then from casts of famous sculptures, and finally from the live model (Hess and Baker 25). Restrictions against completing the course of study forced women to concentrate on still life, portraiture, and landscape, at the time considered less important than history painting that centered on people. After the restrictions were lifted the importance of painting the human form was no longer paramount.

In the field of music women were not admitted to conservatories until the mid-nineteenth century, and even then, in some schools, not to composition classes. They were more accepted as singers, and by the mid-nineteenth century they had also begun to carve out places for themselves in the ranks of virtuoso instrumental performers.

However, the increased number of women receiving rigorous musical training did not translate into proportionally increased numbers in orchestras or on conservatory faculties. Even though the musician's union in the United States was forced to admit women in 1904 (Bowers and Tick 8), that in no way guaranteed them jobs. Numerous women's orchestras and chamber groups were formed that gave these highly qualified instrumentalists opportunity for musical exercise and expression, although these organizations had neither the audience nor the prestige of the all-male groups. Some women gained entrance to major orchestras during the World War eras when qualified male musicians were scarce. More recently women are being admitted to these groups because of affirmative action policies. This does not mean that they are being accepted only to meet a quota—they are beginning to be evaluated as *musicians.* "Blind" auditions in which evaluators are screened from seeing performers have helped create unbiased judgment.

In the music arena, the steps to the podium present women with their most difficult obstacle to equal consideration. Opposition comes from orchestra members who may adjust to or even welcome a woman in their section but have difficulty accepting one wielding a baton. This is partly due to the superstar status of conductors that has developed over the past century. In the seventeenth and eighteenth centuries many groups did not have a conductor. If there was one, his or her job was to set a tempo and beat time. Subsequently the conductor became the all-knowing interpreter, the seer who unlocked the secrets of the score. We now hear and see references to "Maestro X's *Jupiter Symphony,*" giving the conductor prominence over Mozart, the composer of the work. This conditioning of musicians and audiences to view the conductor as the authority makes it difficult— also because of conditioning—to accept a woman in that role. Boards of directors of major orchestras are aware of and undoubtedly share this prejudice and therefore do not give serious consideration to women candidates for conductors' positions.

Some women have been accepted as choral conductors probably because such groups are largely made up of amateurs and are considered "minor league." One such person, Margaret Hillis, renowned conductor of the Chicago Symphony Chorus, has on several occasions proven her ability in the "majors" when she has filled in for an ailing male orchestral leader. Boston's Sarah Caldwell and Philadelphia's Elaine Brown are two other examples of outstanding conductors.

Women in other areas of music have regularly risen above sociological obstacles and achieved success, acceptance, and fame in their own generation, but then have been largely ignored by posterity.

Let me introduce you to several fascinating individuals who have experienced this acclaim only to end life in obscurity.

Hildegard of Bingen

We will begin in the twelfth century in northern Europe with Hildegard of Bingen (1098–1179). Her family promised to give their tenth child to the church, so when Hildegard was eight years old she was placed in a convent (Sadie 8: 533). There she received musical training along with a thorough education in theology, medicine, and science. She came to be respected as a poet and sage, and her advice was sought by popes, princes, and kings. Around 1150 Hildegard collected her music into a volume containing seventy-seven compositions. These were chants for different parts of the Roman liturgy. While her compositions are based on a standard repertoire of melodic formulas, they show distinctive and personalized use of these materials (Bowers and Tick 28). Hildegard also wrote the earliest morality play, containing eighty-two distinct melodies and predating all other works of this type by more than a hundred years (Sadie 8: 554).

That women were involved in the composing and singing of plainsong (chant) is a recent discovery or admission by scholars. Donald Jay Grout's *A History of Western Music* has undoubtedly served as the basic text for more college-level music history courses over the past quarter of a century than any other book. In Grout's book we find that one of the defining characteristics of Gregorian Chant is that it "... consists of single-line melody sung to Latin words by unaccompanied men's voices ..." (Grout 36). I myself accepted the exclusive implications of that definition for many years, never asking the obvious question "just what were all those women in convents singing during the Middle Ages?" But the works of Hildegard are not the only works of music that have the convent as their source. Undoubtedly many other nuns were involved in composing music for the divine service and every convent had its choir of women to sing the chants.

Francesca Caccini

In sixteenth-century Italy there is evidence of a greatly enlightened view toward women's participation in all facets of society. This is expressed most strongly in the most famous poem of that era, Ariosto's *Orlando Furioso*:

Women have arrived at excellence
in every art which they have striven;
in their chosen fields their renown is apparent
to anyone who studies the history books.
If the world has long remained unaware of their achievements,
this sad state of affairs is only transitory;
perhaps envy concealed the honors due to them,
or perhaps the ignorance of historians.
(Bowers and Tick 90–91)

One woman whose "renown is apparent" is Francesca Caccini, who lived in Italy from 1587–1640. She was a virtuoso singer, lutenist, harpsichordist, poet, and composer. Her father was the famous Florentine composer/theorist Giulio Caccini, one of the earliest advocates of the new dramatic singing style that developed in the late sixteenth century. Her mother was also a highly acclaimed singer, so we see that Francesca was one daughter who did carry on the family musical tradition. Francesca spent most of her life in Florence, but was well known outside of Italy. In 1600 she made her debut at the French court, singing at the wedding of Marie de Medici and Henry IV. Her abilities were so much appreciated by the French king that he asked that she become a permanent member of the musical staff. The king's request was denied by the Tuscan court. Francesca returned to Florence and by 1614 was one of the highest paid musicians at that court (Sadie 3: 581). She had by this time married a singer, was eventually widowed and remarried to a Florentine senator. However, domestic duties did not keep her from continuing musical projects. In 1616 Cardinal Carlo de Medici took her along with several male composers and performers to Rome, apparently to show off the musical splendor of the Florentine court. Around 1625 Francesca established in Florence her own school of singing and composition. She wrote several large-scale operatic works, one of which was performed in Warsaw after her death, making it the first Italian opera to be performed in its entirety outside of Italy (Sadie 3: 581). Francesca's skillful use of new stylistic devices makes her works sound more modern than those of some of her contemporaries.

The emergence of Francesca Caccini as a major musical personage of her time is not an isolated case of a woman achieving such a status. Another example is the Venetian, Madalena Casulana, whose madrigals were published in 1566 with those of the great Orlando di Lasso. Existing documents also point to others such as Laura Peverara, Livia d'Arco, Anna Guarini, Adriani Basile, and Barbara Strozzi as accepted and respected professional musicians.

In the seventeenth and eighteenth centuries opportunities for women's participation in musical life increased greatly. A few were even accepted into the ranks of the most esteemed composers. One such was Elisabeth-Claude Jacquet de la Guerre, who was included among the seventh-row composers in one painter's view of Mt. Parnassus, the abode of the Muses. Only Lully, the creator of the French opera, ranked higher (Bowers and Tick 191). But most musically gifted and trained women viewed their skills as merely the marks of a genteel upbringing. This view was to carry over into the nineteenth and even the twentieth centuries.

Fanny Mendelssohn

Let us consider two exceptions to the above statement. These two women appear on the German musical scene of the nineteenth century. The first is Fanny Mendelssohn (1805–1847), long overshadowed by her brother, Felix. *Grove Dictionary* states that her musical talents were viewed by contemporaries as being equal to those of her brother. In the next sentence, however, this prestigious musical tome summarily dismisses her musical accomplishments by saying ". . . her historical importance consists in her having provided . . . essential source material for the biography of Felix" (12: 134). We know that both Mendelssohns had all the advantages of an upper-middle class family, including a thorough education and extensive travel. Both were acclaimed as child prodigies and began composing at an early age. At first Felix was supportive of his sister's work, but after her marriage he as well as her father advised her not to give time to composing since that would detract from her other duties. Her husband and mother continued to encourage her to write, but the approval of her brother was so important to her that her output all but stopped after he advised her to quit composing (Bowers and Tick 230–31). Among her best works are numerous lieder and an oratorio. It is interesting to compare her "Du bist die Ruh" with Franz Schubert's setting of the same poem. While the Schubert version easily carries the weight of familiarity to the point where thinking of the poem brings his melody to mind, Mendelssohn's setting has its own directness and understated sense of calm. In her setting of "Die Nonne" Mendelssohn expresses in the piano part the churning emotions of the young nun whose beloved has died while the serene melody reflects her joy that she can love him without guilt because he is now an angel. How many other worthy creations remained locked inside this able composer because she took to heart her famous brother's advice?

Clara Schumann

Our second exception of the nineteenth century is Clara Wieck Schumann (1819–1896), a musical superstar of that era. She had been rigorously trained by her father in music theory, composition, and performance. His goal was for her to be a concert pianist, and he was determined to let nothing, not even Robert Schumann, get in the way of her success. Clara and Robert were equally determined to marry, and eventually obtained a court order granting them their wish over Mr. Wieck's objections. Up until this time (1840) Clara had been composing regularly, and had successfully presented several large works for piano and orchestra at her concerts. After her marriage, however, she usually performed the works of Robert and other composers. This shift was partly because programming practices were changing and it was becoming acceptable for a virtuoso to present programs of other composers' works, rather than concentrating on his or her own creations, but her declining output of musical works was undoubtedly largely due to increasing family responsibilities. During the sixteen years of her marriage, Clara gave birth to eight children and had one miscarriage. Over that time span she also played nearly 150 concerts, but they were not necessarily concerts of her own works. Robert expressed concern over her lack of writing by saying:

> To have children, and a husband who is always living in the realm of imagination, do not go together with composing. She cannot work at it regularly, and I am often disturbed to think how many profound ideas are lost because she cannot work them out. (Litzmann 2: 21)

Clara, however, had ambivalent feelings about her composing, even before her marriage, as seen in a diary entry of 1839:

> I once believed that I possessed creative talent, but I have given up this idea; a woman must not desire to compose—there has never yet been one able to do it. Should I expect to be the one? To believe that would be arrogant, something which my father once, in former days, induced me to do. (Bowers and Tick 267).

How sad that she did not know of Hildegard of Bingen, Francesca Caccini, and the many other women composers who were her predecessors.

After Robert's death in 1856, Clara resumed concertizing on a regular basis to meet both the financial needs of her large family and her own artistic needs. By the end of her performing career her major concert appearances totaled over thirteen hundred (Bowers and Tick 251). While her compositions are relatively few when compared with Robert's, they do not suffer in a comparison of overall quality. You

need only listen to Clara's setting of the Ruckert poem "Er ist gekommen in Sturm und Regen," to sense her ability to capture the intensity and ecstasy of a text as well as any of her male contemporaries.

Amy Beach

In the latter part of the nineteenth century Amy Cheney Beach (1867–1943), also known as Mrs. H. H. A. Beach, came on the scene as a composer from the United States. Her surgeon-husband supported her career as a composer and pianist, which helped make it possible for her to develop beyond the dilettante level in music. In 1894 she published *Gaelic Symphony* in E Minor—"an impressive symphony . . ." (Hitchcock 150)—and in 1900 she performed her composition, *Piano Concerto in D Major,* with the Boston Symphony Orchestra. Each of these two works was the first of its kind by an American woman. After the death of her husband in the early twentieth century, Mrs. Beach went to Europe for the first time. Her concerts there were highly acclaimed, as were her compositions, some of which she wrote especially for her European audiences. She returned to the United States and continued to write and perform until shortly before her death.

Rebecca Clarke

The next generation of composers is ably represented by Rebecca Clarke (1886–1979). She was born in England, studied at the Royal Academy in London with Sir Charles Stanford, and was known as a virtuoso performer on the viola. Her composing, begun at the age of sixteen, brought her special notice in 1919, when her composition *Viola Sonata* tied with Ernest Bloch's composition *Suite for Viola and Piano* in a contest sponsored by Elizabeth Sprague Coolidge. The works were, of course, submitted anonymously, and only the winner was to be announced. But the jury became hopelessly deadlocked, and Mrs. Coolidge broke the tie by casting the deciding vote, which turned out to be for Bloch. The jury insisted that because the original vote was a tie the name of the runner-up be made public. The sexist bias of the jury is revealed in Mrs. Coolidge's observation "You should have seen their faces when they saw it was a woman." Rebecca Clarke quoted that remark, along with an appreciative chuckle, during an interview at a New York City radio station where she was being honored on her ninetieth birthday.

Ruth Crawford

In the twentieth century women composers have had to deal not only with long-standing prejudice in the musical establishment but also with the public's antipathy to new music in general. Ruth Crawford (1901–1953) is one example of a highly gifted artist who, like Charles Ives, gave up trying to find an audience for her compositions. She turned instead to editing collections of American folk songs in collaboration with her husband, Charles Seeger (Pete Seeger, our contemporary folk singer, is the son of Charles). However, before she turned to editing and while she was composing, she had been accepted by composers such as Maurice Ravel, Béla Bartók, and Henry Cowell (Bowers and Tick 376). She was also the first woman to hold a Guggenheim fellowship in composition, which made a year's study in Europe a possibility for her. Crawford's most highly acclaimed work, *String Quartet 1931*, was written during her year abroad. Machlis calls the work "a concise, arresting work that displays her style at its best" (371). *String Quartet 1931* continues to be performed frequently and has been recorded several times. The strongest indication of its acceptance by the establishment is the inclusion of its third movement in the *Norton Scores* (Kamien 2: 747–50). The resurgence of interest in Crawford's music lends weight to the statement that "it is only in recent years that she has been recognized as belonging to that small group of innovative American composers who in remarkable fashion anticipated developments that became current only several decades later" (Machlis 371).

Other women composers of the twentieth century who prove that the spark of genius is not gender exclusive are Emma Lou Diemer, Miriam Gideon, Julia Perry, and Louise Talma, to name only a few. And the great teacher and mentor, Nadia Boulanger, has nurtured and guided more women and men to compositional success than any other person of the century.

PAINTING

I now turn to the field of painting and in so doing I want to return to the opening quote of the chapter that asserts the absence of "great" women artists. Let me qualify that statement by stating that great works of art have been created by women but that none of these individuals has achieved the status of a Michelangelo or a Rembrandt. Some reasons for this lack have already been discussed; to those let me add the bias of historians and critics. Why did a major book such as

History of Art by H. W. Janson not even mention a woman painter until the 1986 edition? Did Janson not know of the work of Sofonisba Anguissola, who around 1557 created "one of the best European Old Masters" (Russell, "An Old Museum Is Born Again" 33)? Another slighted master artist is Artemisia Gentileschi (1593–1653), "the first woman in the history of western art to make a significant and undeniably important contribution to the art of her time" (Harris and Nochlin 118). Other women artists whose art has gone unrecognized are Judith Leyster (1609–1660), Rachel Ruysch (1664–1750), Angelica Kauffman (1741–1807), Elizabeth Vigee-Lebrun (1755–1844), and Rosa Bonheur (1822–1899). This list is by no means exhaustive, but it does illustrate that since the mid-sixteenth century women have achieved greatness in painting. Before that time women were major contributors to the arts of embroidery, tapestry making, and illuminating manuscripts.

Impressionists

Rather than highlighting historical details from the lives of any of the preceding artists, I want to concentrate on a group of painters active in the last half of the nineteenth century, namely, some of the women who made important contributions to the impressionist and postimpressionist schools. These groups were outside of the French painting establishment, which may partially account for their more open attitude toward women. On the other hand it took a special kind of courage for a woman to align herself with a group of radicals and forgo recognition by the officially sanctioned part of the artistic community.

Berthe Morisot

One of the most well-known members of this group was Berthe Morisot (1841–1895). She came from an upper-middle-class family and both she and her sister studied painting before the age of ten. Part of their early training included copying the works of the masters on display at the Louvre. When they expressed interest in painting out-of-doors, which many of the realist painters were doing at that time, they met with strong opposition. Traditional teachers upheld the idea that the proper subjects for serious painting were lofty ideals exemplified in myths and important historical events. Furthermore, painting out-of-doors would be inconvenient in the case of the young female Morisots because it would be improper for them to appear in public unescorted. However, around 1860 the sisters were befriended by Camille Corot, the mentor of the realists, who respected their desire

and their work, and encouraged them to continue. Berthe did just that, although her sister did not, and she made her debut at the official Salon of 1864. For the next ten years she exhibited regularly.

In 1868 Morisot established a friendship with Édouard Manet and served as a model for him on several occasions. She also encouraged him to experiment more with light and color and to paint out-of-doors (Harris and Nochlin 233). Thus the view often put forth that Manet was the mentor of Morisot is not quite a complete picture.

A few years after meeting Édouard, Morisot married his younger brother, Eugene, himself an amateur artist who gave much support and encouragement to her work.

In 1874 Morisot helped organize the first independent impressionist show in which she also exhibited. She did not return to the official Salon, but continued exhibiting with the impressionists on a yearly basis. Her works have a spontaneity of execution that captures deep and complex feelings. For example, *Young Woman Sewing in the Garden* has a tree dividing the canvas into two worlds. On one side the governess does her stitching; on the other a child cavorts in play. Or consider *Eugene Manet and His Daughter*, a pointed variation on the mother/daughter subjects thought especially appropriate for women artists at that time. Morisot shows her husband and daughter simply basking in each other's company, intent only on sharing the moment.

Monet, Renoir, and Degas were among the friends who helped arrange the exhibition for her memorial show held in Paris in 1896 (Russell, "The Impressionists Saw Her" 25). A retrospective was presented in Paris in 1941 celebrating the centennial of her birth (Harris and Nochlin 233), and a one-woman show of her work was presented in England in 1950. More recently the National Gallery of Art in Washington mounted an exhibition of her work in September 1987. This same show traveled to Mount Holyoke College, which had originated the project, in celebration of the 150th birthday of the college. We can hope that the work of this major talent will not again fall into obscurity.

Marie Bracquemond

A truly talented impressionist whose career ran a course much different from Morisot's was Marie Bracquemond (1847–1916). She was trained in the studio of Jean-Auguste-Dominique Ingres, one of the pillars of the French art establishment, and was recognized as one of his most intelligent and gifted students. In the late 1860s she married Felix Bracquemond, a well-known engraver. This relationship widened her circle of contacts but hindered her artistic development,

possibly because her husband was not able to accept being overshad-owed by his wife's growing success. In any case he began to oppose her associations with the impressionists and her continued pursuit of a painting career. Her sister encouraged her to continue painting, but after a period of struggle with the career and duty-to-husband conflict, Marie gave up painting. She is mentioned only three times in Rewald's *History of Impressionism*, but even then only in connection with her husband in lists of exhibitors as "Bracquemond and his wife" (423, 439, 448). The title of an article by Elizabeth Kane, "Marie Bracquemond, the Artist Time Forgot," aptly refers to her plight.

Mary Cassatt

The American-born painter, Mary Cassatt (1845–1926), spent most of her adult life in Europe. She was born into a wealthy Philadelphia family that did not approve of her desire to become a painter. In spite of their objections she studied at the Pennsylvania Academy of Fine Arts for four years, followed by travel and study in France, Italy, Spain, and Holland. By the early 1870s she was exhibiting regularly at the annual Paris Salon. Her earliest works show that she was not bound by the styles of the old masters whom she had studied in her travels, but had already assimilated the essentials of the realists (Harris and Nochlin 237). Cassatt was accepted as an equal by contemporaries such as Manet and Degas, the latter regarding her as a kindred spirit. Degas invited her to join the impressionist exhibition of 1879 and she remained active with that group during most of the next decade. At the turn of the century Cassatt was best known as a painter of the mother and child theme. One such work that shows the intimacy of the relationship and the complete relaxation and trust on the part of the child is *Mother About to Wash Her Sleepy Child*. Cassatt, like Morisot, varied this theme in at least one instance in *Alexander Cassatt and His Son*. Here she symbolized the closeness of the relationship by painting their dark suits as one mass of color, not defining the torsos; their individuality is clearly seen in the facial expressions.

Two other women who made important contributions to the impressionist movement were Lilla Cabot Perry (1848–1933), a close associate of Claude Monet, and Eva Gonzales (1849–1883). That the works of these women (including Morisot, Bracquemond, and Cassatt) are not more widely known is not due to any lack of quality in their art. It is due somewhat to changing taste, but more so to the commercial vendors' biased promotion of the male impressionists. However, art historians cannot escape blame for their failure to keep

these names and examples of significant works before successive generations of students.

Twentieth-Century Artists

Käthe Kollwitz

To make this effort of highlighting the female presence in art history more complete, let me mention a few women whose works represent twentieth-century art. Käthe Schmidt Kollwitz (1867–1945) produced some of the finest etchings, lithographs, and woodcuts of the first half of the twentieth century. Her continuing concern for the poor gives many of her works strong social overtones. Other works reflect the political climate and her own personal tragedies. For example, her woodcut cycle *War* is both an expression of her grief over the death of her son in World War I and of her horror of warfare. Kollwitz also maintained an interest in the self-portrait and her works in that genre show a deep psychological awareness similar to that of Rembrandt. She was the first woman member of the Prussian Academy of Arts in Berlin and became director of the academy's master classes for graphic arts in 1928 (*Encyclopedia of World Art* 8: 1018). She was dismissed from that position by the Nazis in 1933 and from 1936 until her death exhibitions of her work were prohibited in Germany. Although the major themes of her work are suffering, aging, and death the works are kept from communicating despair by an "underlying . . . almost Christian sense of ultimate salvation" (Harris and Nochlin 263).

Georgia O'Keeffe

One of the major influences on the American art scene has been Georgia O'Keeffe (1887–1985). She left her childhood environment of a Wisconsin dairy farm to study at the Art Institute of Chicago and later at the Art Student's League in New York. An apt student, she assimilated influences from numerous artists and educators of the early twentieth century. After a stint of public school teaching, mostly in West Texas, she held a secret exhibition of her works. Shortly thereafter (ca. 1915), having come to feel that she had been influenced too much by others, she destroyed all of her work (Harris and Nochlin 300). (A recent TV documentary on her life says that she "put all her early works aside.") In any case, she did begin anew, using charcoal to put down shapes that expressed her thoughts and feelings. She sent some of these to New York where the artist/photographer Alfred Stieglitz arranged a show for her in 1917. He continued to support her work and she soon became an accepted part of his

otherwise male inner circle. In 1924 the two were married and O'Keeffe became, with difficult adjustment, a city-dweller. After the death of Stieglitz in 1946 she settled in New Mexico, where she found the vastness and austerity of the landscape appealing. Her works with floral shapes have been interpreted as female genital images, and those with bleached parts of animal skeletons as reflections on death. The artist seems to have viewed her work only as explorations in line, space, and color, perhaps similar to the way a composer of music works with pitch, rhythm, and time without extra-musical overtones. In any case, O'Keeffe's stature as a major contributor to abstract painting is secure.

A FAIR HEARING

In conclusion, I want to give some reasons why I feel that reinstating women's presence in the arts is important. I also want to give some suggestions as to how this goal can be achieved.

First, criticism of any creative effort must be directed at the work, not at the gender of the creator nor at any aspect of her/his personality or lifestyle that we may question. We have regularly separated work from person in relationship to male artists. For example, Richard Wagner is credited with having created some of the most significant and beautiful musical works of the nineteenth century. At the same time he is seen as a contemptible person—opinionated, self-centered, and anti-Semitic. If we can criticize Wagner's works apart from these undesirable, even ungodly personal weaknesses, we should evaluate a woman's creative efforts apart from her God-given sex.

Next, the pain of discrimination is all-pervasive, coming back to weigh on those perpetuating the injustice. In regard to music, I see the church's ban on female participation in church governance and liturgy as the major reason for condoning the inhuman practice of castrating boy choir members in order to maintain their high voice registers. The total musical range of the four voice parts expanded during the Renaissance to the point where the male falsetto voices could no longer match in power or quality the lower natural male voices. Because women were not permitted to sing in church choirs, the creation of these unnatural powerful soprano and alto voices was permitted. And while castrati singers were used extensively in secular music (especially opera) throughout the eighteenth century, public aversion to the mutilating practice had largely done away with its use *long before* the church finally banned castrati from the Vatican choir in 1903 (Sadie 3: 875).

It is true that we cannot overcome centuries of bias toward women's works by citing a few outstanding examples. But we can make a start toward fairness by spreading the news that there was a Fanny Mendelssohn and a Clara Schumann, and no longer use those surnames alone to refer to Felix and Robert. They do not have exclusive rights to their famous last names.

We can add Morisot to Manet and Monet in our studies of impressionist painters. This will help reinstate Morisot as a major talent among her peers and will even add to the alliteration of the list!

Finally, the question of how much creative talent has been stifled because of society's sexual bias should haunt us. While we cannot personally guarantee that every artist, female or male, will receive a fair hearing, we can at least vow to work to that end in our own spheres of influence.

Works Cited

Bowers, Jane, and Judith Tick, eds. *Women Making Music*. Chicago: University of Illinois Press, 1986.

Encyclopedia of World Art. 15 vols. New York: McGraw-Hill, 1959–1968.

Grout, Donald Jay. *A History of Western Music*. 3d ed. New York: Norton, 1980.

Harris, Ann Sutherland, and Linda Nochlin, eds. *Women Artists: 1550–1950*. New York: Knopf, 1984.

Hess, Thomas B., and Elizabeth Baker, eds. *Art and Sexual Politics*. New York: Macmillan, 1973.

Hitchcock, H. Wiley, *Music in the United States*. 3d ed. Englewood Cliffs: Prentice-Hall, 1988.

Janson, H. W. *History of Art*. Englewood Cliffs: Prentice-Hall, 1977.

Kamien, Roger, ed. *The Norton Scores*. 3d ed. expanded. New York: Norton, 1977.

Kane, Elizabeth. "Marie Bracquemond, the Artist Time Forgot." *Apollo* 117 (February 1983): 118–21.

Litzmann, Berthold. *Clara Schumann: An Artist's Life Based on Material Found in Diaries and Letters*. 2 vols. Translated by Grace E. Hadow. London: Macmillan, 1913.

Machlis, Joseph. *Introduction to Contemporary Music*. 2d ed. New York: Norton, 1979.

Nochlin, Linda. "Why Have There Been No Great Women Artists?" *Art and Sexual Politics*. Edited by Thomas B. Hess and Elizabeth Baker. New York: Macmillan, 1973.

Rewald, John. *The History of Impressionism*. New York: Museum of Modern Art, 1961.

Russell, John. "An Old Museum Is Born Again in Baltimore." *New York Times* 19 June 1988: 2:33+.

————. "The Impressionists Saw Her as a Peer." *New York Times* 30 August 1987: 2:1+.

Sadie, Stanley, ed. *The New Grove Dictionary of Music and Musicians*. 20 vols. London: Macmillan, 1980.

For Further Study

Discussion Questions

1. What scriptural examples of women artists and musicians can you think of? Is there any indication that their contributions were thought to be unusual?

2. Reflect on your experience of female leadership of musical groups (school or church). Do you remember gender as being an element in your evaluation of the performance? If so, was your evaluation positive or negative?

3. How will your understanding of issues raised in other chapters of this text affect your view of women artists and performers.

4. How do you view the establishment of the National Museum for Women in the Arts? Is it a necessary step to equal representation in established institutions or do you feel it will tend to isolate women's works?

5. The statement is often made that not all art is pretty. In your mind can this apply as much to women's creations as to men's?

6. Do you think female musicians or male musicians are more aware of their sexuality in performing situations?

Writing Suggestions

1. One assertion of this chapter is that the lack of a female presence in the arts is due more to a lack of opportunity and expectation than to a lack of ability or genius on the part of women. Defend or question this idea.

2. If you are an aspiring artist, composer, or performer, write on how you view your gender as being an asset or a liability in achieving success in your field.

Research Topics

1. Major grants for artists and composers: Are women still disadvantaged?
2. Symphony orchestras: Is the female presence significant?
3. The feminization of church music.

Shorter Reading List

Comini, Alessandra. "Posters from the War Against Women." *New York Times* 1 February 1987: Sec. 7:13.

Garb, Tamar. *Women Impressionists.* New York: Rizzoli, 1986.

Glueck, Grace. "A New Showcase for Art by Women." *New York Times* 1 April 1987: C 23.

Kane, Elizabeth. "Marie Bracquemond, the Artist Time Forgot." *Apollo* 117 (February 1983): 118–21.

Kraus, Henry. "Conflicting Images of Medieval Woman," *Feminism and Art History.* Edited by Norma Broude and Mary Garrad. New York: Harper & Row, 1982.

Nochlin, Linda. "Why Have There Been No Great Women Artists?" *Sexist Society: Studies in Power and Powerlessness.* Edited by Vivian Gornick and Barbara Moran. New York: Basic, 1971.

Longer Reading List

Bowers, Jane, and Judith Tick, eds. *Women Making Music.* Chicago: University of Illinois Press, 1986.

Broude, Norma, and Mary Garrard, eds. *Feminism and Art History.* New York: Harper & Row, 1982.

Citron, Marcia, ed. & trans. *The Letters of Fanny Hensel to Felix Mendelssohn.* New York: Pendragon, 1987.

Faxon, Alicia, and Sylvia Moore, eds. *New England Women in the Arts.* New York: Midmarch Arts, 1987.

Garb, Tamar. *Women Impressionists.* New York: Rizzoli, 1986.

Harris, Ann Sutherland, and Linda Nochlin. *Women Artists: 1550– 1950.* New York: Knopf, 1984.

Heller, Nancy. *Women Artists: An Illustrated History.* New York: Abbeyville, 1987.

Hess, Thomas, and Elizabeth Baker, eds. *Art and Sexual Politics.* New York: Macmillan, 1973.

Koskoff, Ellen. *Women and Music in Cross-Cultural Perspective.* New York: Greenwood, 1987.

Litzmann, Berthold. *Clara Schumann: An Artist's Life Based on Material Found in Diaries and Letters.* 2 vols. Translated by Grace E. Hadow. London: Macmillan, 1913.

Schumann, Eugenie. *Memoirs of Eugenie Schumann.* Translated by Marie Busch. London: Eulenburg, 1985.

Stuckey, Charles F. *Berthe Morisot, Impressionist.* New York: Hudson Hills, 1987.

7

Gender, Society, and Church

Winston A. Johnson

You probably remember very well the first time you attended a formal concert of classical music—the full orchestra with so many instruments and players and a hall filled with enthusiastic listeners. This was certainly the case for Faith Martin whose first such outing was to Carnegie Hall in New York City. She and her friend had excellent box seats. It seemed they could see everyone and everyone could see them. As the orchestra began to play she was thrilled with the array of sounds that filled the auditorium. She describes the experience this way:

> As the strains of the first movement died away, I broke into applause—and immediately wanted to fall dead. Even now I can feel the silence, the rebuke, as a sea of faces turned in unison toward our box and thousands of eyes focused on me, helplessly on display in that choice seat. (Martin 10)

The way Faith Martin describes the embarrassment of applauding in a hall full of silence still brings back the same feelings of having learned a lesson the hard way. There is no law in New York City forbidding applause between movements of a symphony—one is not needed. The same thing is true of much in life. We are taught, frequently through painful experiences, the expectations and customs of our society. These traditional expectations are so powerful that most of us, most of the time, do not question their validity. In the case of this volume and this chapter to question women being in subjection may be just such an issue. Can an entire civilization be wrong?

The man said, . . . bone of my bones and
flesh of my flesh; . . .
they will become one flesh.

<div align="right">

Genesis 2:23, 24

</div>

For those of us who are Christians the issue of women in society is even more complicated than it is for those who are not Christians. That complication centers on the nature of God's revelation. In addition to society's informing our actions, God seeks to inform our actions primarily through theology. Theology is how people think about God and God's revelation. This thinking is valuable and necessary in its own right but may be quite different from what God has revealed through his Word. Martin Luther put it most graciously, writing to the effect that theology must always be reformed, that is, constantly reinterpreted.

As time passes nearly everything changes, even theology. Our understanding of the revelation changes, however, the revelation itself never changes for "the word of the Lord stands forever" (1 Peter 1:25). Specifically theology changes with the era, the time, and the people who interpret the revelation. This chapter, done within the frame-work of a sociologist who is a Christian, seeks to introduce the necessary balance between the assumptions that society offers us and theological and revelational requirements in terms of gender matters. The picture regarding gender roles may not be as clear as we have been led to believe.

This chapter seeks to accomplish four things in terms of the role of women in society. First, we wish to consider the attitudes that exist regarding women among people in the United States. We will briefly examine how these attitudes have changed over time. Gender role expectations are statements about the way in which men and women should behave. Frequently, however, the way in which people actually behave may be different from the expectations. You will see that masculine and feminine are defined by a given culture. For example, differences in gender role attitudes appear in the work of Margaret Mead (1935). She found that the Tchambull in New Guinea defined male and female roles differently than did other cultures. The men reared the children; men were the more emotional ones, were artistically inclined, and gossiped a great deal. On the other hand the women were the primary breadwinners. They were also energetic and domineering and wore almost no jewelry or ornaments. By contrast, in our own culture, sociologists such as Erving Goffman have found that in advertisements in the mass media, men are more likely to be shown as disproportionately larger than real life, more assertive, more in charge, and more protective of other members of their families than

are women when they appear in advertisements. Such depictions subtly preserve stereotypes, especially when you consider the amount of advertising that is subliminal.

Another example may be drawn from Scripture. Nowhere in Scripture are women *as a group* commanded to submit to the authority of men *as a group*. Some contemporary institutional churches, however, are building their biblical case on the mutual-submission passages in Ephesians as being meant to apply primarily to the husband-wife relationship when the actual focus of the chapter is to typify Christ's relationship to the church. Culture, rather than Scripture seems to be the standard-bearer of truth in this particular situation. As Christians we are acting in accordance with a cultural view of equality while delaying the spiritual equality we say we believe in to some future day.

Second, we will explore the life chances of women as compared to men. We will focus on women's participation in education, the economy, political life, and health.

Third, we shall offer explanations for the differences between masculine and feminine and male and female. Many times we are caught up in explanations that confuse the biological differences between the sexes. This area is particularly important in this chapter because one's value system is the starting point for the explanation of differences between the sexes. One's own values determine how one values others. We will consider briefly the various explanations that have been offered for differences between men and women.

Last, we will explore what the future holds for gender roles. Things are changing. Society's perceptions and expectations have been dramatically altered. Many consider the greatest social change of the last twenty years to be the permanent entry of women into the labor force. For example, by the spring of 1987 women occupied the majority of professional positions in the United States. While the rest of society seems to be taking the working woman in stride, evangelical Christianity is still publishing articles that address irrelevant questions such as: "What Should the Church Do When Mothers Need to Work?" According to evangelicals, the problems of mothers in the workplace have always seemed more severe than the problems of fathers in the workplace. For nearly two generations there has not been a single article in *Christianity Today*, *The Christian Herald*, or even *The Christian Century* regarding the impact of the aggressive hard-working father on family life. Differences in expectations seem to explain such a void.

GENDER ROLES AND BEHAVIORS

You have been given fullness in Christ . . .

Colossians 2:10

The Sociological Perspective

Before beginning our discussion I want to make three sociological assumptions clear. These assumptions underlie much of what we describe, and they will be critical in drawing our conclusions.

The first assumption is described by Peter Berger in *Invitation to Sociology* as "society as object." Society is "out there" controlling and manipulating us. It predates us and will be around long after we are gone. It exists to tell us what to do and defines, almost in ultimate fashion, who we are. For our purposes here the dimension of defining who we are is most important. What does it mean to be male and female, not just in society, but in our Christian communities? To what extent do the "powers that be" define perceptions of what is male and female and thus determine our value to the community?

The second sociological assumption is derived from the first: the group is a reality apart from the individuals that compose it. In American culture this concept is a difficult one to grasp because we are highly individualistic in our understanding of one another. However, the group is just as real as you are as an individual. It acts as an entity. In America the legal status of a corporation is the one thing that comes closest to what a group is. A corporation is a group made up of individuals. The reality of that group is so clear that the law treats the corporation as an individual, an entity, with all the rights and legal obligations pertaining to it. That group has all the same rights as you and I. It is a reality. There are also many other groups in society that are not nearly as formal but are just as powerful as the corporation. The family, for example, is a powerful group that is a constant reality for all of us, even long after we have physically left its influence.

Finally, there is our willingness to accept what society wants for us. Peter Berger describes this as "society as subject." If society is powerful it is, in part, because we cooperate with society. Many times its goals and ours are exactly the same. We want the roles society has for us; we accept the values. We grow up learning what it means to be male and female, what it means to be black and white, what it means to be rich and poor. We accept without question what the consequences of these expectations are. With time, as we learn our roles, society becomes a part of us. The truth is that most of us, most of the time, do mostly what is expected of us. In the end, society gets what

society wants. By cooperating with society we make it easier for society to achieve its goals.

Contemporary Views of Gender Roles

> Man looks at the outward appearance, but the LORD looks at the heart.
>
> 1 Samuel 16:7

Traditional gender roles for men and women in the United States included a rigid division of labor, with men responsible for working outside the home and supporting the family economically, and women working inside the home and being responsible for child care and housekeeping. Traditional expectations for men were that they should be strong, decisive, economically successful, sexually skilled, and in control. Such role expectations put tremendous pressure on males to prove themselves at all times. In turn, the pressures to repeatedly prove worth may have produced a fear of failure and feelings of inadequacy. It was often expected of traditional males that they deny their feelings. Thus men were sometimes closed off emotionally from their wives and children.

For most of us who deal with changes in role expectations the focus has been on who does the laundry as opposed to who brings home the bacon. However, the most important question regarding contemporary views of gender roles is not who brings home the bacon or who does the laundry but what is the relationship between male and female—to what extent is male dependent on female or female dependent on male.

The traditional female depended on men—first her father, then her husband, and perhaps later her sons—for social status and economic support. Women were expected to devote their lives and energy to nurturing and enhancing the lives of their husbands and children without regard for their own development or achievement. Most state laws required husbands to support their wives economically and work did not have the moral imperative for wives that it did for husbands, even when it was economically necessary or personally satisfying. Thus, traditional women felt less pressure to be highly successful if they did work. When traditional roles were prescribed for all women, some women found the loss of autonomy to be unbearable, and more women than men were treated and institutionalized for depression and other forms of mental illness (Gove and Tudor 1973; Rosenfeld 1980; Scarf 1980). At the same time, however, traditional women were allowed freedom to express their emotions. In

short, traditional gender roles were beneficial for some men and some women, but they were undesirable for others.

The traditional dependence of female upon male has no parallel for men. From pioneer days through the 1950s men and women performed the same productive roles in the context of the home. However, with the rise of America to unparalleled prominence economically and politically in the 1950s these productive roles changed and women, assumed to be the dependent sex, gave up their productive role in a time of great prosperity. Out of this emerged the myth that women had never *had* a productive role. Women thus became dependent on man devotionally, socially, and economically. Freud's psychology also became popular during this time, in part, because of his attempt to refute any possibility or any normality of the dependence of sons upon mothers. Once again the bottom line became who depends on whom. (And for heaven's sake, do not let a man be dependent on a woman!)

Let us briefly examine contemporary views of gender roles. Figure 1 shows that for the larger population there has been a steady movement toward valuing the same qualities in both men and women. Being a good parent involves spending time with one's children and putting family before anything else. This is true for both men and women. As the graph shows, being a good provider was evaluated as somewhat more important for a man than for a woman.

Three out of four evangelical Christian students agree with the statement that a "woman should put her husband and children ahead of her career" (Hunter 99). This also reflects the opinion of the general American population, 77 percent of whom agreed with the statement (Yankelovich 1981). However, the evangelical students also said that a man should put his wife and family ahead of his career. Nevertheless, there is an unwillingness to designate the domestic sphere as the exclusive realm of women.

Working women have always been a focus of concern when considering views of gender roles. In figure 2 we can see that the percentage of people who approve of married women working has increased dramatically from 21 percent in 1938 to 81 percent in 1984 (*Public Opinion* 1980, 33; 1985, 40). The fact that women work is not new. What is new according to Hunter is the cultural meaning that work has.

> What had been a source of fulfillment and moral aspiration is more recently defined as intellectually hollow and ethically vacuous . . . If the Evangelical specialists are to be believed, Evangelicalism has not been willing to assent to these newer cultural realities. Their passion is to preserve the domestic sphere as the rightful place of women . . . But is this true? (97)

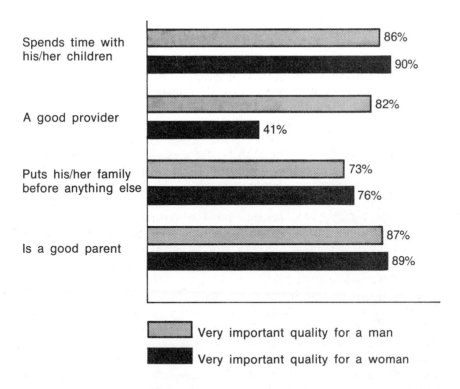

Spends time with his/her children — 86% / 90%

A good provider — 82% / 41%

Puts his/her family before anything else — 73% / 76%

Is a good parent — 87% / 89%

▨ Very important quality for a man

█ Very important quality for a woman

SOURCE: Survey by Yankelovich, Skelly, and White, cited in *Public Opinion*, 1980, p. 32.

Figure 1 Qualities Considered Important for Men and Women by a National Sample of Adult Men and Women. *Spending time with their children, putting their family first, and being a good parent are about equally likely to be considered very important qualities in men and women. Only being a good provider is more likely to be considered very important for men.*

According to Hunter, evangelical students are more traditional in their views of men and more liberal in their views of women. They will advocate a more masculine gender identity for women but are less likely to concede gender identity considered feminine to men. This is strengthened by the reality that 85 percent of evangelicals agreed that "a woman can live a full and happy life without marrying" (112). This is significant because in 1957, 80 percent of the American population had the opposite opinion (Yankelovich 93). How times have changed!

There also exists substantial data from the sixties and seventies on gender roles. Predictably that period saw a trend toward more egalitarian attitudes toward men's and women's roles. It is generally accepted, however, that there has been a more conservative drift since the late 1970s, but despite this more conservative shift the egalitarian trend in gender role attitudes has persisted (Hertzog and Bachman

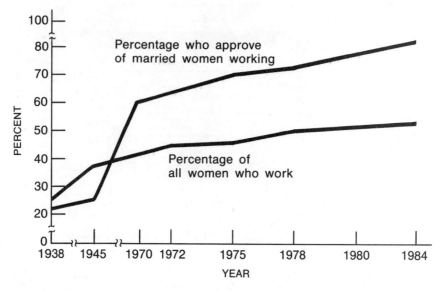

SOURCE: *Public Opinion*, 1980, p. 33; 1985, p. 40.

Figure 2 Percentage of U.S. Adults Approving of Married Women Working and Percentage of all Women Who Work, 1938–1984. *The percentage of U.S. adults who approved of married women working increased dramatically between 1938 and 1984. The percentage approving such behavior has increased even faster than has the percentage of women who work, which has also grown.*

1982). As a matter of fact young people are more egalitarian than their parents. They prefer marriages where husband and wife both have jobs and both help take care of the house and children.

But things have not changed completely. In 1983 Alice Baumgartner asked two thousand American students in grades three to twelve how they felt their lives would be affected if they woke up tomorrow as the opposite sex. Not surprisingly, they felt their lives would be dramatically altered by such a change. Boys saw it as a disaster—girls saw their life chances as increasing considerably.

Gender Role Behaviors

> And he said to them "You have a fine way of setting aside the commands of God in order to observe your own traditions."
>
> Mark 7:9

The most significant social change in the last half century has been the dramatic increase in the number of working women (figure

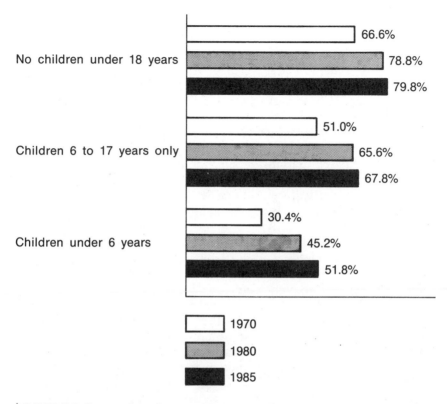

No children under 18 years
- 66.6%
- 78.8%
- 79.8%

Children 6 to 17 years only
- 51.0%
- 65.6%
- 67.8%

Children under 6 years
- 30.4%
- 45.2%
- 51.8%

☐ 1970
▧ 1980
■ 1985

SOURCE: U.S. Bureau of the Census. 1983, p. 25, 1985a, p. 399.

Figure 3 Labor Force Participation Rates for Married Women 16 to 44 with Husbands Present, by Presence and Age of Children: 1970, 1980, and 1985. *Between 1970 and 1985, married women who lived with their husbands moved into the labor force in growing numbers. Those with no children under 18 were most likely to work, followed by those with younger children. But even among those with children under 6, more than half were working in 1985.*

3). Clearly roles and behaviors have changed for women outside the home. What we see is a picture of women's roles expanding into what were once traditionally men's roles. Is the same thing happening for men? Are their roles and behaviors expanding to include traditionally female roles such as cooking, child care, house cleaning, laundry, sewing, planning parties, caring for sick and elderly family members, and so forth?

Available evidence suggests that although some men are taking a more active part in raising their children and some have even begun gourmet cooking, women, even those who work full time, do more of the household work than men. Working women spend ten to fifteen hours more per week than do men on the combined duties of outside

work and family work. Women who do this, in effect, work thirteen months each year. In general, with respect to roles, women and men have yet to become equal (see Pleck).

The majority of evangelicals find gender roles to be confusing. The majority of those surveyed by Hunter declared that men are the final decision-makers in the family and that the husband is primarily responsible for the social well-being of the family. On the other hand the image of "sensitive and gentle men" is preferred over the traditional "masculine" image. On one hand men are encouraged to exercise forceful leadership in the family and on the other they are encouraged to cultivate emotional development within the family. The social distance that is conditioned by the exercise of authority is to be modified by sensitivity and intimacy. Hunter concludes that such expectations, in effect, eliminate paternal authority as it was traditionally exercised. Those in evangelicalism who are "family experts" reinforce Hunter's conclusions. For evangelical males this "lost paternalism" is very confusing indeed.

There have been attempts to reconcile the discrepancy between expectations and behaviors. By far the most popular is the ideology of the "super woman." This is the women who does it all: she goes out, brings home the bacon, fries it up in a pan, and never lets you forget you are a man. This scenario taken from a commercial a few years back outlines the dilemma for today's women. Magazines such as *Working Woman* and *Savvy*, characters such as Elyse Keaton in *Family Ties* and Claire Huxtable in *The Cosby Show* portray the woman who does it all. She is successful in a career, has a wonderful loving relationship with her husband, has thriving children, and an attractive well-run household, apparently without even a once-a-week house cleaner! What are the costs of trying to be super woman? Mainly, there is never enough time for essentials. In addition, very little leisure time is available, and she is frequently exhausted, often with a resultant increase in illnesses.

A most interesting study done in 1985 addresses the super woman syndrome. Arlie Hochschild concludes that the super woman mentality, whatever its problems, offers comfort to a woman who lives with structured inequality. This is something we will address later when we consider the future of gender relations. Before that we will address the objective status of men and women in the United States and the explanations offered for something called gender stratification.

To this point we have concentrated on those qualities that outline gender differences. Gender differences are the combination of social positions, roles, behaviors, attitudes, and personalities of men and women in a society. What we have not considered up to now is the value, in society, of being male as opposed to being female. Gender

stratification addresses the reality that the different sexes are ranked in terms of ownership, power, social control, prestige, and social rewards. Frequently the distribution of these compose one's life chances in society.

LIFE CHANCES: IS ANATOMY DESTINY?

His disciples . . . were surprised to find him talking with a woman.

John 4:27

Differences in the Sexes

The only significant biological differences between the sexes that influence behavior are the reproductive and sexual functions (Money 1977, 1980). Aside from these there *may* be differences in predispositions between the sexes. Men are generally stronger in tasks that require exertion over a short period of time, such as pumping iron. Women tend to show strength at those things requiring endurance, such as swimming. If these differences are significant they exist in the averages of a wide range of male and female scores. We may conclude that individually men and women may vary greatly from the averages.

Differences in hormonal balance between the sexes might account for some very general differences in predispositions between males and females. Certain hormones seem to dispose males to aggressiveness. If females are injected with those same hormones they become more aggressive. Hormones do have an effect on behavior and emotions, but they do not determine behavior. What is of much greater interest to sociologists is the way these predispositions are channeled into life consequences. For example, the emergence of a life of crime, the job of a professional athlete, or the ambitious life of an executive are uses of these predispositions that have been channeled through socialization. Socialization is the process of learning the norms and values necessary to survive in society.

What are some of the explanations that have been offered to account for differences between the sexes? There is no doubt that there are biological differences between men and women. Three factors define the identity of a newborn baby: chromosomes, sex hormones, and internal and external sex organs. In the fertilization process the female always provides an x chromosome in the egg cell. The male may contribute an x or a y chromosome. If an x is contributed then the child is a girl, if a y is contributed the child is a

boy. In most infants biological characteristics work in harmony to give consistent sexual identity.

The record shows, however, that in addition to genetic and hormonal identity biological and social cues interact. The interdependent effect of social learning is difficult to detect because gender roles agree with sexual identities and behaviors. Given that, it seems unlikely that the status gaps between men and women are caused solely by biological differences.

The power of culture in the socialization process cannot be underestimated. This is most obvious when one considers the cross-cultural differences between males and females. Margaret Mead studied three tribes in New Guinea (1935) and found some startling differences. The Arapesh tribe expected men and women to cooperate, to be sensitive to the needs of each other, and to be nonaggressive. These are traits, in our culture, that are held to be female. In another tribe Mead found both men and women to be aggressive and nonresponsive. These are traits labeled as masculine in our culture. In a third tribe, the Tchambull mentioned earlier in this chapter, Mead found dominant, impersonal, and managing women living with emotionally dependent men. These studies and scores of others suggest that cultural values and socialization are instrumental in shaping roles and personalities. This in turn directs us to consider the content and processes of gender role socialization.

There are four theories of socialization: identification theory, social learning theory, modeling theory, and cognitive development theory.

The identification theory, developed by Freud, has been a prominent one for our culture. Basically it concludes that children tend to identify with and copy the same-sex parent. Most of these theories have focused more on boys than girls, noting that identification is riskier and more of a problem for boys than for girls, since both boys and girls begin life more strongly attached to their mothers than to their fathers. Girls simply have to continue this attachment, but boys must break away from their mothers and learn to identify with their fathers. The assumption tends to be that boys who exemplify masculine characteristics are socially and psychologically better adjusted; the social research, however, does not seem to support this assumption.

The social learning theory emphasizes that behaviors that are reinforced or rewarded tend to be repeated more often, whereas those that are ignored or punished tend to occur less often. This theory directs attention to the way children are praised or encouraged for what others consider appropriate behavior. "What a sweet little girl you are." "What a strong little man you are." What is meant by

"good" for boys is different from what is meant by "good" for girls. Children sense what is wanted and try to provide it because if they act in unacceptable ways they may be ignored, discouraged, or even punished. For example, girls are scolded more frequently than are boys for getting their clothes dirty. Is it any surprise, then, that most girls tend to be neater and cleaner than most boys? Daily, hundreds of interactions give reward or punishment for what others consider to be appropriate or inappropriate gender role behaviors.

The modeling theory assumes that children imitate adults they admire, specifically same-sex parents and friends, yet research does not seem to support this (Smith and Daglish 1977). Because parents, teachers, and friends hold conflicting expectations about how one should behave, children have to figure out how to cope with these conflicting demands. Children sort through a *variety* of role models and demands as they seek to figure out the social world.

The cognitive development theory suggests that individuals try to pattern their lives and experiences to form a reasonably consistent picture of their beliefs, actions, and values. By age six boys and girls learn that their gender is permanent and that it is a central organizing principle in social life. Having discovered this they try to figure out the "right" way to behave. Rewards, punishments, and role models may help to show the way, but each person plays an active part in searching for patterns in the world and in their own lives.

Most of us take for granted who and what the primary sources of gender role socialization are. Parents lead the list of active socializers and although parents are likely to say they treat their boys and girls in similar ways, observers find that they actually do not (Will 1978). A most critical component of parenting that influences learned sex roles is task assignment. Girls are more frequently assigned child care responsibilities in the home than are boys. Boys are encouraged by their fathers into mechanical spheres while girls are not. Girls are expected to learn nurturing behaviors while boys are not expected to learn such behaviors.

Games and play also teach gender role socialization. Various studies have detected the following patterns:

1. Elementary school boys played outside more than did girls.
2. Boys were more independent and played more competitive games in larger groups (Best 1983).
3. When boys disputed they argued and worked it out based on the rules or repeated the play that was disputed.
4. Girls often played with a single best friend or in much smaller groups.
5. If girls had a dispute it ended their game (Lever 1978).

6. Girls were less competitive in play than boys and were often verbal and imaginative.

Researchers have difficulty determining what causes these differences, but they know that the differences are related to later actions in life.

Schools and books play an important role in socialization. They describe a society created, settled, and led by men. The books that won the top literary awards for children's books in America have a male bias attached to them. Females were grossly underrepresented among the award-winning books in all areas: titles, pictures, central roles, and stories. Most of the stories were about boys, men, or animals dressed like men. There were eleven pictures of males for every picture of a female. In school boys are rewarded more than are girls. As a result men are more likely to teach advanced math and science classes because as boys they were more strongly influenced by their teachers to respond positively toward science and mathematics than girls were (Lee and Ware 1985).

Television competes strongly for a socialization role. By age fifteen a teenager has spent more time watching television than she or he has spent in school. Eighty-five percent of the leading television characters are male (Travis and Wade 1984). Males are shown solving problems, rescuing others, and receiving rewards. Males are more likely to be "bad guys" and women to be cooperative and affectionate. Men are shown to be more important in shaping events, whereas females are frequently shown as only observers. How influential is television on attitudes, anyway? Teenagers studied for the influence television had on them in 1975 and again in 1977 became more sexist over time, especially those who were least sexist in the earlier study. Boys were more sexist than girls, whether or not they watched television. Girls who watched television were more negative in their attitudes toward women than girls who watched less television (Morgan 1982).

Whatever the precise configuration of socialization influences, the *consequences* of gender role socialization are profound indeed. Here is an example of a writing assignment: "Anne, a medical school student, finds herself at the top of her medical school class at the end of her first semester. Write a short story about Anne's life."

When ninety female undergraduates wrote this exercise, 65 percent of them created stories with negative themes—Anne lost all her friends; she was ugly, unattractive and lonely; she even dropped out of medical school. When male undergraduates were asked to write a comparable story about John instead of Anne, he was depicted in the stories as bright and competent with an exciting future. Matina Horner concludes from her 1969 study that there are anxiety blocks to

achievement in many very bright women. Other scholars picked up on this conclusion very quickly and further concluded that these blocks were internal, not outside of the women themselves. That conclusion may not be warranted.

Another important aspect of normal gender role socialization for women is low self-esteem. Females tend to rank themselves lower in terms of their abilities, performances, and likelihood of future success (Parsons et al. 1976). Their evaluations reflect the lower expectations of women by society as a whole. These attitudes, however, are many times not related to real ability and despite the lower expectations, women do not accept the negative image society presents. Women do, however, accept the lower level of expectations.

Given the effects of gender role socialization, only some of which social researchers have studied, how are women doing in contemporary society? What are their chances as compared to men? We will consider these questions in four spheres of human activity: educational attainment, participation in the economy, involvement in political life, and health and life expectancy.

Women and Education

There have been tremendous gains in educational achievement for women. Women's representation at the degree level is expected to increase rapidly so that by 1993 women will be earning at least as many bachelor's and master's degrees as men. It is expected that by 1993 women will earn about a third of all professional degrees, including one-half of all doctor's degrees. The so-called "soft" areas of learning—communications, literature and language, library science, and public affairs—are most likely the areas of achievement for women. Men, on the other hand, are more likely to earn advanced degrees in the "hard" sciences such as agriculture, engineering, law, mathematics, and theology. Some of these fields of study are almost exclusively the domain of men. To the extent that employers require degrees in certain disciplines and women lack those degrees, women are less likely to be considered for certain entry-level positions and for certain career paths. Certainly, having degrees does not guarantee positions but it is equally certain that *not* having the degrees bars women from even being candidates.

Women in the Economy

By the year 2000 projections are that 75 percent of all women will be in the labor force. This represents a new way of life, at least for middle-class females growing up today. Gone are the days when a

woman can assume that a man will marry her and support her and their children for life.

According to the Bureau of the Census in 1985, nearly 50 percent of the labor force in the United States is female (1985:852). Among certain segments of the population, however, the percentage of working women is even higher. For example, in 1987 the Bureau of the Census reported that nearly 51 percent of new mothers remained in the job market after the birth of their children. By contrast, in 1976 only 31 percent of new mothers remained on the job. In 1987, 63 percent of new mothers with college degrees were likely to remain on the job. The number of mothers continuing in or returning to jobs increased the number of two-worker families to 13.4 million in 1987, up from 8.5 million in 1976. Sixty-seven percent of women with children six to seventeen years of age are in the workplace and 53 percent with children from birth to five years of age are in the workplace.

The reality is that, among working women, the working class has a larger number of women in the labor force than does the middle class. However, the biggest change regarding women in the economy has been the record number of middle-class women who have entered the work force. The results of working outside the home are predictable. Women have greater independence from their husbands and more responsibilities while men have less economic power over their wives and are spared the total responsibility of providing for their families. Once a woman goes to work she will end up working most of her life whether she planned to or not.

Thus, the status of men and women in American society seems to be converging. That is, the relative social value of the positions both men and women are occupying seem to be coming together. For example, as women become better educated they are filling positions previously occupied largely by men. Women represent just over half of all professional workers (figure 4). As expected, women are overrepresented in the traditionally female occupations of nursing, library science, teaching, health technology, social work, educational and vocational counseling, as well as clerical and technician jobs. Women occupy 80 percent of all clerical positions, but only 36 percent of all managerial and administrative positions and 47 percent of all sales positions.

As long as women do not hold the same positions as men the possibilities of ending stratification are slim. With these differences in mind, discrepancies in the earnings of the two sexes should be noted only within similar occupations.

In the United States women earn sixty-five cents for every dollar men earn for doing the same work. In all occupational groups women

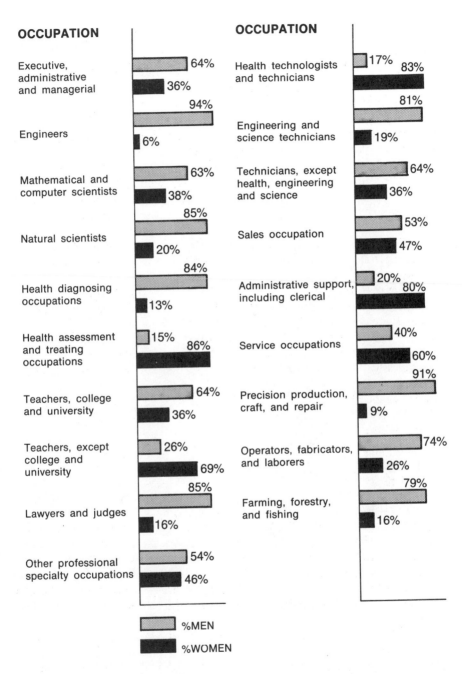

OCCUPATION

Executive, administrative and managerial	64% / 36%
Engineers	94% / 6%
Mathematical and computer scientists	63% / 38%
Natural scientists	85% / 20%
Health diagnosing occupations	84% / 13%
Health assessment and treating occupations	15% / 86%
Teachers, college and university	64% / 36%
Teachers, except college and university	26% / 69%
Lawyers and judges	85% / 16%
Other professional specialty occupations	54% / 46%

OCCUPATION

Health technologists and technicians	17% / 83%
Engineering and science technicians	81% / 19%
Technicians, except health, engineering and science	64% / 36%
Sales occupation	53% / 47%
Administrative support, including clerical	20% / 80%
Service occupations	40% / 60%
Precision production, craft, and repair	91% / 9%
Operators, fabricators, and laborers	74% / 26%
Farming, forestry, and fishing	79% / 16%

%MEN
%WOMEN

SOURCE: U.S. Department of Labor, 1986, p.

Figure 4 Percentages of Men and Women in Various Occupations, 1986. *Men and women are not evenly distributed among most occupations.*

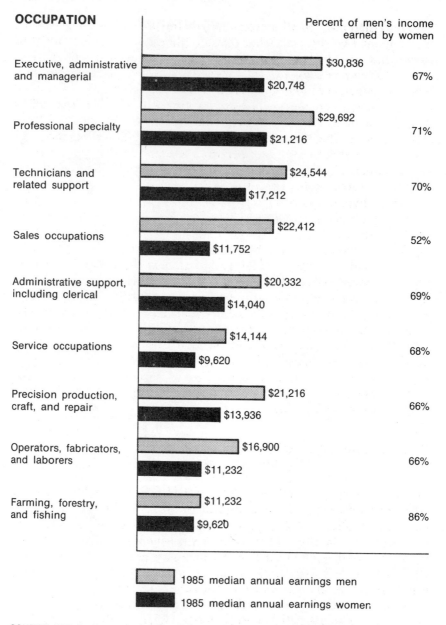

OCCUPATION

Percent of men's income earned by women

Executive, administrative and managerial
$30,836
$20,748
67%

Professional specialty
$29,692
$21,216
71%

Technicians and related support
$24,544
$17,212
70%

Sales occupations
$22,412
$11,752
52%

Administrative support, including clerical
$20,332
$14,040
69%

Service occupations
$14,144
$9,620
68%

Precision production, craft, and repair
$21,216
$13,936
66%

Operators, fabricators, and laborers
$16,900
$11,232
66%

Farming, forestry, and fishing
$11,232
$9,620
86%

1985 median annual earnings men

1985 median annual earnings women

SOURCE: U.S. Department of Labor, 1986, p. 212; U.S. Bureau of the Census, 1985a, p. 419.

Figure 5 Sample of Median Income in 1985 by Occupational Group and Sex (Persons 15 years old and over, working year-round, full time). *In every type of occupation, full-time women workers earn considerably less than full-time men workers, with women earning the lowest percent of men's income among sales workers.*

earn less than men. In all professional, technical, and like jobs women make about two-thirds of what men do (figure 5). In sales work they earn about half. In 1978 the average income for women doctors was $39,820 as compared to $67,450 for men, a gap of 41 percent. Similarly women business-school graduates who had been out of school between seven and ten years were earning $34,036 as compared to $48,000 for men. Overall we may conclude with Treiman and Roos (1983) that in the United States women earn, on the average, 57 percent of what men earn. In most other western democracies, women earn between 67 and 77 percent of what men earn. Thus one can see that the United States has more pay inequity.

The obvious question is: Why? Four explanations have been offered by observers of society. The first explanation is that women earn less than men because overall they have less education and job experience, which in turn makes them less productive. Therefore, they are paid less. The second explanation is the existence of dual career responsibilities. Women must choose to devote less time and energy to advancement because family responsibilities hamper competition for pay increases. Therefore, married women earn even less than non-married women. A third explanation is called occupational segregation. Basically men and women are working in different occupations or at different places in the same job classification (figure 4). Finally, discrimination is offered as an explanation for why the differences are so dramatic. Seniority, race, or age, as well as sex may affect a woman's earnings.

Women and Political Participation

Clearly, women have lower economic status than men. But does that lower status extend into the political arena? If holding elected office is a criterion, then the answer is "yes." In 1985 women held twenty-two seats in Congress (5%), two Senate seats, and two governorships. In 1984, 14 percent of the seventy-four hundred state legislators were women. Although women are greatly underrepresented politically, they are seeking office much more frequently today, especially in municipal and state governments.

Since women comprise over half of the American population they are a highly sought-after voting block. Every politician seeks to acknowledge the needs of this block of voters and each does the usual political things to be assured of that population's vote. The change in women's role in the labor force has brought politicians to the point of recognizing the need for things like day care and maternity leaves that protect jobs. These are becoming hot political issues.

Women and Health

It is still generally more difficult to remain alive and healthy if you are a man than if you are a woman. Woman are expected to live an average of seventy-eight years; men, seventy-one years. Men are three times more likely to be murdered or to commit suicide than women are. Women are less likely to get serious diseases than men are.

Women, however, are quickening their pace toward unhealthy lives. With increased involvement in the workplace they are experiencing higher rates (but still not as high as those of men) of deaths from heart disease, strokes, accidents, and cancers. In fact, the leading cause of death for women is cancer. Although men are still experiencing a higher frequency of stress-related illnesses, women are on their way. These illnesses include ulcers, spastic colon, asthma, and migraines. Women are also drinking and smoking more than they used to.

The rate of mental problems among women is also quickening. Literally dozens of study results show that married women have more mental problems than married men. This may, in part, be due to the traditional isolation of the wife and mother in a not very highly valued social role. However, there is no evidence to indicate that by entering the workplace women *increase* the likelihood of mental health problems developing. Perhaps this more valuable social role is easing the mental stress of constant homemaking. Much work remains to be done by those who study such patterns.

THE FUTURE

There is no authority except that which God has established.

Romans 13:1

Whether one is an evangelical Christian or not, the question of gender roles boils down to the same issue: male authority. The goal in the larger society is to move in the direction of greater equality between the sexes whereas in evangelicalism the direction of change is still being debated. The debate settles on this: Which has had the most influence in determining the role of women, particularly in the church—Scripture or the traditionally male-dominated culture? In this section we seek to address the concerns of both our larger society and the evangelical community regarding the future role of women. Such consideration can only be cursory but that's the point of an

introduction to a subject: it starts us on our way toward in-depth study.

How did we get to where we are today? Several major factors have contributed to the changing roles of women in society. There have been dramatic shifts in the female life cycle, improved contraception, increased labor-market demand, and social movements pressing for equality. Childbearing is no longer the central fact of a woman's life. Whereas women once spent most of their productive life bearing, rearing, and helping to support children, now they spend less than 15 percent of their lives doing so. Nowadays when her youngest child starts school, the average American woman has forty productive years ahead of her.

A significant part of this dramatic change is the result of the nearly complete control women can exercise over their reproductive potential. They can limit or time their pregnancies, or opt not to have children, yet they do not need to restrict their sexual activity to do so. At the same time that effective contraception became legal and common, an expanding economy increased the labor-market demand. This demand was complicated further by cycles of inflation that reinforced the need to maintain the middle-class standard of living that could only be done with a serious "second" income. Women have thus continued to enter the labor force en masse seeking to preserve the "American way of life."

In addition to improved contraception and increased labor demand, one particular social phenomenon has placed us where we are today. The women's movement of the 1970s and 1980s has been the primary focus of those seeking greater equality between the sexes, as well as those who do not. The National Organization for Women constitutes the older reformist branch of this movement. It arose out of an effort by the Equal Employment Opportunity Commission to exclude women from discriminatory review. The reforms that NOW seeks are in the areas of equal pay for equal work, equality under the law, equality in credit, and the opening of career lines to women. Another dimension of the contemporary women's movement is found in the views of the radical feminists and the socialist feminists. Radical feminists see sex stratification as grounded in a man's desire to have his ego override that of a woman. They want to eliminate all male privileges and all unnecessary sex distinctions. Socialist feminists, on the other hand, view stratification as arising from an economic system that is dominated by males. They feel that women contribute to profits because they are low-paid employees. Radical and socialist as well as reformist feminists favor a restructuring of society. The combined effort of all feminists contributed to the early success of the movement, including discernible changes in educational, legal,

economic, and political opportunities. The movement, as such, has now lost some momentum as greater equality has become more of a reality and the expectation of equality has become a norm in society.

As noted above, society is headed in the direction of greater equality. What will this equality look like? Let us speculate based on what we have presented to this point.

Carolyn Etheridge (1978) has identified four conditions necessary for equality based on her analysis of the Oneida Community, a kibbutz, several American communities, and two-paycheck families in the United States and Great Britain. First, she declares, men and women must be economically independent. This occurs when men and women have equal access to the productive process and receive equal shares. Second, individuals need to be committed to the ideology of equality. Without that commitment there will be no way to make practical changes in the home and work experience. The third condition is the equal allocation of tasks in the public and private spheres. This flows directly out of commitment to an ideology of equality. In society and its groups this means women will participate equally in the political processes that exist. This condition is essential for gender equality because people with relatively more information, access to resources, and control over decisions feel and in fact are more powerful in their daily lives. Public and private tasks need to be equally allocated between men and women, for assigning tasks solely on the basis of gender is a major means of maintaining definitions of masculine and feminine. Fourth, if tasks are shared in both spheres of human activity then both partners will work less and some form of help with child rearing will exist. If this condition is not present then parents will be severely overworked in all of their activities.

Can these conditions be realized in society? In a time of high and rapid inflation the two-income family becomes a necessity in many cases. In low-income homes two incomes can ensure that the family stays together. In higher-income families two wage earners can ensure better housing, education, health care and recreational opportunities. During periods of unemployment the two-income family has more of a financial cushion than the single-earner family in which loss of a job for the sole breadwinner may mean disaster.

Warren Farrell (1976) notes the benefits that equality brings to men. A woman who is more in charge of her own life may make less effort to control her husband's life. When a man's partner is economically independent he may choose a career because he is interested in it and not be forced to hold onto a position just because it pays well. Men may also lose some of the legal discrimination against them—responsibility for alimony and child support could be reduced.

If the picture for equality is so bright for all concerned, why isn't

there more structured equality in society? Hochschild (1985) suggests that the economic inequality women face in the workplace (that is, less pay than men) and the unequal marriage market (there are fewer chances for women to marry or remarry as they get older compared to men) put them at a disadvantage in the negotiations over division of labor in the home. Perhaps many women feel they cannot push their husbands too hard to help at home because of the potential economic or emotional results.

There do exist some models for equality that might help as we consider the future of gender equality. Alice Rossi (1972, 1983) has suggested three possible models—pluralism, assimilation, and hybrid. In general these derive from discussions of inequality in racism. Pluralism suggests that it is possible for groups to coexist in society. Therefore, the differences between the sexes should be retained as a benefit to the whole society. Of course, this conclusion suggests that the value of the existing differences rests primarily on the nature of men and women as population groups. It does not consider that many dimensions of the unequal treatment of men and women rest in the structures of society itself. Examples of such inequity might be less pay for the same work, closed occupations, and lower educational levels. Such inequities have nothing to do with presumed natural differences of men and women. They are structured into society as a consequence of male authority. The pluralist model makes true gender equality virtually impossible.

Assimilation suggests that, over time, those excluded from social process are brought into the mainstream by acquiring the psychological, behavioral, and social characteristics of the majority or the powerful. For women this model proposes that they should become more like men. This model also suggests that socialization caused the inequality and that resocialization will help to eliminate it. However, it overlooks the fact that changing individuals does not necessarily change society. It also overlooks the reality that behind every successful husband is a hardworking wife who makes his successes possible, but the contributions of wives are not considered valuable. In addition to this substantial weakness in the assimilation theory, there are those who maintain that competitiveness and aggressiveness are undesirable traits in *both* sexes and that cooperation, tenderness, and emotional sensitivity should be fostered in both sexes.

Rossi (1972) has proposed a third model for equality. She calls it the hybrid. This model calls for a change in both the dominant and subordinate members of the society. Biological determination of social characteristics is rejected. Traditional institutional structures erected by white males are rejected. Gender-specific socialization is also rejected. Family and relationships are on equal footing with regard to

work, politics, and finance. Community is fostered in all dimensions of life. Basically this model humanizes life in a society as both sexes share in a wide variety of tasks in both the public and private sphere. Sweden is one country that has moved in the direction of such a model. They have successfully argued, in a report made to the United States, that the status of women cannot be improved by having measures aimed solely at women. The truth is that as the roles and expectations of women change so do the roles and expectations of men. In contemporary American society this fact is reflective of the principle that power is a zero-sum game: if one person gains power, another loses. Sweden, acting on this principle, has removed conditions which give privileges to men. Policy statements in Sweden stress that men and women are obligated to share child-rearing and home-care activities.

It seems unlikely that, in the near future, American society will move substantially in the direction Sweden has taken. Sex roles, however, have been one of the most rapidly changing dimensions of American society. Yet America is still far away from achieving sexual equality. Some argue that the discrimination that does exist may be, in part, because social structures are lagging behind the changes in attitudes that have already taken place. Therefore, rapid change at the macro level of society may severely disrupt the unity of the family, whose generally traditional structures are struggling to survive. On the other hand, the slow pace of equality is frequently chalked up to male dominance. Men benefit in a number of ways from maintaining traditional sex roles. Just as clear, though, is that men would probably be better off psychologically and physically with less restricted sex roles. Thus it would appear that although both sexes would have something to gain from greater equality, gains in that direction will be slow in our society.

WOMEN AND THE CHRISTIAN COMMUNITY

Mary has chosen what is better, and it will not be taken away from her.

Luke 10:42

Male authority is not a doctrine of authentic Christianity; it originated in the human institutions of Christianity—the visible church under the influence of society. Nor is it the only doctrine slipped into the portfolio by a ruling class anxious to defend its sins: slavery, racial supremacy, and the divine right of kings were at one time considered legitimate social doctrines for believers.

The church must drop its defensive attitude on the question of women and come to terms with the culture into which Christianity was born. To what extent did the church conquer pagan culture? In the determining of the role of women, which has the greatest influence—the teaching of Scripture or a male-dominated culture? (Martin 52)

This quote contains the heart of the concerns in the evangelical community. Primarily, it draws attention to the close relationship that exists between the structures of the church and the society within which the church ministers. Whether we want to admit it or not we are directly affected by all the changes that are taking place in women's and men's roles in society. We do not operate as Christians in a social vacuum any more than the early church did. In the New Testament all kinds of concerns are raised because of the relationship of Christ to culture, but not because the truth of Christ was to be isolated from culture. It was by relating to culture that the church could be most effective in its ministry.

We hardly notice, for example, that the first evangelists were women. Those who bore the news of Christ's resurrection were women who took the message, "He's alive!" to a group of men, the disciples, who felt women were not to be believed under these emotional circumstances. If the Word of God is inspired then this is no accident sneaked into the record by concerned feminists. It explicitly declares that God calls all to deliver his message and that the basis for delivering that message lies in personal commitment, not in the authority structure of either the church or society. As Martin puts it: "Both sexes following Jesus were products of a culture that taught men to strive for mastery and at the same time taught women to expect nothing" (53). In the clamor of this debate in evangelicalism, women must be careful not to sound like the sons of Zebedee talking about their positions in the kingdom. Rather women should engage the debate at the level of service. There is much to be done in extending the kingdom of God. God needs both sexes fully participating in the "call" to change the world.

Authority, male or otherwise, cannot be a goal for Christians. Christ is the best example as described in Philippians where the apostle Paul writes that Christ emptied himself of his equality with God. That describes a clear surrender of authority.

Martin has done an excellent job of describing how male authority over the past two thousand years has been consistently drawn from society's structure of inequality and not from Scripture. Clearly the reasons for male dominance throughout the Christian era have changed and traditional theology has altered the concept of male authority to suit societal changes. "Headship," of course, is the

newest synonym for male authority and it also works nicely in today's secular culture. By using this term the American evangelical community can confirm male authority as being the norm. Man has control over the women folk in his family, therefore larger issues of social equality and justice can be ignored. The dictator is hidden.

Along with this home, it is business as usual at the church. It all seems so logical. The husband is "head" of his wife. Therefore, women are not permitted to have authority in the religious community. (The result might be that she would end up ruling in the church over her husband. Thus she would use her Christian liberty to reject God's "natural order" for the home.) This doctrine extends to all social roles in the church and thus the single woman is also affected; she is viewed as a freak of nature in God's order of things. She has no head!

It remains clear then that, for all its acceptance as a doctrine, the principle of male authority remains elusive when one searches Scripture. But when one examines society for the past two thousand years the doctrine is solidly in place. The teaching that God's perfect plan places women under the authority of men has been brought to Scripture from male-dominated cultures and a church run on the basis of authority, not grace. Yes, I agree with Martin, male authority is a "false teaching inserted into theology by a male-dominated culture in love with authority"(55).

Underlying the conclusions of this last paragraph is, I think, the most important thing that can be said in this chapter: Everything about male dominance in society and especially in the church suggests men have a unique relationship to God. But Scripture, properly understood, does not in a single phrase indicate this and 1 Corinthians 11:3 is an excellent example of a problem passage. How the passage is read affects everything. If one reads this passage, "The head of every man is Christ and the head of woman is man," without reference to culture it does not mean anything. It is meaningless; it cannot be interpreted for there is no context for understanding it. If one recognizes that it is in reference to some culture that Paul is speaking, the passage is easier to understand even if in itself it is not liberating for women of the faith. One can at least begin to understand why Paul made the statement. The cultural context assures us that the point of this passage is not that there exists some kind of unique relationship to Christ that men have and that women do not. Yet, that is the underlying truth that some people today would have us believe. My point in this chapter is not to exegete the passage but to indicate the indispensable value of cultural understanding in dealing with Scripture. Scripture holds all the spiritual information we need and contains it in a fashion that is culturally relevant. The fact that

Scripture presents the revelation in culturally relevant fashion makes the task of interpretation easier than it would be otherwise. Surely no one in evangelicalism would argue that men have a special relationship to Christ that is not available to women. Not taking culture into account in interpreting any passage, however, can lead to such incorrect conclusions.

Overall, I suggest that dogmatic conclusions are not the way of the future for those evangelicals concerned about women's issues. Positions may be taken but not to the exclusion of acknowledged differences of opinion. As we have seen, these differences concern the interpretation of Scripture and its application to contemporary society. When women have been restricted they have expressed themselves in unique ways but not without cost to the church as well as to themselves. Servanthood has been superseded by rank and authority. The latter two have no place in the church as mechanisms of control. We are *all* called to faithful service.

The attitude and actions of American women will continue to dramatically shape our society for at least the rest of this century. With the changes that have already taken place, there has been a stimulating reappraisal of American values. Dramatic shifts have taken place in the last twenty years. Looser definitions of what is masculine and feminine and changes in parenting expectations have occurred. Equal pay for equal work and female participation in family decision-making are nearly accepted norms. However, new values do not mean new practices. Very little has been done yet in American institutions to promote equal rights for women. For example, the United States remains the only industrial country not to have a national day-care program. The women's movement will not end soon.

Evangelical Christians have been more influenced by culture than by Scripture in their attitudes toward women. Despite the changes that have taken place in society and that have directly altered evangelical life, male authority persists. Traditional roles continue in the family and in the institutional church. Nonetheless, every bit of sociological evidence indicates that paternal authority in evangelicalism is on its last legs. Conflicting expectations for men and the large number of Christian women in the workforce threaten this tradition significantly. The institutional church is engaged in serious debate about women in ministry. Since this debate arises from male-female relationships in the family, one can conclude that as paternal authority becomes less viable, increased pressure will be placed on the church to take women into more active roles. This inclusion will be legitimated by new understandings of the biblical materials. This means the church will be less concerned about rank and authority and

more concerned about ministry and servanthood. The whole world should benefit from this kind of renewal.

Works Cited

Baumgartner, Alice. "My Daddy Might Have Loved Me: Student Perceptions of Differences Between Being Male and Being Female." Denver: Institute for Equality in Education, 1983.

Berger, Peter. *Invitation to Sociology.* New York: Bantam, 1962.

Best, Raphaela. *We've All Got Scars: What Boys and Girls Learn in Elementary School.* Bloomington: University of Indiana Press, 1983.

David, Deborah S., and Robert Brannon, eds. *The Forty-Nine Percent Majority: The Male Sex Role.* Reading, Mass.: Addison-Wesley, 1976.

Etheridge, Carolyn F. "Equality in the Family: Comparative Analysis and Theoretical Model." *International Journal of Women's Studies* 1 (1978): 50–63.

Farrell, Warren. "Women's Liberation as Men's Liberation: Twenty-one Examples." *The Forty-Nine Percent Majority: The Male Sex Role.* Edited by Deborah S. David and Robert Brannon. Reading, Mass.: Addison-Wesley, 1976.

Goffman, Erving. *Gender Advertisements.* New York: Harper & Row, 1976.

Gove, Walter R., and Jeanette F. Tudor. "Adult Sex Roles and Mental Illness." *American Journal of Sociology* 78 (1973): 812–32.

Hertzog, A. Regula, and Jerald G. Bachman. "Sex Role Attitudes Among High School Seniors: Views about Work and Family Role." Ann Arbor, Mich.: Institute for Social Research, 1982.

Hochschild, Arlie Russell. "Housework and Gender Strategies for Getting Out of It." Paper presented at American Sociological Association Meeting, Washington, D.C., 1985.

Horner, Matina, "Fail: Bright Women." *Psychology Today* 3 (1969): 36.

Hunter, John Davidson. *Evangelicalism: The Coming Generation.* Chicago: University of Chicago Press, 1987.

Lee, Valerie, and Norma C. Ware. "Factors Predicting College Science Major Choice for Man and Woman Students." Paper presented at the American Educational Research Association annual meeting, Chicago, 1985.

Lever, Janet. "Sex Differences in the Complexity of Children's Play and Games." *American Sociological Review* 50 (1978): 1–19.

Martin, Faith. *Call Me Blessed.* Grand Rapids: Eerdmans, 1978.

Mead, Margaret. *Sex and Temperament in Three Primitive Societies.* New York: Morrow, 1935.

Money, John. "The Givens from a Different Point of View: Lessons from Intersexuality for Theory of Gender Identity." *The Sexual and Gender Development of Young Children: The Role of the Educator.* Edited by Evelyn K. Oremel and Jerome D. Oremland. Cambridge, Mass.: Ballinger, 1977. 27–33.

———. *Love and Sickness: The Science of Sex, Gender Difference, and Pair Bonding.* Baltimore: Johns Hopkins University Press, 1980.

Morgan, Michael. "Television and Adolescents' Sex Role Stereotypes: A Longitudinal Study." *Journal of Personality and Social Psychology* 43 (1982): 947–55.

Oremel, Evelyn K., and Jerome D. Oremland, eds. *The Sexual and Gender Development of Young Children: The Role of the Educator.* Cambridge, Mass.: Ballinger, 1977.

Parsons, J.E., D.N. Ruble, K.L. Hodges, and A.W. Small. "Cognitive-developmental Factors in Emerging Sex Differences in Achievement-related Expectancies." *Journal of Social Issues* 32 (1976): 47–61.

Pleck, Joseph H. *Working Wives, Working Husbands.* Beverly Hills, Calif.: Sage, 1985.

Plisko, Valena White, and Joyce D. Sterne. *The Condition of Education.* U.S. Department of Education, National Center for Educational Statistics. Washington, D.C.: U.S. Government Printing Office, 1985.

Rosenfeld, Sarah. "Sex Differences in Depression: Do Women Always Have Higher Rates?" *Journal of Health and Social Behavior* 21 (1980): 32–42.

Rossi, Alice. *Seasons of a Woman's Life.* Amherst: University of Massachusetts, Social and Demographic Research Institute, 1983.

_____. "Sex Equality: The Beginning of Ideology." *Toward a Sociology of Women.* Edited by Constantina Safilios-Rothschild. Lexington, Mass.: Xerox College Publishing, 1972. 344–53.

Safilios-Rothschild, Constantina, ed. *Toward a Sociology of Women.* Lexington, Mass.: Xerox College Publishing, 1972.

Scarf, Maggie. *Unfinished Business: Pressure Points in the Lives of Women.* New York: Ballantine, 1980.

Smith, Peter K., and Linda Daglish. "Sex Differences in Parent and Infant Behavior in the Home." *Child Development* 48 (1977): 1250–54.

Travis, Carol, and Carole Wade. *The Longest War.* 2d ed. New York: Harcourt Brace, 1984.

Treiman, Donald J., and Patricia A. Roos. "Sex and Earnings in Industrial Society: A Nine-Nation Comparison." *American Journal of Sociology* 89 (1983): 612–50.

Tucker, Ruth A. "Working Mothers." *Christianity Today* 32:10 (1988): 17–21.

Will, Jerrie A. "Neonatal Cuddliness and Maternal Handling Patterns in the First Month of Life." *Dissertation Abstracts International* 38 (1978): 6128–29B.

Yankelovich, Daniel. *New Rules: Searching for Self-fulfillment in a World Turned Upside Down.* New York: Bantam, 1981.

For Further Study

Discussion Questions and Writing Suggestions

1. How does your experience of gender roles in your family compare with the analysis of society that is provided in this chapter?

2. Are gender roles an issue in your local church? If so, how are conclusions being drawn? What is the role of Scripture in the discussions? What is the role of culture?

3. How do you view your life chances as a male or female in the changing environment described in this chapter? What concerns you most about the role changes taking place?

4. What are the underlying values that allow you to respond the way you do to the women's issue or any other social concern? What value do you place on people?

5. What do you find most disturbing in this chapter in terms of women's issues? Would change be required on your part to resolve this feeling of being disturbed? Can you make such a change?

Research Topics

1. The call of women to ministry

2. The majority as minority

3. The political economy of women in the welfare system

4. Changing definitions of masculine and feminine

5. Whose kids are they anyway? Changing women's roles and child rearing

6. Women in the workplace: the impact of a massive social change

7. Changing women's roles and their impact on traditional men's roles

8. Confusion in the aisles: the impact of society on the local church regarding women's issues

9. The nuclear family: God's idea or society's, and how the new role of women has changed it

10. Why must women work?

11. House husband: A new role for American men

12. What men have to lose: church politics and the equality of women in ministry

13. The impact of feminism on American society: whose life hasn't been changed?

Shorter Reading List

Boxer, Marilyn J. "For and About Women." *Signs.* 7:2 (1982): 661–95.

Erickson, Joyce Quiring. "Women in the Christian Story." *Cross Currents* Summer 1977: 183–253.

———. "Let Us Now Praise Women." *The Reformed Journal* May 1986: 6–11.

Gilder, George. "The Princess's Problem." *National Review* 28 February 1986.

Goldman, Daniel. "Psychology Is Reviewing Its View of Women." *New York Times* 20 March 1984: C1+.

Grossholtz, Jean. "Battered Women's Shelters and the Political Economy of Sexual Violence." *Families, Politics and Public Policy.* Edited by Irene Diamond. New York: Longmans, 1986.

Hardesty, Nancy, et.al. "Evangelical Feminism." *Post American* August–September 1974.

Hardesty, Nancy. "Whosoever Surely Meaneth Me: Inclusive Language and the Gospel." *Christian Scholar's Review* 17 (March 1988): 3.

McLaughlin, Eleanor. "The Christians Past: Does It Hold a Future for Women?" *Woman-Spirit Rising.* Edited by Carol Christ and Judith Plaskow. New York: Harper & Row, 1979.

Moulton, Janice. "The Myth of the Neutral 'Man.'" *Feminism and Philosophy.* Edited by Mary Vetterlingen-Braggin et al. Totowa, N.J.: Rowman & Littlefield, 1977.

Shakesshaft, Carol. "A Gender at Risk." *Phi Delta Kappan* March 1986: 499–503.

Steinem, Gloria. "Why Young Women Are More Conservative." *Outrageous Acts and Everyday Rebellions.* New York: Rinehart and Winston, 1983. 211–18.

Wall, Robert. "Wifely Submission in the Context of Ephesians." *Christian Scholar's Review* 17 (March 1988): 3.

Westkott, Marcia. "Feminist Criticism in the Social Sciences." *Harvard Educational Review* 49:4 (1979): 422–30.

Longer Reading List

Friedan, Betty. *The Feminine Mystique.* New York: Dell, 1974. The book that started it all—the women's movement, that is.

Hardy, Thomas. *Far From the Madding Crowd.* (1874; reprint, New York: St. Martin, 1978). A novel filled with observations about women made by men of the late-nineteenth century.

Hunter, John Davidson. *Evangelicalism: The Coming Generation.* Chicago: University of Chicago Press, 1987. A survey of the "coming generation" of evangelicals and their attitudes on a wide range of issues.

Hurley, James. *Man and Woman in Biblical Perspective.* Grand Rapids: Zondervan, 1978. A survey of biblical passages in the context of traditional male and female roles.

Martin, Faith. *Call Me Blessed.* Grand Rapids: Eerdmans, 1978. A solid and comprehensive examination of women's issues for the Christian.

Mickelsen, Alvera, ed. *Women, Authority, and the Bible.* Downers Grove: InterVarsity, 1986. A collection of writings by prominent evangelicals on the women's issue; a variety of perspectives.

Tucker, Ruth A., and Walter L. Liefeld. *Daughters of the Church: Women and Ministry From New Testament Times to the Present.* Grand Rapids: Zondervan, 1984. A history of women in the church and in society from the New Testament to the present.

8

Prelude to Equality:
Recognizing Oppression

Sarah J. Couper

INTRODUCTION

Objectivity is at best an elusive perspective; how one views the world depends a great deal on personal experiences and one's position in life. Although I cite many statistics in this chapter, your own position and perspective relative to the issues raised is probably just as important as understanding the objective information. Before we get to the issues at hand, therefore, I want to explain to you some of the reasons why I, as a white, well-educated woman of relative privilege, believe so deeply that women continue to be discriminated against in America and why I am a proponent of women's rights.

While doing research for this chapter I started to think back through the generations of women in my family, wondering for the first time what kinds of connections my beliefs and positions might have to the history of my family. I was surprised to find many links. My maternal great-grandmother divorced my great-grandfather on grounds of adultery at a time when divorcées were ostracized regardless of the circumstances. She had to fend for herself. Later, when she became ill and bedridden, her only child, my grandmother, bore significant responsibility for the care of the home and of her mother—coming home from school at midday to give her lunch.

My paternal grandmother was one of many children, most of whom were boys. Her parents allowed the girls the unusual privilege of being able to attend college, but only on the condition that they train to become teachers. My grandmother had no intention of

teaching, and with the help of one of her brothers, managed to convince her parents that she was in college when, in fact, she had gone to the West Coast and was working. She returned after about a year, married, had children, and stayed home to raise them. Then when she was in her forties she was suddenly widowed and found herself alone with two children to raise. I remember her telling me that when she went on job interviews, if she didn't know how to do something like type or keep books, she would say that she did and then spend the first few days on the job secretly teaching herself.

My own mother has worked as a registered nurse most of her adult life and in fact provided a much more stable income than my father did during the last few years of their marriage. When she decided to divorce, she needed a small loan to cover a security deposit, the expenses of moving, etc. The bank where she had long been a customer told her that she was too much of a risk because as a woman she might get pregnant and not be able to work. (As if that had stopped her three times before!) As a twelve-year-old, hearing information like that and feeling its effects, I was left with a lasting impression about power—who has it, who does not have it, and why.

In spite of all this history, I did not fully recognize the extent of gender discrimination in our society until much later, after I had taken a master's degree in social work and had worked in programs for sexual-assault and domestic-violence victims in New York City. On the other hand, my sister and my mother who have not been in close contact with abused women do not understand nor do they see the necessity in advocating women's rights as I do. Thus, while personal experiences in themselves do not determine the way we look at things, they do play a significant role. The greatest challenge we all face when working with new material is to keep our minds open, even when our way of looking at the world seems threatened. Discrimination is a threat whether we recognize it or not, but recognizing it and naming it gives us a way of dealing with it.

The purpose of this chapter is not to provide a technical analysis of public policies, the assumptions behind them, and their effects. Rather the purpose is to establish for those who may still be doubting, that discrimination does exist, and to serve as a catalyst for readers who are new to the material to ask questions and to think further about sexism and what its existence in our society means for them.

THE FEMINIZATION OF POVERTY

Before we begin talking about the feminization of poverty, let's be clear about poverty in general and who we are talking about when we

talk about "poor people." Stop and give some thought to your image of the average family on welfare. Now compare your image to these facts:

- The most typical size of welfare families is one adult and one child; the next most typical size is one adult and two children;

- Only about one-third of poor families get help from federal cash-welfare programs. Most poor people do not get welfare, nor have they ever.

- Nearly two-thirds of poor families have wage earners and pay taxes.

- About 60 percent of the poor receive some help from in-kind benefits (food stamps, Medicaid, housing). Forty percent do not receive these benefits.

- The average amount of time spent on welfare is about two years, with half of the families getting off AFDC [Aid to Families with Dependent Children] within one year. For most families, welfare means help during a crisis (serious illness, loss of a job, desertion), or a supplement to low wages. Many of those helped during a crisis never need welfare again; the country is full of welfare success stories.

- Average food stamp benefits amount to $.50 per person per meal.

- Programs for poor people (cash welfare, food stamps, subsidized housing, education, etc.) represent less than 10 percent of federal spending (7 percent by some estimates). These programs are not the major cause of the federal deficit, and cutting the programs will not save enough dollars to significantly reduce the deficit.

- Benefits to families on AFDC remain well below the poverty level in most states. (Amidei. qtd. in *NASW News* 12).

The term "feminization of poverty" is now widely used and in this chapter it indicates the social and economic structures that keep women economically dependent on men. Yes, women have made great strides in this country in the last century. We can own property, testify in court, establish a business, and vote. But the attitudes and values that made it illegal for women to do those things not so many years ago still prevail, sometimes in very subtle forms. And because of the way our society is structured, because of public policies both explicit and implicit, women are more likely to be poor than are men.

The U.S. Census Bureau's recent report on poverty confirms this: The rate of poverty for all people rose from 13 percent in 1980 to 13.5 percent in 1987; for single female heads of households the rate rose from 36.7 percent to 38.3 percent. Women not only represent a greater

proportion of those with incomes below the poverty line, but they are also becoming poor at a greater rate than men. Remember, too, that when we talk about women and poverty, we're also talking about the children who live with them. In the same report, the U.S. Census Bureau reported that in 1980 17.9 percent of children under the age of eighteen lived in poverty and that by 1987 that figure had risen to 20.6 percent (U.S. Bureau of the Census 27). Because their mothers are poor, these children, over thirteen million of them, are more susceptible to health problems, will live shorter lives, have fewer educational opportunities, and become victims of abuse and neglect more than if their mothers were not poor (Hewlett 109).

When reading facts like these most caring people feel that something ought to be done and ask, "Don't we have programs to help all these people living in poverty?" Aid to Families with Dependent Children (AFDC) is the major source of financial assistance to poor families. Yet, eligibility is not based solely on a family's income; it is also based on the father's absence (due to death, continual absence, physical or mental incapacity) and in some rare cases, his unemployment. As Beeghley points out, this program is antifamily in orientation in as much as it is not intended to support intact poor families (49). Neither has increased welfare spending caused or encouraged the increase in single female-headed households and out-of-wedlock births as some believe. Women on welfare do not have children to gain additional benefits. In fact, while overall welfare expenditures have increased, the benefit levels that families receive have decreased and the rate of out-of-wedlock births has increased, especially among whites who are outnumbered by blacks on the welfare rolls (Wilson 67–78). "There is little evidence to provide a strong case for welfare as the primary cause of family break-ups, female-headed households and out-of-wedlock births" (Wilson 90). Wilson and Wright-Edelman, among others, argue that the increase of women and children among the poor is primarily a result of joblessness among men (particularly black men), which in turn reduces their eligibility as husbands.

Further, as Beeghley explains, the design of the AFDC program keeps its beneficiaries poor by discouraging their entry (or reentry) into the labor force. The federal eligibility requirements were tightened by the Reagan administration to the extent that it is nearly impossible for AFDC recipients in most states to work while also receiving benefits, even if their total income remains below the poverty line. "Thus, a woman with three children who gets a full-time job at the minimum wage of $6,968 yearly, is automatically ineligible [for AFDC] in twenty-seven states. . . . Her income, by the way, is only three-fourths of the poverty line and in most states she would be ineligible for Medicaid" (52). With policies like these the dangers of

welfare dependency are all too real, but hardly because recipients are lazy and would rather not work; welfare dependency is a problem only to the extent that many women cannot make as much money from a full-time job as they can from welfare. The mistaken belief that these welfare mothers are dependent is not really the issue because when women marry, stay home and raise their children, or perhaps even earn their own modest incomes and yet remain "one man away from poverty" (i.e., dependent), the situation is perfectly acceptable.

WORKING WOMEN

Now that it is no longer legal to discriminate based on gender, either in hiring or in determining wages (Equal Pay Act, 1963 and Title VII of the Civil Rights Act, 1964) women have made remarkable progress in fields previously closed to them. Between 1962 and 1982 representation of females in the field of engineering rose from 1 to 6 percent; among mail carriers, 3 to 17 percent; among physicians 6 to 15 percent; and among bus drivers from 12 to 47 percent (Hewlett 75). Figures for 1986 indicate that women constitute 44 percent of accountants, 31 percent of mathematical and computer scientists, 18 percent of physicians, and 17 percent of lawyers (New York State Division For Women 7).

Nevertheless, most women remain segregated in pink-collar jobs (teachers, secretaries, nurses), earn less than men, are promoted less often even when working at the same job, and are penalized in the job market because they maintain dual responsibilities at work and home. In 1984 over forty-eight million women participated in the paid labor force; only 7 percent were in managerial positions and only 10 percent earned incomes over $20,000 yearly (Hewlett 71). Estimates of women in upper management positions are between 1 and 2 percent; 25 percent are in middle-management positions and 50 percent are in entry-level management jobs (Hewlett 74).

Most people respond to facts like these with what is known as the human capital theory: If women were as well educated and well trained as men, if they produced as much as men, if they performed as well as men and showed as much commitment—if they were as good as men, such inequalities would not exist in what is purported to be a free market. But clearly "there are some basic difficulties with this theory, including the fact that productivity is almost impossible to measure in some jobs, that wages do not reflect the entire reward paid for a job and that we do not have an open competitive market for all jobs" (Richmond-Abbott 325). The fact is that women who have

Table 1

WOMEN'S WAGES

Women's Earnings in the U.S. as a Percentage of Men's, by Age of Women

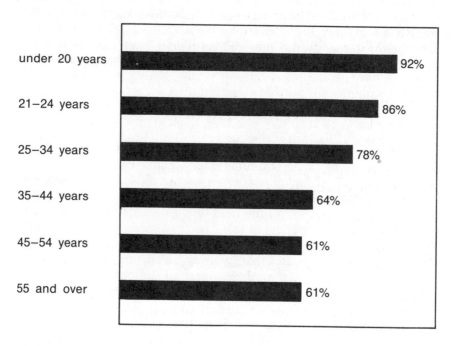

under 20 years	92%
21–24 years	86%
25–34 years	78%
35–44 years	64%
45–54 years	61%
55 and over	61%

SOURCE: Labor Department as reported in the *Wall Street Journal*, February 20, 1987.

completed four years of college earn less throughout their working years than men who have only completed high school (Hewlett 84).

Once hired, women still earn only a proportion of what men earn, and as Table 1 shows, that proportion decreases with age. Men who work in jobs that are traditionally female earn an average of $1,200 more than women in those jobs, and women who work in jobs that are traditionally male earn an average of $2,400 less than their male peers. The average salary for all physicians, for example, according to the American Medical Association, is $75,000, but for female physicians, that figure drops to $45,000 (Richmond-Abbott 328).

If a woman is able to get into the job arena and stay there, overcoming these obstacles, the difficulties inherent in trying to have children and maintain a career, will put tremendous strain on her and may very well prevent her from pursuing her career, at least at the same level. Taking care of children can be a formidable and exhausting job by itself. It is important to note that most women work because they have to—choosing to work is only rarely a true choice.

Twenty-three percent of women who work are single; 19 percent are widowed, divorced, or separated and are their families' main support; and 26 percent are married to men who earn less than $10,000 a year (Richmond-Abbott 329).

Fewer than 20 percent of American families fit the stereotyped model of a male wage earner and a female mother/homemaker, and more than 60 percent of women with children under age fourteen are working (*Wallis* 54). Yet ours is the only industrialized country that does not have structural supports to help women participate in the nation's economy while also raising children. For example, America is the only industrialized country that does not have a statutory maternity-leave policy. The *one* federal provision in existence, the 1978 Pregnancy Disability Amendment to Title VII of the Civil Rights Act, prohibits employers from firing because of pregnancy. Thus, a pregnant woman is entitled to the same disability coverage as her co-workers, but not to other benefits. Federal law, however, does not require employers to have disability insurance and even in the five states that do require disability insurance, such as New York, government workers, farm workers, and organizations with fewer than fifteen employees are exempt from the requirement. So, what the law provides is an average of six to ten weeks leave with partial earnings and even then it is a law that cannot be enforced for all employees. Further, not a word is mentioned in this law about job protection should a woman choose to take unpaid leave beyond the amount of time covered by disability (Hewlett 92).

One hundred and seventeen other countries, most with many fewer resources than the United States, guarantee women the right to fully or partially paid job-protected leave from work for childbirth. In Italy women are entitled to five months leave at 80 percent earnings plus six months at 30 percent and they are given two years seniority for each child they bear (Hewlett 96). In Sweden, families are given twelve months maternity leave, the first six of which are reserved for the mother who is paid at 90 percent of her salary. Israel gives mothers twelve weeks paid leave and forty weeks unpaid leave, and the Soviet Union gives mothers four months leave at 100 percent earnings and up to twelve months at 25 percent (*Wallis* 60).

It is clear from the policies of other countries that supporting women through pregnancy and their children's first months could be done in the United States if it were a priority. Likewise child care at affordable prices could be made available if it were considered important. A truly "pro-family" government would take these steps.

The situation for women does not necessarily improve as women age. Retirement benefits, including Social Security, are based on earnings, so because women earn less than men, they will retire on

less. Also because women live longer than men, they have to live on less for a longer period of time.

Women have become an integral part of the economy, both their families' and the nation's. To continue to demand that women bear the dual responsibility of home and work without structural supports (equal pay for equal work, maternity leaves, job protection, and day care among others) is oppression. It keeps women poor and dependent on men for economic viability. One wonders whether our public policies were really designed to *aid* the poor or to *keep* them poor. Regardless of what the original purpose may have been, current public policies maintain the base of power where it is—out of the hands of women.

DOMESTIC VIOLENCE

One of the more brutal ways in which our society permits and even condones the oppression of women is through domestic violence. The term itself is somewhat inaccurate because by qualifying the word "violence" with such words as "domestic," "family," or "spousal," there is an implication that it is not true violence, that it is not that bad, and that it is not criminal. In fact, battering is the single major cause of injury to women, exceeding rapes, muggings, and even auto accidents (U.S. Attorney General 11).

Contrary to popular belief, battering is not restricted to any ethnic, economic, or racial group, nor are batterers necessarily mentally ill or alcoholic. Families with low incomes get more attention from police, hospitals, and social service agencies "because they have less privacy and fewer private resources than families with higher incomes," and are thus more likely to show up on official records and statistics (National Institute of Justice 3).

Gathering data about so-called domestic violence is difficult because it is thought to be a private family matter. Additionally, many men and women terminate their relationships over violence; yet most of the data collected focuses on marriage relationships that have remained intact (Gelles *Family Violence* 32), so many statistics on the subject are considered underestimates. In spite of that, some of the available figures are staggering:

- The National Institute of Justice estimates that well over two million people are beaten by their spouses each year (7).

- Almost one-third of all female homicide victims are killed by their husbands or boyfriends (U.S. Attorney General 11).

- Among all women, 2 in 1,000 contemplate suicide; among battered women, the figure jumps to 46 in 1000; of those who considered taking their lives, 34 in 1,000 go on to attempt suicide (Gelles and Straus 138).

- Fifty to sixty percent of U.S. couples have suffered at least one violent incident and 10 to 25 percent experience violence regularly (Gelles *Family Violence* 35–36).

Women have long been considered the property of men and battering has been an accepted norm for centuries. (The phrase "rule of thumb" evolved out of the notion that men could and, in fact, *should* beat their wives if they were not compliant—but only with a stick as wide as one's thumb and no wider.) As women have gradually gained increasing control over their lives, physical abuse in the home has come to be seen for what it is: criminal abuse of power. During the women's movement of the 1970s, battered women and their advocates began to fight back and develop shelters for abused women (cf. Schecter). In the process, justice and law-enforcement systems have had to examine and modify their concept of battered women that had developed around the assumption that victims are equal partners in abusive relationships. In spite of these and many other changes, the perennial question is asked: "Why do they stay?"

To answer that question, we have to look at the dynamics which operate in families or other relationships that cause abuse. It should be noted that violence occurs in all kinds of relationships—among people who are dating, gay, married, cohabiting, separated, or divorced and who may or may not have children in common. Violence and abuse against the aged by their children or other relatives is also increasingly recognized. Most violence, 95 percent of it, is perpetrated by men on women (Bureau of Justice Statistics, 1986). For that reason and because this chapter is about women's rights, I will use the pronoun "she" when referring to survivors of family violence.

Whatever the relationship, when power is abused, the abusive partner generally manipulates many aspects of the other's life. Many battered women are prohibited from having contact with friends and family, or are permitted to have such normal supportive contacts only under highly prescribed circumstances. A woman's work outside the home tends to be a source of tension (if it also is not prohibited). The couple's financial matters and sexual life are all under the abusive partner's control. Gradually, the woman finds herself isolated from friends and family and has little if any control over even the small details of her own life. She is disempowered, she has lost self-esteem and has no confidence that she can make it on her own.

What further complicates the situation is that the bad times are

mixed in with the good. There is a cycle to the tension and violence that occurs in three stages. The first stage is the time during which tension grows: the abuser is critical and verbally abusive, often humiliating his partner. She is afraid and accepts his behavior, hoping it won't escalate. The second, or explosive, stage is the point at which the batterer becomes violent. The final stage is the repentant stage. The abuser, often in the face of injuries he has caused (bruises, burns, broken bones), is afraid his partner will leave him. He becomes repentant, genuinely regrets his actions, and is much more loving and promises to change (Walker 95–97). The existence of violence in a relationship does not preclude the existence of positive feelings. When they coexist, however, leaving or remaining in the relationship are both difficult options, particularly so for women who have been traumatized, stripped of self-esteem, and isolated from friends and family.

Research has shown that women stay in violent relationships because they have low self-esteem and confidence; they believe their husbands' promises to change; they have financial considerations (which become more weighty when children are involved); they fear the stigma of divorce; and they experience the difficulties of working while still having children at home (Gelles *Family Violence* 97). Notice that masochism is not included in this list. Most of the reasons for staying have to do with lack of power, lack of access to resources, and a feeling of being trapped in the relationship. The question ought not be "Why do they stay?" but rather, "How do so many manage to leave?"

Unfortunately, the legal system, in conjunction with the economic and social pressures of our patriarchal society, has failed battered women who are trying to flee from abusive relationships. If a woman is able to get to a phone and call the police, by the time they arrive the abuser has calmed down and begun to apologize, has threatened her about what he will do to her if she tells the police the truth, or has left. In any of these cases, it is difficult for the woman to press charges. Police have been reluctant to arrest, and have even been known to refuse to arrest a batterer especially if the woman has no noticeable injuries. Tracy Thurman's case provides a graphic illustration of the problem police face when responding to domestic dispute calls. Ms. Thurman and her child had gone to a friend's house. When her abusive husband went to that house demanding to see her, she called the police. Just before the police came she went outside to talk to him and was stabbed thirteen times, primarily in the chest, neck, and throat. When the police arrived her husband was standing over her body holding the knife. Then with the police looking on, he proceeded to kick her in the head until she was unconscious. She somehow

survived the injuries, took the Torrington, Connecticut, Police Department to court on charges of neglect, and won. Because of cases like this and because of research indicating that police response to family violence can reduce subsequent violence (Bureau of Justice Statistics, 1986; Berk and Sherman, 1984), the New York City Police, among others, are required to make an arrest if a severe injury has occurred and whenever the woman requests an arrest.

But certainly arrest does not provide the whole answer. Men are generally released within twenty-four hours of being arrested and Orders of Protection, otherwise known as "restraining orders," provide minimal protection. The process of getting one requires a woman to appear before a judge—a complicated, intimidating procedure. The order prohibits the batterer from assaulting the complainant. It also prohibits, in varying degrees, contact with her and any children involved but the strength of the order depends on the severity of the abuse and the complainant's knowledge of her rights and ability to advocate for herself. Even then, an Order of Protection is merely a piece of paper and cannot in itself prevent further violence. An added risk for women is that some men are incensed to further violence when confronted with an Order of Protection.

The number of shelters for battered women has increased tremendously in recent years, but even this increase does not come close to meeting the need. Shelters provide emergency, that is, temporary, refuge and often are in the unfortunate position of having to turn women away due to lack of space. While in a shelter women must find a job and an apartment, perhaps follow up on assault charges or divorce and custody negotiations, change their children's school, etc. Women who work often have to leave their jobs. They must recreate their lives and hope their batterers do not find them in the process, which makes the providing of references and the checking of credit histories problematic. In New York City, the maximum shelter stay is ninety days. Because of the enormous housing crisis there, the task of finding an affordable apartment is difficult for nearly everyone and more so for women who must also do all of the other things mentioned, while at the same time recuperating from what may be years of trauma.

Until recently, it was commonly thought that if a woman had been a better wife, more supportive, and more responsive to her partner's needs, he would not have had to beat her. But what we have learned from women is that abusers beat capriciously—because the chicken is baked or because the chicken is fried, because the children are in bed or because they're still awake. Whatever it is that sets an abusive partner off is beside the point. He probably would *not* hit a co-worker or a stranger on the street. If he did there would undoubtedly

be negative consequences and no one would blame the victim. However, some people indirectly blame women by focusing on their passivity and learned helplessness as the problem. But make no mistake—these women are courageous. What outwardly may seem to many like passive acts, such as calling a friend for help or saving small amounts of money without her partner's knowledge, are in fact very courageous acts under the circumstances.

For years researchers have tried to find out why families are abusive. Among the factors found to be associated with, though not necessarily causes of, violence in relationships are: history of childhood abuse, economic and social stress, isolation, and alcohol and drug abuse. Richard Gelles, who has done or been involved with much of the research and theorizing himself, has stated that all he knows for sure is that "people abuse family members because they can" and until there are enforceable negative consequences to the abuse, it will continue (Gelles *Unhappy Families* 5–6).

Victim Services Agency produced a video in 1987 as part of training seminars for Law Enforcement Executives on Domestic Violence Policies. While making that video, the following exchange between a domestic violence victim and a police officer was found in the Newport News Police Department's files. It vividly illustrates the degree of power that batterers wield over their partners, the degree of courage that women often exercise in defending themselves, and the extent to which police as well as others must be trained to go in order to begin to adequately respond to a situation where power is being abused.

Police Officer: This is Newport News Radio Dispatcher 86.

Woman: Yes, I want the Police to 395 (street address).

P.O.: O.K. what's going on there? . . . Hello?

Woman: No, I'm sorry, disregard that, O.K. I'm just angry.

P.O.: Ma'm?

Woman: No, it's O.K., honest.

P.O.: Who else is there with you?

Woman: No, it's all right, please.

P.O.: You sounded very upset when you called.

Woman: I know . . . it was. . . . I'm having a temper tantrum. I'm sorry.

P.O.: Are you sure you don't need the police?

Woman: Positive.

P.O.: O.K. ma'm.

Woman:	O.K., bye.

—LATER—

Man:	Hello?
P.O.:	Hello, this is Newport News Police Communications.
Man:	Yeah?
P.O.:	I was talking to a lady there—is this 395 (street address)?
Man:	Yeah.
P.O.:	May I speak to the lady I was talking to a minute ago?
P.O.:	Hello?
Woman:	Yes?
P.O.:	Ma'm, I was just a little concerned about your welfare. This is the Police Dispatch Center.
Woman:	Uh-huh?
P.O.:	Are you sure you don't need the police?
Woman:	No sir, I was just having a temper tantrum and I was mad.
P.O.:	O.K. ma'm, if you really don't need us tell me a number between one and five.
Woman:	O.K.—six.

THE CHURCH'S RESPONSE

Christian theology has, until recently, been based on a patriarchal system of authority. For the most part, the church has not been able to support feminism, for to do so would threaten its theology and its way of looking at the world. As a result, the church is among those institutions that have perpetuated the oppression of women. It is only in very recent history that positions of leadership in the church have been opened up to women, and then only in some churches. I do not mean to cast blame though, because the church evolved and grew within cultural contexts that did not support women's rights, and consequently it saw no reason to do so. Much as we hate to admit it, we are all to some extent products of our environment and so is the church.

Neither am I apologizing for the church. The Bible is replete with

directives to care for poor and marginalized people. The way I read the Bible, we are not responsible just to care for people *after* they have become poor and disenfranchised; we are called to help recreate our world in such a way that compassion precludes poverty and violence. I don't mean to say that that is an easy task. Before we can refashion our world we must first envision it, and even that is difficult at times. It is difficult for everyone, including feminists, to move away from known entities and forge new territory, but it must be done. The world has changed and so must our ways of living in it. With the fresh perspectives on the Bible that liberation theologians and feminist scholars have been developing, attitudes and behavior are slowly starting to change. As discouraged as I sometimes get about women's status in our society, I think that some major changes are close at hand, and this is an exciting and challenging time to be a feminist *and* a woman of faith.

Works Cited

Attorney General's Task Force on Family Violence. *Attorney General's Task Force on Family Violence.* Washington, D.C.: Department of Justice, 1984.

Beeghley, Leonard. *Living Poorly in America.* New York: CBS Educational and Professional Publishing, 1983.

Berk, R.A., and Lawrence Sherman. "The Specific Deterrent Effects of Arrest for Domestic Assault." *American Sociological Review* 49 (1984): 261–71.

Bureau of Justice Statistics. *Preventing Domestic Assault Against Women.* Washington, D.C.: Department of Justice, 1986.

Gelles, Richard J. *Family Violence.* Beverly Hills: Sage, 1979.

———. "Family Violence: What We Know We Can Do." *Unhappy Families.* Edited by Eli Newburger and Richard Bourne. Littleton, Mass.: PSG Publishing, 1985.

Gelles, Richard, and M. Straus. *Intimate Violence.* New York: Simon & Schuster, 1988.

Hewlett, Sylvia Ann. *A Lesser Life: The Myth of Women's Liberation in America.* New York: Warner, 1986.

National Association of Social Workers. "Safety Nets in Shreds." *NASW News* July 1988: 12.

National Institute of Justice. *Confronting Domestic Violence.* Washington, D.C.: Department of Justice, 1986.

New York State Division for Women. *A Bigger Piece of the Pie: The Emerging Role of Women in the New York Economy.* New York: New York State Division for Women, 1987.

Richmond-Abbott, Marie. *Masculine and Feminine: Sex Roles Over the Life Cycle.* New York: Random House, 1983.

Schecter, Susan. *Women and Male Violence: The Visions and Struggles of the Battered Women's Movement.* Boston: South End Press, 1982.

Straus, Murray, Richard Gelles, and Susan Steinmetz. *Behind Closed Doors: Violence in the American Family.* Garden City, N.J.: Anchor/Doubleday, 1980.

United States Bureau of the Census. *Money, Income and Poverty Status in the U.S., 1987*. Washington, D.C.: United States Bureau of the Census, 1988.

Walker, Lenore. *The Battered Woman Syndrome*. New York: Springer, 1984.

Wallis, Claudia. "Who's Bringing Up Baby?" *Time* 22 June 1987: 54–60.

Wilson, William J. *The Truly Disadvantaged, The Inner City, The Underclass and Public Policy*. London: University of Chicago Press, 1987.

Wright-Edelman, Marion. *Families in Peril: An Agenda for Social Change*. Cambridge, Mass.: Harvard University Press, 1987.

For Further Study

Discussion Questions

1. Why do you think people in poverty aren't able to get out of poverty or find it extremely difficult to do so?

2. What role, if any, should churches take in helping poor and abused women? Do you know of any support programs in local congregations? In your opinion, are they adequate?

3. Have you ever known anyone who came from a home in which there was violence? Did the family fit the stereotyped image? If the violence is no longer going on, how did it stop?

4. Before you read this chapter what was your image of a family on welfare? Has that image changed? Why or why not?

Writing Suggestions

1. Women have had the right to vote since the 1920s. Why haven't they been able to improve their status any more than they have?

2. Respond to the following: "Women, not men, bear children, and young children need their mothers. If women aren't willing to take this responsibility with all it means for their jobs, they shouldn't have children."

3. What is your church's attitude toward women and the women's movement?

4. Has your family ever experienced severe financial difficulty? What caused the difficulty and how did your family deal with it? How did you feel about it at the time it was happening? How do you think it has affected you?

Research Suggestions

1. How has the women's movement in America differed from that in Europe? Where do you think women are better off?

2. Examine several major Protestant denominations to find their programs of support for women in poverty or violent situations. Do their seminaries offer courses that deal with these?

3. Compare black and Hispanic women with white women regarding the issues in this chapter. Are there differences? How do you account for the differences?

4. Research day care—availability, cost, non-traditional alternatives, how children are affected by being in day care. What do you think the government's response should be to the issues involved in day care?

5. What services for domestic-violence victims are available in your community? Do services meet the need? What are your police department's and district attorney's policies on domestic violence and what is your assessment of them?

Shorter Reading List

Gelles, Richard, and M. Straus. *Intimate Violence.* New York: Simon & Schuster, 1988. Chapter 1 "Because They Can."

Morey, Ann-Janine. "Blaming Women for the Abusive Male Pastor." *Christian Century* 5 Oct. 1988: 866–69.

NiCarthy, Ginny. *The Ones Who Got Away.* Seattle: Seal, 1987. Any 3 biographies.

Oakley, Ann. *Subject Women.* New York: Pantheon Books, 1981. Chapter 13 "Power."

Schaef, Anne Wilson. *Women's Reality.* Minneapolis: Winston, 1981. Chapter 1 "Fitting In: The White Male System and Other Systems in Our Culture" and Chapter 7 "An Introduction to Female System Theology."

Sidel, Ruth. *Women and Children Last.* New York: Viking, 1986. Chapter 2 "The New Poor."

Longer Reading List
Poverty/Economy

Beeghley, Leonard. *Living Poorly in America.* New York: CBS Educational and Professional Publishing, 1983.

Ferguson, Kathy. *The Feminist Case Against Bureaucracy.* Philadelphia: Temple University Press, 1984.

Hewlett, Sylvia Ann. *A Lesser Life: The Myth of Women's Liberation in America.* New York: Warner, 1987.

Kammerman, Sheila, and Alfred Kahn. "Income Maintenance, Wages and Family Income." *Public Welfare* 3 (1983): 23–48.

Phillips, Ann, ed. *Feminism and Equality.* New York: New York University Press, 1987.

Sidel, Ruth. *Women and Children Last.* New York: Viking, 1986.

Wilson, William J. *The Truly Disadvantaged, The Inner City, The Underclass and Public Policy.* London: University of Chicago Press, 1987.

Wright-Edelman, Marion. *Families in Peril: An Agenda for Social Change.* Cambridge, Mass.: Harvard University Press, 1987.

Violence

Finkelhor, David, and Kersti Yelo. *License to Rape.* New York: Holt Rinehart and Winston, 1985.

Finkelhor, David, Richard Gelles, and Murray Straus. *The Dark Side of Families.* Beverly Hills: Sage, 1983.

Gelles, Richard. *Family Violence.* Beverly Hills: Sage, 1979.

Gelles, Richard, and Murray Straus. *Intimate Violence.* New York: Simon & Schuster, 1988.

Newburger, Eli, and Richard Bourne, eds. *Unhappy Families.* Littleton, Mass.: PSG Publishing, 1985.

NiCarthy, Ginny. *The Ones Who Got Away.* Seattle: Seal, 1987.

Schecter, Susan. *Women and Male Violence.* Boston: South End Press, 1982.

Schur, Edwin. *Labeling Women Deviant: Gender, Stigma and Sexual Control.* Philadelphia: Temple University Press, 1983.

Straus, Murray, Richard Gelles, and Susan Steinmetz. *Behind Closed Doors.* Garden City: Anchor/Doubleday, 1980.

The Church

Carmody, Denise Lardner. *Seizing the Apple: A Feminist Spirituality of Personal Growth.* New York: Crossroad, 1984.

Fiorenza, Elizabeth Schüssler. *Bread Not Stone: The Challenge of Feminist Biblical Interpretation.* Boston: Beacon, 1984.

Morey, Ann-Janine. "Blaming Women for the Abusive Male Pastor." *The Christian Century* 5 Oct. 1988: 866–69.

Oseik, Caroly. *Beyond Anger: On Being a Feminist in the Church.* New York: P ulist Press, 1986.

Schaef, Anne Wilson. *Women's Reality.* Minneapolis: Winston, 1981.

9

Encounter With Women's Spirituality

Roger M. Evans

To show great love for God and our neighbor we need not do great things. It is how much love we put in the doing that makes our offering something beautiful for God. —Mother Teresa

How is it possible for me, a man, to understand women's spirituality? And if I could, why should I want to? I'm not a woman; indeed as a man I am one of those whom some radical feminists would label their oppressors. As a member of a minority group—men—I am for them not unlike what the white ruling class of South Africa is for the blacks, holding the majority group in our society in subjugation. As one of the ruling party, I am the possessor of power, one in control and in a position to dominate the culture. I have held this place in human history prepared for me over the millennia simply by virtue of my gender. I have not encountered the pain of marginalization or the loneliness of being the outsider such as that known by Hagar in the Old Testament, who experienced total exclusion from her community, including her ancestry and history, the community of wives and other women, the community of relationships, and the community of legacy and descendants (Ochs 34–40).

When I began this study as a participant in The King's College Women's Studies Group, I was attracted by the wonderful opportunity to engage in a stimulating, collegial study of a subject, in this case women, that I thought would be accompanied by the usual comfortable speculation and generalizing. I soon became aware, however, that what I was beginning would be much more than that. It quickly assumed the character of what, at the time, I thought of as a spiritual

quest. For I discovered that I could never be satisfied with less than entering as fully as possible the world as women see it, as they have experienced it, and as they have named it. I needed to listen to their story and to understand it as it related to my story.

How then could I make my approach? I was feeling the pressure of the demands, constraints, and expectations that were placed on me, and I was becoming concerned about my feelings, which were becoming frayed by the constant tension caused by overextension. The work of the women's study group had an exhilarating, buoying effect, but it threatened to take on the weight of a task—of data processing that in the end would leave only a residual of cognitive and affective overload.

There were insights, struggles, discoveries. With each of these came a sense that I needed and wanted to tell others about it. What I was learning was *useful*, for it invested me with power and value. It afforded a measure of control over my world and satisfied, for the moment, my need to know. Surely, it could do the same for others.

I was determined not to be victimized by demands, expectations, and compulsions and thus tyrannize the study and the subject of the study. I resolved to be open and honest in my inquiry. I sincerely wanted to hear, to see, to feel, to understand. As I was grappling with where to begin, I recalled a lecture that I had heard given by Parker Palmer, whose book *To Know as We Are Known* I had also recently read. His work seemed to hold the clue I needed for structuring my approach to women's studies in general and women's spirituality in particular.

KNOWLEDGE AS TRUTH

Knowledge (which includes knowledge of women's spirituality), according to Palmer, springs from love and is committed to truth. Indeed, both knowledge and knowing have their being in love (9). Love, then, is not just a feeling but a category, a category through which I can view reality and in which I will live. As such, love will involve me and integrate me into the very fabric of life (Ochs 54).

In women's studies, then, it is love that will enable me to enter into the lives, the stories, and the experiences of women. It will not allow me to stand apart as a mere spectator. It will draw me in. It will "wrap [me as a knower] and the known in compassion, in a bond of awesome responsibility as well as transforming joy; it will call [me] to involvement, mutuality, [and] accountability" (Palmer 9). I will become interdependent with what I know.

The starting point for my study of women's spirituality was derived from Palmer's view of truth. It holds that:

1. Both men and women have their own integrity and otherness.
2. One party cannot and must not be collapsed into the other.
3. I must acknowledge and respond to the fact that the knower (me, a man) and the known (women) are implicated in each other's lives.
4. In committing to truth I enter into a covenant with women and other men to engage in a "mutually accountable and transforming relationship"—one "forged of trust and faith in the face of unknowable risks." (31)
5. Truth is not a concept that works, but an incarnation that lives. What my knowledge seeks is not a "verbal construct but a reality in history and the flesh," the Word (the Logos). Truth is embodied. (14)

As I pondered this approach to women's spirituality, it quickly became apparent that it was going to cost me. I would expend a great deal of energy because it would elicit strong emotional responses. It threatened to make me reshape my categories and concepts. And that in turn would force me to reconstruct my relationships and reexamine my self-understanding, my very identity.

CONTEXTS

I live in a culture and a society that value behavior reckoned by the bottom line. I have on many occasions felt the sanctions society can levy when I could not produce what it demanded according to its agenda and schedule and in the manner and form it required. Therefore, I have learned to measure myself, others, and my world by the same quantifiable rule that asks, How does it make me feel? How will it serve me? How useful is it? etc. I have become thoroughly performance-oriented. Hence, the nonacquisitive nature of spirituality is very hard to grasp. The idea that there is nothing that I can possess by "being spiritual" is completely alien. To think of being receptive, of waiting, of trusting causes my very being to revolt. When I am confronted by the scriptural affirmation that "in him we live and move and have our being" (Acts 17:28), I am left not knowing how to respond.

In the midst of the clamor of my days, I find it very difficult to find solitude, to be silent, to listen, to hear, to receive. No matter how much I may want it to be a part of me, reflection remains elusive. Re-creation is remote, an anomaly. The sometimes hated and cursed

distractions that push in upon me frequently become welcome, for they keep me disengaged and distant, and thus they sometimes provide a few moments of what on the surface appears to be serenity.

By keeping busy with external matters I can justify having neither the time nor the energy to engage my inner world or the world of others, especially the world of those so unlike me. I have good reason for remaining aloof and distant. Everyone understands why I can talk about women's studies only on a superficial level and why I always converse with women in a casual manner.

I've become quite adept at remaining safely on the fringe of dialogue, attending only to those parts of women's story that I find interesting and useful. I am able to refrain from having to make any responses that could either draw me out or draw me in. I can go on about my life and my business untroubled and unsullied—managing to escape from the need to clarify and perhaps revise my value system. The agility that I have acquired over the years keeps me safely away from any decision making that I am unaccustomed to. I am thankful that it also protects me from what I dread most, the need to change the way I live. I am, therefore, able to continue on, relatively risk-free.

Risk is a nasty four-letter word. It describes what I have frequently experienced as an intruder whose position and power are threatened. It represents the prospect of growth and gain but also the fear of encountering something that I might not understand. Lack of understanding brings anger and its twin, fear, to the surface as it threatens my ability to control.

Risk also requires that I become vulnerable. Being vulnerable cracks open the door to change. Change requires the relinquishing of hard-won, strategic position or status. That is something that I'm not going to relinquish without a fight, even though I know that change leads to growth and understanding and freedom and all those good things. I have to consider my security (my rights), my self-respect (it's taken a long time to gain it), my space (I've fought and sacrificed for it), and my possessions (I've earned everything I have).

My religious life has almost always provided me with the comfort and security that I wanted. Its rites and rituals dutifully delivered the experiences I sought for meeting my "felt needs," and they consistently presented programs aimed at ecstasy and the ever-higher levels of stimulation I crave. Rites of community were invariably directed toward the "exciting" and toward ways of getting me outside of personal life as I knew it. They encouraged me to seek experiences vicariously in the stories and adventures of others, and I rarely paid attention to individual, contemporary experience. Because I never learned to attend to my experiences, I never discovered what they had to offer me or others.

It has taken more than a little effort to begin to turn from the relief and escape that vicarious experiences and the quest for ecstasy provided from the humdrum routine of everyday existence—whether it was the church's promise of a pain-free religion of unbounded joy and eternal bliss beginning here and now or the seduction of television to mindless trysts with one-dimensional characters offering temporary deliverance. But I had to begin to become aware, to pay attention to what I was experiencing.

As I began to turn into my experiences instead of away from them, I started to sense them directly. I discovered how to name and own what was going on inside of me, how to face my past and present experiences, and how to confront my feelings (including my fears and anxieties). I began to claim for myself what belongs to me—my joy, my pain, my impulses, my anger—to come into a relationship with them. I started to act and live in relation to who I was becoming. As this pattern developed, I began to experience the dissipation of the need to resist and reject life patterns that I did not like and did not want to hear about.

My eyes began to see the beauty in the ordinary that had previously been obscured by my constant straining for the extraordinary, and my ears began to hear God speak in common things and in common ways. I began to move from the position of being an indifferent observer to being a witness to the dignity of the bent, aged woman sojourning on the park bench. I set to the work of freeing myself from the self-insulation constructed to fend off the banter of newscasters and learned to welcome the heralding of peace and hope exemplified by the baby sleeping at her mother's breast. My passion for the magnificent and the astounding is diminishing as I become able to gaze with reverence upon the majesty of the Hudson Valley and wonder at my daughter's smile. My compulsion to be on time and to have what I want *now* is being displaced by the gift of my wife's patience and gentleness as she teaches me to celebrate with her the changing seasons of our life together.

TRADITION

As I reflected on the intellectual tradition that I have inhabited during most of my adult life, I discovered that early on there was a nascent sense of being alienated from what I knew and how I knew. My education emphasized dividing up and separating (differentiation, analysis, etc.) and made only polite reference to unity (integration). It relegated transcendence to the esoteric, to things like "worship."

Hence, my way of knowing set me over and against myself, others, the world, and God.

Because I had learned to describe my relationships in terms of Kantian categories, I learned to love in time-bound ways and in quantitative ways. I was taught to think about love in terms of space, time, quantity, antecedent, and consequence rather than understanding each of them in terms of love. Therefore, my understanding of knowledge was restricted to that which enabled me to predict, manipulate, or control. This inevitably led me to experience life in a mechanistic way (Ochs 52). I was led to believe that the only way I could find truth was through my senses and logic. Reality was thereby reduced to the narrow terms of my limited capacity to know, and the world around me was forced into those limits (Palmer 12).

My schooling convinced me to equate reality with real estate. I was persuaded to view stories, poems, and religion—all of which involve conviction or devotion—as having little or nothing to contribute to my knowledge, because they "are not about the real world" (Palmer 24). It became impossible to see and experience the world as gift, for my way of knowing could not function as a channel for receiving and responding to a gift. Instead, I learned to control. I became skilled at asking for facts from God, the world, others, and myself, but I never came to *know* any of them.

My commitment to facts often led me on a quest for data, answers to foreclose on questions. This led to foreclosure on experience and ultimately on life. My impressive collection of facts easily provided me with my very own set of rules for playing "the game." With that collection I constructed a livable world for myself; I became quite adept at selecting just the facts, including the Scripture passages, that I needed.

Facts, of course, mount up and eventually develop into theory. I really loved theories! They put me in such a comfortable seat from which to view life. For quite some time, I thoroughly enjoyed being a spectator, keeping what was knowable "out there on stage." I experienced a certain feeling of ecstasy as I safely related to life at a distance. I became what Palmer describes as a "theatre goer." I could remain "free to watch, applaud, hiss and boo." But I never came to understand myself as "an integral part of the action" (23).

My spiritual tradition was strongly influenced by a preoccupation with the sentimental and the other-worldly. It attracted my gaze outward toward "the spiritual" (the extraordinary, the extra special, the world to come), keeping me from ever turning to see my need to celebrate another person or with another person. Even as I sat enraptured, listening to someone tell of the wonders of the world to

come, I felt a nagging fear that something was missing. What was missing was substance.

Notions of potential linkage between intellect and spiritual traditions were sparse. The proposition that spirituality could be a way of knowing was never proffered. Spirituality that was said to be centered in Incarnate Love was curiously never named as a way of knowing. Such a way of knowing, through compassion and love, extends an invitation to the knower to enter into the hope of reunification and reconstruction of self, the selves of others, the knower's world, and the world of others.

Wanting to be a good Christian, I became moderately skilled in *talking about* God's creation and about his truth. However, I never came to know much of it. I never entered into relationship with it in any substantial way. My way of knowing was fractured, and so was I. Fed by the notion that there is nothing that I could not know, though, I had every reason to be optimistic and confident. I developed a voracious appetite for knowledge. I tried to cram in every bit I could because it promised to give me what I needed and it could help me get what I wanted. But I was never satisfied. I was unaware that the knowledge that I came to possess also possessed me.

TEMPTATIONS

It was with this background and history that I came to women's studies and the particular subject of women's spirituality. I determined that if I was to engage in any kind of significant and meaningful study there were several tendencies that I would have to address. Remembering Parker Palmer's statement that "curiosity is an amoral passion, a need to know that allows no guidance beyond the need itself" (8), I resolved that my first concern had to be the avoidance of treating women's studies as a curiosity.

I began by acknowledging to myself that I am a consumer. Years of being subjected to the seductions and the bashings of the media have persuaded me that possessing things is not only the acceptable but also the desirable way of life. I learned my lessons well. That I *must* possess and that I *need* to know became my central motivation. So I consume. At times I am less attracted by the usefulness of facts than I am addicted to possessiveness. My possessiveness, with its attendant superficiality, values packaging more than the thing itself. How easy it is to become like a spoiled child at Christmas when the brightly wrapped packages, surrounded by twinkling lights and anxious parents, elicit expectation, excitement, and desire. Soon,

though, the emotional high has passed, the packages are all opened, and wrap and contents are strewn about. Disappointment and even despair move in.

I know that if I am not careful, I can easily be seduced by the novel and the controversial. If I had come to women's studies with my usual approach, I could, without recognizing what I was doing, reduce the study and its subjects to the level of a pastime, a plaything, a diversion, an entertainment, scripted according to whatever self-serving images I devised.

For me, knowledge is power. I need information and facts, for they have the ability to endow me with both power and authority. They enable me to control. Even though I now recognize this as a dangerous notion, there remains, nevertheless, a powerful predisposition to believe that when I've collected enough facts I will be in control. So, as I began to engage in women's studies, I had to consciously resist the temptation to go about gathering facts the way a lifelong resident of New York City gathers hen's eggs for the first time on an egg ranch: collecting them without concern for how they should be gathered, breaking several, never learning to recognize a fresh egg, and thus even putting round, smooth stones into the basket.

I also had to address the temptation to use the study of women merely for "figuring them out" so that I would then know "what to do with them." I knew that if I were not vigilant I could easily have opted for my functional theological approach. I could simply develop nice, neat categories that I could then use to "put things in perspective," which is a euphemism for "putting things and people in their place," or enslaving them, or exiling them from my consciousness. Doing this with women and women's studies certainly would have saved time and energy.

I realized that this proclivity to categorize is related to the tendency to patronize. On several occasions I have experienced painful relationships in which sincere people confused knowing *about* me with knowing me. Even with these experiences fresh in my memory, I was tempted to enter into my encounter with women's studies in that way.

INSIGHTS FROM CAROL OCHS

I have always understood the foundation of my spiritual life to be a struggle for salvation, a struggle facilitated by the grace and mercy of God, but nonetheless a lonely journey that I had to take by myself. As an old spiritual says, "I've got to walk this lonesome valley, I've got to

walk it by myself. Oh, nobody else can walk it for me, I've got to walk it by myself." The idea that spiritual development is a struggle that is shared with other people never surfaced. The significance of the dependency that I had experienced since infancy and the mutuality of my marriage remained irrelevant to my spiritual life. Thus the full meaning of salvation as the overcoming of separation remained elusive.

Of course there were things "essential to my survival" that I was told to take with me on my journey. A fundamental piece of equipment, the fathers told me, was reason—abstract reason. I was told that if I packed it and it carried well that I could lighten my burden of nonessential things such as emotion and feelings, excess weights that encumber travel. The fathers eagerly provided me with a map that identified my destination as maturity and that set a course through the only sure way to get there, through the valley of individuation. One gentleman, who appeared particularly wise, pressed home that above all else I had to separate myself from my environment.

It was only after I had got well into my journey that I met someone who told me that these well-meaning men were mistaken. The object of my longing would not be found by taking a journey but by "staying home" and experiencing and knowing my interconnectedness. I needed, she said, to come into relationship with reality. At the time her saying mystified me.

At the beginning of my journey I was advised to stay particularly alert for the extraordinary, for it was ultimately (and I had heard some say exclusively) the extraordinary that would help me through the tortuous miles of ascetic "decentering" that was near the boundaries of my destination. It did not occur to them or to me at the time that decentering was a much more common and earthy phenomenon that resulted from true devotion. I didn't even have a clue then that decentering occurs first and foremost from physical caring. I'm not sure why, but I did not then remember my wife who simply does what has to be done, whose spiritual development, devoid of haughtiness and apparent effort, just seems to gracefully unfold.

I was warned that there would be numerous snares and temptations along the way. But, I was reminded, my heavenly Father, who, they said, judges all creation from his throne, would evaluate my spiritual progress in terms of his plan (ideal form). I could count on him to keep me according to the schedule and on the specified route. I could be sure that he would inform me if I strayed from the path and went too fast or too slow.

As I look back now, I realize that at the time I began I forgot to ask about the physical and psychological part of my journey. It simply

did not seem necessary for me to query something so obvious. Usually all of me goes when I travel. It was only later that I discovered that those who had sent me on my way didn't account for physicality. To them God created in a nonphysical way and thus they believe that nonphysical creations are more divine than physical ones. This, I came to discover, had profound implications for my journey.

Those who sent me on my way, it turned out, were highly skilled in journey recruitment and planning, map making, equipping, and encouraging, but few had followed their own plans and recommendations. Because they operated on the assumption and the illusion that to achieve enlightenment one must be other-worldly, they could not anticipate, let alone prepare me for, the physical and psychological challenges and demands that I would encounter. (I suspect that they were not interested in doing that either.)

The journey has been extraordinarily difficult. I'm quite sure now that I was given the wrong instructions. As I reflect on my experience, it seems to me that there is probably not just one way to spirituality. (This should not be confused with the universalistic idea that there are many ways to God.) I have also learned that when I encounter a definition of what it is to be human and find that it is not true to my experience, the definition may be insufficient and I should look for other perspectives. For example, "fathering" may be only a partial image of humanity; my friend offered to me another image: mothering.

I have had to learn the hard way that everything I had experienced and encountered along the way was as important as where I was headed. I regret that when I began I did not realize that the model of spiritual maturation as a journey carried with it the view that events and experiences in my life had meaning and value only insofar as they contributed to the goal of the journey. The consequence was that living itself never did, nor *could* for that matter, have value in itself. I was simply astounded when I become aware that I (as well as other human beings) do not even experience life in a linear, developmental fashion.

Because I had accepted the judgment of others as to what was "real" in my world, much of what I had done, experienced, and suffered in my daily life was trivialized. When I first heard the suggestion of needing to live life and to enjoy it, I felt insulted. I thought I already knew how. But, in time, I began to listen to it as an invitation. It became especially alluring as I gradually became aware that spirituality is more than a journey filled with obstacles and traps to scramble over and struggle with, that it cannot be reduced to being only a flight from "tainted fleshly existence" to an unworldly life that is more real.

It was then that I began to discover my commonality and connectedness with others. I did not, as a seeker, need to deny this world and my experiences of it in order to find reality. As had been purported, the world was not a trap that distracted my soul from other-worldly reality. Instead, I came to find out, it existed in conjunction with other-worldly reality. And I stand at that conjunction as a cocreator and a colaborer with God, at one with him in Jesus Christ, the Incarnate Word.

PERSPECTIVE

As I write this I am very much aware that my spirituality has been profoundly affected and marked by my encounter with women's spirituality. I have grown from understanding spirituality as merely a way of knowing to encountering it also as a way of being and doing that involves my deepest religious beliefs, convictions, and patterns of thought, emotion, and behavior as they have developed and continue to develop over the course of my life in relation to God (Carr 49).

Engagement with the perspectives and experiences of women has contributed to my process of letting go of earlier images of myself and the life that went with it. As I have responded to the offering of new experiences and insight, both my self-understanding and my understanding of the world have been deeply affected. I have for the first time begun to seriously encounter the fundamental differences in styles of understanding and relationships that exist between men and women. I have found that one of the most significant challenges is to my analytic view of spirituality.

While I have been trying to define what I knew and to find explanations for it (including an apology for it), women have been working at understanding, at creating a synthesis. They have given me an invitation to come in out of the cold, alienating world of the objective and have affirmed for me the value of the affective and the aesthetic as a full partner with the cognitive and behavioral. My way of doing things, indeed my life, has always been defined by a goal and has been regulated by the clock. The focus of women's spirituality on process and its understanding of time as process has caused me to become much more aware of, and resident in, the present—what is going on in and around me.

For some years now, I have been moving away from the typical male hierarchical understanding of relationships toward an understanding that is more peer-oriented and typical of females. My center

of focus is now somewhere between the exclusive male focus on self and work and the female's centering on her network of relationships.

It has become important for me to understand that my relationship to sexuality and to intimacy is probably significantly different from that of females. Generally speaking, for me as a male, sexuality is central, whereas for women, it is a part of the whole. My main concern in regard to intimacy tends to be primarily with physical intimacy, while a woman is more oriented toward verbal intimacy.

Men have usually understood friendship as a team effort, as something that remains essentially external and somewhat detached, a behavior where everyone does his part. In contrast, the female has understood friendship as being more internal and involving attachment, as knowing and being known.

I have been especially fascinated by the notion that for me as a man, power has a zero-sum quality, it has to be carefully regulated and guarded. But women understand it as being limitless. This difference in the understanding of power seems to be closely related to the different views of money: men tend to view money as being absolute and real, while women view it as being relative and symbolic.

From my earliest recollection, leadership has meant to lead in the sense of being ahead of others. Women, on the other hand, have perceived it as enablement, connoting service. Negotiation, for me as a white male, is centered in winning; for the female, negotiation is framed in creativity (Anne Wilson Schaef, *Women's Reality*, qtd. by Carr in Conn 51, 52).

To begin to understand and approach love as a way of living, it has been helpful for me to reflect on it as it was first experienced within the child-mother relationship. As love was manifested as physical caring that was both nonpossessive and nonmanipulative, it offers a way of coming into relationship with reality that "engenders freedom and transforms the lover and the beloved." Because I have been loved, I am free, and I can freely pass on the gift (Ochs 15, 16).

Work, which is what I do and how I act, is one of the primary ways in which I understand my relationship to others and the world. Like love as a way of living, work began with the "enormous gift of my mother's love." It is that love that presaged my "being and my well-being." Work, then, becomes for me a way to make reparations for what I have received. It is how I can make a contribution; it is my way to give. The work per se, though, is not what is important. The value is found in my relationship to the work, the discipline involved in the work, and the dedication learned from it (Ochs 16–17).

I have often found life in community to be a frustrating experience. Perhaps this is because of my first experience of community. Early in my life, I, like other infants, became aware that I live in

relationship. This probably occurred when my mother did not meet some particular need of mine and I learned that she was not an extension of me. When I sensed separateness, frustration and fear resulted. But, as Ochs suggests, community also made possible my first love. Because of my mother's action, I discovered that she was alive and real. Applying this perspective to the ambivalence that I experience now, it seems that when I have sought some group, it has been for the purpose of finding a place where I could move from being one of "us," as a discrete member of a group, to being "I" in community, where I could find unity. When the members of the group, like my mother before, do not anticipate my desires, I feel frustrated, but their unpredictability also convinces me that they are alive and real. Community, then, is where I come to recognize shared value, where I can discover reverence for life and where my concern is expanded to include larger and larger aspects of life (Ochs 17–18).

Like others, I have worked very hard to "get it together," to achieve an integrated self. Therefore, the injunction of traditional spirituality to deny myself, in effect to destroy myself, has not been received as particularly good news. Yet, while achievement of integration is an important accomplishment, I have been aware that it can also harbor a major obstruction.

When I make myself the center of my universe, I see only what affects me and perceive things only as they have an effect on me. The result is pain, loneliness, and repeated disappointments. Occasionally, when I have entered into someone else's world or story, I have experienced freedom both from self-consciousness and from self-obstruction. I have experienced decentering.

Decentering has almost always been presented to me in some form of asceticism. I was encouraged to overcome whatever preferences or aversions I had by challenging them. Since the spiritual life was viewed as extraordinary, my temptations and worldly attachments had to be addressed in an extraordinary fashion. When I encountered Ochs' idea of decentering, I think it is fair to say that I was astounded. She suggested that the decentering I was taught to seek through asceticism could be accomplished as well (or better) through devotion. She describes devotion as "first and foremost physical caring."

> In caring for their infants, mothers don't seek to mortify their sensitivities—they simply know that babies must be diapered and that infants who spit up must be cleaned. They count their action as no great spiritual accomplishment. By merely doing what must be done, their spiritual development proceeds without pride and without strain—it gracefully unfolds. (Ochs 18, 19)

It is a fundamental way of being in the world.

EXPERIENCE

As I have begun to understand spirituality as involving total human development, I have become painfully aware of how problematic women's spiritual development has been and continues to be. Over the span of the last several months, the character of their struggle has been slowly but persistently working its way into my consciousness as I have sought to confront and engage the reality of their experience. I have found four areas of the experience of women to be particularly salient: their exclusion from ministry, the effects of socialization, the masculinizing of religious experience, and the restrictiveness of an exclusively male God (Schneiders 31–48).

Exclusion From Ministry

As I have reflected on the more than twenty years that I have been associated with the church and ministry in one form or another, I have been slow in realizing that the real possibility for women to participate in any official form of ministry in the church has often been missing. Ministry, as I have understood it as a male, has been generally closed to women. There has been only one occasion that I can recall when a woman was allowed a public or independent role in the church and even that was male-dependent. I must also confess that I cannot grasp the full significance of the fact that men make the religious rules that women are required to live by, and men administer the sacraments and govern the church. I cannot fully relate to how it would have felt as a professional minister to have had others refer to me in some such way as I have heard women referred to: "the daughter of," "the mother of," or "the wife of" some male person.

The role for women in the official functioning of the church is given the designation of "help-mate"—which, being translated from the *male* text, means supporter of men in their ministries and in their advancement to higher levels of church authority and/or to ever-larger churches. On the other hand, the considerable work that women have undertaken over the years on behalf of Christ and his church has been called "auxiliary" service. I have never heard anyone argue that such services are not essential, but they have never been able to earn the designation of "official services."

Women have never done ministry, they have always *helped* in ministry. I remember many occasions when a pastor was seeking a

church position, it was simply assumed that his wife would come along as part of a package deal. She was expected to run the Sunday school, supervise vacation Bible school, and, of course, play the piano. (If she couldn't play the piano, the pastor would not get the job.)

It is not particularly surprising that women seldom considered themselves called to ministry.

As Sandra Schneiders points out (33–35), this kind of experience has had profound consequences. Because women are excluded from serving Communion, reading the Word of God in public, teaching men, and leading in public prayer, they develop early in life a sense of being of no use to God or other people. This is exacerbated by the fact that, in most contexts, they cannot approach God except through a man. Because official participation in the church has been so severely restricted, few models of women shape the religious imagination of girls as they mature.

The Effects of Socialization

In reviewing how the church has functioned to socialize women into conformity and predetermined passive roles, it seems that Conn (3) is correct in observing that their opportunity for maturity and autonomy (i.e., self-direction, self-affirmation, and self-reliance) is severely limited.

One example of this is the way in which women have been excluded from shaping the church's internal and external policies. This work has often belonged exclusively to male groups, such as deacons. (Deaconesses are separated out to "serve.") Women have sometimes been asked for their opinions regarding proposed policies, but they have been excluded from making those policies even when the policy profoundly impinges on their lives (Schneiders 35).

Because women have been socialized to private, male-dependent roles in the church, they have rarely exercised religious leadership except in those areas that have come to be known as auxiliary enterprises, such as the women's missionary society. I have rarely known a woman to question or to do other than accept as normal men's monopoly of leadership and authority. Significantly, they have appealed to sacred writ (taught and interpreted to them by men) as their mandate for accepting their relegation to subordinate status and the passivity that characterizes it. Women have continued on, apparently unaware that their very status may have kept them from asking if their condition was indeed biblically mandated or if it was rather something that they have grown into and found security in over many years and centuries.

Since women have always experienced themselves as subordinate

to men and have been dependent on men for affirmation and approval, they have remained unwilling and unlikely to do anything to jeopardize that tenuous relationship. In fact they are often threatened by anything that presents a danger to that relationship, such as the emergence of leadership potential in other women (Schneiders 36).

The Masculinizing of Religious Experience

For many years I did not recognize the significance of the fact that most theologians, counselors, spiritual directors, preachers, and teachers are men. I had no idea of, or even interest in knowing about, how women's lives have been affected by the theology, ethics, and aesthetic sense that men had developed. I was ignorant of the existence of a feminine approach to the spiritual life that might be quite different from my own (Schneiders 38). In short, I fell victim to the age-old trap of egocentricity and succumbed to the easy route of generalization. I assumed that spirituality for women, as well as for everyone else who was not a white Anglo-Saxon Protestant male, was no different from my spirituality. I felt fortified in my position by the notion taught long ago that as God's children we all see things in the same way.

One of the tragic outcomes of my ignorance has been my tendency to join with other men in warning women away from "specifically male vices" such as pride, aggression, disobedience to lawful hierarchical structures, and lust. But I have failed to alert women to the vices of weakness, submissiveness, fearfulness, of being filled with self-hatred, jealousy, timidity, self-absorption, small-mindedness, the submersion of personal identity, and manipulation (Schneiders 39). These seemed to me suitable behavior for women—but never for men.

Throughout my years of development as a Christian, people often suggested that I should seek to know God primarily, if not exclusively, through the intellect. In a variety of ways it was implied that I should not "play around" with knowing God through the affectual part of my being; on more than one occasion, such a search was called not only fruitless but also potentially dangerous. For example, when on very rare occasions instruction was given in prayer, the focus was always on the method of prayer. Intuition in prayer never merited consideration.

Moreover, the spiritual life was always represented as Christian warfare. "Onward Christian Soldiers" was sung nearly every Sunday. Of course, the ideal model was typified by a combat soldier. For some reason there was an inability to discover Jesus as friend and an unwillingness to identify such a feminine quality as vulnerability

with the One before whom every knee shall bow. Images such as this seemed to lie beyond the purview of the then-prevailing masculinized understanding of sanctification (spiritual formation). Consonant with a military model, asceticism was preferred to mysticism, and submission to authority was preferred to personal initiative in interpersonal relations in the church and in relations with God (Schneiders 39).

As a good Christian soldier, I would never have recognized nor would I have looked for evidence of feminine experience and feminine models in Scripture. If I had inadvertently stumbled across one, I would have been chagrined, to say the least. I was trained by and with men to fight a man's fight. I was encouraged to choose for myself a model who was one of the great heros of my faith—a hero who exhibited courage and bravery as he pressed his quest unrelentingly and unswervingly in the name of a noble cause toward a celestial goal while overcoming indescribable adversity. With such an orientation how could I ever have hoped to enter into the story of Leah? That record portrays heroism in terms of the more natural processes of "becoming open to those forces that transform us; . . . by being able to endure and find nourishment even in the most arid times; . . . and by being able to live and pass on the gifts of life, trust, openness, and the capacity to love" (Ochs 34).

In contrast to the repeated admonition for boys to "dare to be a Daniel" and thus grow into Christian heroes, "women have rarely been encouraged to imitate the great women of salvation history." Instead, they have been "conditioned to evaluate anything in their spiritual experience that seemed especially feminine as questionable or negative"—e.g., compassion, gentleness, and passivity in prayer. They have been taught to value the masculine in themselves, to think and pray in masculine ways (Schneiders 40).

An Exclusively Male God

Because God has been cast only in male terms, many women have felt a deep sense of exclusion from him. My language betrays my inability to identify with how they have felt as outsiders in relation to God—notice how easily I have written about women's feeling of exclusion from *him*. Yet at times I have felt some of the pain as I have read passages such as James 1:12: "Blessed is the *man* who perseveres under trial, because when *he* has stood the test, *he* will receive the crown of life that God has promised to those who love *him*" (my emphases).

Women have often experienced God the way they have experienced men. Thus they have come to understand their value not in terms of who they are but in terms of what they do. They feel that

their worth has been measured by their sins without regard for their character. Many women have learned how to admire, depend on, and defer to God, with the result that they have often easily come to feel "dominated, used, undervalued and basically despised by God. They are ever guilty, a nuisance, and can justify themselves only by unrelenting service, continual performance and lowly self-efface-ment." Because of the deep sense of shame, it is understandable why they "instinctively feel that they must go to God through and by permission of men" (Schneiders 42, 43). They certainly cannot go to God themselves!

THE RESPONSE OF WOMEN

The exclusion of women from ministry, their socialization, the experience of having their religious experience masculinized, and their exposure to an exclusively male God have contributed to women's sense of powerlessness, servitude, and suffering. Yet without justifying or condoning the conditions leading to this sense, many women have found meaning in their experience by exercising their creativity and freedom. They have come to know that they are indeed more than what others have done to them.

As they have lived with the chronic pain of exclusion from ministry through years of church history, women have discovered that because their ministry has rarely been recognized or named it has rarely been ritualized. Therefore, they have been able to carry on God's business unencumbered by the restrictions that identification and role formalization have placed on the ministry of men. Women's ministry has been able to remain, simply, "the personal service of one human being to another in the name of Christ." It has "never lost its entirely personal and interpersonal character" and has usually with-stood the tendency to become an exercise of power or social control or a means to discipline someone (Schneiders 34).

Without benefit of official title or ordination, women have faithfully continued to serve as spiritual directors for children, "initiating [them] into the Christian experience at every level" of their development. Much like the pastor, they have "heard the anguished avowals of the guilty and loved them to reconciliation." As the celebrant at Communion would lead a congregation in worship, they have "made meal times experiences of Christian unity." Like the pastoral counselor, they "have consoled the sick and assisted the dying into the arms of God" (Schneiders 34).

In spite of the debilitating effects of society's continuous pressure

on women to conform and to be content in predetermined passive roles, combined with the church's subordination of them to men in ministry, women have accumulated more experience of men in ministry than men have of women. As a result, women are better prepared for entering into partnership with men in ministry than men are with women (Schneiders 37). I have to wonder if some of the resistance that I have felt toward women in ministry has been less a matter of biblical precedent and more a matter of my own inexperience with women in ministry.

American culture prescribes the private world as the proper domain for women and the public arena as the kingdom for men. As a result, women have developed an advantage over men. It has been comparatively easier for women to move out of the private sector into public roles and adjust to them than it has been for men to move from public roles to private ones. The skills needed in the private world, such as empathy and a sense of the tone of a complicated situation, are more difficult to learn, especially later in life, and without the benefit of the years of practice that most women have had (Schneiders 37).

In the world dominated by males, the primary concern has been with the institution and the "bottom line." Holding firm against the advancing tide of materialism and market economy and its threat to submerge everything in its wake, women have steadfastly resisted the forces that seek to establish the institution as the only high ground. They have continued to work to hold back the waters that would wash away the human and interpersonal qualities of interaction by emphasizing mutuality, shared responsibility, nonauthoritarian policies and procedures, and basic humanness in operation.

In the limited history of the involvement of women in the institutional life of our society, women have frequently been victimized by hierarchical organizations and have seldom been allowed to be full participants in it. Instead of seeking to destroy the institution, letting it destroy them, or allowing themselves to simply become a part of the system, they have, in many cases, been able to name and own their experience and repudiate for others that from which they themselves have suffered so much. As a result, they have been free to express their creativity. They have found it easier than men to imagine and create nonhierarchical structures and to talk of participative government, shared authority, noncoercive discipline, empowerment, and mutuality (Schneiders 37, 38).

Even though God has been presented to women in an exclusively male fashion that has caused many to feel they are not included among "the Godlike," women have developed a valuable sense of the "otherness" and noncontrollability of God that far exceeds that of

men. They have also developed a greater sensitivity to the "reality of God's actual and free intervention in their lives" and they have become less ready than men to explain this intervention away or attribute it to talent or luck. They have become "more ready to appeal to God for help and believe that God can and will respond." "Because they have not experienced themselves as representatives of God, they have almost never taken it upon themselves to persecute others in the name of God." Finally, "women have specialized in the one area where they could without male permission or help"—prayer (Schneiders 43).

CONCLUSION

As I began my study of women's spirituality with reading *Reinventing Womanhood* by Carolyn Heilbrun, I was immediately challenged to reevaluate the very procedure and method I intended to follow in my work. I felt compelled to go beyond the accepted, traditional method that promised to lead me to an objective accumulation of facts and ultimately to the mastery and subsequent control of this area of reality.

I discovered in Parker Palmer's *To Know as We Are Known* an orientation to knowing and understanding that offers an alternative, a way of encountering and engaging women, their perspectives, their experiences, and their stories: a covenant in which I, *with* women, as well as with other men, could engage in a "mutually accountable and transforming relationship forged of trust and faith" (Palmer 31).

Reflecting on my brief encounter with women's spirituality, I am aware of many times when I have felt challenged, stretched, and even, on occasion, intimidated. At times I found things to be incongruent with my understanding and my experience. I suspect that that will continue to be the case. The object of my work was not to find points of agreement and disagreement, nor to label things truth or error. My purpose was not so much to think about life—though I found it very difficult to abandon this approach—but to enter into it, to learn to understand from the viewpoint of daily life, and to comprehend it as others who inhabit it do, especially those who have been marginalized in our society. I have sought a perspective that would serve to deepen my own and others' life with God.

I have come to recognize that the failure to take the experience of women seriously, thereby helping them neglect to name or even to misname their experience, will profoundly affect my spiritual life and the spiritual life of all people. Subjecting women to such abuse will

result in the cessation of those experiences. If that should occur, we will all lose some of life; we will become estranged from life and live unauthentically. We will begin to twist ourselves in order "to make our experience conform to what counts as 'real experience' in the prevailing system" (Ochs 25).

Lastly, I have become profoundly aware that there are many places where I have taken my stand with the oppressors. One of the laws of justice and mercy in Exodus states, "Do not oppress an alien; you yourselves know how it feels to be aliens, because you were aliens in Egypt" (Exod. 23:9). As I have become able to "know how it feels to be (an) alien," and begun to identify and name those of my beliefs, attitudes, values, and behaviors that are oppressive, I have experienced growing freedom. I have begun to know the reality of what has until now been only a concept for me, namely, that when I am an oppressor, whether overtly or covertly, consciously or unconsciously, I am also oppressed.

Works Cited

Carr, Anne. "On Feminist Spirituality." *Women's Spirituality: Resources for Christian Development.* Edited by Joann Wolski Conn. New York: Paulist Press, 1986.

Conn, Joann Wolski, ed. *Women's Spirituality: Resources for Christian Development.* New York: Paulist Press, 1986.

_____. "Women's Spirituality: Restriction and Reconstruction." *Women's Spirituality: Resources for Christian Development.* Edited by Joann Wolski Conn. New York: Paulist Press, 1986.

Heilbrun, Carolyn. *Reinventing Womanhood.* New York: Norton, 1979.

Ochs, Carol. *Women and Spirituality.* Totowa, N.J.: Rowman & Allanheld, 1983.

Palmer, Parker. *To Know as We Are Known.* San Francisco: Harper & Row, 1983.

Schneiders, Sandra M. "The Effects of Women's Experience on Their Spirituality: Resources for Christian Development." *Women's Spirituality: Resources for Christian Development.* Edited by Joann Wolski Conn. New York: Paulist Press, 1986.

For Further Study

Discussion Questions and Writing Suggestions

1. Male spirituality is characterized as being other-worldly. Women's spirituality holds that our world is not wrong and we do not need to escape it. It is, rather, our way of relating to the world that is either right or wrong. How does women's spirituality help you understand your relationship to the world?

2. Carol Ochs writes that the male journey model of spirituality carries with it the view that each part of our life has meaning and value only insofar as it contributes to the goal of the journey. Living itself is not considered intrinsically valuable. The only value is the goal we long to achieve. Is the journey model the only one that is biblical? How has the journey model affected your spirituality?

3. In examining the role of experience in your spirituality, weigh each of the following statements. Do you agree or disagree? Why?

 • I should view those experiences that distract from the life of works and prayer as suspect.

 • When I ignore the usual and focus on the transcendental, the paranormal, or the unusual, I begin to devalue much of what I do and experience, and I develop the tendency to "seek rarefied experiences." As a result, I do not attempt to gain insight into all that occurs to me.

 • Experience can lead me into self-centeredness and self-gratification.

 • Comparing my experiences with those of different people can cause me to classify and rank them and lead me to deny experiences such as anger, boredom, etc. It can also keep me from feeling and claiming my experience for myself.

 • Measuring my experiences against external standards can lead to inauthenticity.

 • Focusing on emotional experiences alone can lead me to confuse the experience with the reality that underlies it.

4. Do you experience love as a fleeting sensation, a sentimentality, or as a way of devotion, physical caring, and emotional concern? How would the way of experiencing love that you *do not* now know affect your spirituality?

5. Is women's spirituality congruent with the traditional "plan of salvation" or does it require that the plan be feminized or rejected?

Shorter Reading List

Conn, Joann Wolski, ed. *Women's Spirituality: Resources for Christian Development*. New York: Paulist Press, 1986.

Ochs, Carol. *Women and Spirituality*. Totowa, N.J.: Rowman & Allanheld, 1983.

Palmer, Parker. *To Know as We Are Known*. San Francisco: Harper & Row, 1983.

Longer Reading List

Dillard, Annie. *An American Childhood*. New York: Harper & Row, 1987.

Jones, Cheslyn, Geoffrey Wainwright, and Edward Yarnold, SJ, eds. *The Study of Spirituality*. New York: Oxford University Press, 1986.

Julian of Norwich. *Showings*. New York: Paulist Press, 1978.

L'Engle, Madeleine. *The Crosswicks Journal, Book 1: A Circle of Quiet*. New York: Seabury, 1972.

_____. *The Crosswicks Journal, Book 2: The Summer of The Great Grandmother*. New York: Seabury, 1974.

_____. *The Crosswicks Journal, Book 3: The Irrational Season*. New York: Seabury, 1977.

Lovelace, Richard F. *Renewal as a Way of Life*. Downers Grove: InterVarsity, 1985.

Richards, Lawrence O. *A Practical Theology of Spirituality*. Grand Rapids: Zondervan, 1987.

Senn, Frank C., ed. *Protestant Spiritual Traditions*. New York: Paulist Press, 1986.

Teresa of Avila. *The Way of Perfection*. New York: Doubleday, n.d.

GENERAL INDEX

Abolition movement, 85, 99–103
Adam, 56–58, 71, 168–69
Adams, Abigail, 94
Adams, John, 94–95, 160
Adams, Maurianne, 139
Addams, Jane, 104
Alcott, Louisa May, 125
Allen, Ronald and Beverly, 38
American Revolution, the, 94–95
Amherst Academy, 173
Amherst College, 173
Anderson, Charles, 188
Angels, 68
Anguissola, Sofonisba, 209
Antinomianism, 93
Apocrypha: Ecclus. 42:9–14, 61; Ecclus. 42:13–14, 60; Sirach 25:24, 60
Aquinas, Thomas, 27
Art: feminist view of, 199–203; sociology of, 200; women artists in history of, 203–14
Art history: and genius, 200–201; and isolationist methodology, 200; lack of female presence in, 199–203; and women artists, 203–14
Art Institute of Chicago, 212
Art Student's League (New York), 212
Atwood, Margaret, 120
Auerbach, Nina, 133
Austen, Jane, 121
Authority, 241

Bach, Johann, 199–200
Baptism, 64
Bartchy, Scott S., 65–70
Barthes, Roland, 133
Bartók, Béla, 208
Basile, Adriani, 204
Basinger, David, 42–45
Baumgartner, Alice, 224
Baym, Nina, 124
Beach, Amy Cheney (Mrs. H. H. A. Beach), 207

SCRIPTURE INDEX